BABETTO

The Entity of Being
L'Entità dell'Essere
Die Einheit des Seins

BABETTO

The Entity of Being
L'Entità dell'Essere
Die Einheit des Seins

With contributions by
Fred Jahn
Friedhelm Mennekes
Andrea Nante
and Thereza Pedrosa

arnoldsche

Acknowledgements Ringraziamenti Danksagung

Thereza Pedrosa
P. Friedhelm Mennekes S.I.
Fred Jahn
Andrea Nante

Arnoldsche:
Dirk Allgaier
Matthias Becher
Isabella Flucher
Silke Nalbach
Wendy Brouwer

Studio Babetto:
Camilla Babetto
Maria Bertin
Sabina Bertin

Fondazione Giampaolo Babetto

Table of Contents

6
Thereza Pedrosa
Tension and Harmony
Tensione e armonia
Spannung und Harmonie

30
Friedhelm Mennekes
Giampaolo Babetto: Between Craft, Art and Architecture
Giampaolo Babetto tra artigianato, arte e architettura
Giampaolo Babetto zwischen Handwerk, Kunst und Architektur

 53
 Sacred Sacro Sakrales

 73
 Jewellery Gioielli Schmuck

234
Fred Jahn
Giampaolo Babetto's Drawings as Part of a Diverse Œuvre
I disegni di Giampaolo Babetto come parte integrante della sua opera universale
Giampaolo Babettos Zeichnungen als Teil seines universellen Œuvres

 243
 Drawings Disegni Zeichnungen

 251
 Silver Argenti Silber

 269
 Furniture Mobili Möbel

 281
 Architecture Architetture Architektur

 293
 More Works Altre Opere Weitere Werke

302
Andrea Nante
Giampaolo Babetto: The Man, the Artist
Giampaolo Babetto: l'uomo, l'artista
Giampaolo Babetto: der Mensch, der Künstler

319
Appendix Appendice Anhang

Thereza Pedrosa

Tension and Harmony

Beyond categories

For many centuries there was a distinct separation between arts and crafts; painting and sculpture were classified as arts whereas the goldsmith's art was relegated to the category of crafts. A process of renewal of jewellery was launched throughout the twentieth century in Europe and the United States that led to a review of this historic distinction. Nevertheless, while it is true that, especially after the Second World War, sculptural and visual artists felt freer to make forays into the various forms of art, breaking down the strict existing boundaries, it is equally true that many contemporary jewellery artists shut themselves up within their own category, rarely trespassing over the marked borders. Giampaolo Babetto has the inestimable merit of having ventured beyond the historic delimitations, ranging into the various artistic sectors with tenacious fervour, believing in his work and addressing every new field of research professionally and with the utmost dedication. Shattering the stigma of categories and the hierarchisation of the arts, Babetto has brought contemporary artistic jewellery to the

Tensione e armonia

Al di là delle categorie

Per molti secoli si è imposta una distinta separazione tra arti e mestieri, dove pittura e scultura facevano parte della prima mentre la gioielleria era relegata alla seconda. Nel corso del XX secolo si innesca tuttavia in Europa e negli Stati Uniti un processo di rinnovamento dell'oreficeria che porta a una rivalutazione di questa storica distinzione. Ma se è vero che, soprattutto dopo la seconda guerra mondiale, artisti plastici e visuali si sono sentiti più liberi di spaziare tra le varie forme d'arte, spezzando i rigidi confini esistenti, è altrettanto vero che molti artisti del gioiello contemporaneo si sono rinchiusi nella propria categoria, raramente fuoriuscendo dai confini tracciati. A Giampaolo Babetto va l'inestimabile merito di aver oltrepassato le delimitazioni storiche dell'oreficeria, spaziando nei vari settori artistici con fervore e tenacia, credendo nel proprio lavoro e affrontando ogni nuovo ambito di ricerca con estrema professionalità e dedizione. Spezzando lo stigma delle categorie e della gerarchizzazione delle arti, ha portato il gioiello d'autore contemporaneo all'attenzione di collezionisti d'arte, curatori e musei di fama internazionale, contribuendo più di qualsiasi altro artista orafo contemporaneo a raggiungere l'obiettivo, ambìto fin dagli anni '60 del Novecento, dell'elevazione del gioiello come vera e propria forma d'arte, al fianco di scultura e pittura.

Spannung und Harmonie

Jenseits der Kategorien

Jahrhunderte lang galt eine strikte Trennung zwischen Kunst und Handwerk: Malerei und Bildhauerei wurden zu den Schönen Künsten gezählt, Schmuckgestaltung zum Handwerk. Erst im zwanzigsten Jahrhundert kam es in Europa und in den Vereinigten Staaten zu einer Erneuerung der Schmuckkunst, die auf eine Aufhebung dieser Dichotomie zielte. Besonders in der Nachkriegszeit bewegten sich Vertreter der plastischen und visuellen Kunst mit neu gewonnener Freiheit zwischen den Kunstformen und jenseits eingefahrener Gattungsdefinitionen. Gleichzeitig ist nicht zu leugnen, dass viele zeitgenössische Schmuckdesigner kaum den Blick über den Horizont ihres Gewerbes hinaus richten. Giampaolo Babetto kommt vor diesem Hintergrund das Verdienst zu, die historischen Grenzlinien seiner Kunst überwunden zu haben. Mit Beharrlichkeit und großem kreativen Elan betätigt er sich auf den verschiedensten Feldern der Kunst und stellt sich jedem neuen Arbeitsfeld mit einem Höchstmaß an Professionalität und künstlerischer Hingabe. Babetto sprengte die Kategorisierung und Hierarchisierung der Künste und konnte dem zeitgenössischen Künstlerschmuck die Aufmerksamkeit von Sammlern, Kuratoren und Museen von internationalem Ruf sichern. Mehr als jeder andere zeitgenössische Schmuckkünstler ist ihm damit gelungen, was seit den 60er Jahren viele versucht hatten: Schmuck als

attention of art collectors, curators and world-famous museums. In doing so, he has contributed more than any other contemporary goldsmith artist to achieve the goal – pursued since the 1960s – of raising jewellery to the status of a true art form alongside sculpture and painting.

In Italy the first pioneering steps towards this updating of jewellery were made starting in the 1940s, not by goldsmiths but through the ingenuity of several individual artists and sculptors. Breaking out of their main sphere of investigation, they turned to jewellery design, infiltrating the goldsmith sector proper with the new, modern ideas that were spreading through the art world. In the early 1950s famous trailblazers of this practice were the brothers Arnaldo and Giò Pomodoro, whose jewellery experiments employed the ancient technique of cuttlefish-bone casting. This procedure, with its high level of unpredictability, was perfectly suited to their informal poetics.[1] The brothers were joined by many other artists, ushering in a new artistic season. The artists involved included Afro, Turcato, Tancredi, Novelli, Santomaso, Vedova and Scanavino, who were mainly interested in creations with symbolism and colours rich in material implications. Despite the difficulty of transposing into a small object made of precious metal the signs, gestures and forms that took shape on the canvas spontaneously, and often

In Italia i primi passi propulsori per questo aggiornamento dell'oreficeria, avvenuto a partire dagli anni '40 del Novecento, non provengono dagli orafi, bensì dalla genialità di alcuni singoli artisti e scultori che evadono dal loro principale ambito d'indagine, dedicandosi alla progettazione di gioielli e permeando l'ambito strettamente orafo con le nuove e moderne idee che si stanno diffondendo nel mondo dell'arte. A partire dai primi anni '50 sono noti precursori di questa usanza i fratelli Arnaldo e Giò Pomodoro, i quali ripropongono nella loro sperimentazione orafa l'antica tecnica di fusione con ossi di seppia. Tale procedimento, grazie alla sua forte percentuale di casualità, si adatta perfettamente alla loro poetica informale[1]. A loro si affiancano numerosi artisti, inaugu-

eine eigenständige Kunstform neben Malerei und Skulptur zu etablieren. Die entscheidenden Impulse zu einer Erneuerung der Schmuckkunst in Italien in den 40er Jahren des zwanzigsten Jahrhunderts gingen nicht von Goldschmieden und Schmuckgestaltern aus, sondern von einzelnen Künstlerpersönlichkeiten aus Malerei und Skulptur. Ihre genialen Kreationen überschritten die Grenzen der eigenen Disziplin und vermittelten zugleich der Welt der Schmuckgestaltung jene Ideen und Formen, die sich damals in der Kunst gerade Bahn brachen. Anfang der 50er Jahre agierten Arnaldo und Giò Pomodoro als Vorreiter dieser Entwicklung. Der seit der Antike bekannte Sepiaguss, mit dem sie für ihre Objekte experimentierten, überlässt dem Zufall großen Spielraum und entsprach damit dem am Informel orientierten Ansatz der Pomodoro-Brüder.[1] Ihrem Beispiel folgten zahlreiche weitere Künstler und begründeten damit die italienische Spielart des Informel, namentlich Künstlerpersönlichkeiten wie Afro, Turcato, Tancredi, Novelli, Santomaso, Vedova und Scanavino,

with a fair dose of randomness, there were many artists who tried their hand at jewellery production in this period.[2] Particularly famous among them, starting from the 1960s, were Fontana, Burri and Capogrossi.

The artists' incursions into the realm of the goldsmith were paralleled by the interest of other figures from the world of art and of jewellery. Mario Masenza, the owner of one of the oldest jeweller's in the city of Rome, was the first to grasp the importance of the artist's jewel. It was also thanks to his spirit of commercial enterprise – which led him into the exclusive production of unique creations designed by famous artists – that other jewellers realised the value of a concept encapsulated in a jewel and turned to artists for exclusive designs. Already in 1949 the Galleria del Milione in Milan displayed the jewels of Afro, Dino and Mirko Basaldella, Franco Cannilla, Emilio Greco and Renato Guttuso, among others. Then in 1967 GianCarlo Montebello established his goldsmith's studio to collaborate with Italian and international artists, including the American artist Man Ray and the Belgian sculptor Pol Bury. In Padua in the 1950s the gallerist Alberto Carrain was the first to take an interest in the works of the goldsmith artists of Padua, stimulating their personal and professional development, encouraging them, purchasing their creations and promoting them as works of

rando quella che si rivelerà essere una nuova stagione artistica. Tra questi si ricordano Afro, Turcato, Tancredi, Novelli, Santomaso, Vedova e Scanavino, i quali si interessano principalmente a grafismi in cui segni e colori sono ricchi di implicazioni materiche. Nonostante la difficoltà di trasporre in un'opera di ridotte dimensioni in metallo prezioso segni, gesti e forme che sulla tela prendono forma spontaneamente e spesso con una forte dose di accidentalità, sono molti gli artisti che in questo periodo sfiorano la produzione orafa[2]. Particolarmente noti, a partire dagli anni '60, sono Fontana, Burri e Capogrossi. Alle incursioni degli artisti in ambito orafo si aggiunge l'interesse di altri protagonisti del mondo dell'arte e della gioielleria. A Roma, Mario Masenza, titolare di una delle

die in Duktus und Farbgebung die Stofflichkeit des künstlerischen Materials bewusst hervorhoben. Mit Arbeiten an der Grenze zur Goldschmiedekunst stellte sich damals eine ganze Reihe von bildenden Künstlern der Herausforderung, die Formensprache der Malerei von der großen Leinwand in die reduzierten Dimensionen eines Edelmetallobjekts zu transponieren.[2] Als prominente Vertreter dieser seit den 60er Jahren wirksamen Tendenzen gelten etwa Fontana, Burri und Capogrossi.

Neben den Ausflügen bildender Künstler auf das Gebiet der Schmuckgestaltung spielte auch das wachsende Interesse von Vertretern der Kunstwelt und des Juwelierhandels an neuen Formen eine Rolle. Mario Masenza, Inhaber einer der ältesten Juwelierhandlungen Roms, erkannte als erster die Bedeutung des Künstlerschmucks und ließ exklusiv für seine Kundschaft Einzelkreationen nach Entwürfen von renommierten Künstlern fertigen – ein Beispiel, dem andere Juweliere folgen sollten. Schon 1949 wurden

art to all effects and purposes.[3] In the galleries he ran – La Chiocciola, La Stagione and, later, Adelphi – Carrain ignited the interest of his collectors in contemporary jewellery, displaying not only paintings and sculptures but also artists' jewels.[4] When Carrain met Babetto in 1969, he was fascinated by the talent of this very young artist and his innovative creations, and the encounter marked the start of a long collaboration. These meetings with figures from the contemporary artistic scene rapidly made Babetto realise the importance of opening up to the world of art without any self-imposed restrictions or historic censures.

And so, by creating a strong synergetic network between artists' jewellery and the collectors and art enthusiasts, the artists and the gallerists played a crucial role in the evolution of contemporary Italian jewellery. In recent years their fundamental contribution has been paralleled by a significant development in the sections devoted to metalworking in various vocational schools all over Italy. In the general post-war spirit of renewal and research, jewellery courses in the 1950s were in fact set up in many technical and artistic institutes. Among these, under the guidance of Mario Pinton, the Instituto Statale d'Arte Pietro Selvatico in Padua became distinguished for a new formal style related to an essential geometricisation of forms and a

più antiche gioiellerie della città, è il primo ad intuire l'importanza del gioiello d'artista ed è anche grazie alla sua intraprendenza commerciale, che lo porta a produrre in esclusiva creazioni uniche disegnate da artisti rinomati, se altri operatori orafi colgono il valore dell'idea concettuale racchiusa in un gioiello e si rivolgono ad artisti per ottenere disegni in esclusiva. A Milano già nel 1949 la Galleria del Milione espone i gioielli di Afro, Dino e Mirko Basaldella, Franco Cannilla, Emilio Greco, Renato Guttuso ed altri, mentre nel 1967 GianCarlo Montebello fonda il suo studio orafo per collaborare con artisti italiani ed internazionali, tra cui l'artista americano Man Ray e lo scultore belga Pol Bury. A Padova, negli anni '50, il gallerista Alberto Carrain è il primo ad interessarsi ai gioielli degli artisti orafi padovani, contribuendo alla loro crescita personale e professionale, incoraggiandoli, acquistandone le creazioni e promuovendole quali opere d'arte a tutti gli effetti[3]. Nelle gallerie che dirige, La Chiocciola, La Stagione e successivamente la Adelphi, il gallerista accende l'interesse dei collezionisti per il gioiello contemporaneo, esponendo non solo pitture e sculture, ma anche creazioni orafe di artisti[4]. È proprio Carrain che nel 1969 conosce un giovanissimo Babetto e, affascinato dal suo talento e dalle sue opere innovative, inizia con lui una lunga collaborazione. Questi primi incontri con i protagonisti della scena artistica del tempo fanno rapidamente capire all'artista l'importanza di aprirsi al mondo dell'arte, senza vincoli autoimposti o censure storiche.

in der Mailänder Galerie Il Milione Schmuck nach Entwürfen von Afro, Dino und Mirko Basaldella, Franco Cannilla, Emilio Greco, Renato Guttuso und anderen Künstlern gezeigt. In das Jahr 1967 fällt die Gründung des Goldschmiedeateliers – ebenfalls in Mailand – von GianCarlo Montebello, der sich auf die Arbeit mit italienischen und internationalen Künstlern wie Man Ray oder dem belgischen Bildhauer Pol Bury spezialisierte. In Padua schließlich ist es der Galerist Alberto Carrain, der sich in den 50er Jahren als Erster für die Kreationen der ansässigen Schmuckkünstler interessiert und ihre Arbeit durch Ankäufe und Ausstellungen unterstützt und fördert.[3] Indem er in den von ihm geführten Galerien (La Chiocciola, La Stagione und später die Galerie Adelphi) neben Malerei und Skulptur auch Künstlerschmuck ausstellt und diesem damit den Status von Kunstwerken einräumt, gelingt es Carrain, auch bei Sammlern das Interesse für die zeitgenössische Schmuckkunst zu wecken.[4] 1969 lernt Carrain den damals 22-jährigen Giampaolo Babetto kennen, von

marked interest in jewellery production carried out from the design phase through to realisation. The marquis Pietro Estense Selvatico, an art critic and architect who founded the art institute in 1867, was deeply convinced that manual skill, technical knowledge, historic culture and aesthetic research were different faces of the same prism that cannot and should not be considered separately.[5] Manual skill has no value without the concept that enriches it with meaning, the object cannot exist without the idea that creates it and, conversely, the creation cannot be complete if the idea is not combined with the technical capacity to develop it. This was the conviction underlying Selvatico's structuring of the institute, where the numerous craft workshops were accompanied by theoretical courses considered indispensable for the development of creative thought. His years of training at the Selvatico, and in particular the guidance of Mario Pinton, left an indelible sign on Babetto, who attended the institute from 1963 to 1966, studying architecture first and then metalworking. The artist himself recalls how the teaching of Professor Pinton was fundamental to his artistic training. 'I immediately recognised him as the Master to be followed, and I learnt how to approach design with rigour, sensitivity and respect for the materials, and all these elements continue to be important in my research.'[6]

Gli artisti e galleristi, creando una forte rete di sinergie che dal gioiello d'autore arriva ai collezionisti ed agli appassionati d'arte, hanno dunque un ruolo rilevante nello sviluppo del gioiello contemporaneo italiano. Al loro fondamentale apporto si somma in questi anni un significativo sviluppo delle sezioni dedicate alla lavorazione del metallo presso alcuni istituti professionali di tutto il territorio nazionale. Negli anni '50, nel generale spirito di rinnovo e ricerca del dopoguerra, nascono infatti indirizzi scolastici dedicati all'ambito orafo in varie scuole professionali d'Italia. Tra queste l'Istituto padovano Pietro Selvatico si distingue, sotto la guida di Mario Pinton, per uno stile formale nuovo, legato ad una geometrizzazione essenziale delle forme e all'indiscusso interesse per una produzione orafa eseguita dalla progettazione alla realizzazione. Critico d'arte e architetto, il marchese Pietro Estense Selvatico, fondatore dell'Istituto nel 1867, è profondamente convinto che abilità manuale, conoscenze tecniche, cultura storica e ricerca estetica siano diverse sfaccettature di un unico prisma, che non possono e non devono essere considerate separatamente[5]. La manualità non ha valore senza il pensiero che arricchisce di significato, l'oggetto non può esistere senza l'idea che lo crea e d'altra parte la creazione non può essere completa se all'idea stessa non si unisce la capacità tecnica di svilupparla. È con questa convinzione che Selvatico sviluppa la struttura dell'Istituto, affiancando ai numerosi laboratori artigianali altri corsi teorici, ritenuti

dessen Talent und innovativen Arbeiten der Paduaner Galerist sich so beeindruckt zeigt, dass daraus eine dauerhafte Zusammenarbeit entsteht. Die Begegnung mit wichtigen Akteuren der Kunstszene jener Jahre bestärken wiederum den jungen Babetto, sich dem Kosmos der zeitgenössischen Kunst ohne Rücksicht auf althergebrachte Kategorien und selbst auferlegte Grenzen zu öffnen. Für die Entwicklung des zeitgenössischen Künstlerschmucks in Italien spielte das Zusammenwirken von Künstlern und Galeristen also eine entscheidende Rolle. Die hieraus erwachsenden Synergien ließen schließlich auch die Sammler und das kunstinteressierte Publikum nicht unberührt. Hinzu kam ein weiterer Faktor: Getragen von der allgemeinen Aufbruchs- und Erneuerungsstimmung der Nachkriegszeit wurden in den 50er Jahren in ganz Italien an örtlichen Berufsbildungsschulen Ausbildungszweige der Fachrichtung Goldschmiedekunst eingerichtet. Ein besonderes Profil erwarb sich hier das Istituto Pietro Selvatico in Padua. Unter der Leitung seines Direktors

Babetto also stresses how for him 'there is no value in manual skill in itself, only when linked to a thought'.[7] If the thought is therefore essential to the realisation of a work of art, for Babetto – enamoured of the process of manipulating materials and gifted with exceptional manual skill – personally creating his jewels is an irresistible delight. Melting gold into sheets and then moulding the individual components that come together to form a harmonious whole is for him a matchless opportunity for meditation and personal reflection.

Babetto attended the Accademia di Belle Arti in Venice from 1966 to 1967, when his studies were interrupted by the student protests and occupations, after which he left to perform national service. On his return, in 1969 at the age of just twenty-two, he was invited to replace his former teacher Pinton on the Professional Design course at the Instituto d'Arte, a position that he held up to 1983. Through the cooperation between Mario Pinton, Francesco Pavan and Giampaolo Babetto, the jewellery section of the Instituto Statale d'Arte Pietro Selvatico achieved formal results of supreme quality, giving rise to what is now known worldwide as the Padua School.[8] Niello, enamels, burnished silver, gold, ebony, gems and other materials are used as highlights and contrasts in works of increasingly pure and essential geometrical

indispensabili per lo sviluppo del pensiero creativo. Gli anni di formazione al Selvatico e in particolare la guida di Mario Pinton lasciano un segno indelebile su Babetto, che frequenta l'Istituto tra il 1963 e il 1966, prima nell'indirizzo di architettura e poi in quello di arte dei metalli. Lo stesso artista ricorda che l'insegnamento del professor Pinton è stato fondamentale nella sua formazione artistica. "In lui ho immediatamente riconosciuto il Maestro da seguire, ed ho appreso ad affrontare la progettazione con rigore, sensibilità e rispetto per i materiali, elementi questi tutt'ora importanti nella mia ricerca"[6]. E sottolinea come per lui "la manualità non ha valore di per se', ma solo legata ad un pensiero"[7]. Se il pensiero è dunque essenziale per la realizzazione di un'opera d'arte, per

Mario Pinton setzt man dort von Beginn an auf eine neue, geometrisch reduzierte Formensprache sowie auf die strikte Vermittlung des gesamten Entstehungsprozesses vom Entwurf bis zur Fertigung. Dies entspricht den Grundideen des Marchese, Kunstexperten und Architekten Pietro Estense Selvatico, der das Institut im Jahr 1867 ins Leben rief. Selvatico war zutiefst davon überzeugt, dass handwerkliche Fertigkeiten, technisches Wissen, Kenntnis des historischen Formenschatzes sowie ästhetische Kreativität und Innovation unterschiedliche Facetten eines einzigen Gesamtprismas bilden. Keines dieser Elemente darf dabei isoliert betrachtet werden:[5] Handwerkskunst allein hat keinen Wert, wenn kein Gedanke dahinter steht. Ein Werkstück kann nicht entstehen ohne die Idee, aus der heraus es kreiert wird, ebenso wie eine Idee nur dann kreative Gestalt annehmen kann, wenn technisch-handwerkliches Können hinzukommt. Aus dieser Grundüberzeugung gestaltete Selvatico den Lehrplan des von ihm gegründeten Instituts, der neben der Ausbildung in den angeschlossenen Werkstätten auch Theoriekurse vorsah, die der Weiterentwicklung des kreativen Denkens der Schüler dienen sollten. Für Babetto, der das Istituto Selvatico von 1963 bis 1966 besucht – zunächst in der Fachrichtung Architektur, später im Bereich Metall- und Goldschmiedekunst – wird die dortige Ausbildungszeit zu einer prägenden Erfahrung. Besonders der Unterricht bei Mario Pinton, dem Direktor der Schule, hat den jungen Babetto in seiner künstlerischen Entwicklung nachhaltig geprägt, wie dieser selbst

forms that have come to characterise the Padua School. Each of the leading exponents was distinguished by his personal artistic research. Therefore, while Pinton was famous for the poetic lyricism that allowed him to soften the geometrical forms used, Pavan instead aimed at the total depersonalisation of the works through an extreme geometric abstraction and a constant experimentation of the surfaces. Although he followed the approach mapped out by his master, Babetto manages to reinterpret it, playing on the composite effect of laminar planes, geometric volumes and chiaroscuro contrasts in which the use of niello plays a leading role. The artist achieves a personal artistic language in which the use of geometrical forms is targeted towards an absolute minimalism where attention is focused on the idea, stripped of all mere decorativism.

A minimalist classicist

Giampaolo Babetto is a man of culture, distinguished by his insatiable intellectual curiosity and artistic sensitivity. His works are distillates of what he has treasured from his studies, his travels and his life experience. It is therefore no surprise to find in his works extraordinary and unexpected internalisations, both of contemporary Italian artistic movements – such as

Babetto, innamorato del processo di manipolazione dei materiali e dotato di una straordinaria manualità, realizzare personalmente i suoi gioielli è un piacere irrinunciabile. Il ridurre l'oro in lastre e successivamente creare i singoli componenti che si uniscono a formare un unico armonioso, sono per lui un insostituibile momento di meditazione e riflessione personale.
Dopo aver frequentato l'Accademia di belle Arti di Venezia tra il 1966 e il 1967, l'interruzione degli studi a causa delle occupazioni studentesche e la partenza per il servizio militare, nel 1969 Babetto, a soli ventidue anni, viene chiamato a sostituire il suo ex docente Pinton nell'insegnamento di Disegno professionale e progettazione, cattedra che terrà fino al 1983. La cooperazione tra Mario Pinton, Francesco Pavan e Giampaolo Babetto porta la sezione orafa del Pietro Selvatico a raggiungere risultati formali di altissimo livello, dando vita a quella che è oggi conosciuta a livello mondiale come la Scuola di Padova[8]. Il niello, insieme agli smalti, all'argento brunito, all'oro, all'ebano, a pietre e altri materiali viene utilizzato per evidenziare e creare contrasti nei lavori che assumono forme geometriche sempre più pure ed essenziali, arrivando a caratterizzare la scuola padovana. Ognuno di loro si distingue nella propria ricerca artistica e se Pinton è dunque celebre per il suo lirismo poetico, che gli permette di ammorbidire le forme geometriche utilizzate, al contrario Pavan cerca la totale spersonalizzazione delle opere attraverso una geometrizzazione estrema e una

betont: „In Pinton erkannte ich sofort den Meister, dem es zu folgen galt. Von ihm habe ich gelernt, den Entwurfsprozess mit formaler Strenge, Gespür und Respekt für das Material anzugehen – Elemente, die bis heute für meine Arbeit sehr wichtig sind."[6] Auch für Babetto „hat das Handwerkliche keinen Wert an und für sich, sondern nur dann, wenn es an einen Gedanken gebunden ist."[7] Der Gedanke ist unverzichtbarer Bestandteil der Entstehung eines Kunstwerks. Diese Maxime bedeutet für den Schmuckkünstler Babetto, der sich der Bearbeitung des Materials bei all seinen Stücken und mit großer Leidenschaft und Hingabe widmet, dass auch das Flachklopfen eines Rohlings zu Goldblech, aus dem dann die Einzelelemente einer harmonischen Gesamtheit entstehen, einen unverzichtbaren Moment der individuellen Meditation und Reflexion darstellt.
Nach dem Besuch der Kunstakademie in Venedig in den Jahren 1966 bis 1968 und einer durch Studentenunruhen und Einberufung zum Militär bedingten Zwangspause übernimmt Babetto 1969 mit nur zweiundzwanzig Jahren die Stellung seines ehemaligen Lehrers Mario Pinton als Dozent für Zeichnung und Entwurf in Padua, die er bis 1983 bekleidet. Unter der gemeinsamen Ägide von Mario Pinton, Francesco Pavan und Giampaolo Babetto erreicht der Fachbereich Goldschmiedekunst des Istituto Pietro Selvatico höchstes künstlerisches Niveau und legt damit den Grundstein für die heute international als Paduaner Schule bekannte Gestaltungsrichtung.[8] Elemente wie Niellotechnik und Emaille, die Verwendung von Poliersilber, Gold

und Ebenholz werden kontrastreich zu einer immer reduzierteren geometrischen Formensprache vereint, die als kennzeichnendes Stilmerkmal der Paduaner Schule gelten kann. Dessen ungeachtet verfügt jeder ihrer Vertreter über eine eigene Handschrift. Während Mario Pinton für eine eher lyrisch-weiche Linienführung bekannt ist, die seine Interpretation des elementaren Formenkanons charakterisiert, setzt Francesco Pavan auf die völlige Entpersonalisierung seiner Arbeiten. Er erreicht sie durch eine ins Extreme getriebene Geometrisierung – verbunden mit immer neuen Experimentierformen in der Oberflächengestaltung. Babetto wiederum folgt den Spuren seines Lehrers Pinton, entwickelt aus dessen Vorgaben indes eine ganz eigene Lesart. Babetto setzt auf die kompositorische Wirkung sich überlagernder Schichten und elementarer Volumenformen im Wechselspiel von Licht und Schatten. Die Niellotechnik spielt hier als Gestaltungsmittel eine entscheidende Rolle. Babettos eigenen Stil, der ein Höchstmaß an Reduktion anstrebt, erreicht er durch den Einsatz einer elementaren geometrischen Formensprache und sein Fokus liegt ganz auf der Idee jenseits der Kategorien des Dekorativen.

Kinetic Art and Programmed Art – and, even more, of reminiscences of the past. His constant desire for knowledge led him to explore the Renaissance, in which he rediscovered himself.

The tactile sense of depth, the formal simplicity, the line conceived as a generator of form and the qualities of light and shade so deeply rooted in Babetto's work derive from the Renaissance sculptures of Donatello.[9] The *Madonna dei Pazzi* was produced by Donatello around 1420 and is now conserved at the Bode-Museum in Berlin. The bas-relief is considered innovative in terms of realisation, composed in strict adherence to the rules of linear perspective and through the use of the *stiacciato* technique, developed by Donatello, to achieve an illusion of greater depth through the gradual decrease in the thickness from the foreground to the background. Babetto uses this same concept of *stiacciato* in his perspective jewels, which are always nothing short of monumental in the innovative impact of the design. The classic principles of formal clarity, measure and proportion that Babetto has always loved and sought were drawn from the frescoes of the Mannerist artist Jacopo da Pontormo, whom he engaged with in a long series of works begun at the end of the 1980s, inspired by the frescoes of the Certosa of Galluzzo in Florence and the Medici Villa of Poggio a Caiano.

Un classicista minimalista

Giampaolo Babetto è un uomo di cultura, che si distingue per la sua insaziabile curiosità intellettuale e sensibilità artistica. Le sue opere sono distillati di ciò che ha catturato dagli studi, dai viaggi e dalle esperienze di vita.
Non sorprende dunque ritrovare nei suoi lavori delle straordinarie e inaspettate interiorizzazioni, sia dei movimenti artistici italiani a lui contemporanei, quali l'Arte Cinetica e Programmata, ma anche e soprattutto delle reminiscenze del passato. Il suo costante desiderio di conoscenza lo porta infatti ad esplorare il Rinascimento, in cui riscopre se stesso.
Il senso tattile della profondità, la semplicità formale, la linea intesa come generatrice della forma e i valori di continua sperimentazione delle superfici. Pur seguendo la linea tracciata dal suo maestro, Babetto riesce a reinterpretarla giocando sull'effetto compositivo di piani laminari, volumi geometrici e contrasti chiaroscurali in cui l'uso del niello ha un ruolo da protagonista. L'artista raggiunge un personale linguaggio artistico in cui l'utilizzo delle forme geometriche è dovuto al desiderio di raggiungere un minimalismo assoluto dove l'attenzione si concentra sull'idea, spogliata di ogni inutile decorativismo.

Ein minimalistischer Klassiker

Giampaolo Babetto ist von einer unstillbaren intellektuellen Neugier und künstlerischen Sensibilität beseelt. Seine Werke repräsentieren das Destillat aus allem, was ihm seine Studien, seine Reisen und das gelebte Leben vermittelt haben. Es überrascht daher nicht, dass der Paduaner in seinem Werk neben Impulsen zeitgenössischer italienischer Kunst und anderer Kunstrichtungen, wie etwa der Kinetischen Kunst der 60er und 70er Jahre, vor allem auch Reminiszenzen an die Kunst vergangener Jahrhunderte verinnerlicht hat. Namentlich mit der italienischen Renaissance hat Babetto sich intensiv beschäftigt und sich in ihr wiedergefunden.
Das haptische Gespür für Tiefe, die Einfachheit der Formen, die Rolle von Licht und Schatten, die für Babettos Werk so charakteristisch sind, finden ihr Vorbild in der Kunst des Renaissancebildhauers Donatello.[9] Dessen um 1420 entstandene, heute im Bodemuseum in Berlin befindliche *Pazzi-Madonna* gilt als frühes Beispiel für eine rigorose Anwendung der Linearperspektive in der Bildhauerei. Zugleich veranschaulicht sie den Einsatz der von Donatello entwickelten Technik des *stiacciato*, die es erlaubt, dem Medium des Flachreliefs durch feinste Abstufungen eine ungeahnte Tiefenillusion zu verleihen. Es ist eben diese Technik, die Babetto in seinen perspektivischen Schmuckarbeiten aufgreift und ihnen damit eine geradezu monumentale Note verleiht.
Die klassischen Formprinzipien von Klarheit, Maß und Proportion, die Babetto in seinem Werk von Beginn

Another inexhaustible source of inspiration came from Babetto's travels. Between 1970 and 1971 he explored Morocco, where he was surprised and fascinated by the majestic architecture of the imperial cities. Between 1979 and 1980 (and again in 1983) he lived in The Hague in the Netherlands, teaching the art of metalwork, jewellery and design at the Rietveld Akademie in Amsterdam. During these sojourns, Babetto consolidated his friendship with the gallerist Ton Berends of the Galerie Nouvelles Images in The Hague. This was the oldest gallery of modern and contemporary art in the Netherlands, which closed in 2018 after almost sixty years and had hosted Babetto's first solo show in 1972. The special quality of the light, already made famous by the Dutch masters in previous centuries, the play of reflections on the water in the canals, the architecture and the neoplastic art certainly did not escape Babetto's watchful eye. Nevertheless, on his own admission, he was even more struck by the simple geometrical forms of the reliefs of Ad Dekkers, who died prematurely in 1974.
In 1986 Babetto was invited by Hermann Jünger and Friedrich Becker to teach at the Fachhochschule in Düsseldorf, thus immersing himself in German culture too and coming into contact with the influences of the Bauhaus, albeit marginally. Architecture has always been the principal

luce e ombra, così profondamente radicati nell'opera di Babetto, emergono dalle sculture rinascimentali di Donatello[9]. Nella Madonna dei Pazzi, realizzata da Donatello intorno al 1420 e oggi conservata al Bode-Museum di Berlino, il bassorilievo è considerato innovativo per la sua realizzazione, composta rigorosamente secondo le leggi della prospettiva lineare e attraverso l'uso dello *stiacciato*, tecnica sviluppata dallo stesso artista per ottenere un'illusione ottica di maggiore profondità attraverso la diminuzione graduale degli spessori. E proprio il concetto di stiacciato ideato dallo scultore rinascimentale è ripreso da Babetto nei suoi gioielli prospettici, i quali, nell'impatto innovativo del disegno, risultano semplicemente monumentali.

an erstrebt hat, findet er bei dem Manieristen Jacopo Pontormo wieder. Pontormos Freskenzyklen in der Medicivilla in Poggio a Caiano und der Kartause von Galuzzo bei Florenz hat Babetto, beginnend in den späten 80er Jahren, eine umfangreiche Werkreihe gewidmet.
Eine weitere Inspirationsquelle für den Künstler sind zweifelsohne seine ausgedehnten Reisen. In die Jahre 1970/71 fällt ein Aufenthalt in Marokko, wo Babetto Bauwerke der dortigen Königsstädte sieht, die ihn zutiefst faszinieren. Von 1979 bis 1980 und 1983 lebt er in Den Haag, wo Babetto Metall-, Goldschmiedekunst und Design an der Amsterdamer Rietveld-Akademie unterrichtet. In diese Zeit fällt eine verstärkte Zusammenarbeit mit Ton Berends und dessen Galerie Nouvelles Images in Den Haag, der ältesten Galerie für moderne und zeitgenössische Kunst in den Niederlanden, die 2018 nach fast sechzig Jahren ihre Pforten schließen musste. Schon 1972 fand dort eine erste Einzelausstellung mit Werken von Giampaolo Babetto statt. Das ganz besondere Licht, wie wir es von den

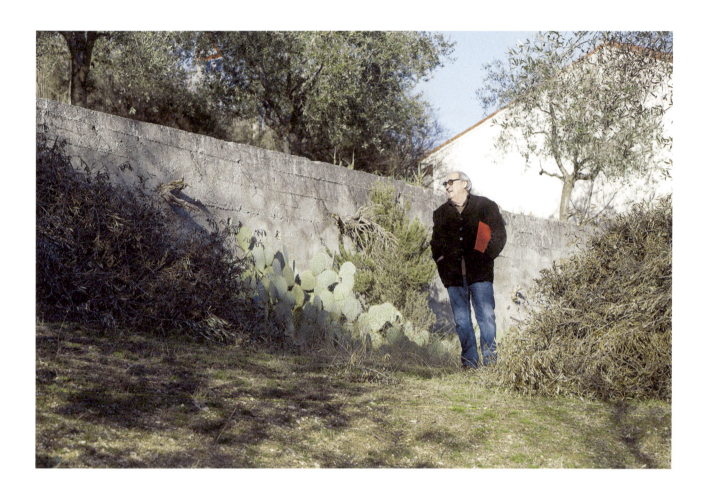

Gemälden der niederländischen Alten Meister kennen, aber auch Architektur und Kunst der De Stijl-Bewegung werden dem aufmerksamen Betrachter Babetto nicht entgangen sein, auch wenn er nach eigenem Bekunden zu jener Zeit vor allem von der elementaren Formensprache der Reliefkunst des 1974 früh verstorbenen Ad Dekkers beeindruckt war. 1986 holte Hermann Jünger Babetto an die Fachhochschule Düsseldorf, so dass dieser auch die deutsche Kulturlandschaft, darunter – wenn auch nur am Rande – das Bauhauserbe kennen lernen konnte. Denn es ist die Architektur, die für Giampaolo Babetto die wichtigste Inspirationsquelle darstellt. Zu seinen Lieblingsarchitekten zählen der Mexikaner Louis Barragán und der Meister der architektonischen Moderne Mies van der Rohe, dessen *„Less is more"* wie ein Leitmotiv auch das Werk des Schmuckkünstlers Babetto durchzieht. Hier wie dort bilden einfache Formen, klare Linien und sich überschneidende Flächen das Grundvokabular des künstlerisch-gestalterischen Ausdrucks.

Obschon also ein unverkennbarer Minimalismus der Form das Werk von Giampaolo Babetto in die Nähe von De Stijl, Bauhausschule und russischem Konstruktivismus zu rücken scheint, sagt dieser doch von sich selbst: „Bei der Umsetzung meiner Entwürfe habe ich gar nicht an diese Stilrichtungen gedacht." Was den Paduaner jedoch mit ihnen verbindet, ist die Grundeinsicht, dass künstlerische Inspiration und handwerkliches Können in jedem kreativen Bereich Anwendung finden können, und zwar über alle Sektorengrenzen

source of inspiration for Giampaolo Babetto, who names Luis Barragán and Mies van der Rohe among his favourite architects. The aphorism of the master of modernism 'less is more' is a leitmotif running through all Babetto's artistic research. For both, it is precisely the essence of the forms, the purity of the lines and the intersection of the planes that allow the artist's ideas to come to life.

And so, although it is true that Giampaolo Babetto's formal minimalism apparently links him to De Stijl, the Bauhaus and Russian Constructivism, the artist himself admits that 'when creating my projects I wasn't thinking about these stylistic currents at all'.[8] The main element that he does actually share with these movements is the recognition that artistic inspiration and manual skill can be applied to any creative sphere whatsoever, without sectoral boundaries between art, architecture and design. Babetto eloquently explains this non-hierarchical approach: 'I don't want to be bound to a single artistic discipline, and I want to foster a general discussion, a global idea of the things in themselves. At times I have immersed myself in architecture before making a particular piece of jewellery. At times I paint or experiment like a jeweller.'[9]

I principi classici di chiarezza formale, misura e proporzioni, amati e perennemente ricercati da Babetto, li ha riconosciuti negli affreschi del manierista Jacopo da Pontormo, con cui si è confrontato in una lunga serie di opere iniziata alla fine degli anni '80, ispirata dagli affreschi alla Certosa del Galluzzo di Firenze e alla Villa Medicea di Poggio a Caiano.

I suoi viaggi sono certamente un'altra inesauribile fonte d'ispirazione per lui. Tra il 1970 e 1971 esplora il Marocco, dove le imponenti architetture delle città imperiali lo sorprendono e affascinano. Tra il 1979 e il 1980 (e successivamente nel 1983) vive a Den Haag, in Olanda, insegnando arte dei metalli, oreficeria e progettazione alla Rietveld Akademie di Amsterdam. Durante questi soggiorni Babetto rafforza il suo sodalizio con il gallerista Ton Berends della Galerie Nouvelles Images di Den Haag, la più antica galleria d'arte moderna e contemporanea d'Olanda, chiusa dopo quasi sessant'anni di attività nel 2018, che già nel 1972 gli aveva dedicato la sua prima mostra personale. Le peculiarità della luce, già resa celebre nei secoli precedenti dai maestri olandesi, i giochi di riflessi nelle acque dei canali, l'architettura e l'arte neoplasticista sicuramente non sfuggono all'occhio attento di Babetto, che per sua stessa ammissione viene però più fortemente segnato dai rilievi dalle forme geometriche semplici di Ad Dekkers, mancato prematuramente nel 1974.

Nel 1986 viene chiamato da Hermann Jünger a insegnare alla Fachhochschule di Düsseldorf, immergendosi così

zwischen Kunst, Architektur und Design hinweg. Babetto erklärt diesen nicht-hierarchischen Ansatz so: „Ich will nicht an eine einzige künstlerische Disziplin gebunden sein. Ich möchte eine umfassende Debatte anstoßen und eine Gesamtvorstellung davon geben, wie die Dinge in ihrem Inneren beschaffen sind. Manchmal vertiefe ich mich in architektonische Fragen, bevor ich ein bestimmtes Schmuckstück entwerfe; manchmal male ich und manchmal experimentiere ich als Goldschmied."

Der Wandel der Funktionen

Das vielschichtige Schaffen Giampaolo Babettos erschließt sich vollständig erst aus der Beobachtung, wie eng seine Stücke mit den übrigen Formen der Kunst verbunden sind, mit denen der Paduaner sich im Laufe der Jahre beschäftigt hat. Für Babetto besitzen sie unterschiedslos die gleiche Wertigkeit. Er widmet sich einer Schmuckarbeit, einem Möbel, einem liturgischen Gerät oder einem Architekturentwurf mit gleichem Ernst und der gleichen präzisen Aufmerksamkeit. Jedes Objekt hat seine

The alteration of functions

To fully understand Babetto's complex personality it is crucial to observe how his jewels are closely related to the other forms of art that he has pursued over the years. Placing them on the same level, without giving one precedence over another, the artist addresses the creation of a jewel, a piece of furniture, a liturgical object or an architectural project with the same dedication and meticulous professionalism. Each object exists in relation to its function, while at the same time every object created by Giampaolo Babetto exists as an entity in its own right. Hence a jewel is linked to its function of being worn while at the same time it is also a sculpture, free from all external ties. It succeeds in capturing one's gaze and taking one's breath away thanks to the extreme pathos that the artist evokes by yoking the minimal simplicity of the forms to the emotional impact of the composition. What he ultimately achieves is a harmony so delicate, sublime and impalpable that it seems ephemeral but turns out to be a moment suspended in time, a creative impulse captured for eternity. This, without doubt, is Giampaolo Babetto's paramount virtuosity.

His jewels are clear and structured, yet they possess a soul, an innerness generated by the artist himself that makes every work unique, moving and

anche nella cultura tedesca ed entrando, seppur marginalmente, in contatto con le influenze del Bauhaus. L'architettura è sempre la principale fonte di ispirazione per Giampaolo Babetto, che tra i suoi architetti più amati cita Louis Barragan e Mies van der Rohe. "Less is more", aforisma del maestro del modernismo, è un *leitmotiv* impregnato in tutta la ricerca artistica di Babetto. In entrambi è proprio l'essenza delle forme, la purezza delle linee e l'intersezione dei piani che permette all'idea dell'artista di prendere vita.

Se è dunque vero che il minimalismo formale di Giampaolo Babetto lo avvicina apparentemente al De Stijl, al Bauhaus e al costruttivismo russo, è lui stesso a dire che "realizzando i miei progetti non ho affatto pensato a queste

eigene Funktion und gleichzeitig existiert jedes seiner Stücke als eigenständige Wesensform. Eine Schmuckarbeit ist an die Funktion des Getragenwerdens gebunden; zugleich aber ist es eine Skulptur und als solche frei von allen äußeren Bindungen. Seine Fähigkeit, Blicke und Bewunderung auf sich zu ziehen, verdankt sich dem *pathos*, das der Künstler schafft, indem er die Einfachheit der Formen mit der Ausdruckskraft seiner Kompositionen zusammenbringt. Auf diese Weise stellt sich eine subtile Harmonie ein, feingliedrig, delikat, geradezu flüchtig und vergänglich. Ein Augenblick im Verschweben der Zeit, ein kreativer Impuls, eingefangen für die Ewigkeit. Genau hierin zeigt sich die virtuose Meisterschaft des Künstlers Giampaolo Babetto.

Bei aller Geradlinigkeit und Klarheit besitzen Babettos Arbeiten eine Seele, ein Innenleben, erschaffen von der Hand des Künstlers. Jedes seiner Werke ist einzigartig, aufregend und besitzt die Fähigkeit, auf tiefe, unbewusste Weise mit allen in Berührung zu treten, die es betrachten oder

capable of connecting with the observer or the wearer at a deep, unconscious and almost primordial level. The predilection for geometrical forms is the artist's intuitive choice; it is related to the formal simplicity of the jewels and allows him to focus on the idea he wishes to convey through an absolute minimalism free of needless decorativism. However, although Babetto is famous for his geometrical forms, over the years his love of feminine contours also emerges clearly in his artistic production. In his works these are transformed into spontaneous sinuous lines where the surfaces can be silky, scratched or tactile, depending on what he wants at the time. Like the forms, the use of colour too is essential, pondered and functional to the transmission of the idea, resisting all temptation for excess. Babetto has used countless different materials over the years, experimenting and seeking the right combination for his creations. Ebony contrasting with golden surfaces highlights the dramatic nature of the composition. Niello, used according to the ancient formula of Theophilus, makes it possible to play on the chromatic impact, to eliminate the planes by focusing attention on specific sections or details, or to create tactile surfaces that can be worked on like a canvas. The pigments, applied in the primary colours of red and blue, are frequently placed in internal parts of the composition in

correnti stilistiche". L'elemento predominante che lo accomuna invece a questi movimenti è l'aver riconosciuto come l'ispirazione artistica e l'abilità manuale siano applicabili a qualsiasi ambito creativo, senza confini di settore tra arte, architettura e design. Un approccio non-gerarchico che lo stesso artista spiega: "Non voglio essere vincolato a una sola disciplina artistica e vorrei promuovere una discussione generale, un'idea globale delle cose in sé stesse. A volte mi sono immerso nell'architettura prima di fare un particolare pezzo di gioielleria. A volte dipingo o sperimento come orafo".

La modifica delle funzioni

Per comprendere appieno la complessa personalità di Babetto è dunque fondamentale osservare come i suoi gioielli sono strettamente correlati alle altre forme d'arte che ha perseguito nel corso degli anni. Ponendole sullo stesso piano senza prediligerne una rispetto all'altra, l'artista affronta la realizzazione di un gioiello, di un mobile, di un oggetto liturgico o di un progetto architettonico con la stessa dedizione e meticolosa serietà. Ciascun oggetto esiste in relazione alla sua funzione, ma al tempo stesso ciascun oggetto di Giampaolo Babetto esiste in quanto essere a sé stante. Un gioiello è dunque legato alla sua funzione di indossabilità, ma al tempo stesso è una scultura, libera da ogni legame esterno. È in grado di

tragen. Babettos Vorliebe für elementare geometrische Formen entspringt einer intuitiven künstlerischen Entscheidung. Durch sie kann er sich ganz auf die Idee konzentrieren, die er, mit den Mitteln eines extremen Minimalismus und jenseits der Banalität des Dekorativen, zum Ausdruck bringen will. Ungeachtet dieser Vorliebe für das Geometrische ist in Babettos Werk über die Jahre jedoch auch eine Vorliebe für weibliche Formen nicht zu verkennen. Diese übersetzt sich in frei fließende Linien und mit ebenso frei gewählten Oberflächen, mal seidenglatt, mal zerkratzt, mal rau und nah am Material. Ähnlich wie in seinem Formenrepertoire meidet Babetto auch in seinem auf das Wesentliche blickenden, stets ausgewogenen und funktionalen Umgang mit Farbe als Gestaltungsmittel jedes Übermaß. Die Materialien, mit denen der Paduaner im Laufe der Jahrzehnte gearbeitet und auf der Suche nach der jeweils passenden Kombination für seine Entwürfe experimentiert hat, sind vielfältig. Ebenholz etwa verleiht im Zusammenwirken mit dem Goldgrund seinen Stücken eine besondere Kontrastwirkung, während die Niellotechnik, die Babetto nach den Vorgaben des Theophilus anwendet, es ihm erlaubt, chromatische Effekte zu setzen und das Schichtengefüge aufzubrechen. Mit ihr gelingt es ihm, die Aufmerksamkeit auf einzelne Stellen und Details zu lenken oder Materialoberflächen zu schaffen, auf denen sich agieren lässt wie auf einer Leinwand. Farbpigmente in den Primärtönen Rot und Blau nutzt Babetto im Inneren einer Formkomposition häufig, um Kontrapunkte zum Spiel der

opposition to the pure forms, transmitting all the passion and power that the artist conceals within him. The artist is fascinated by methacrylate, which he chooses in essential white or strong, electrifying colours, permitting a new level of exploration of the planes.

Most of us pay only passing attention to the world around us. We admire its beauty, but without pausing to reflect on it, to study it and internalise it. This is what makes Giampaolo Babetto different. So, a blue sky is not just a beautiful view to be admired for a moment: the clouds show themselves to be a series of forms, lines and colours in continual transformation, impossible to ignore. The artist observes them, memorising not only the essential, formal elements but, above all, the emotions they trigger in him. A stroll through his beloved olive grove is much more than mere physical exercise: it is a moment of personal regeneration. His travels in Europe, the United States, Australia and Japan are opportunities to discover new cultures, flavours and fragrances, as well as architectural elements to be stored in the mind for future elaboration. The fact that the artist often accompanies his jewels with photographs of architectural details, glimpses of sky, sketches and designs is further proof of how for him the different disciplines such as art, architecture, photography, drawing and design are interconnected.

catturare lo sguardo dell'osservatore e toglierne il respiro grazie all'estremo *pathos* che l'artista riesce a creare combinando la minimale semplicità delle forme e l'impatto emotivo delle composizioni, raggiungendo infine un'armonia così delicata, sublime e impalpabile da apparire effimera, ma che si rivela essere un attimo sospeso nel tempo, un impulso creativo catturato nell'eternità. Questo è senza dubbio il più grande virtuosismo di Giampaolo Babetto.

I suoi gioielli, pur essendo chiari e strutturati nella forma, possiedono un'anima, un'interiorità generata dall'artista stesso, che rende ogni opera unica, emozionante e in grado di connettere a livello profondo, inconscio e quasi primordiale con chi lo osserva o indossa. La predilezione per le forme geometriche è una scelta intuitiva dell'artista, legata alla loro semplicità formale, e gli consente di concentrarsi sull'idea che desidera trasmettere attraverso un minimalismo assoluto, libero da inutili decorativismi. E sebbene sia noto per la geometricità delle sue forme, nel corso degli anni si può chiaramente vedere nella sua produzione artistica l'amore per le linee femminili, trasformate nelle sue opere in spontanee linee sinuose, in cui le superfici possono essere setose, graffiate o materiche, a seconda del suo desiderio del momento. Come per le forme, anche l'uso del colore è essenziale, ponderato e funzionale a trasmettere l'idea, rifiutando ogni tentazione all'eccesso. Nel corso degli anni Babetto ha utilizzato innumerevoli materiali, sperimentando e ricercando il

reinen Formen zu setzen; oft lassen gerade sie die verborgene Leidenschaft und den individuellen Impetus des Künstlers erahnen. Acrylglas – in der weiß durchsichtigen oder starkfarbig leuchtenden Variante – fasziniert Babetto als Werkstoff, der in seiner Transparenz die Sichtbarmachung von Tiefenschichten ermöglicht.

Die meisten von uns schenken der Welt, die uns umgibt, nur oberflächliche Aufmerksamkeit. Wir bestaunen ihre Schönheit, ohne uns die Zeit zu nehmen, sie genauer zu betrachten, tiefgehender über sie nachzudenken und uns einzuprägen. Giampaolo Babetto tut genau dies. Für ihn ist ein blauer Himmel mehr als eine Momentaufnahme, die Wolken darin offenbaren sich ihm unübersehbar als ein Zusammentreffen von Formgebilden, als ein ununterbrochener Wandel von Konturen und Farbschattierungen. Dabei beobachtet und verinnerlicht der Künstler nicht allein die elementaren Formmuster, die sich ihm bieten, sondern auch und vor allem die Empfindungen, die diese in ihm auslösen. So ist für Giampaolo Babetto ein Spaziergang zwischen seinen geliebten Ölbäumen manchmal sehr viel mehr als eine physische Entspannungsübung, nämlich ein Moment innerlicher Erneuerung. Auch seine Reisen in Europa, in die Vereinigten Staaten, nach Australien und Japan bieten Babetto nicht allein Gelegenheit, neue Kulturen, neue Geschmäcker und Gerüche zu entdecken. Oft begegnen ihm dort auch Architekturformen und -elemente, die er in sein inneres Archiv aufnimmt, um sie später in seine Arbeit einfließen zu lassen. Wenn Babetto seinen

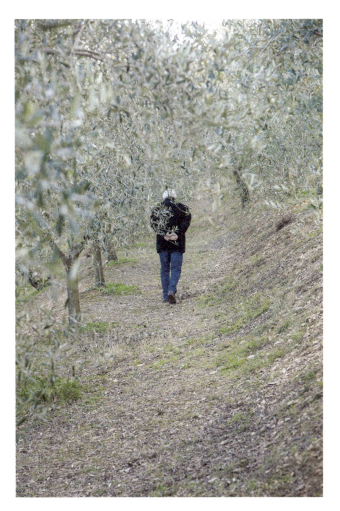

giusto abbinamento per le sue creazioni. L'ebano, in contrasto con le superfici auree, evidenzia la drammaticità compositiva. Il niello, utilizzato nell'antica formula del Teofilo, consente di giocare con l'impatto cromatico, di annullare i piani puntando l'attenzione su sezioni o dettagli specifici, o di creare superfici materiche su cui lavorare come una tela, intervenendo sulla superficie.
I pigmenti, applicati nei colori primari di rosso e blu, sono spesso situati in aree interne della composizione, in opposizione alle forme pure, e trasmettono tutta la passione e la potenza celate nell'artista stesso. Il metacrilato, scelto nell'essenzialità del bianco o in forti colori elettrizzanti, affascina l'autore per la sua trasparenza, che consente un nuovo livello di esplorazione dei piani.

Schmuckarbeiten häufig Fotografien von Architekturdetails oder von Wolkenformationen beigibt, sowie Skizzen und Entwurfszeichnungen, belegt dies nur noch mehr, in welchem Maße die Teilbereiche und Disziplinen – Kunst, Architektur, Fotografie, Zeichnung und Gestaltung – sich im Werk des Paduaners miteinander verbinden und zu einem Ganzen verschmelzen. Das Geflecht ihrer wechselseitigen Beziehung ist es, das sich als seine künstlerische Signatur erweist. Babetto destilliert die Essenz des Lebens aus den Dingen, die ihn umgeben, und deutet sie auf seine Weise neu. Jedem seiner Stücke prägen sich die Linien seines Denkens und Lebens ein.
Es ist also nur folgerichtig, wenn Giampaolo Babetto sich intensiv mit Möbeldesign und Architekturentwürfen befasst, erlauben diese Disziplinen ihm doch eine geradezu handfeste Auseinandersetzung mit der Lebenswelt. In seinen Interventionen erstattet der Künstler Elemente an die Lebenswelt zurück, die er zuvor aus ihr gewonnen hat. Er verändert einen Teil der Welt und lässt

In the end they all come together in his work, generating cross-references that prove to be his signature as an artist. Babetto extrapolates the essence of life from things and reinterprets them in his own way, leaving in every object he creates the imprint of his reflection and his life experiences. Consequently, he cannot fail to be intrigued by furniture design and architectural design, since they allow him to engage in a tangible manner with the environment around him. In these operations the artist restores to the world elements that he has taken from it, thus partially altering that very environment that has inspired him and leaving direct evidence of his passage. These, for instance, were the premises for his creation of the table for Casa Romanin Jacur in Padua, where what is particularly striking is the artist's capacity to interact with the space. The table is conceived in its pure style, but the dramatic intensity normally encapsulated in the work is achieved here by the power of the contrast between Babetto's minimal, contemporary composition and the classical setting that surrounds it.

Therefore, while the perspective and focus of his work are constantly shifting, in perpetual evolution, what stays the same is the characteristic creative process. With an almost childlike smile on his lips, Giampaolo Babetto admits that once he has had the intuition, the excitement, the enthusiasm

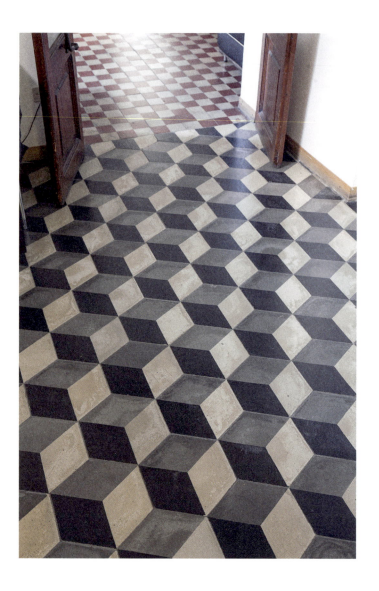

ein Zeugnis seiner Gegenwart in ihr zurück. Aus diesen Prämissen ist etwa ein Tisch für den Palazzo Romanin Jacur in Padua entstanden, an dem vor allem die Fähigkeit besticht, mit dem Raum in Dialog zu treten. Der Entwurf trägt die für Babetto typische minimalistische Handschrift. Die gewöhnlich allein im Werk selbst angelegte dramatische Intensität erwächst hier jedoch auch aus der Konfrontation des zeitgenössischen Formengestus mit dem klassischen Ambiente, für das das Möbel geschaffen wurde.

and the thrill of seeing the idea take shape in his hands, he continues to be as moved by it today as he was fifty years ago. The artist develops the idea through sketches and designs, always striving to represent it in its most essential form. This frequently leads him to adopt
complex technical solutions that allow him to conceal the mechanisms from the eyes of the observer. And while for Babetto the design is methodical, introverted and rational, its realisation is impulsive, rapid and passionate. 'I'm a combination of rationality and impulsiveness. When I have an idea or concept in my mind, I want to realise it in the most linear way possible. Once I have found the mechanism, I want to achieve it as quickly as possible, and I throw myself wholeheartedly into it.'[10] The result is works taken to the extreme essence of form and line that allow those looking at them to instantly perceive the formal tension and the impact of the composition. Every one of them reveals his passions, his love for architecture and his eye for detail.

La maggior parte di noi presta solo una superficiale attenzione al mondo che ci circonda. Ne ammiriamo la bellezza, ma senza soffermarci a riflettere su di essa, a studiarla ed interiorizzarla. Questo è ciò che differenzia Giampaolo Babetto. E così un cielo blu non è solo un bel paesaggio da ammirare per un momento, le nuvole si rivelano in un insieme di forme, linee e colori in continua trasformazione, impossibili da ignorare. L'artista le osserva e ne memorizza non solo gli elementi formali essenziali, ma anche e soprattutto le emozioni che in lui fanno scaturire. Una passeggiata tra i suoi amati ulivi è molto più di un semplice esercizio fisico, è un momento di rigenerazione personale. I suoi viaggi in Europa, Stati Uniti, Australia, Giappone sono l'opportunità di scoprire nuove culture, sapori e profumi, ma anche elementi architettonici da archiviare nella mente per una futura rielaborazione. Il fatto che l'artista spesso accompagni i suoi gioielli con fotografie di dettagli architettonici, scorci di cielo, schizzi e progetti, evidenzia ulteriormente come per lui i vari settori disciplinari quali arte, architettura, fotografia, disegno e design siano interconnessi e, in definitiva, si fondono in un tutt'uno nel suo lavoro, creando riferimenti incrociati che si rivelano essere la sua firma d'artista. Babetto estrapola l'essenza della vita dalle cose e la reinterpreta a modo suo, lasciando in ogni oggetto che crea un'impronta del suo pensiero e delle sue esperienze vissute. In questo contesto il design di mobili e i progetti architettonici non possono che affascinarlo,

Babettos Kunst präsentiert sich als ein unaufhörlicher Prozess. Fluchtpunkt und Perspektive seiner künstlerischen Arbeit sind darin ständigem Wandel und Werden unterworfen. Dennoch bleibt der kreative Prozess, aus dem diese Kunst hervorgeht, stets gleich. Mit jungenhaftem Lächeln erklärt Babetto, dass für ihn die Aufregung und die Begeisterung darüber, eine einmal aufgetauchte Idee unter seinen Händen Form annehmen zu sehen, heute noch genauso prickelnd sind wie vor fünfzig Jahren. Bei der Ausarbeitung seiner Ideen anhand von Skizzen und Entwurfszeichnungen strebt Babetto eine auf das Wesentliche reduzierte Darstellung an. Dieses Bestreben führt ihn häufig dazu, mit technisch komplizierten Lösungen zu arbeiten, die es erlauben, die zugrunde liegende Mechanik vor den Augen des Betrachters zu verbergen. Doch so sehr der Entwurfsprozess für Babetto den Charakter des Methodischen, Introvertierten und Rationalen trägt, so sehr vollzieht sich seine Umsetzung unter den Vorzeichen von Spontaneität, Impulsivität, ja Leidenschaftlichkeit. "Ich bin eine Kombination aus Rationalität und Impuls. Wenn ich eine Idee habe, wenn mir eine Konzeption in den Kopf kommt, will ich sie so geradlinig wie möglich umsetzen. Habe ich den Mechanismus einmal gefunden, möchte ich ihn so schnell wie möglich umsetzen und setze meine ganze Energie dafür ein."[10] Das Ergebnis sind Arbeiten mit reduzierten, elementaren Linien und Formen, in denen der Betrachter unmittelbar die gestalterische Spannung und Energie der Komposition wahrnehmen kann. Jeder dieser Ent-

An artist's house

The artist ranges fearlessly and without hesitation from interior architecture to furniture design, jewellery, liturgical objects and teaching. At first glance there doesn't seem to be any connection between these activities, but it is Babetto himself – with his intense and complex personality – who provides the thread linking them together. Every project, every creation and every idea reflects the legacy of his experience and his dreams. His art and his life are inseparable, and the art can be fully understood only through knowledge of the life. This is why, when you visit his home – an eclectic building from the early twentieth century set amidst the gentle hills of Arquà Petrarca and surrounded by a vast garden of olives – you discover the world of Giampaolo Babetto. Entering the house you can instantly feel the connection between the setting and the artist. The house is of a perfect, linear simplicity and has conserved its period atmosphere in the tiled floors and the merlons on the roof, and because very few changes have been made to the original structure. But Babetto's presence is everywhere, in the elements bearing his hallmark minimalist style that he has introduced, which enhance and complete the eclectic mood of the house. His great passion for entertaining and cooking – he is indeed an excellent cook – are evident

poiché gli consentono di confrontarsi in maniera tangibile con l'ambiente che lo circonda. Nella creazione di questi interventi, l'artista restituisce al mondo elementi che da esso ha acquisito, andando così in parte a modificare quell'ambiente stesso che lo ha ispirato e lasciando diretta testimonianza del suo passaggio. È con queste premesse che crea, ad esempio, il tavolo per casa Romanin Jacur a Padova, dove colpisce particolarmente la capacità dell'artista di interagire con lo spazio. Il tavolo è ideato nel suo stile puro, ma l'intensità drammatica normalmente racchiusa nell'opera, è qui ottenuta dalla potenza del confronto tra la composizione minimale e contemporanea di Babetto e l'ambiente classico che lo avvolge.

Se la sua arte è dunque un processo dove la prospettiva e il focus del suo lavoro cambiano in continuazione, in una evoluzione perpetua, ciò che resta immutato è il processo creativo che lo caratterizza. Giampaolo Babetto ammette, con un sorriso quasi fanciullesco sulle labbra, che una volta avuta l'intuizione, l'eccitamento, l'entusiasmo e il brivido di vedere l'idea prendere forma tra le sue mani lo emozionano ancora oggi come cinquant'anni fa. Attraverso schizzi e progetti, l'artista sviluppa l'idea, cercando sempre di rappresentarla nella sua forma più essenziale. Questo lo porta spesso a risolversi attraverso soluzioni tecniche complesse, che gli consentono di celare i meccanismi agli occhi dell'osservatore. E se per Babetto la progettazione è metodica, introversa e razio-

Ein Künstler und sein Haus

Giampaolo Babetto bewegt sich völlig selbstverständlich und ungezwungen zwischen Innenarchitektur und Möbeldesign, Schmuckkunst und dem Entwurf von liturgischem Gerät; nicht zu vergessen seine Tätigkeit als Dozent. Was auf den ersten Blick wenig miteinander zu tun haben mag, findet seinen gemeinsamen Nenner in der ebenso facettenreichen wie passionierten Persönlichkeit des Künstlers. Jeder Entwurf, jede Kreation, jede Idee spiegelt Babettos Erfahrungen und seine Träume wider. Kunst und Leben gehören untrennbar zusammen, nur wer sein Leben kennt, kann seine Kunst verstehen. Dies wird vor allem deutlich, wenn man Babettos Zuhause, ein in den Hügeln von Arquà Petrarca inmitten eines Olivenhains gelegenes Landhaus, besucht. Dort offenbart sich dem Besucher Giampaolo Babettos Welt. Wer das im Stil des Eklektizismus des frühen 20. Jahrhunderts erbaute Haus betritt, spürt sofort den Gleichklang von architektonischem Ambiente und Künstlerpersönlichkeit. In der Schlichtheit seiner baulichen Formen geradezu vollkommen, hat das Haus mit seinen Kachelböden, dem kleinen Zinnenkranz auf dem Dach und nur ganz wenigen Umbauten seine ursprüngliche Atmosphäre bewahrt. Zugleich ist dank der gestalterischen Akzente, die das stilistische Ambiente ergänzen und bereichern und die Handschrift des Künstlers verraten, dessen Gegen-

würfe lässt Babettos Passion, seine Liebe zur Architektur und sein Auge für Details erkennen.

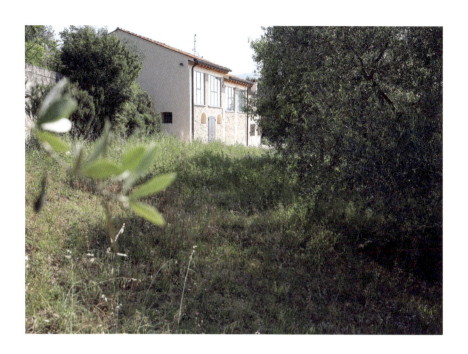

nale, la sua realizzazione è impulsiva, rapida e passionale. "Sono una combinazione di razionalità e impulso. Quando ho un'idea, un concetto in testa, lo voglio realizzare nel modo più lineare possibile. Una volta trovato il meccanismo, desidero raggiungerlo il prima possibile e ci metto tutta la mia energia"[10]. Il risultato sono opere portate all'essenza totale di forme e linee, permettendo a chi le osserva di percepire istantaneamente la tensione formale e l'impato della composizione. In ognuna di esse si scoprono le sue passioni, il suo amore per l'architettura e il suo occhio per i dettagli.

Una casa d'artista

L'artista spazia senza timori o titubanze dall'architettura d'interni al design di mobili, dalla gioielleria agli oggetti liturgici, all'insegnamento. Ad un primo sguardo sembra quasi non esserci connessione tra tutte queste attività, ma è proprio lo stesso Babetto, con la sua complessa e intensa personalità, il filo conduttore che unisce tutto. Ogni progetto, ogni creazione, ogni idea riflette il suo retaggio, la sua esperienza e i suoi sogni. La sua arte e la sua vita sono inscindibili ed è possibile comprendere appieno la prima solo attraverso la conoscenza della seconda. Per questa ragione- quando visiti la sua casa, una costruzione eclettica di inizio '900 situata tra le soffici colline di Arquà Petrarca, circondata da un immenso

wart unverkennbar. Dass Babetto ein großartiger Gastgeber und noch dazu ein exzellenter Koch ist, davon zeugen der selbst entworfene Esstisch ebenso wie das selbst gestaltete Besteckservice. Beides kommt zum Einsatz, wenn Babetto seine Freunde bei exquisitem Essen, besten Weinen und angeregtem Gespräch zu Tisch lädt. Babettos Begeisterung für die Kunst der italienischen Renaissance und speziell für die des großen Manieristen Pontormo findet in der Gestaltung des Kopfteils des Ahornholzbettes von 1990 Ausdruck, das Konturen aus einem Pontormo-Fresko in minimalistische Formen übersetzt. Von der großen Liebe, die Babetto zu seinen Ölbäumen hegt, war schon die Rede. Gestalt geworden ist diese Leidenschaft im Atelier des Künstlers, jenem Ort, wo er viele Stunden der Beschäftigung mit seinen Entwürfen und der Arbeit an seinen Werkstücken verbringt. Ein mächtiger Balken aus uraltem, krummgewachsenem Olivenholz dient dort als Träger für die zahlreichen verschiedenen Ambosse des Goldschmieds. Der Künstler

in his creation of the dining table and the set of cutlery used to entertain the friends who come to enjoy flavoursome dinners accompanied by good wine and stimulating conversation. His strong bond with the Renaissance, with classicism and the Mannerism of Pontormo, are reflected in the maple wood bedhead dating to 1990, which represents a detail of Pontormo's work with the essentiality of Babetto. His unconditional love for olive trees invades even his studio, where he spends endless hours designing or manually working his jewels and objects over a sinuous, ancient trunk transformed into a stand for his numerous anvils. Here we see how the artist surrounds himself with the things he loves and the values he holds dear. The table, the accessories and the drawings on the walls illustrate the complex personality of Giampaolo Babetto, at once classicist and minimalist, determined and humble, powerful and polite, passionate and reserved, instinctive and rational, in an admixture that makes him truly extraordinary, as a man and as an artist.

giardino di ulivi, scopri il mondo di Giampaolo Babetto. Entrando nella casa si avverte immediatamente la connessione tra l'ambiente e l'artista. Perfetta nella sua lineare semplicità, la casa ha conservato l'atmosfera di un tempo, grazie ai pavimenti piastrellati, il merletto sul tetto e le pochissime modifiche apportate alla struttura originale. La presenza di Babetto è però ovunque, grazie agli interventi da lui realizzati nel suo distintivo stile minimalista che complementano e arricchiscono lo stile eclettico della casa. La sua grande passione per l'ospitalità e per la cucina, è infatti un eccellente cuoco, sono evidenti nella sua realizzazione del tavolo da pranzo e del servizio di posate, con i quali accoglie gli amici per magnifiche serate all'insegna di cene saporite, accompagnate da buon vino e stimolanti conversazioni. Il suo fortissimo legame con il Rinascimento, il classicismo e il manierismo di Pontormo, si ritrovano nella testata di letto in legno d'Acero del 1990, che ripresenta un dettaglio dell'opera di Pontormo nell'essenzialità di Babetto. Il suo amore incondizionato per gli ulivi è trasportato nel suo studio, dove trascorre infinite ore progettando o lavorando manualmente ai suoi gioielli e oggetti, attraverso un lungo, antico e sinuoso tronco trasformato in supporto per le sue numerose incudini. Possiamo così vedere come l'artista si circonda di ciò che ama e dei valori in cui crede. Il tavolo, i soprammobili, i disegni esposti alle pareti ci raccontano la complessa personalità di Giampaolo Babetto, al tempo stesso classicista e minimalista, determinato e umile,

Babetto umgibt sich mit dem, was er liebt und woran er glaubt. Der große Tisch, die Objekte im Raum, die Zeichnungen, die an den Wänden hängen, all das spricht von einer vielschichtigen Persönlichkeit. Liebhaber des Klassischen und zugleich minimalistisch, zielstrebig und bescheiden, passioniert und kontrolliert, intuitiv und rational – es ist diese Verbindung des scheinbar Gegensätzlichen, die Giampaolo Babetto auszeichnet, als Mensch und als Künstler.

Anmerkungen

1 *British Gold – Italian Gold*, Ausst.-Kat. hrsg. von G. Folchini Grassetto, C. Jensen (Edinburgh, The Scottish Gallery), 1998.
2 A. Sandonà, *L'arte contemporanea e la produzione orafa degli artisti: per una ricostruzione storica*, in *Gioielli d'Autore. Padova e la Scuola dell'oro*, Ausst.-Kat. hrsg. von M. Cisotto Nalon, A.M. Spiazzi (Padua, Palazzo della Ragione), 2008, S. 66 – 78.
3 V. Baradel, *Alberto Carrain, cercatore d'arte*, in *Mario Pinton - L'oreficeria*, Ausst.-Kat. hrsg. von G. F. Martinoni (Padua, Stabilimento Pedrocchi, Piano Nobile), Padua 1995.
4 Aus einem Gespräch mit Annamaria Carrain, Gattin von Alberto Carain, und Tochter Orsola, Padua, 2. Juli 2014.
5 P. E. Selvatico, *Sulle necessità che nello insegnamento dell'arte il lavoro sia compagno dell'istruzione*, in *Scritti d'arte di Pietro Selvatico*, Florenz 1859, S. 381.
6 G. Babetto, *Testimonianze*, in *Mario Pinton – L'oreficeria*, a. a. O.
7 Mündliche Mitteilung Giampaolo Babetto, Arquà Petrarca, 15. September 2014.
8 M. Cisotto Nalon, *Da Umberto Bellotto, maestro del ferro, alla scuola dell'oro di Mario Pinton*, in *Il Selvatico. Una scuola per l'arte dal 1867 ad oggi*, Treviso 2006, S. 138 – 167.
9 Aus einem Gespräch mit Giampaolo Babetto in seiner Werkstatt in Arquà Petrarca, 21. Dezember 2021.
10 Ibid.

Notes

1. *British Gold – Italian Gold*, exh. cat. The Scottish Gallery, curated by G. Folchini Grassetto and C. Jensen (Edinburgh, 1998).
2. A. Sandonà, 'L'arte contemporanea e la produzione orafa degli artisti: per una ricostruzione storica', in *Gioielli d'Autore: Padova e la Scuola dell'oro*, exh. cat. Palazzo della Ragione, Padua, curated by M. Cisotto Nalon and A. M. Spiazzi (Turin, 2008), pp. 66–78.
3. V. Baradel, 'Alberto Carrain, cercatore d'arte', in *Mario Pinton – L'oreficeria*, exh. cat. Stabilimento Pedrocchi, Piano Nobile, curated by G. F. Martinoni (Padua, 1995).
4. From my conversation with Annamaria Carrain, Alberto's wife, and their daughter Orsola at Annamaria Carrain's home in Padua on 2 July 2014.
5. P. E. Selvatico, 'Sulle necessità che nello insegnamento dell'arte il lavoro sia compagno dell'istruzione', in *Scritti d'arte di Pietro Selvatico* (Firenze, 1859), p. 381.
6. G. Babetto, 'Testimonianze', in *Mario Pinton* (see note 3).
7. From my conversation with the master goldsmith Giampaolo Babetto at his studio in Arquà Petrarca, on 15 September 2014.
8. M. Cisotto Nalon, 'Da Umberto Bellotto, maestro del ferro, alla scuola dell'oro di Mario Pinton', in *Il Selvatico: Una scuola per l'arte dal 1867 a oggi* (Treviso, 2006), pp. 138–167.
9. From my conversation with the master goldsmith Giampaolo Babetto at his studio in Arquà Petrarca, on 21 December 2021.
10. Ibid.

potente e gentile, passionale e contenuto, istintivo e razionale, in una combinazione che lo rende straordinario, come uomo e come artista.

Note

1. *British Gold – Italian Gold*, catalogo della mostra a cura di G. Folchini Grassetto, C. Jensen (Edinburgh, The Scottish Gallery), 1998.
2. A. Sandonà, *L'arte contemporanea e la produzione orafa degli artisti: per una ricostruzione storica*, in *Gioielli d'Autore. Padova e la Scuola dell'oro*, catalogo della mostra a cura di M. Cisotto Nalon, A.M. Spiazzi (Padova, Palazzo della Ragione), 2008, pp. 66–78.
3. V. Baradel, *Alberto Carrain, cercatore d'arte*, in *Mario Pinton – L'oreficeria*, catalogo della mostra a cura di G. F. Martinoni (Padova, Stabilimento Pedrocchi, Piano Nobile), Padova 1995.
4. Testimonianze di Annamaria Carrain, moglie di Alberto Carain, e della figlia Orsola, raccolte personalmente a casa della prima, a Padova, il 2 luglio 2014.
5. P.E. Selvatico, *Sulle necessità che nello insegnamento dell'arte il lavoro sia compagno dell'istruzione*, in *Scritti d'arte di Pietro Selvatico*, Firenze 1859, p. 381.
6. G. Babetto, *Testimonianze*, in *Mario Pinton – L'oreficeria*, op. cit.
7. Testimonianza del maestro orafo Giampaolo Babetto, raccolta personalmente nel suo studio di Arquà Petrarca, il 15 settembre 2014.
8. M. Cisotto Nalon, *Da Umberto Bellotto, maestro del ferro, alla scuola dell'oro di Mario Pinton*, in *Il Selvatico. Una scuola per l'arte dal 1867 ad oggi*, Treviso 2006, pp. 138 167.
9. Testimonianza del maestro orafo Giampaolo Babetto, raccolta personalmente nel suo studio di Arquà Petrarca, il 21 dicembre 2021.
10. Ibid.

Friedhelm Mennekes

Giampaolo Babetto: Between Craft, Art and Architecture

It sounds like professing a creed. If you talk to Giampaolo Babetto about his vocation, he sees himself as both an *artisan* and an *artist*. First of all, he is an *artisan*, a craftsman. He works with his hands to shape his handicraft but has only one objective in mind: creating coherent pieces. Yet he wants to heighten the work plane to the transcendental. The work thrusts into and above itself. Into its interior and into what is beyond it. Into the depths plumbed and the trajectories spanned by his materials and the forms challenging the ideas of a gold- and silversmith. Nor does he live from his daily work alone, but rather from living and working fully in space and time, from designing the spaces and the perspectives of his environment. All this allows the *artisan* in him to surpass himself, to grow into the creations of an *artist* and consistently into those of a *designer of spaces* as well as those of an *architect*.

In French the terms *artiste* and *artisan* are viewed in a dialectical tension that must not be torn asunder. This is equally true of the English terms *artist*

Giampaolo Babetto tra artigianato, arte e architettura

Sembra una confessione. A parlare con lui della sua vocazione, Giampaolo Babetto si considera sia *artisan* che *artiste*. Prima di tutto, però, lui è un *artisan*, un artigiano, che crea con le sue mani, plasma il *lavoro delle sue mani* e ha solo una cosa in mente: creare *utensili* coerenti. Tuttavia vuole poi trascendere la sfera della mera esecuzione per raggiungere l'eccezionalità. L'opera incalza dentro di sé e oltre se stessa. Dentro e fuori. Nelle profondità e nelle potenzialità dei suoi materiali e nel modellamento delle audaci idee di un orafo e argentiere che non vive di sola produzione quotidiana, ma della vita in toto e del lavoro nello spazio e nel tempo, dell'allestimento di spazi e dello sguardo sull'ambiente. Tutto ciò consente all'*artisan* di superare se stesso e di spingersi verso creazioni da *artiste*, e da qui con coerenza verso quelle da *interior designer* e *architetto*.

In francese, i termini *artiste* e *artisan* sono visti in una tensione dialettica che non va lacerata. A troppi esponenti dell'artigianato artistico piace rinnegare l'*artisan* e definirsi esclusivamente *artiste*. Secondo il dizionario *Larousse,* questi è un *maestro del bello,* un *interprete competente* che si è liberato da tutte le convenzioni borghesi. In tale dualismo i confini sono percepiti per poi venire trascesi. Da qui il mondo oltre l'ignoto viene intuito,

Giampaolo Babetto zwischen Handwerk, Kunst und Architektur

Es klingt wie ein Bekenntnis. Wenn man mit ihm über seine Berufung spricht, dann begreift sich Giampaolo Babetto als *artisan* und *artiste* zugleich. Dabei ist er aber zunächst ein *artisan*, ein Handwerker. Er schafft mit seinen Händen, formt *seiner Hände Werk*, hat nur eins im Sinn: stimmige *Gerätschaften* zu schaffen. Doch dann will er die werkhafte Ebene zugleich ins Einzigartige übersteigen. Das Werk drängt in sich hinein und über sich hinaus. Ins Innere und ins Weitere. In die Tiefen und Spannweiten seiner Materialien und dem Gestalten der herausfordernden Ideen eines Gold- und Silberschmieds. Und der lebt nicht vom alltäglichen Schaffen allein, sondern vom vollen Leben und Arbeiten in Raum und Zeit, vom Gestalten der Räume und den Perspektiven der Umwelt. Das lässt diesen *artisan* über sich hinaus wachsen, in die Kreationen eines

and *artisan*. All too many gold- and silversmiths tend to deny the *artisan* and simply call themselves *artists*. According to the *Larousse Dictionary*, an artist is defined as a 'master of the beautiful', a 'competent interpreter', someone who has liberated themselves from all bourgeois conventions. In this double-sidedness, boundaries are perceived and transcended. Now the world beyond the unknown is sensed and interpreted on the fundamental plane of the creative itself. In the here and now, the *artisan* senses artistic quality as something that seems to exist above and beyond what has been worked and, in tracking it down, becomes an *artist*. It would be one-sided, both theoretically and practically, to remain in craftsmanship alone. Without any expansion into the ideal, a practitioner would degrade himself to the incidental. Hence he must pursue the brilliance of the idea and, in structuring and conceiving, mark out the new paths into the aura of the artist. Giampaolo Babetto, born in Padua in 1947, lives in the unity of *artist* and *artisan*. The commensurate craftsmanly translation of theoretical concepts is his sole guideline for dealing with that state of being. Only in so doing does he achieve artistic perfection. This is a personal, artistic and voluntarily assumed stance for grounding himself, which, although pre-shaped in terms of content and form, bears independent witness to his own interiority

quindi compreso nella dimensione fondamentale della creazione. Nel qui e ora, l'*artisan* intuisce la qualità *artistica* come qualcosa che sembra esistere al di là di ciò che è stato creato, diventando così *artiste*. Sarebbe limitante, sia in teoria che nella pratica, rimanere all'interno di una dimensione prettamente artigianale. Senza alcuna tensione verso l'ideale ridurrebbe se stesso al contingente. E dunque segue il balenio dell'idea e traccia sentieri non battuti, strutturando e progettando, muovendosi verso l'aura di un *artiste*.
Nato a Padova nel 1947, Giampaolo Babetto vive nel connubio di *artiste* e *artisan*. Regola unica è per lui la messa in pratica di concetti teorici in coerenza con i dettami artigianali. Solo così può raggiungere la perfe-

artiste und konsequent in die eines *Raumgestalters* sowie die eines *Architekten*.
Im Französischen werden die Begriffe *artiste* und *artisan* in einem dialektischen Spannungsverhältnis gesehen, das nicht auseinandergerissen werden darf. Allzu viele Kunstschmiede verleugnen gerne den *artisan* und nennen sich selbst nur *artiste*. Nach dem Wörterbuch *Larousse* versteht man darunter einen *Meister des Schönen*, einen *kompetenten Interpreten*, jemanden, der sich von allen bürgerlichen Konventionen befreit hat. In dieser Zweiseitigkeit werden Grenzen wahrgenommen und überstiegen. Jetzt wird die Welt jenseits des Unbekannten erspürt und in der fundamentalen Dimension des Schöpferischen selbst begriffen. Im Hier und im Jetzt erspürt der *artisan* die *künstlerische* Qualität als etwas, das über das Erarbeitete hinaus zu existieren scheint, und wird auf dieser Spur zum *artiste*. Einseitig wäre es, theoretisch wie praktisch, im Handwerklichen allein zu bleiben. Ohne jegliche Weitung ins Ideelle würde er sich selbst ins Nebensächliche herabsetzen. Darum gilt es, dem Glanz der Idee zu folgen und im Strukturieren und Konzipieren die neuen Wege in die Aura eines *artiste* abzustecken.
Giampaolo Babetto, 1947 in Padua geboren, lebt in der Einheit von *artiste* und *artisan*. Im Umgang damit ist ihm die angemessen handwerkliche Umsetzung der theoretischen Konzepte alleinige Richtschnur. Nur so erreicht er die künstlerische Perfektion. Diese ist eine persönliche, künstlerische und frei zu verantwor-

– and to his own standpoint. That is what defines the *artist*: he stands in the midst of creative energy, stands tall, in his freedom. That is why he is always in motion and, caught up in a restlessness inherent in that state, is always striving above and beyond whatever he is working on. Should that aim be ultimately achieved, it nonetheless invariably remains embedded in the process of an uncertain further quest.

The artistic act takes place, as every intellectual and spiritual act does, in the dialectic of position and negation, of craftsmanly placement and doubting query. This doubt is the actual *movens*, the force driving such creative processes as *artisan* and *artist*, restless, never satiated creativity: art as a permanent investigation of the primary inner realities or, rather, as investigation and further development of our means to shape reality – art, therefore, which is constantly beginning anew to give form to that which is inchoate. However, in Giampaolo Babetto's work it is not just an abstract idea that stands at the beginning but always a piece of material, of silver, gold or iron, or be it merely the sight of one of those small colourful sherds from Murano that he has collected since childhood. The raw material properties of any found piece arouse the idea of working and designing. This *artisan* loves the protracted gazing entailed in looking at and thinking. Then a spark, an

zione artistica. Si tratta di una personale presa di posizione artistica, liberamente scelta, che al di là di impostazioni preesistenti rispetto a contenuti e forme è una testimonianza autonoma del mondo interiore dell'artista – nonché del suo punto di vista. Questo è ciò che contraddistingue l'*artiste*: è al centro dell'energia creativa, in maniera autentica e in piena libertà. Ecco perché è sempre in movimento e, in un'inquietudine tutta propria, incalza sempre oltre l'opera specifica. L'obiettivo, ogni volta raggiunto pur se a fatica, rimane tuttavia parte di un processo di ricerca continua e incerta.

Come ogni attività intellettuale, anche quella artistica si compie nella dialettica tra posizione e negazione, impostazione artigianale e interrogativi pieni di dubbi. Proprio il dubbio è il vero *movens*, la forza motrice di processi creativi come quelli dell'*artisan* e dell'*artiste*, la creatività inquieta e mai soddisfatta: l'arte come esplorazione continua delle realtà interiori primarie, o meglio, come esplorazione e sviluppo dei mezzi che abbiamo a disposizione per forgiare la realtà; arte, dunque, che si propone sempre di dare forma all'informe.

Tuttavia, all'origine del lavoro di Giampaolo Babetto non c'è solo un'idea astratta, ma sempre un pezzo di materiale, argento, oro o ferro; a volte basta anche solo la vista di uno dei frammenti colorati di Murano che ha raccolto fin dall'infanzia. La natura materica e grezza di un oggetto trovato risveglia l'idea di mettersi al lavoro, di creare. L'*artisan* ama lo sguardo che indugia nella contempla-

tende Verortung seiner selbst, die trotz aller inhaltlichen und formalen Vorgeprägtheit ein unabhängiges Zeugnis seines eigenen Inneren ist – und seines Standpunktes. Das macht den *artiste* aus: Er steht mitten in der schöpferischen Energie, im aufrechten Gang, in seiner Freiheit. Darum ist er immer in Bewegung und will in einer ihr eigenen Unruhe stets über das jeweilige Werk hinaus. Ist dies am Ende mühsam errungen, bleibt es doch immer eingebettet in den Prozess eines ungesicherten weiteren Suchens.

Das Künstlerische vollzieht sich wie jedes geistige Tun in der Dialektik von Position und Negation, von handwerklichem Setzen und zweifelndem Fragen. Dieser Zweifel ist das *movens*, die treibende Kraft solch schöpferischer Vorgänge als *artisan* und *artiste*, die unruhige, nie zufriedengestellte Kreativität: Kunst als dauerhafte Erforschung der primären inneren Wirklichkeiten, oder besser: als Erforschung und Weiterentwicklung unserer Mittel zur Wirklichkeitsgestaltung; Kunst also, die zur Gestaltung des Gestaltlosen ansetzt. Aber:

In Giampaolo Babettos Schaffen steht am Anfang nicht eine abstrakte Idee allein, sondern immer ein Stück Material, aus Silber oder Gold oder Eisen; und sei es auch nur der Blick auf eine der kleinen bunten Scherben aus Murano, die er von Kindheit an sammelte. Die je rohe materielle Beschaffenheit eines Fundstücks weckt die Idee zum Arbeiten und Gestalten. Dieser *artisan* liebt die gedehnten Blicke des Anschauens und Überlegens. Dann blitzt ein Funke, eine Idee aus und den Einfall gilt es zu bearbeiten. Geduldig ist dieser

idea, ignites, and the sudden inspiration must be worked on. This gold- and silversmith patiently engages in mulling over the craftsmanly processes of his discipline and practising them, patiently and devotedly. While doing this he does not lose sight of his ideas, nor do they elude his alert, searching interest. Design, idea and realisation always remain an entity and are operative in the sense they would be for an *artisan* who is existentially aware of the creative aspects relevant to an *artist* and lives with them.
Structures grow out of a sudden inspiration and are gradually realised. First into sketched notes, then in the courage to design and finally on the way to realisation via bar and angle, fabric and frame, moving and bending, via folding and connecting, association and lengthening ... The ways vary; they lead back and forth, through colour and contrast, brilliance and transparency, object and reflection ... In between this, thinking – and waiting. Yet then further in a direction that leads beyond all beginnings to load-bearing forms, to circle or oval, square or triangle, to a centring point or into an explosive zone. He endlessly hammers and turns the precious materials, searching and doubting, methodically and playfully. Technique tends to turn into obstinacy just as easily as the fascination of the instant can leap into a change in time.

Gold- und Silberschmied dabei, den handwerklichen Prozessen seines Fachs nachzusinnen und nachzugehen, geduldig und ergeben. Seine Ideen verliert er dabei weder aus den Augen, noch entfallen sie seinem wachen wie suchenden Interesse. Entwurf, Idee und Umsetzung bleiben stets eins und wirken im Sinn eines *artisan*, der existentiell um die kreativen Aspekte eines *artiste* weiß und damit lebt.
Aus einem Einfall wachsen die Strukturen und werden nach und nach umgesetzt. Erst hinein in zeichnerische Notation, dann im Mut zum Entwurf und schließlich auf den Weg in die Verwirklichung über Stab und Winkel, Geflecht und Rahmen, Bewegen und Biegen; über Knicken und Verbinden, Assoziieren und Verlängern ... Es sind unterschiedliche Wege, sie führen hin und zurück, über Farbe und Kontrast, Glanz und Transparenz, Objekt und Reflexion ... Dazwischen das Überlegen – und Warten. Doch dann weiter in eine Richtung, die über alle Anfänge hinaus zu tragenden Formen führt, zu Kreis oder Oval, Quadrat oder Dreieck, zu einem zentrierenden Punkt oder in eine explosive Zone. Schier endlos wird an den edlen Materialien gehämmert und gedreht, suchend und zweifelnd, überlegt und spielerisch. Leicht wandelt sich hier Technik in Eigensinn, ebenso leicht, wie die Faszination des Augenblicks in die Veränderung der Zeit zu springen weiß. Bis die letzte Form sich klärt, bewegt sich das Konstruieren. Am Ende dann zeigt sich ein ästhetisches Kleinod. Es schimmert und schillert im Glänzen und verwandelt sich im gestaltenden Blick: in die Assoziationen von Natur

33

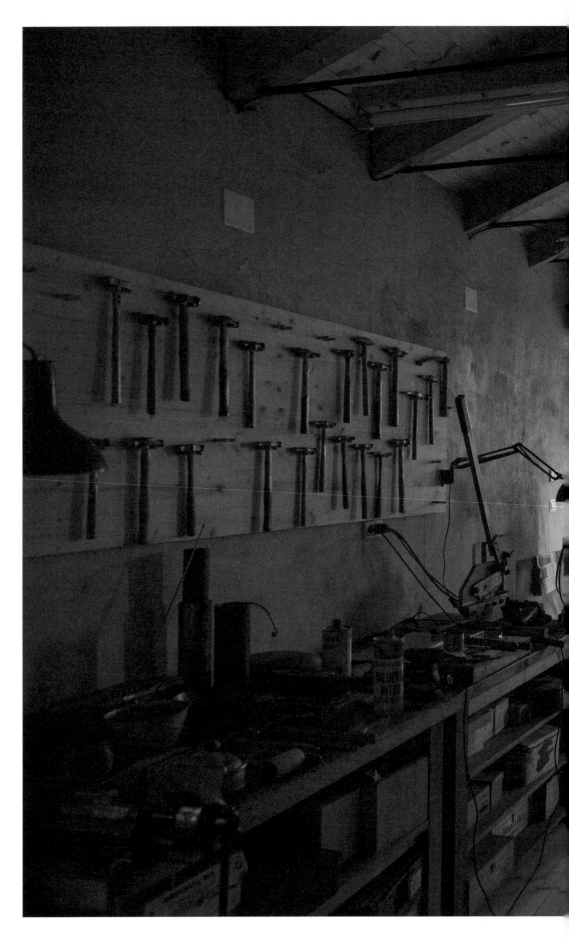

Giampaolo Babetto in his working studio in Arquà Petrarca

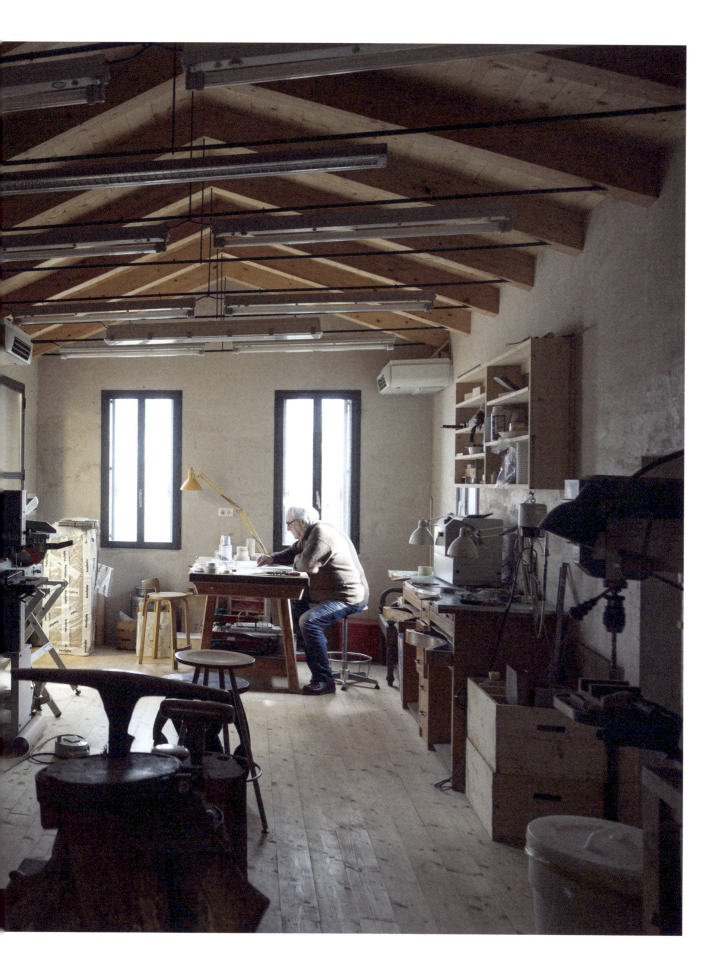

Constructing goes on until the last form has been clarified. The outcome is finally an aesthetic treasure. Gleaming and iridescent in its sheen, it is transformed in the designing eye: into associations of nature and symbol on up to fantastic flashes of lightning, followed by pride and joy. Thus the exquisite configurations emerge into the light of the present – like a house of light, a house in the here and now.
In many years of working as a creative gold- and silversmith, Giampaolo Babetto has amassed wide-ranging knowledge, stored up a rich inner treasure trove of forms. Here and there they surface to become gradually palpable again. Sometimes a remembered whole moves into the open, depending on the source of inspiration, the idea and the impact made. Yet then also a countervailing perception that views everything sceptically and rejects it. The quiescent motive for the form moves and is transformed, both gradually and permanently. Associations ignite, stimulate, inspire. They often remain at a loss for a moment, only to be captured with a line on paper and adhere to a notation, or again the artist's hand varies them deliberately and transports them animatedly to a subject. In such situations the creative often allows themselves to be guided and led onwards by emotions. No sooner has a pencil dropped than the *artist* has got stuck on the drawing without

zione e nella riflessione. Poi una scintilla, un'idea balena e ora si tratta di lavorare all'intuizione. L'orafo e argentiere riflette con pazienza sui processi artigianali del suo mestiere e li mette in pratica, con pazienza e dedizione, senza perdere mai di vista le proprie idee, sempre presenti al suo interesse vigile e curioso. Schizzo, idea e realizzazione costituiscono un tutt'uno nel rispetto dell'intenzione dell'*artisan,* che conosce nella sostanza le possibilità creative dell'*artiste* e ci convive.
Da un'intuizione prendono forma strutture che poi vengono realizzate gradualmente: dapprima nell'appunto grafico, poi azzardando lo schizzo, infine nel processo di esecuzione con barra e squadra, intreccio e intelaiatura, muovendo e flettendo; e poi piegando e saldando,

assemblando e prolungando... Sono vari i percorsi, spesso tortuosi, che passano per il colore e il contrasto, la lucentezza e la trasparenza, l'oggetto e il riflesso...
E intanto pondera, in attesa, per poi procedere in una direzione che al di là di qualsiasi inizio conduce infine a forme fondamentali, al cerchio o all'ovale, al quadrato o al triangolo, a un punto centrale o a una zona da cui tutto erompe. I preziosi materiali vengono martellati e ritorti senza sosta, cercando e dubitando, valutando ma non senza spirito ludico. L'estro prende il posto della tecnica con facilità, così come il fascino per l'attimo sa abbracciare il cambiamento che il tempo porta con sé.
Finché l'ultima forma non è chiarita, il processo di realizzazione è in divenire. Alla fine emerge un gioiello di

und Symbol, bis hin zu fantastischen Blitzen, gefolgt von Stolz und Freude. So setzen sich die feinen Gebilde ns Licht der Gegenwart – wie in ein Haus durchdrungen von Licht, ein Haus im Hier und Jetzt.
In den vielen Jahren seines freien Schaffens als Gold- und Silberschmied hat sich bei Giampaolo Babetto im Inneren ein breites Wissen angesammelt, ein reicher Schatz an Formen eingelagert. Hier oder da tauchen sie auf und werden langsam wieder greifbar. Manchmal bewegt sich ein erinnertes Ensemble ins Offene, je

nach Anregung, Einfall und Wirkung. Doch dann auch ein Gegensinn, der alles skeptisch sieht und verwirft. Der ruhende Formgrund bewegt sich und transformiert sich, so langsam wie permanent. Assoziationen springen über, regen an, inspirieren. Gern setzen sie sich im Ratlosen für einen Moment wie von selbst mit einem Strich auf dem Papier fest und halten sich an einer Notation, oder aber die Hand des Künstlers variiert sie bewusst und überführt sie bewegt auf ein Thema. Gern lässt sich der Schaffende in solchen Situationen von

Emotionen führen und weiterleiten. Dann fällt ein Bleistift hin und schon bleibt der *artiste* an der Zeichnung fraglos hängen. Schon greift der *artisan* zum kleinen Hammer, weg vom Papier, hin zu Blech, zum Amboss zum Kitt. Auf den Spuren von Gold und Silber laufen jetzt Hand und Werkzeug ins Treiben und Formen, zeitlos gehalten von meditativer Dichte, gelassen begleitet in kreativem Warten, wie die Devotion vor dem einfachen Tun. Dann können sich manche Strukturen wie von allein erfinden. Doch plötzlich wieder stoppt

question. The *artisan* is already reaching for the little hammer, away from paper towards sheet metal, to the anvil, to putty. On the track of gold and silver, hand and tools run to the beating and shaping, kept timeless by meditative intensity, casually accompanied in creative waiting like devotions before a simple act. Then some structures can invent themselves as if of their own accord. Yet all acting abruptly comes to a halt again. A pause! A glance outdoors – and stones, or other, additive, elements, are already rolling into play. Metallic colours glow with iridescence. Diagonals obstruct. Variations in form and material stand in ... At the end comes the tightening up, the decision. The transfigured form, perhaps also 'just' an inner glimpse of a person who may ultimately wear the work?

Stillness surrounds Giampaolo Babetto's work. His life centres on two locations. First, the cell, like that of a Carthusian monk, and then the studio with a spirituality all its own in an expansive atmosphere. Here, too, the silence at work, the stillness and tension in the studio, accompanied by two introduced female assistants. Soft tones of hammer blows, quieter filing, milling, rasping, fine filing, sanding ... And everything converges on jewellery, rings and brooches, necklaces and bracelets ... on finger, ear, neck, arm and chest.

impatto estetico. Brilla e riluce nel suo sfolgorio, e negli occhi di chi crea trasfigura le associazioni tra natura e simbolo, fino a risultare in formidabili sfolgorii a cui fanno seguito l'orgoglio e la gioia. In questo modo, le delicate creazioni vedono la luce del presente – come in una casa permeata di luce, una casa nel qui e ora.

Nei tanti anni di attività da orafo e argentiere Giampaolo Babetto ha accumulato una vasta gamma di conoscenze, e si è andato costituendo un ricco tesoro di forme. Qua e là ricompaiono e lentamente diventano di nuovo tangibili. A volte, sulla scia di una suggestione, un'intuizione o un effetto, un insieme di forme archiviate torna a manifestarsi. Ma poi può farsi strada anche il pensiero opposto, che vede tutto con scetticismo e rigetta. La forma di base, in sospeso, prende a muoversi e si trasforma, lentamente ma in maniera duratura. È un flusso di associazioni che stimolano, ispirano. Nella perplessità, per un momento si fissano sulla carta con un segno, come da sé, seguendo un'annotazione, oppure la mano dell'artista le modifica deliberatamente e, con emozione, le spinge verso un tema. In tali situazioni, l'artista si lascia condurre e guidare volentieri dalle emozioni.

Poi però cade una matita e allora l'*artiste* si ferma inevitabilmente al disegno. E già l'*artisan* allunga la mano verso il piccolo martello, allontanandosi dal foglio di carta, muovendosi verso la lamiera, l'incudine e il mastice. Guidati dall'oro e l'argento, la mano e l'attrezzo si affrettano ora a sbalzare, a modellare, nella sospensione

alles Tun. Ein Halt! Ein Blick hinaus ins Freie – und schon rollen Steine ins Spiel, oder andere, additive Elemente. Metallfarben changieren. Diagonalen legen sich quer. Variationen in Form und Material springen ein ... Am Ende steht die Straffung, die Entscheidung. Die geklärte Form, vielleicht auch ‚nur' der innere Blick auf eine Person, die das Werk schlussendlich tragen mag?

Im Umfeld von Giampaolo Babettos Arbeit ist es still. Sein Lebenszentrum hat zwei Orte. Erst die Zelle allein, wie die eines Kartäusers; und dann

dell'intensità meditativa, gesti accompagnati in tutta calma nell'attesa creativa, come in un atto di devozione per il fare più puro. Allora succede che alcune strutture prendano forma come da sé. Poi d'improvviso tutto si blocca di nuovo. Un'interruzione! Basta uno sguardo fuori e già entrano in gioco le pietre, o altri elementi aggiuntivi, i colori per metalli risaltano di riflessi, le diagonali si incrociano, vengono eseguite variazioni sulla forma e sul materiale... Alla fine arriva il momento di semplificare, di prendere una decisione: la forma chiara, forse anche 'solo' l'immagine di chi poi vorrà indossare il pezzo? Intorno a Giampaolo Babetto c'è calma durante il lavoro. La sua vita ruota intorno a due luoghi: innanzitutto la cella, come quella di un certosino; e poi lo studio, un ambiente più ampio con una spiritualità tutta sua. Anche qui lavorando senza parlare, in silenzio e tensione, affiancato da due esperte assistenti. Suoni delicati di colpi di martello, più fievoli quelli prodotti limando, fresando, raspando, sgrezzando, smerigliando... E tutto incalza verso il gioiello, ossia anelli e spille, collane e bracciali... verso dita, orecchi, collo, braccio e petto.

Poi all'improvviso una chiamata che annuncia l'interesse di una chiesa per coppe in argento martellato! A parlare al telefono è il rettore della chiesa gesuita di Sankt Michael a Monaco di Baviera. Con la sua sontuosa volta a botte la chiesa è stata eretta alla fine del tardo XVI secolo e rimane una delle testimonianze più impressionanti del Rinascimento d'oltralpe. Saggiamente consigliato da un

das Studio mit seiner ganz eigenen Spiritualität in erweiterter Atmosphäre. Auch hier das Schweigen beim Schaffen, die Stille und Anspannung im Atelier, begleitet von zwei eingeführten Assistentinnen. Sanfte Töne von Hammerschlägen, leiser das Feilen, Fräsen, Raspeln, Hieben, Schmirgeln... Und alles zieht zum Schmuck, zu Ringen und Broschen, zu Ketten und Reifen..., zu Finger, Ohr, Hals, Arm und Brust.

Dann plötzlich ein Anruf mit kirchlichem Interesse an gehämmerten Silberbechern! Der Rektor der Münchener Jesuitenkirche Sankt Michael ist am Telefon. Die Kirche wurde in den letzten Jahren des auslaufenden 16. Jahrhunderts mit ihrem dominanten Tonnengewölbe errichtet und ist bis heute eine der beeindruckendsten Markierungen der Renaissance nördlich der Alpen. Klug beraten von einem Galeristen, sucht der Geistliche zeitgemäßes, liturgisches Gerät: Gefäße und Kummen, Patenen und Becher; einen vertikalen Kelch und eine bauchig hochwandige Schüssel – alles in geschlagenem Silber.

Das Motiv liegt in der zu erneuernden Liturgie. Der Impuls liegt Jahrzehnte lang zurück und vollzieht sich seit dem Konzil in den sechziger Jahren radikal an vielen Altären. Sie stehen jetzt frei im Raum und die Priester umstellten sie mit Blick auf die Gemeinde. In St. Michael dominiert der neue Altar seither den Kirchenraum. Er steht zentral am Beginn des tiefen Chores, am Ende einer hohen goldenen Altarwand mit dem Bild des Erzengels in der Mitte. Was früher von den Rücken der Geistlichen verborgen war, die Handlung der Heiligen Messe, voll-

Then suddenly out of the blue a telephone call announcing ecclesiastical interest in hammered silver beakers! The caller is the rector of St Michael's, a Jesuit church in Munich. Built in the closing centuries of the sixteenth century, the Jesuit church with its overwhelming barrel vaulting is still one of the most impressive markers laid down by the Renaissance north of the Alps. Taking some sensible advice proffered by a gallerist, the priest was looking for liturgical vessels that would be in keeping with the times: vessels and bowls, patens and beakers, a vertical chalice and a high-sided globular bowl – all of them to be executed in beaten silver.

His motive was the ongoing liturgical revival. A movement launched decades before, it had radically influenced the status of altars in many churches since the Second Vatican Council in the 1960s. Now they were freestanding, and priests rearranged them to face the congregation. Since then the new altar in St Michael's has dominated the church interior. It is centrally positioned at the start of a deep chancel which ends in a high, golden retable with an image of the archangel. What was once hidden by the backs of priests celebrating Mass now takes place before the eyes of the congregation. Partly concealed beneath brightly coloured cloths, partly gleaming in the glancing gold of liturgical vessels. Yet the change went no further than that.

gallerista, l'ecclesiastico cerca oggetti liturgici di fattezze contemporanee: vasi e ciotole, patene e coppe, un calice e una patena offertoriale a pareti alte – tutto in argento martellato.
Il motivo della richiesta è il desiderio di rinnovare la liturgia, desiderio maturato già decenni prima e che dal Concilio Vaticano II negli anni Sessanta sta coinvolgendo in modo radicale molti altari. Ora in posizione esposta, gli altari permettono ai sacerdoti di girargli intorno con lo sguardo rivolto verso la congregazione. Il nuovo altare di Sankt Michael domina da allora lo spazio. Si trova in posizione centrale all'inizio del profondo coro, alla cui fine si trova un imponente altare maggiore dorato con l'immagine dell'arcangelo al centro. Ciò che un tempo era nascosto alla vista dietro al celebrante, ossia lo svolgimento della Santa Messa, viene ora eseguito sotto lo sguardo della congregazione. In parte sotto panni colorati, in parte nello splendore dorato degli oggetti liturgici. Tuttavia il cambiamento si era arreso qui.
Il nuovo inizio per la nuova generazione di celebranti prende ora avvio con una consulenza competente, durante la quale viene azzardato un nome: quello dell'orafo e argentiere Giampaolo Babetto della zona di Padova. La cosa avrà conseguenze, per il rituale e per il materiale degli oggetti liturgici. Nel caso di questa richiesta da parte di una congregazione numerosa, che all'epoca contava non meno di tremila fedeli, si trattava, generalmente parlando, di una sorta di commissione per inter-

zieht sich jetzt zu den Augen der Gemeinde hin. Teils unter bunten Tüchern verborgen, teils in gleißendem Gold-Glanz des Mess-Geschirrs. Doch so blieb die Veränderung stecken.
Der neue Anfang von neuen Zelebranten steht endlich unter einer kompetenten Beratung. Ein Name wurde ins Wagnis gesetzt, der gestaltende Silber- und Goldschmied Giampaolo Babetto aus dem Raum Padua. Jetzt sollten weitere Konsequenzen folgen, für das Ritual und für das Material des ‚Mess-Geschirrs'. Bei diesem Anliegen aus einer riesigen Großstadtgemeinde mit damals an die 3.000 Gottesdienstbesuchern handelte es sich – allgemein gesagt – um eine Art Auftrag für *bühnenbildnerische* und *szenische* Initiativen in einem *theatrum sacrum*.
Giampaolo Babetto hatte in seiner Arbeit längst die Ebene des kleinteiligen Schmucks verlassen und die Bühnen der Mobiliargestaltung und der Architektur betreten. Das Thema des *Raums* und seiner Gestaltung befasste ihn längst. Das lebte aus dem Formgefühl für die Renaissance-Villen Venetiens, in deren Umgebung er aufwuchs, und stand vor allem im Geist und in der Atmosphäre der Architektur Andrea Palladios. Dieses Empfinden wurde fortgesetzt in der Arbeit als Gold- und Silberschmied im Geist der sog. Paduaner-Schule. Sie hatte eine lange Tradition, wurde Anfang des 20. Jahrhunderts von Mario Pinton (1919–2008) reformiert und später auch von jüngeren Künstlern wie Babetto weitergeführt. Zunächst ging es da wieder um das Mysterium der Renaissance, die Schönheit der Geometrie, die Propor-

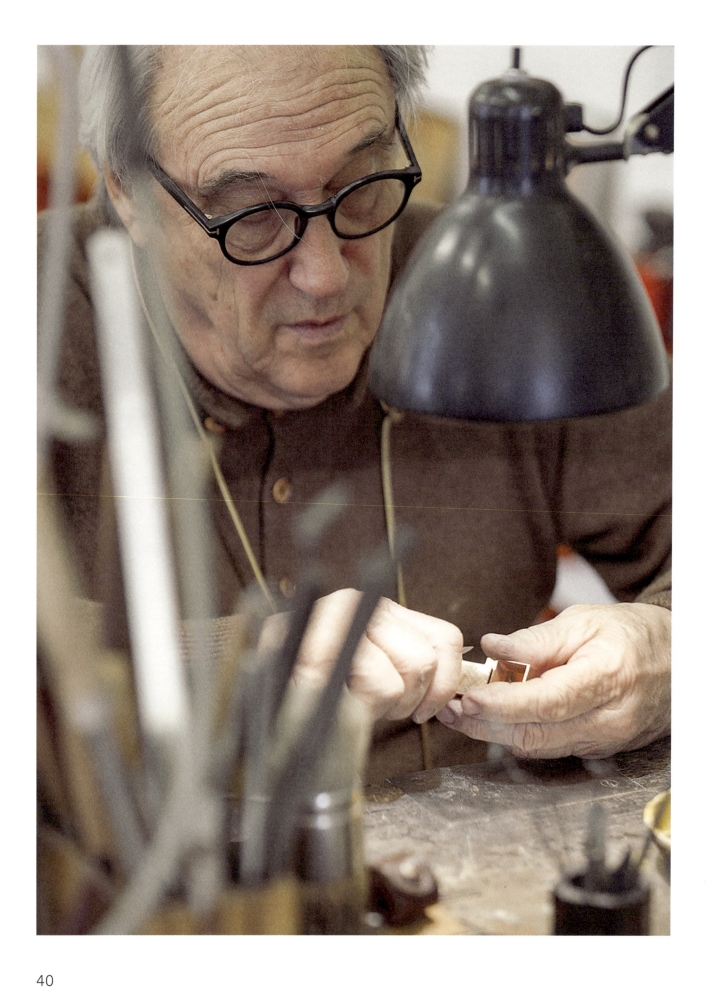

A fresh beginning with new celebrants was finally under competent counsel. A name was added to the risk equation: Giampaolo Babetto from Padua province, a silver- and goldsmith and designer. More consequences would be forthcoming for the ritual and the material of the 'sacred vessels'. In this case, where a huge urban congregation with some three thousand attending at the time was concerned, this meant – put in general terms – commissioning, as it were, *stage settings* and *scenic* initiatives in a *theatrum sacrum*. In his work Giampaolo Babetto had long since abandoned the plane of small-scale jewellery and entered the stage with furniture design and architecture. For quite some time he had been preoccupied with the subject of *space* and designing it. It drew on a feeling for the form of the Renaissance villa in the Veneto, where he had grown up, and was informed above all by Andrea Palladio's architecture. This sensibility continued in his work as a gold- and silversmith in the spirit of what is known as the Padua School. Looking back on a long tradition, it was reformed in the early twentieth century by Mario Pinton (1919–2008) and later on was also upheld by younger artists, including Babetto.

At first it was once again about the mystery of the Renaissance, the beauty of geometry, proportion and scale, designing the movable elements of

venti *scenografici* e *scenici* all'interno di un *theatrum sacrum*.
Giampaolo Babetto si era lasciato alle spalle da tempo l'ambito della piccola gioielleria per entrare sulle scene del design d'arredi e dell'architettura. Da molto si occupava del tema dello *spazio* e del suo allestimento. Ciò scaturiva dal senso per la forma sviluppato per le ville venete, nei cui dintorni era cresciuto e dove in particolare aveva subito l'influenza dell'architettura di Andrea Palladio. Questo modo di percepire era stato esteso al lavoro di orafo e argentiere nello spirito della cosiddetta "Scuola Padovana". La lunga tradizione della scuola era stata riformata all'inizio del XX secolo da Mario Pinton (1919-2008) e poi portata avanti da artisti più giovani come Babetto.

tionen von Maß und Zahl, die Gestaltung der beweglichen Elemente des Raums, die Konzentrierung der Licht- und Schattenwürfe, die Konzentrierung der Gefäße auf das getriebene Silber allein und der Verzicht auf die bunten Textilien, die theatralische Formung der liturgischen Bewegungen. Der Silberglanz war bislang den Kerzen und Kreuzen vorbehalten, die den Altar umstellen. Er sollte nun in die gehämmerten Gefäße auslaufen und so dem reduzierten Glanz des Silbers auf dem Altar ein neues Zentrum geben.

Aus diesen Perspektiven wollte der Künstler jetzt ein Ensemble für eine konsequentere Zelebration der Eucharistie entwerfen. Babetto wusste, diese Bedeutung ernst zu nehmen, und begann, neue Dimensionen seines Œuvres zu kreieren. Zwei Dimensionen werden jetzt bedeutsam und zwei vorgegebene Perspektiven miteinander verbunden: die gemessenen Größen von Kirchenraum, Apsis und Altar einerseits, sowie die Hände der Liturgen und die Schalen andererseits. Im Zentrum der Handlung werden die Hände des Priesters verschieden tätig. Sie bilden daher mit den Gefäßen eine Einheit: bei der Gabenbereitung im Einschütten von Wein und Wasser in den Kelch und bei seiner Erhebung im Gebet sowie in der betenden Darbringen des Brotes in der großen Schale. Abgeschlossen wird diese erste Handlungsfolge durch ein sakrales Waschen der Hände.
Diese Handlungen werden wiederholt durch liturgische Gesten des Gebets unterbrochen, im formalen Ausbreiten der Hände. Im späteren Verlauf der Messe werden die in

space, concentrating the fall of light and the shade cast, concentrating with vessels solely on beaten silver and eschewing colourful textiles, the theatrical shaping of liturgical movements. Until then the gleam of silver had been reserved for the candles and crosses surrounding the altar. Now it was supposed to end in hammered vessels, thus giving the reduced sheen of silver on the altar a new centre. That was the perspective from which the artist was now to design an ensemble for a more cogent celebration of the Eucharist. Aware of what that signified, Babetto took the commission seriously and began to create new dimensions within his oeuvre.

Two dimensions were now significant and two prescribed perspectives were interlinked: on the one hand, the measured spatial entities of church interior, apse and altar and, on the other, the hands of those celebrating the liturgy and the open liturgical vessels. At the centre of the sacrament the priest's hands have various tasks to perform. Hence they form a unit with the liturgical vessels: when preparing the offertory by pouring wine and water into the chalice and raising it in prayer as well as praying when the sacramental bread is offered up in a large paten. This first part of the celebration closes with the ritual washing of hands in a lavabo.

These rites are repeatedly interrupted by the liturgical gestures of prayer,

Al centro della richiesta c'era innanzitutto il "santo mistero" del Rinascimento, la bellezza della geometria, le proporzioni di misura e numero, l'allestimento degli elementi mobili dello spazio, la concentrazione di luci e ombre, la riduzione dei vasi a solo quelli in argento cesellato, la rinuncia ai tessuti colorati, la configurazione teatrale dei movimenti liturgici. Lo splendore argenteo era stato finora riservato alle candele e alle croci intorno all'altare. Ora doveva riverberarsi sui vasi martellati, dando alla ridotta lucentezza dell'argento una nuova posizione centrale sull'altare. Questi gli obiettivi da cui l'artista doveva ora progettare un gruppo di oggetti per una celebrazione più coerente dell'Eucaristia. Babetto seppe prendere sul serio il significato della richiesta e cominciò a dare nuove dimensioni al proprio lavoro.

A questo punto diventano significative due dimensioni, mentre due degli obiettivi stabiliti vengono collegati: le solenni misure di spazio sacro, abside e altare da un lato, le mani dei liturgisti e le patene dall'altro. Nel momento centrale dell'azione liturgica le mani del sacerdote svolgono varie attività, andando a formare un'unità con gli oggetti sacri: durante l'offertorio, nel momento in cui vino e acqua vengono versati nel calice, e poi quando questo viene innalzato in preghiera e durante l'offerta del pane nella patena grande. Questa prima sequenza rituale si conclude con l'abluzione delle mani.

Le azioni vengono ripetutamente interrotte da gesti liturgici di preghiera, quando le mani vengono aperte. Più

zentralen Gefäßen geborgenen Gaben zu Christi Leib und Christi Blut. Als solche werden sie dann zum Austeilen an die Gemeinde verteilt. Dabei geht es um das Umschütten der Gabe des Blutes Christi in kleinere Becher und um das Verteilen der Hostien mit der Hand des Priesters in kleinere Schalen. Vieles hängt dabei von der Größe des Sakralraums ab und von der Zahl der Gläubigen. Die Austeilung kann sich auf zwei bis etwa sechs Stellen verteilen.

Kelch und zentrale Schale haben ihre Gestalt in zwei verschiedenen Behältern, die sich mit ihren Gaben szenen- und zeichenhaft nach oben hin unterschiedlich öffnen. Sie gleichen so dem Bild von der Jakobsleiter, die Erde und Himmel, Gott und die Menschen verbindet. Dagegen haben die kleineren Behältnisse, Teller und Becher, eher den Charakter der Präsenz heiliger Gaben im Verborgenen. Der Priester erhebt die größere Schale vor die Menschen hoch, entnimmt eine sichtbare Hostie und zeigt sie den Gläubigen als Leib Christi. Dann nimmt er den Kelch und erhebt ihn als den Kelch des Blutes Christi. Beide Gaben suchen auf dem Weg zu einer erneuerten Liturgie Wege zum Brechen des Einen Brotes für die vielen Gläubigen auf kleinere Teller und die Verteilung des Weins aus dem Einen Kelch in kleinere Becher. Sie werden von den Austeilenden als sakramentale Gabe Gottes an den gläubigen Menschen gereicht, Aug' in Aug', gemeinsam im Glauben, an verschiedenen Orten.

Die Entwicklung dieser erneuerten Liturgie lag nun nicht mehr nur im Blick der Theologen, sondern auch in den formenden Händen eines

in the formal spreading of hands. Later on in the course of Holy Mass, the host and wine concealed in the central vessels are changed into the body and blood of Christ. As such they are distributed to the congregation.
The priest's hands do this by pouring the blood of Christ into smaller beakers and distributing the altar bread on smaller plates. Much depends on the size of the sacral space and the number of worshippers. The distribution can be shared out to a number of ministers ranging from two to about six.
The chalice and central plate, the paten, are designed as two separate receptacles which open at the top in different ways to reveal their sacramental content as both sequence and sign. Thus they are equated with the image of Jacob's Ladder, which links Heaven and Earth, God and man. The smaller receptacles, on the other hand – plates and beakers – have instead the character of the hidden presence of sacred offerings.
The priest raises the paten high above the communicants, takes an altar bread visibly from it and shows it to the worshippers as the body of Christ. Then he takes up the chalice and raises it as the chalice containing the blood of Christ. In the ongoing liturgical revival, both offerings seek ways of breaking the One Bread for the many worshippers on smaller plates and distributing the wine from the One Chalice in smaller beakers. They are

Chalice, silver 925, 2013

Silberschmieds. In seinen Entwürfen zeigt er sowohl seine besondere Sensibilität für Formen und Größen der Geräte als auch für die Einheit im liturgischen Vorgang.
Giampaolo Babetto hat neben seinen liturgisch theatralischen Überlegungen auch die Formwelt des christlichen Glaubens neu für sich und seine Arbeit entdeckt. Neben den Gefäßen beeinflusste ihn die Gestalt des Kreuzes. Dieses Bildmotiv legt er in der weiteren Entwicklung in eine breite Spur aus, die sich in vielen Zeichnungen, Skizzen und Entwürfen niederschlägt. Die allerdings sind von keinem ikonografischen Interesse bestimmt. Es ist von den Formen bestimmt – und vom Formen selbst. Sein Zugang zum Kreuzthema wird vor allem von den formalen Bewegungs- und Variationsaspekten bestimmt, nicht von den biblischen Geschichten. Es steht vielmehr im Zusammenhang mit seinem eigenen Schaffen.
Schon in seinen Zeichnungen begegnet man dem Kreuz als ein schlankes, hoch gerichtetes Zeichen ganz ohne Körper. Es fehlt die Annäherung an die menschliche Figur; es ist klein, der Schaft ist entfremdend stark verlängert. Bestimmend ist das Material in drei Versionen, in Kupfer, Silber und Gold. In den ersteren Versionen tritt es gerne in einer variantenreichen Entwurfsfreude auf, wobei die anderen Materialien eher sensibel, sehr ausgereift auftreten.
In der Entwurfsentwicklung findet das Kreuz in seinem Werk eine neue Identität. Es sitzt auf einem überlangen Stab an seinem Ende. Im liturgischen Vergleich ist es dem Prozessionskreuz ähnlich, wo sich

handed by the ministers to the devout as sacramental offerings to God, 'eye to eye', united in faith, in different places.
Developing this reformed liturgy no longer rested solely in the eyes of theologians but also in the shaping hands of a silversmith. In his designs he shows a special sensitivity for both vessel forms and sizes and the unity of the liturgical process.
While thinking about how to stage the liturgy, Giampaolo Babetto rediscovered the world of forms of the Christian faith personally and for his work. Apart from liturgical vessels, he was influenced by the design of the Cross. Laying down his ideas in numerous drawings, sketches and designs, he used a wide-ranging approach to further develop this motif. They are not shaped by any particular iconographic bias. The visual motif is determined by forms – and by the act of forming. Above all, it is the formal aspects of movement and variation, not the biblical stories, that inform his approach to the Cross as a motif. Rather, it is associated with his own work.
In the drawings the Cross is already encountered as a slender, tall sign devoid of corporeality. There is no rapprochement with the human figure; it is small, with the shaft defamiliarised by considerable lengthening. The paramount factor is the material in three versions: copper, silver and gold. In

tardi nel corso della messa, i doni posti nei contenitori al centro diventano il Corpo e il Sangue di Cristo. Come tali vengono poi amministrati alla congregazione durante la distribuzione della comunione. Si tratta di versare il dono del Sangue di Cristo in coppe e di distribuire le ostie in patene più piccole, tutto per mano del sacerdote. Molto dipende dalle dimensioni dello spazio sacro e dal numero di fedeli, la distribuzione può venire eseguita in vari punti, da due a sei.
Calice e patena offertoriale hanno forme che derivano dalla loro diversa funzione; sono contenitori che con i loro doni si aprono verso l'alto in maniera emblematica e scenica, ciascuno a modo suo. In questo richiamano l'immagine della scala di Giacobbe, che collega la terra e il cielo, Dio e gli esseri umani. Dal canto loro, i contenitori più piccoli, ossia piatti e coppe, hanno fattezze che indicano la presenza dei doni sacri in maniera più celata.
Il sacerdote solleva la patena offertoriale davanti ai fedeli, ne estrae un'ostia in maniera visibile a tutti e la mostra ai fedeli quale Corpo di Cristo. Poi prende il calice e lo innalza nella sua qualità di calice del Sangue di Cristo. All'insegna di una liturgia rinnovata, si cercano modi durante l'offertorio per distribuire in piatti più piccoli il pane spezzato per i molti fedeli e per versare il vino dal calice nelle coppe più piccole. In luoghi diversi, il celebrante amministra le offerte quale dono sacro di Dio ai fedeli, occhi negli occhi, uniti nella fede.
L'elaborazione di questa liturgia rinnovata non era ora

das ausgeformte Kreuz als Kruzifixus hoch aus einer Gruppe heraushebt. Bei Babetto ist das Kreuz hingegen eher ein abstraktes Zeichen, herausgehoben aus allen inhaltlichen Anwendungen, ein Zeichen unter Zeichen.
Eine weitere Gruppe dieser Formsonderungen zeigt sich auf kleinen, rechteckigen Blechen, auf denen die überkreuzenden Linien ihre Form finden, mit zwei Strichen eingezeichnet, eingeritzt oder eingeschnitten. Auf anderen Versionen wird die Form in das Metall eingebrannt. Dann

Cross, silver 925, 2013

più solo al centro dell'attenzione dei teologi, ma anche nelle mani plasmanti di un argentiere. Nei disegni l'artista rivela sia la sua peculiare sensibilità per forme e dimensioni degli oggetti che per l'unità nello svolgimento liturgico.
Oltre alle sue considerazioni liturgico-teatrali, Giampaolo Babetto ha riscoperto per sé e per il suo lavoro anche il mondo formale della fede cristiana. A suggestionarlo non sono tuttavia solo le forme dei vasi sacri, ma anche quella della croce. Nell'evoluzione che ne segue, il motivo della croce viene ampiamente declinato, come riflettono i numerosi disegni, schizzi e bozzetti. Questi, tuttavia, non prendono avvio da alcun interesse iconografico, ma dalle forme – e dall'atto stesso del forgiare. Il suo approccio al tema della croce è determinato soprattutto dagli aspetti formali del movimento e della variazione, non dai racconti biblici, e risale piuttosto al suo stesso lavoro.
La croce è presente già nei disegni, in forma di segno snello ed eretto, nella completa assenza del corpo. Non vi è difatti alcun approccio alla figura umana. La croce è piccola, il fusto è fortemente allungato fin quasi allo straniamento. Il materiale è tassativamente di tre tipi: rame, argento e oro. Quello principale appare ricco di variazioni, sotto la spinta di una gioia nel progettare, mentre gli altri materiali risultano piuttosto delicati, molto ponderati.
Nel processo di elaborazione la croce trova una nuova identità nel lavoro dell'artista. È posizionata all'estremità

tauchen die dunklen Brennspuren auf, formal exakt oder informell, als Spur. Dem entsprechen andere Variationen von Kreuzen, in denen das tragende Metall die Form eines Kreuzes durch Überlagerung oder durch kleine Auslassungen am Rand annimmt.
Schließlich kombiniert er das Kreuz mit einer Raumvorstellung in einem kleinen Kubus. Er markiert einen dunklen Raum, in dem an den vier Seitenwänden fast wandgroße Ritzen in Form eines gekippten Kreuzes für den Lichteinfall sorgen: die Vorstellung eines sakralen Raums, in dem allein das Kreuz der Lichtträger ist.
Zum liturgischen Bezug haben diese Kreuze der Form nach ihren Bezug verloren. Doch sind sie aufragende autonome Zeichen. Eine weitere Variation zeigt sich an einem langen Stab, an dem im oberen Bereich nicht ein, sondern zwei kleine Stäbe auf gleicher Ebene eingesetzt sind. Als solches sticht in dessen Mitte ein Stab hindurch und zeigt so in der Höhe ein liegendes Kreuz, ein abstraktes, elegantes Zeichen.

Ein letzter großer Entwurf gilt wieder der Eucharistie, dem Altar und dem gesamten sakralen Raum. Babetto schafft es, eine den Raum greifende Monstranz zu kreieren. Es gelingt ihm dabei, das Heilige als eine dauerhafte Präsenz in der Kirche zu artikulieren. Das ist nicht vielen Architekten in ihren Kirchen gelungen. Dominant und erfahrbar gelang dies den gotischen Kirchen in ihrem Versuch, das Licht und den gebauten Stein miteinander zu verbinden. Babetto wagt hier den kühnen Versuch, einer überzeitlichen Architektur eine moderne,

the earlier versions it often appears in an outpouring of divergent designs, while the other materials are reserved for sensitive, highly mature handling. As developed in the design drawings, the Cross finds a new identity in his work. It sits on its end on an elongated vertical element. Liturgical comparison reveals that it is similar to a processional cross, where a cross formed as a crucifix rises high from the midst of a group. In Babetto's work, on the other hand, the Cross is an abstract sign, detached from all applicable content, a sign among signs.

Another group of such discrete forms is revealed on small, rectangular sheets of metal on which criss-crossing lines assume form, drawn in with two strokes, either incised or cut in. On other versions the form is burnt into the metal. In that case, dark scorch marks surface, formally precise or informally, as a trace. Other variations on the Cross correspond to it, in which the metal support assumes the form of a cross through layering or small omissions on the edge.

Finally, he combines the Cross with a spatial idea in a small cube. He marks a dark space in which cracks running nearly the full length of the four side walls in the form of a tilted cross allow light to shine in: the idea of a sacral space in which the Cross is the sole source of light.

di un'asta bislunga. A voler fare un confronto liturgico, risulta simile alla croce processionale, dove, in qualità di crocifisso, si innalza sopra un gruppo. Viceversa, nell'opera di Babetto la croce è piuttosto un segno astratto, sollevato da ogni impiego contestuale, un segno tra i segni. Un altro gruppo di queste forme a se stanti si presenta su piccoli pezzi di lamiera rettangolari, sui quali prendono forma le linee che si incrociano, due tratti tracciati, incisi o intagliati. In altre versioni la forma è impressa nel metallo, e allora risaltano i segni scuri del fuoco, di una precisione formale o al contrario astratti, come un segno. Esistono poi altre variazioni in cui il metallo portante assume la forma di una croce tramite sovrapposizione o omissioni ai margini.

Infine, l'artista presenta la croce in abbinamento a un'idea di spazio, ossia in un cubo di piccole dimensioni. Lo spazio scuro viene contrassegnato da fessure a forma di croce inclinata che si estendono per quasi tutta l'altezza delle quattro pareti, permettendo così alla luce di entrare: si tratta di uno spazio sacro in cui la croce è unica portatrice di luce.

Pastoral Staff, prototype,
silver 925, 2013

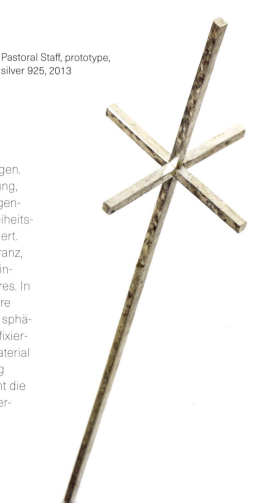

raumbestimmende Form zu geben: eine über ein Meter große Monstranz, eine Skulptur in der Kraft, die ganze Fülle von Raum und Formen in einen Punkt zusammenzufassen. Das Material ist aus Silber, technisch geschnitten und in die Form getrieben. Einige Farben leuchten aus dem Edelmetall rot und weiß und schwarz. Der Rest stammt aus der Geometrie, Kreis und Kegel, dann lang gezogene, konzentrische Stäbe und störend frei fliegende, schmale Rechtecke. Dem offenen Rund mit den Silberstrahlen setzt er spannungsvoll gegenläufige Sperren in Weiß und Rot entgegen. Sie verweigern sich aller Ordnung, leben aus selbstbewusstem Eigensinn, der sich chaotisch und freiheitsbewusst aller Ordnung verweigert. Alles ist leicht an dieser Monstranz, das Licht fällt durch die Form hindurch und durchdringt ihr Inneres. In Distanz verlieren die Formen ihre Kontur und lösen sich in einem sphärischen Schein auf, ohne darin fixierbar zu sein. Fülle und Leere, Material und Licht werden gleich wichtig und egalisieren sich. So gewinnt die Skulptur ihren Mehrwert an ener-

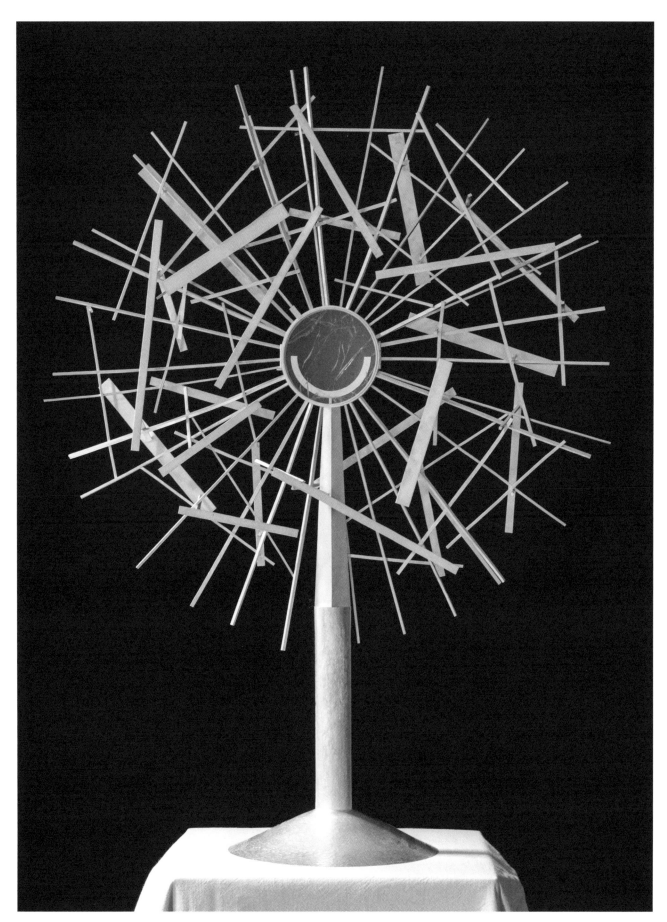

Monstrance for the St Michael's Church, Munich, silver 925, gold 750, pigment and rock crystal, 2008

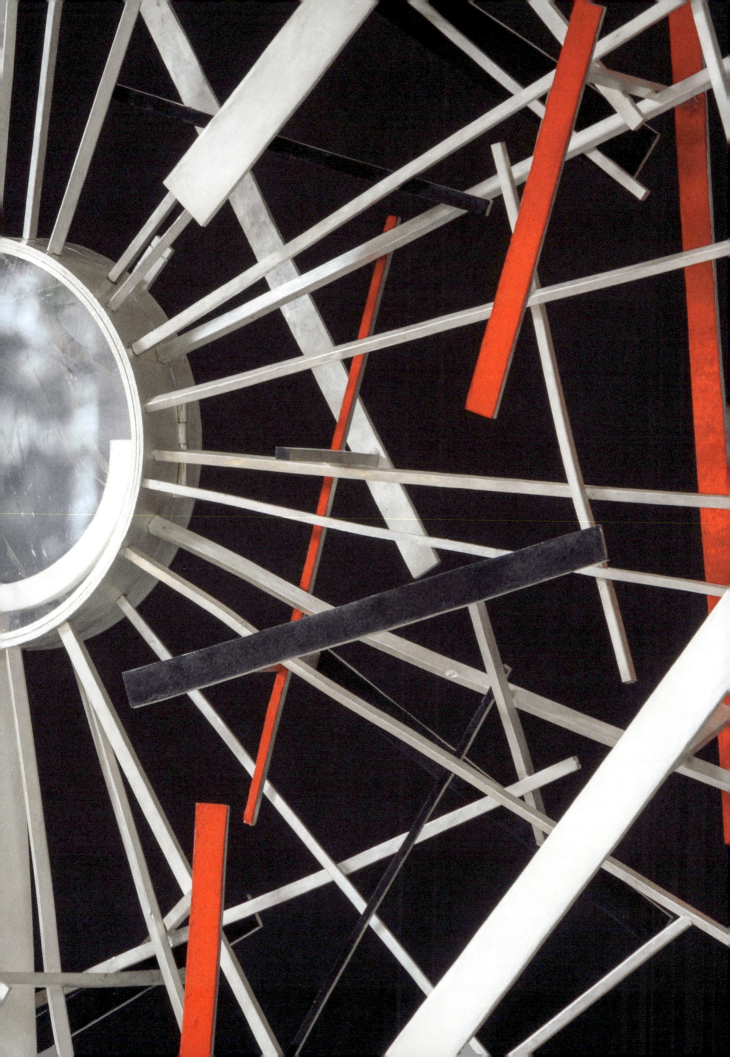

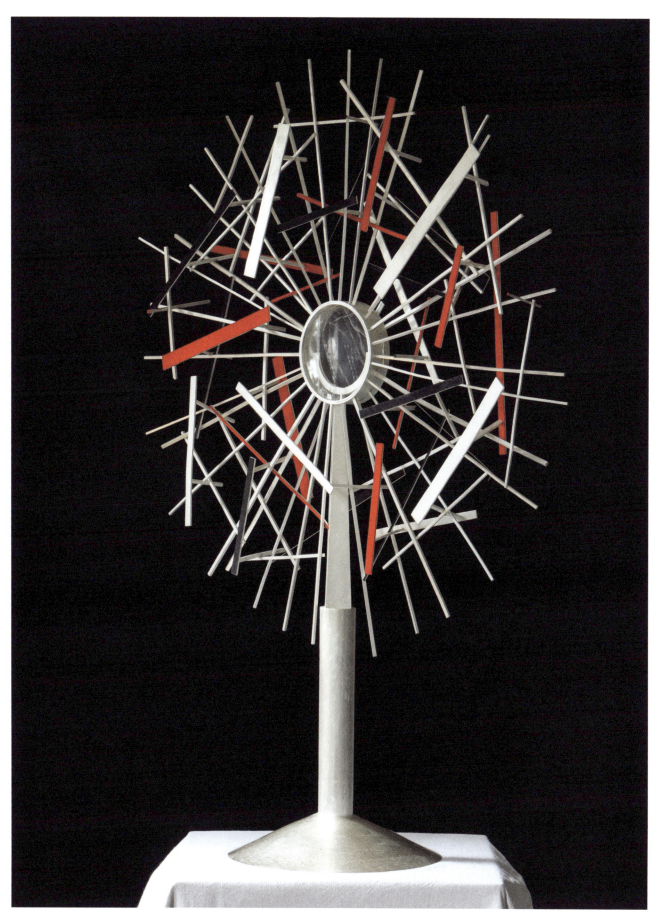
Monstrance for the St Michael's Church, Munich, silver 925, gold 750, pigment and rock crystal, 2008

As far as form is concerned, these crosses have lost any reference to the liturgy. Yet they are soaring, autonomous signs. Another variant appears on a long rod, to the upper zone of which not one but two small rods are attached in parallel on the same plane. A rod pierces it at the centre, thus revealing from above a recumbent Cross, an elegant abstract sign.

A final design on a grand scale is devoted to the Eucharist, the altar and the entire sacral space. Babetto has succeeded in creating a monstrance that intervenes in space. In so doing, he has managed to articulate holiness as a permanent presence in the church. Not many architects have been successful at doing that in their churches. The builders of Gothic churches did just that in their attempt at linking light and the built stone to induce an overwhelming and tangible experience. Here Babetto has ventured on the bold experiment of giving timeless architecture a modern, space-determining form: a monstrance that is over a metre tall, a sculpture with the power to concentrate the entire fullness of space and forms in a single point. The material is silver, cut and hammered into shape by machine. Some colours – red and white and black – glow from the precious metal. The rest comes from geometry, circle and cone, then drawn-out concentric rods and narrow rectangles that are disconcertingly free to fly. He has created

In termini di forma, queste croci hanno perso il loro riferimento liturgico. Eppure sono segni eretti a se stanti. Un'altra variante mostra un'asta lunga in cui sono state aggiunte in alto non una ma due aste più piccole alla stessa altezza. Ne risulta a sua volta una croce in orizzontale, un segno astratto, elegante.

Al centro di un ultimo grande progetto ci sono di nuovo l'Eucaristia, l'altare e tutto lo spazio sacro. Babetto crea un ostensorio che si staglia nello spazio. Qui il maestro riesce a rendere manifesto il sacro come presenza permanente nella chiesa. Non molti architetti hanno saputo fare lo stesso nelle loro architetture sacre. Ci sono riuscite le chiese gotiche, in modo imponente e tangibile, nel tentativo di creare un connubio tra la luce e la pietra di costruzione. Qui Babetto osa fare un tentativo audace conferendo a una struttura sovratemporale una forma moderna dal forte impatto nello spazio: un ostensorio alto più di un metro, simile a una scultura nel concentrare in un punto la ricchezza di spazio e forme con intensità. Il materiale è l'argento, tagliato a macchina e sbalzato. Dal metallo prezioso risplendono alcuni colori, il rosso, il bianco e il nero. Il resto è una questione di geometria, cerchio e cono, e poi aste che si allungano a raggiera, e rettangoli oblunghi che sorprendentemente appaiono come sospesi. Allo spazio circolare aperto individuato dai raggi d'argento il maestro contrappone barrette bianche e rosse rivolte in altre direzioni. Come rifiutando qualsivoglia ordine, esse hanno ragion d'essere in un estro riso-

getischer Bewegung und belebender Dynamik, bemerkt die bekannte und mit dem Werk vertraute Kunstkritikerin Gisela Jahn zum Werk. Dies verleihe ihr die Qualität, über sich hinaus zu weisen. Keine Frage, diese Monstranz zeigt, was sie trägt, und bewegt, was das Innere des Betrachters sieht. Der deutsche Bildhauer Joseph Beuys würde hier von einem bestimmten Ton des Optischen sprechen, der sich vernehmen lässt, wenn man das Eigentliche erschaut; es ist wie ein Ton, der von einer sichtbaren sakramentalen Substanz ausgeht – von einer Quelle der Erinnerung und der Erneuerung.

Die Monstranz an diesem Ort: Ihre Fähigkeit, die architektonische und künstlerische Vielfalt im Raum zusammenzubinden und seine Einheit atmosphärisch in einem Punkt aufscheinen zu lassen. Auf diese Weise schafft sie es, den betenden und meditierenden Menschen zu konzentrieren und in seiner Seele zu erregen.

tension by opposing the open round and its silver rays with contra-rotating barriers in white and red. Rejecting any order, they live on in self-confident obstinacy that chaotically resists tidiness with a libertine love of freedom. Everything about this monstrance is light and airy: light shines through the form to penetrate into its interior. When viewed from a distance, the forms lose their contours to dissolve in a spherical glow without seeming fixed within it. Fullness and emptiness, material and light become equally important and are on an equal footing. Thus the sculpture gains surplus value as energetic movement and vitalising dynamism, notes Gisela Jahn, an art critic who is familiar with the work. That in turn lends it the quality of referring above and beyond itself. This monstrance shows what bears and moves it, what the viewer's inner eye sees. The late German sculptor Joseph Beuys would speak in this case of a particular tone of the visual that can be perceived if the real has been spotted; it is like a tone that radiates from a visible sacramental substance – from a wellspring of memory and renewal. The monstrance in this place: its ability to link architectonic and aesthetic diversity in a space and allow its unity to shine forth atmospherically in a single point. Thus it succeeds in concentrating a praying and meditating person and stir them to the depths of their soul.

luto che si sottrae all'ordine, nel caos e in piena consapevolezza della propria libertà.
Nell'ostensorio tutto è leggerezza, la luce attraversa la forma e penetra al suo interno. Da lontano le forme perdono il loro contorno, dissolvendosi in un bagliore sferico in cui è impossibile fissarle. Ricchezza e vuoto, materia e luce assumono la stessa importanza e finiscono con l'equivalersi. È così che la scultura si carica di un valore aggiunto, quello di un movimento energetico e di un dinamismo vigoroso, come osserva la nota critica d'arte Gisela Jahn che ben conosce l'opera. Ciò gli conferisce la qualità di trascendere se stesso. Non v'è dubbio che l'ostensorio renda palese ciò che contiene, e che alla sola vista riesca a commuovere l'osservatore nell'animo. Lo scultore tedesco Joseph Beuys parlerebbe qui di una particolare sfumatura dell'elemento ottico, che è possibile recepire guardando ciò che c'è di più autentico, una sfumatura, in questo caso, che emana da una sostanza sacramentale visibile, da una fonte del ricordo e del rinnovamento.
E dunque l'ostensorio in questo luogo, con la sua capacità di accentrare nello spazio la ricchezza architettonica e artistica, permettendo alla sua unicità di risplendere in un punto, creando un impatto fortemente atmosferico.
In questo modo l'opera permette alla persona che prega e medita di concentrarsi, facendo provare alla sua anima forti emozioni.

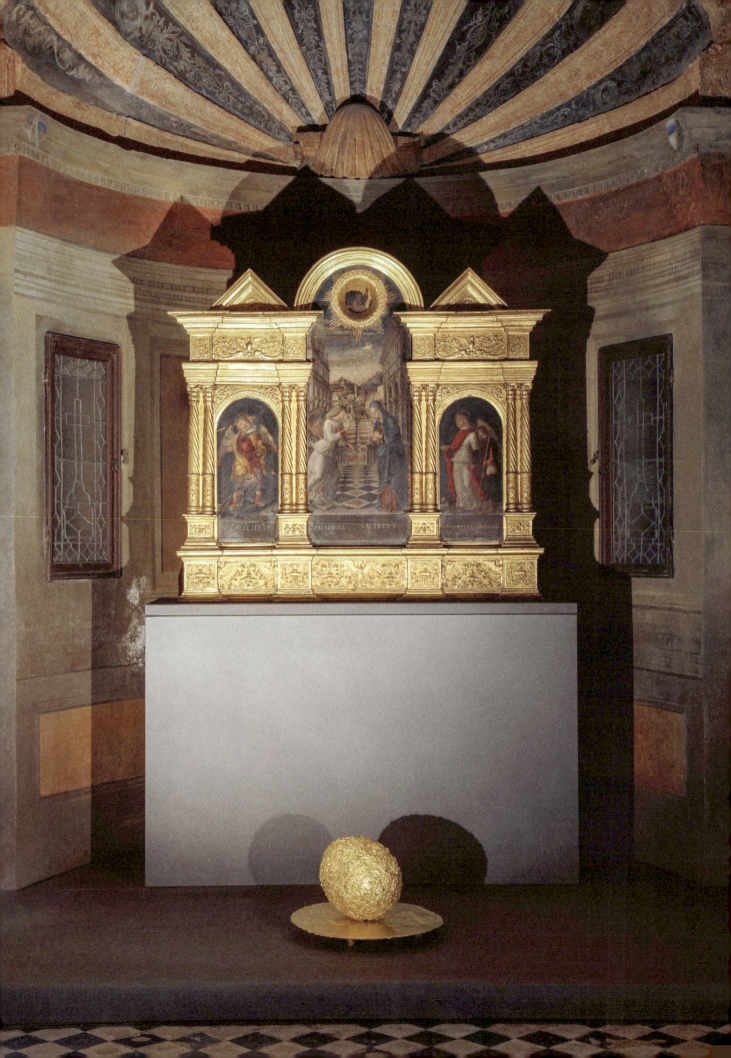

Sacred
Sacro
Sakrales

"Physiologus", bronze, gold leaf, 2013

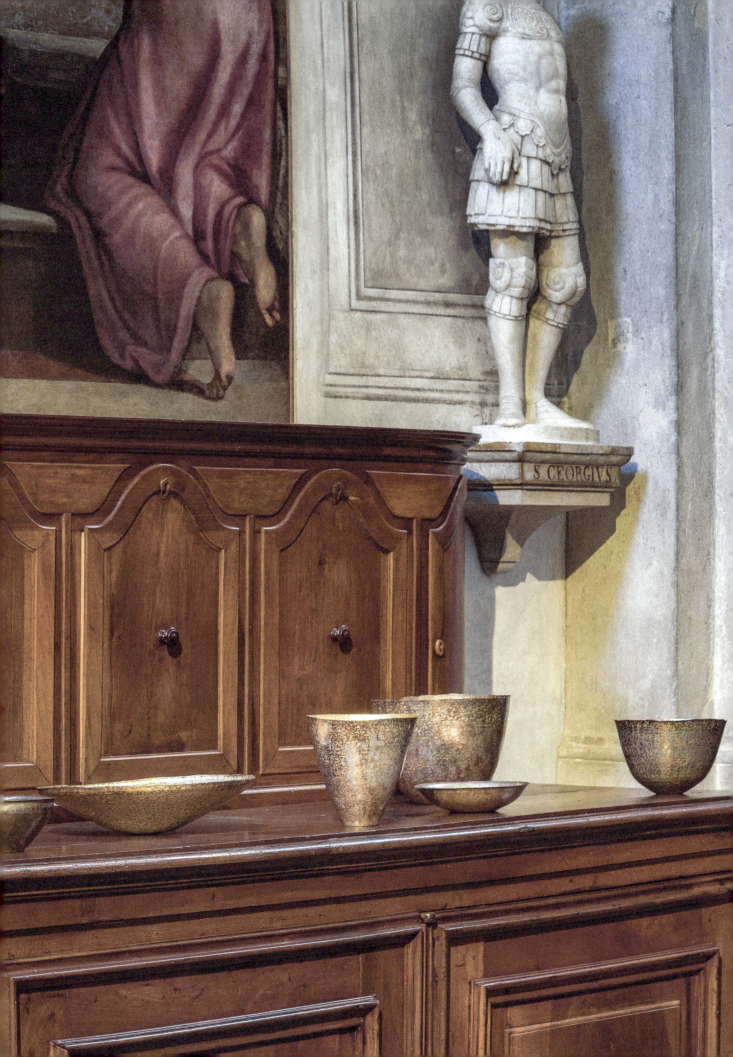

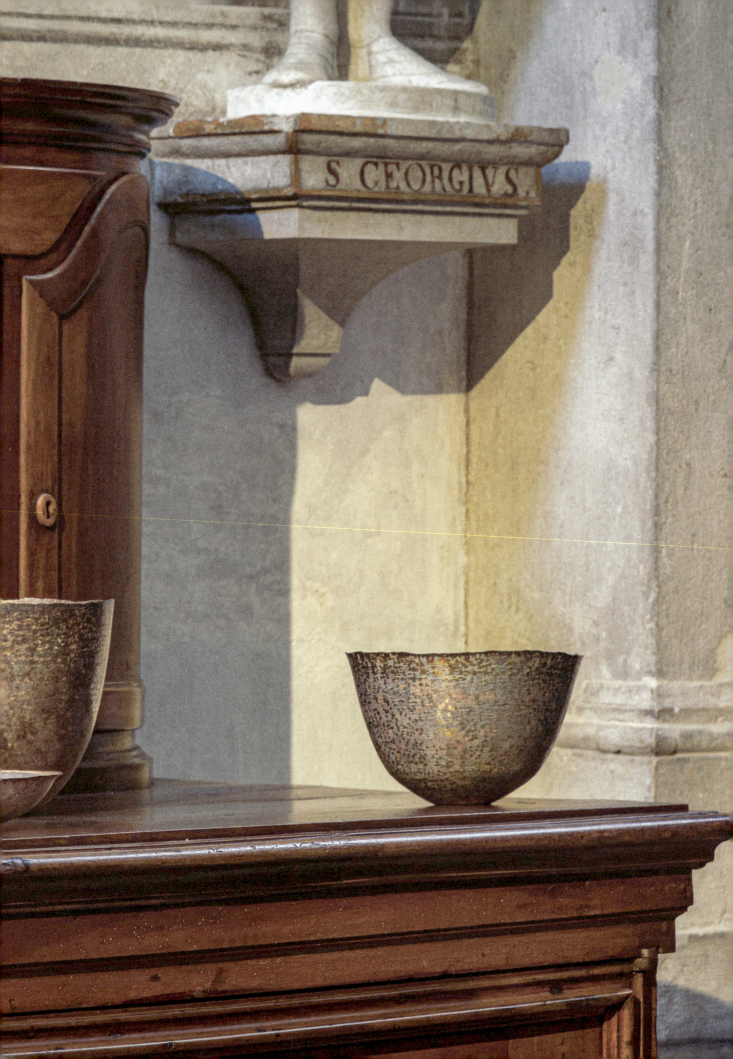

1 Chalice and Paten for the Dick Sheppard Chapel, St Martin-in-the-Fields, London, silver 925, gilding, 2016
2 Candelabra for the Dick Sheppard Chapel, St Martin-in-the-Fields, London, silver 925, gilding, 2015

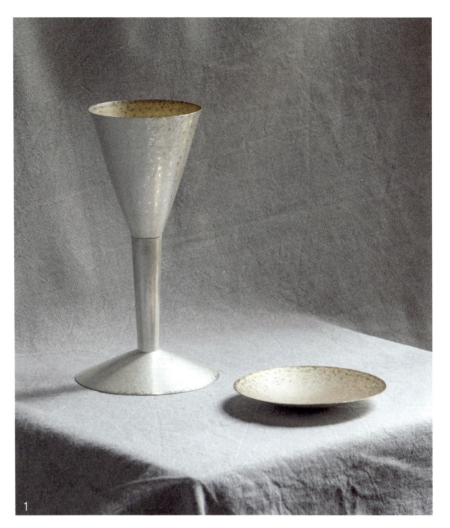

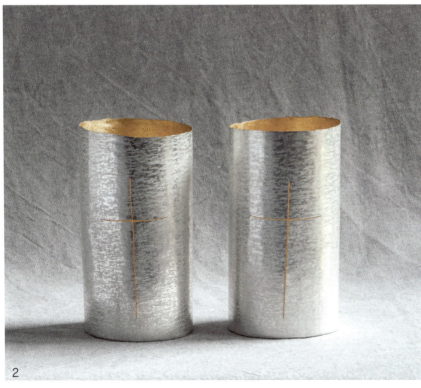

3 Chalice, silver 925, 2013

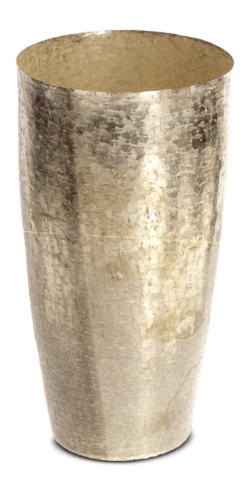

4–6 Chalices, silver 925, 2013

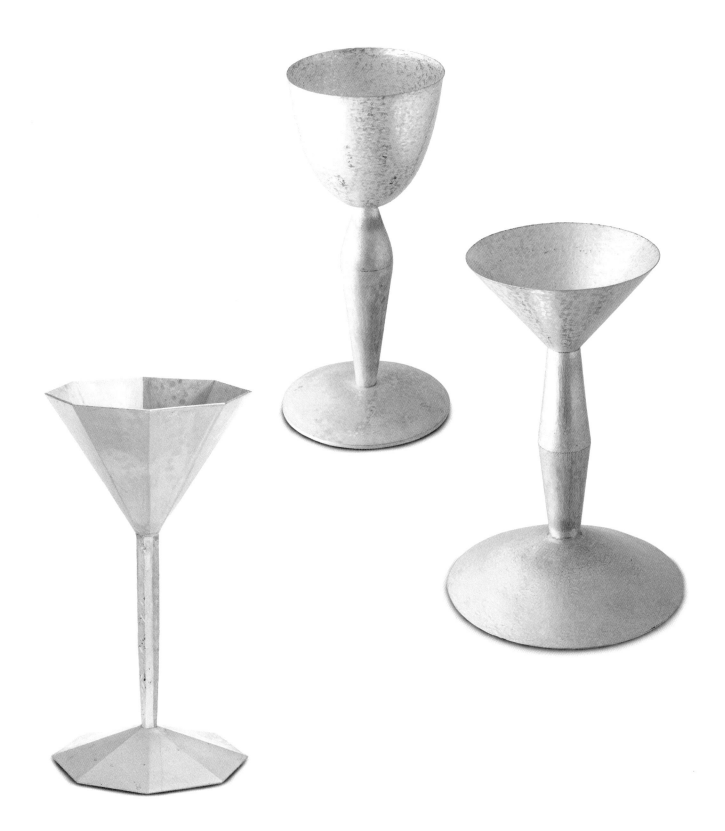

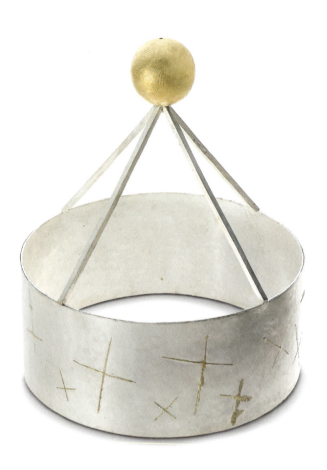

7 Crown for the Parrocchiale di Pernumia Church (PD), silver 925, yellow gold 750, 2013

8 Crown for the Parrocchiale di Pernumia Church (PD), silver 925, yellow gold 750, stones, 2013

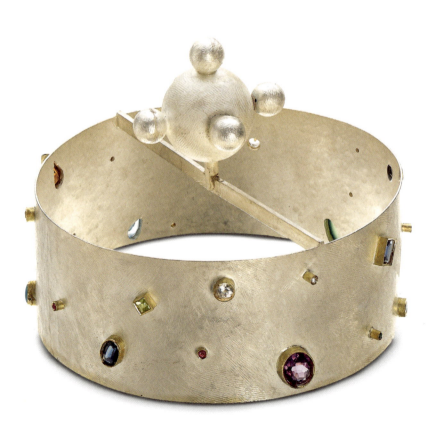

9 Crown for the Parrocchiale di Pernumia Church (PD), yellow gold 750, pigment, 2013

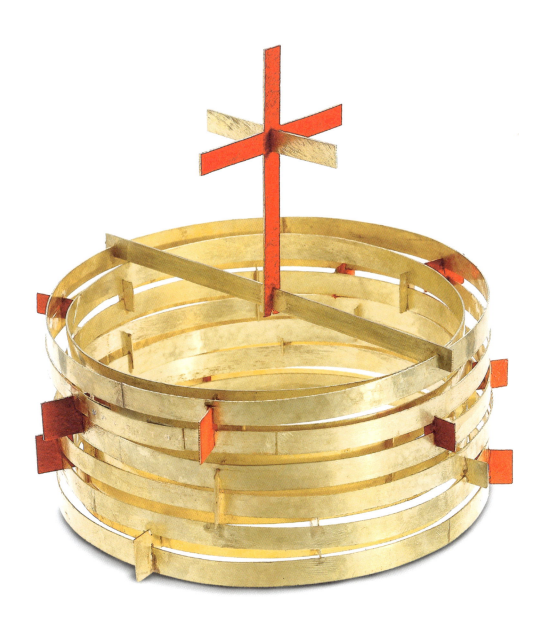

10 Shrine for Sacro Cingolo, Prato
 Chapel of the Sacro Cingolo, Dome,
 Prato, white gold 750, silver 925
 gildening, rock crystal, Lapis lazuli,
 coral, 2008

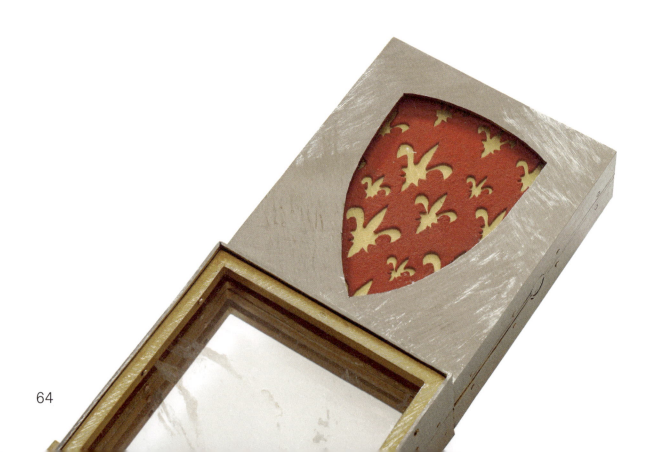

11 Architecture model for meditative space, silver 925, 2013
12 Pastoral Staff, prototype, yellow gold 750, ebony, 2013
13 Pastoral Staff, prototype, silver 925, 2013

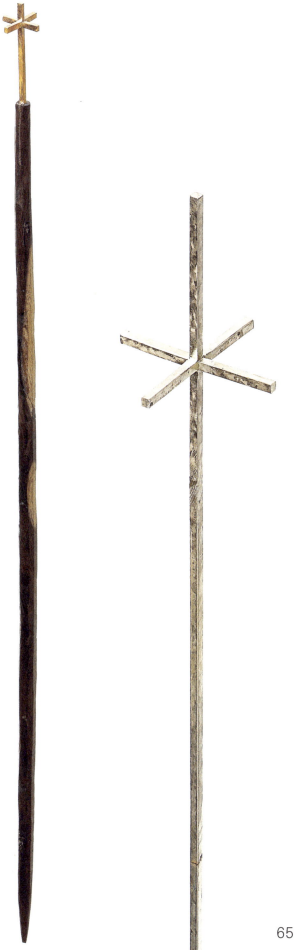

14 Cross, silver 925, methacrylate, 2013

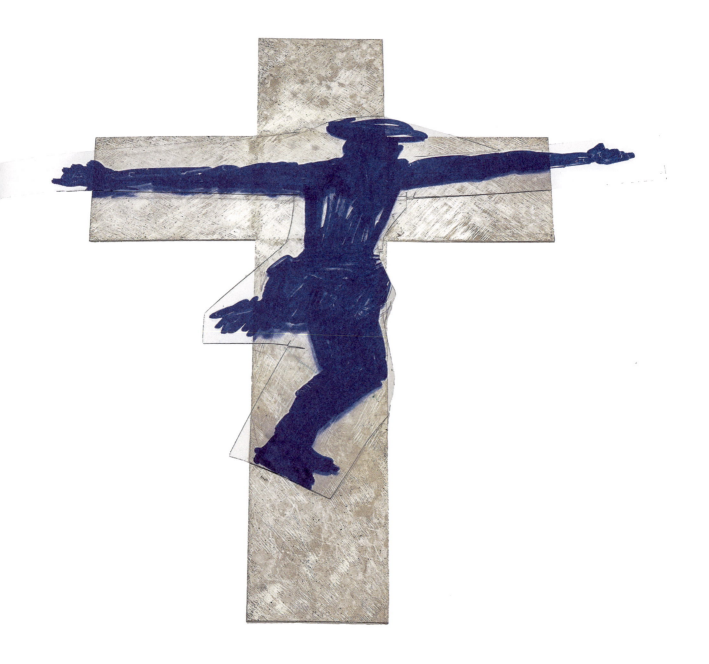

15 Cross, silver 925, ebony, 2015

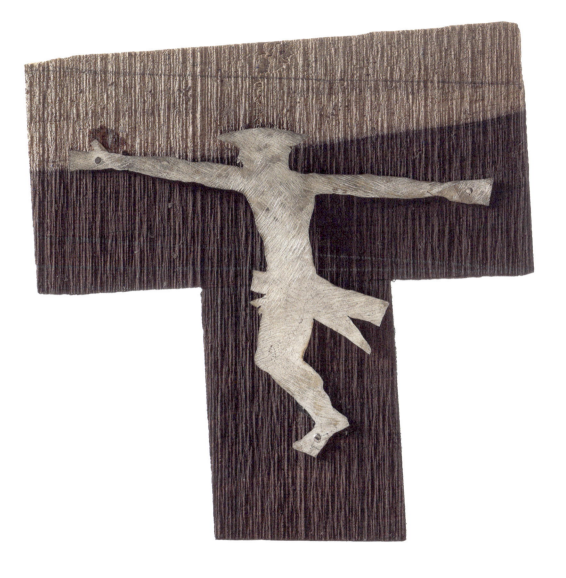

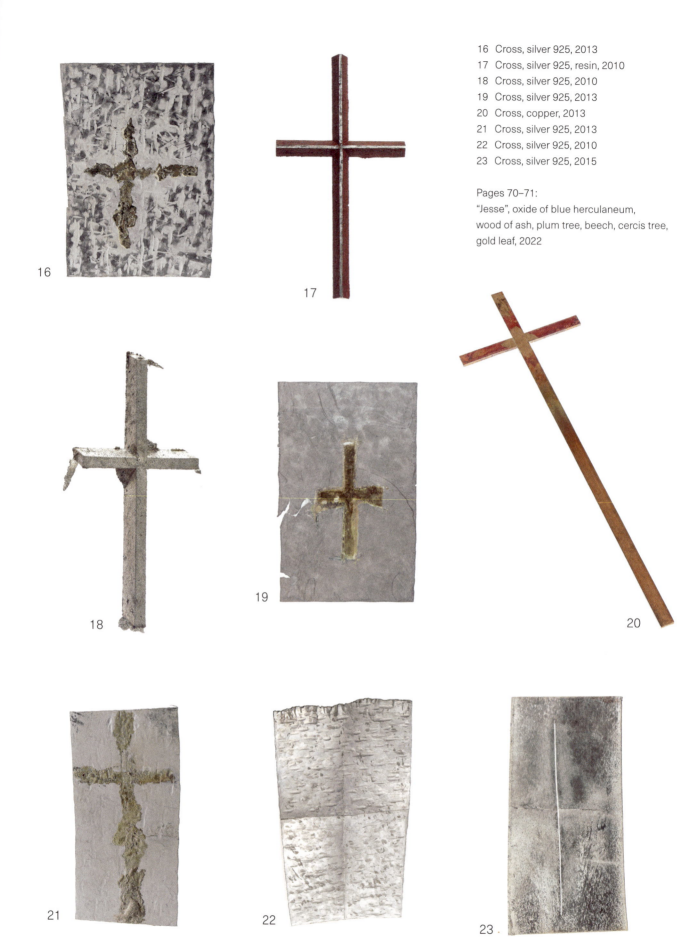

16 Cross, silver 925, 2013
17 Cross, silver 925, resin, 2010
18 Cross, silver 925, 2010
19 Cross, silver 925, 2013
20 Cross, copper, 2013
21 Cross, silver 925, 2013
22 Cross, silver 925, 2010
23 Cross, silver 925, 2015

Pages 70–71:
"Jesse", oxide of blue herculaneum, wood of ash, plum tree, beech, cercis tree, gold leaf, 2022

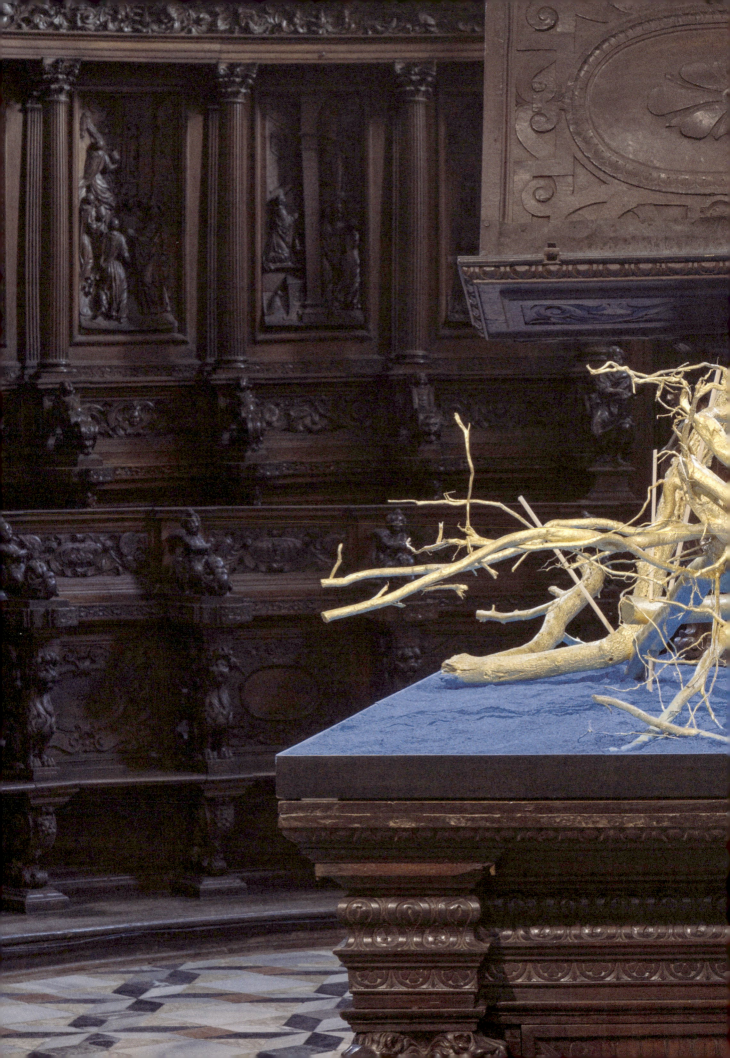

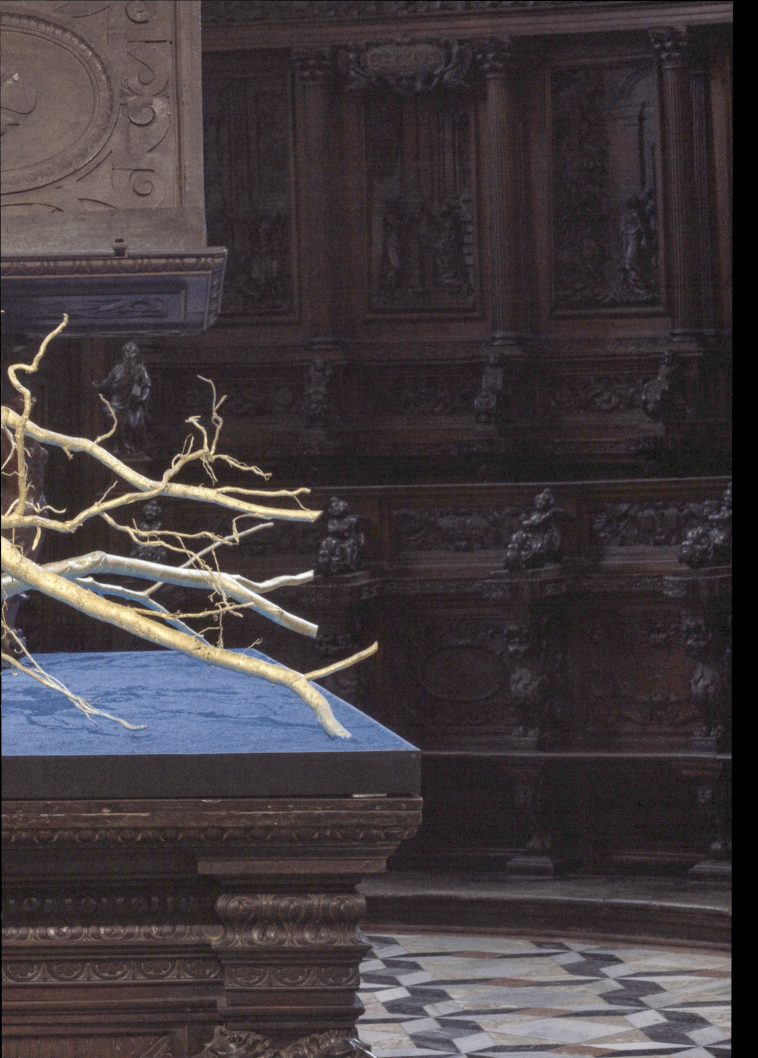

Jewellery
Gioielli
Schmuck

24 Brooch, white gold 750, 1970

25 Ring, yellow gold 750, niello, 1970

26 Brooch, yellow gold 750, ebony, 1973

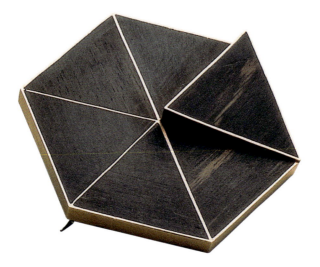

27 Necklace, yellow gold 750, 1970

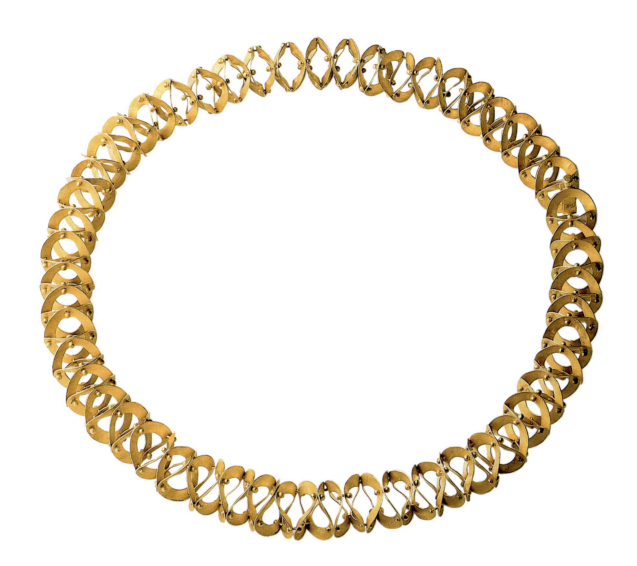

28 Earring, yellow gold 750, 1967
29 Ring, yellow gold 750, niello, 1969
30 Necklace, green gold 500, 1968
31 Necklace, yellow gold 750, 1968
32 Bracelet, yellow gold 750, 1969
33 Ring, white gold 750, niello, 1970

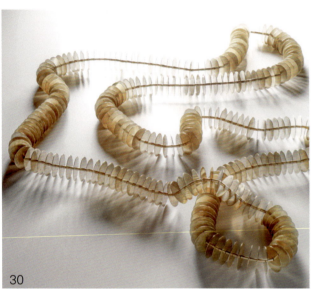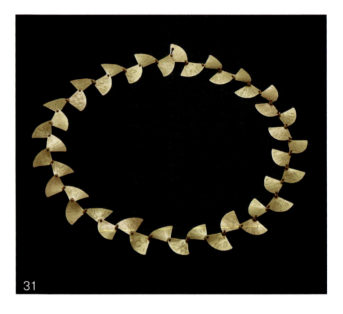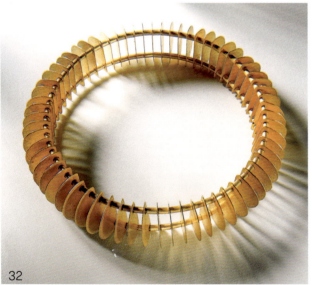

34 Necklace, yellow gold 750, mother-of-pearl, 1970
35 Necklace, yellow gold 750, 1970
36 Necklace, white gold 750, niello, 1972
37 Brooch, yellow gold 750, ebony, 1973
38 Necklace, white gold 750, niello, 1973

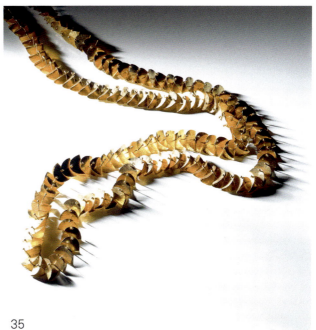

35

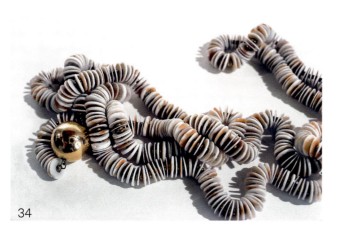

34

37

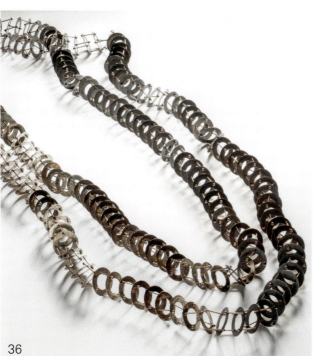

36

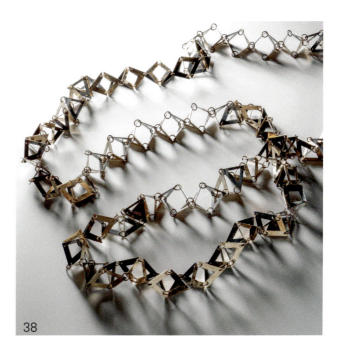

38

39 Brooch, yellow gold 750, ebony, 1974

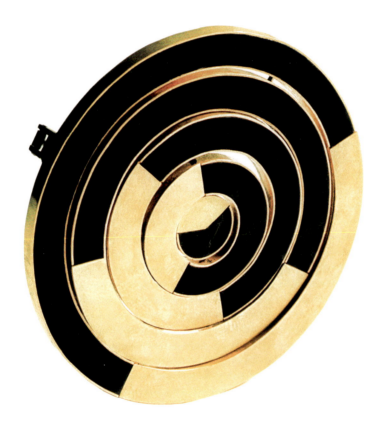

40 Ring, white gold 750, 1981
41 Ring, white gold 750, ebony, 1976

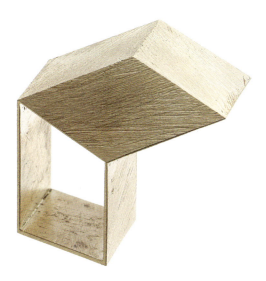

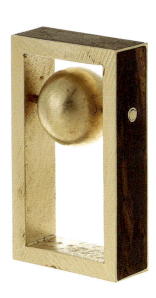

42 Bracelet, yellow gold 750, ebony, 1976

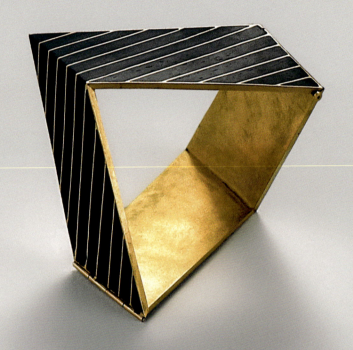

43 Bracelet, yellow gold 750, ebony, 1976

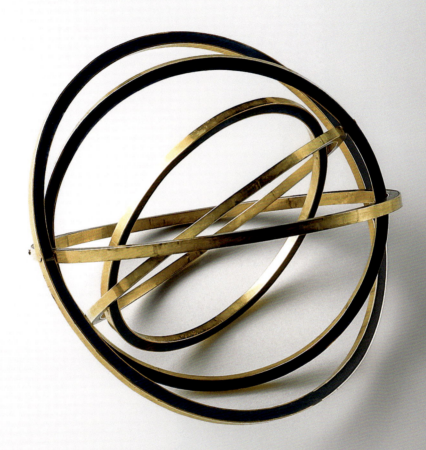

44 Bracelet, white gold 750, niello, 1976

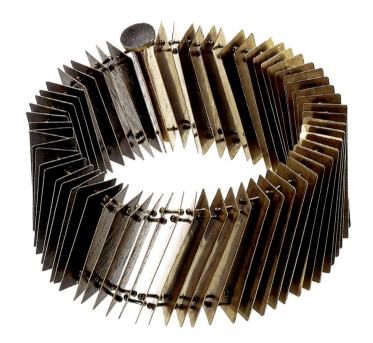

45 Necklace, yellow gold 750, niello, 1976

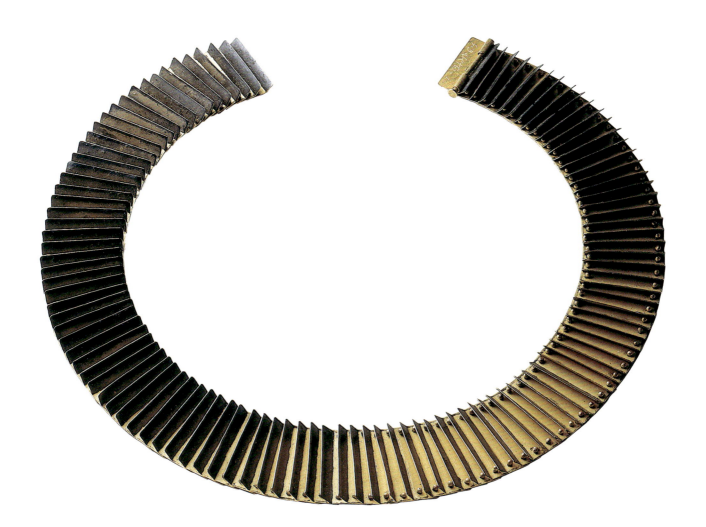

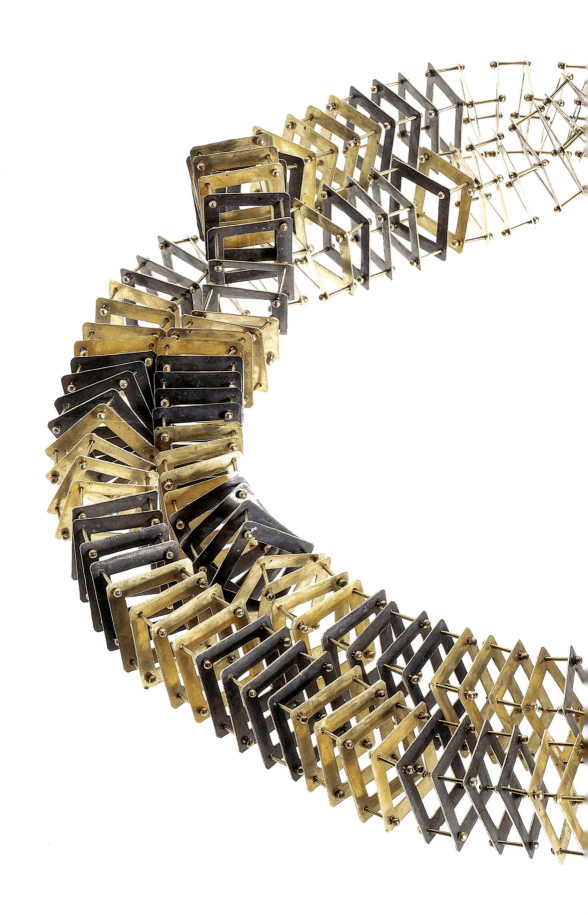

46 Necklace, yellow gold 750, niello, 1977

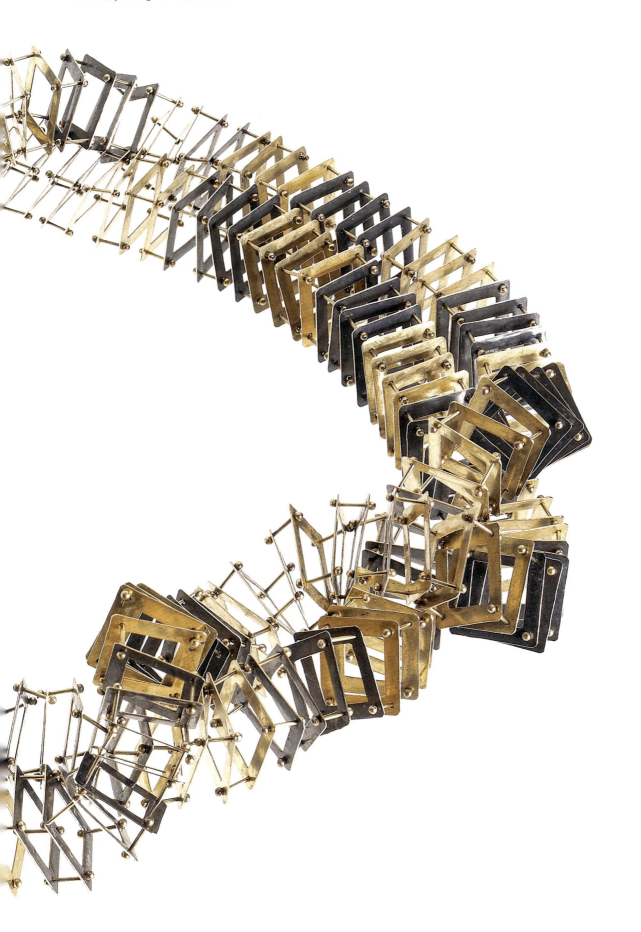

47 Bracelet, yellow gold 750, 1976

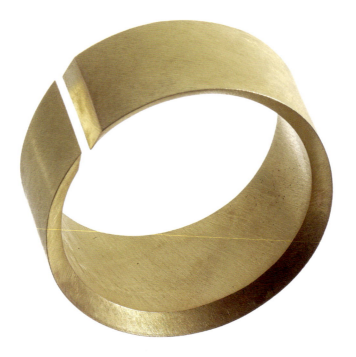

48 Necklace, yellow gold 750, 1977

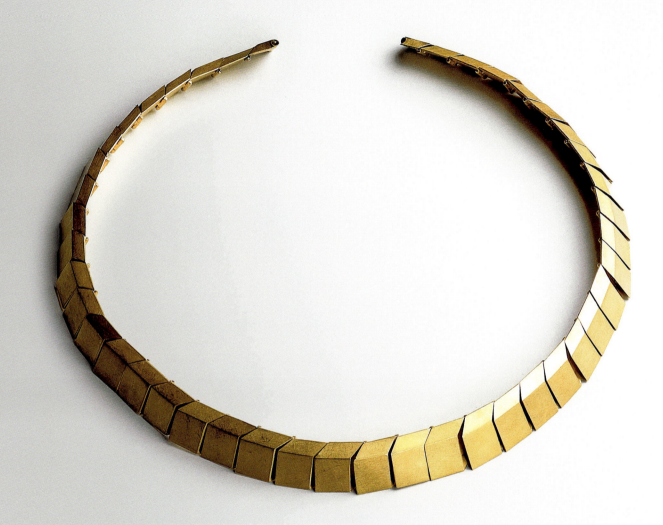

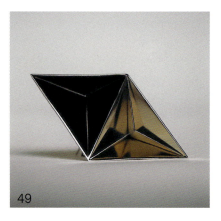
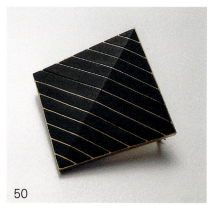

49 Brooch, green gold 500, ebony, 1974
50 Brooch, yellow gold 750, ebony, 1976
51 Necklace, yellow gold 750, niello, 1975
52 Bracelet, yellow gold 750, ebony, 1976
53 Bracelet, white gold 750, niello, 1976
54 Brooch, yellow gold 750, niello, 1976
55 Brooch, yellow gold 750, resin, 1984
56 Brooch, yellow gold 750, 1976
57 Brooch, white gold 750, resin, 1976
58 Brooch, white gold 750, niello, 1976

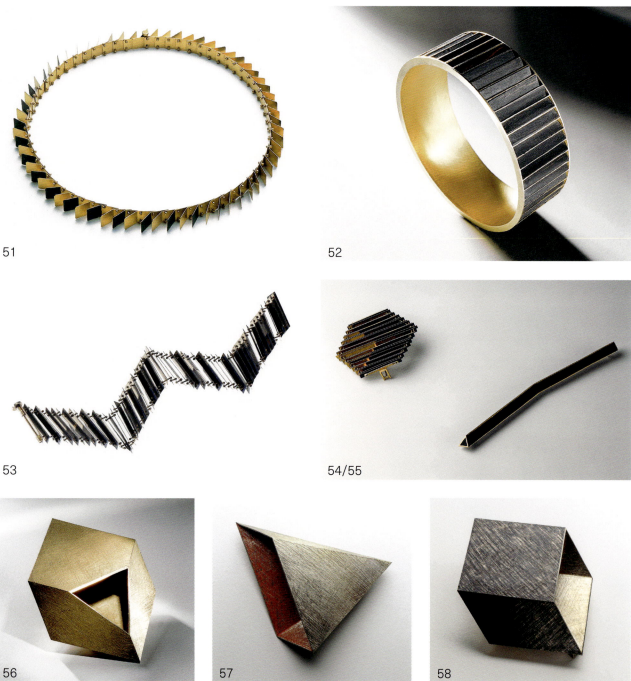

59 Ring, yellow gold 750, ebony, 1977
60 Necklace, yellow gold 750, 1977
61 Bracelet, yellow gold 750, ebony, 1977
62 Bracelet, yellow gold 750, ebony, 1977
63 Ring, yellow gold 750, 1979
64 Ring, white gold 750, 1979
65 Ring, yellow gold 750, ebony, 1979
66 Brooch, yellow gold 750, 1984

59

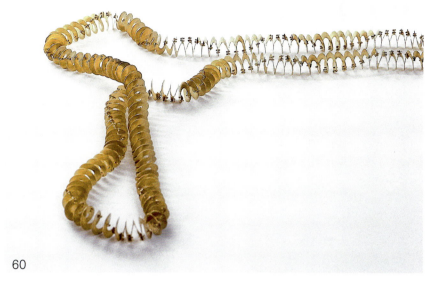
60

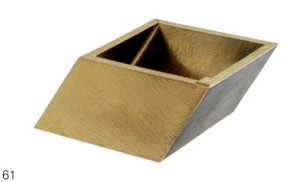
61

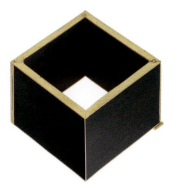
62

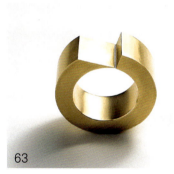
63

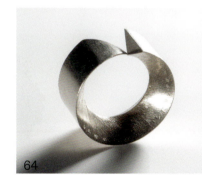
64

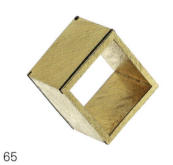
65

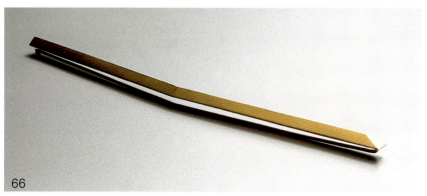
66

67 Bracelet, yellow gold 750, ebony, 1980

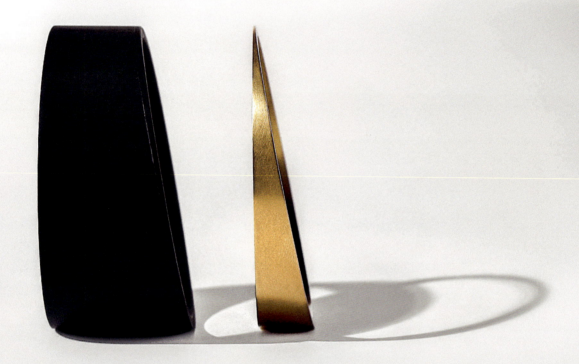

68 Necklace, white gold 750, 1982

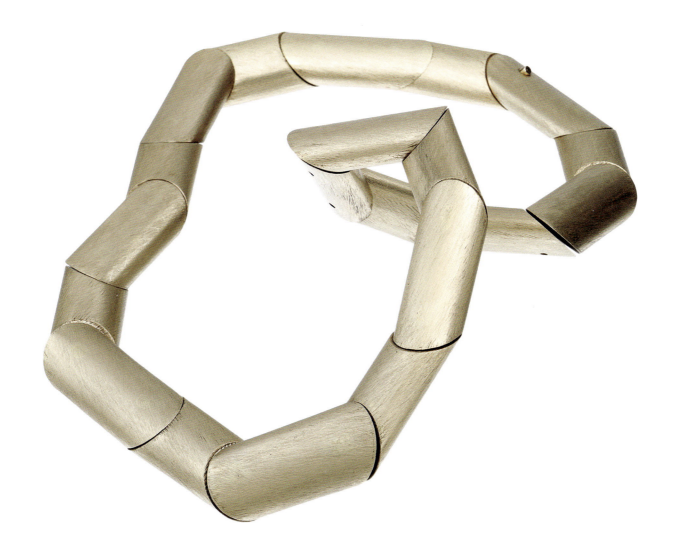

69 Ring, nickel silver, 1983
70 Ring, nickel silver, 1983
71 Necklace, yellow gold 750, 1980
72 Necklace, yellow gold 750, 1980
73 Brooch, yellow gold 750, 1983
74 Rings, yellow gold 750, resin, nickel silver, 1983
75 Brooches, yellow gold 750, ebony, 1982
76 Necklace, white gold 750, 1981

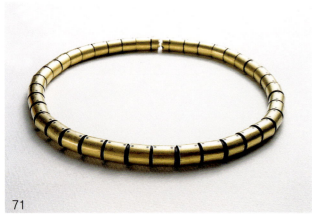
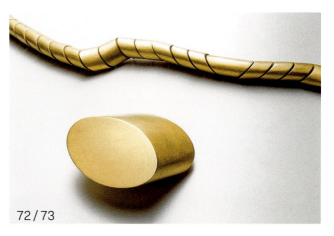
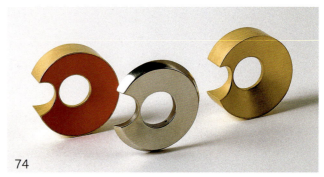
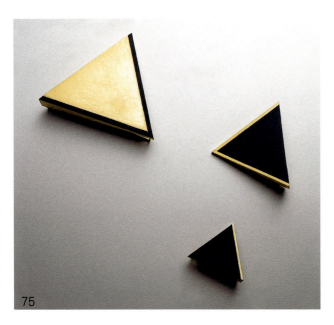
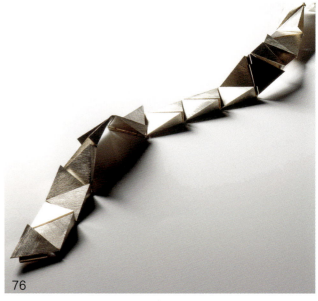

77 Necklace, nickel silver, resin, 1983
78 Brooch, nickel silver, resin, 1983
79 Brooches, yellow gold 750, resin, 1983
80 Ring, white gold 750, niello, 1983
81 Rings, yellow gold 750, resin, 1983
82 Brooch, yellow gold 750, 1983
83 Necklace, yellow gold 750, resin, 1983
84 Brooch, yellow gold 750, resin, 1983

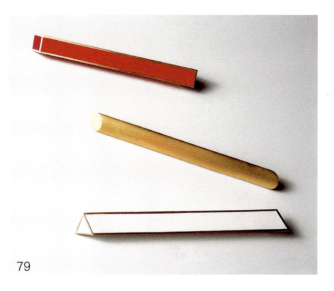
79

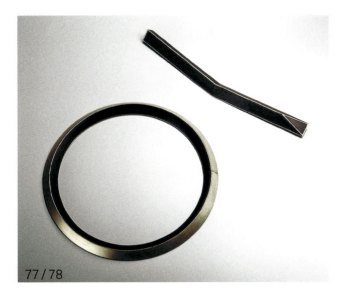
77 / 78

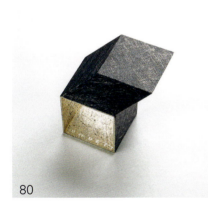
80

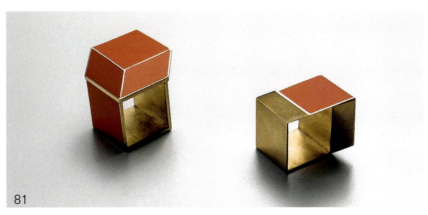
81

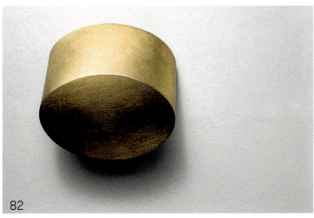
82

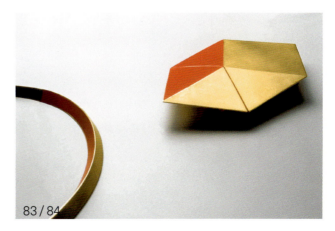
83 / 84

95

85 Rings, yellow gold 750, resin, 1983

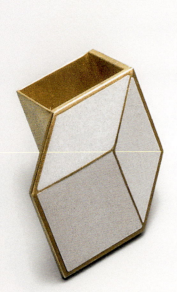
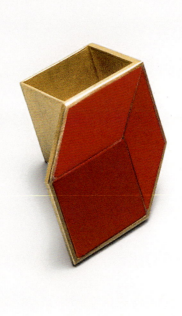

86 Necklace, yellow gold 750, resin, 1983

87 Ring, yellow gold 750, 1983
88 Ring, yellow gold 750, resin, 1983

89 Brooches, nickel silver, resin, 1984
90 Ring, nickel silver, resin, 1984

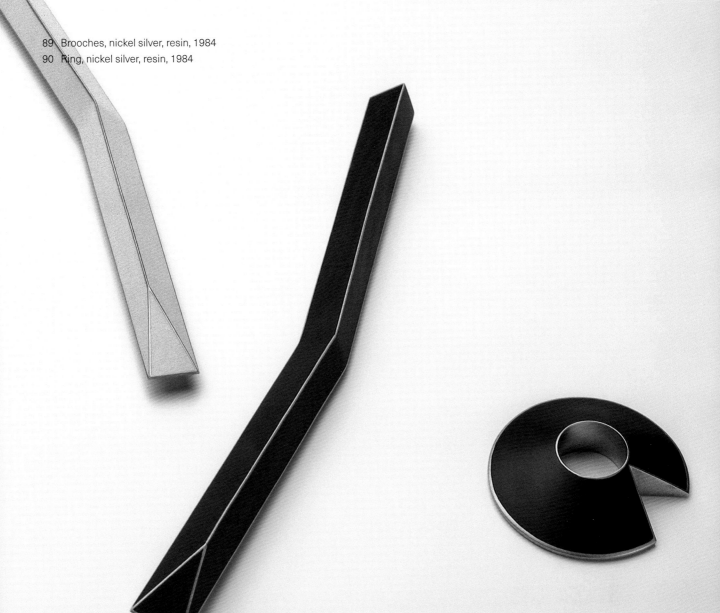

91 Necklace, white gold 750, 1983

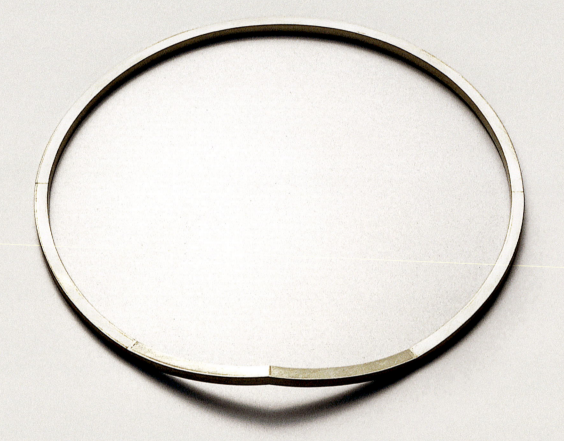

92 Ring, white gold 750, niello, diamond, 1984

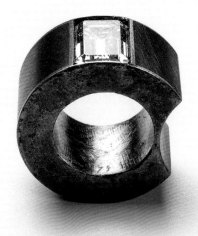

101

93 Rings, yellow gold 750, 1984

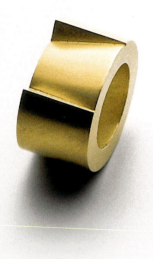
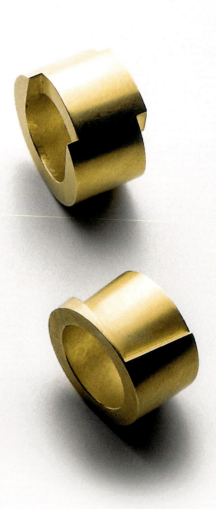

94 Brooch, yellow gold 750, 1987

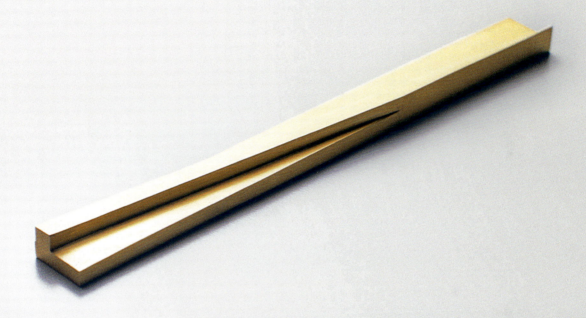

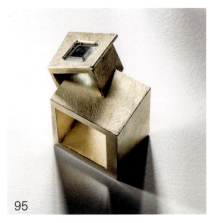
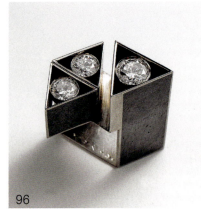

95 Ring, yellow gold 750, emerald, 1983
96 Ring, white gold 750, niello, diamonds, 1983
97 Necklaces, yellow gold 750, white gold 750, 1983
98 Brooches, nickel silver, 1984
99 Rings, yellow gold 750, 1984

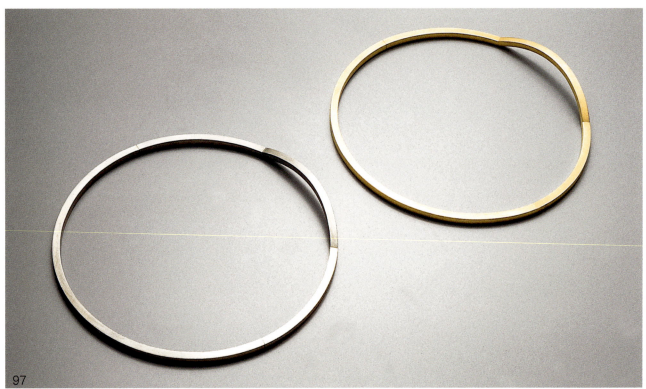

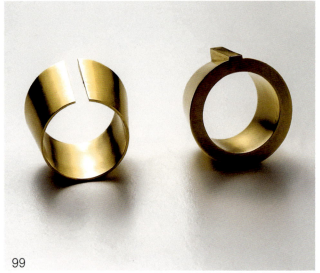

100 Earrings, yellow gold 750, resin, 1985
101 Ring, yellow gold 750, 1984
102 Necklace, yellow gold 750, 1984
103 Necklace, yellow gold 750, 1986

100

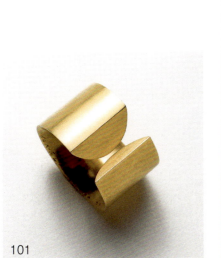

101

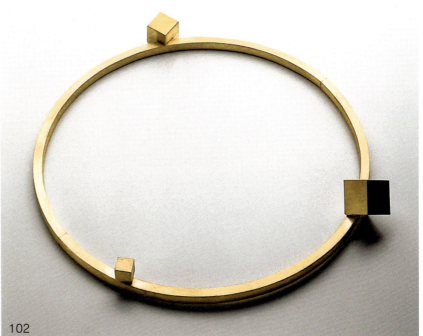

102

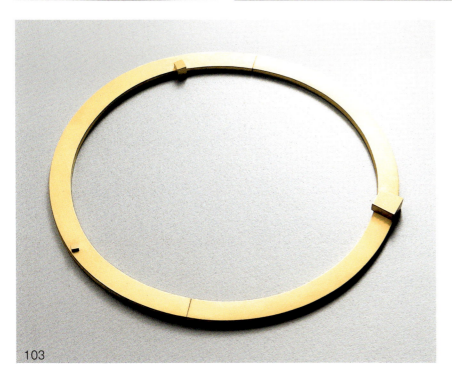

103

104 Brooches, yellow gold 750, 1987
105 Brooch, yellow gold 750, 1986
106 Ring, yellow gold 750, 1986
107 Ring, yellow gold 750, 1986
108 Earrings, yellow gold 750, 1987
109 Brooches, yellow gold 750, 1987

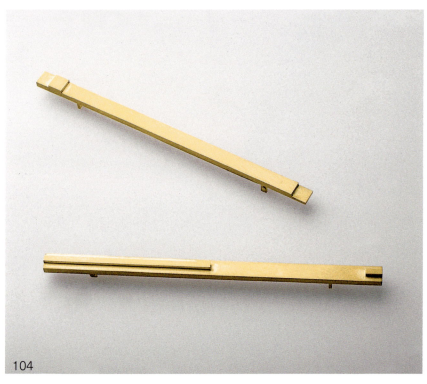

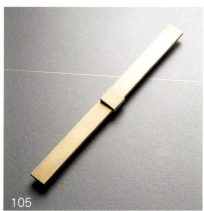

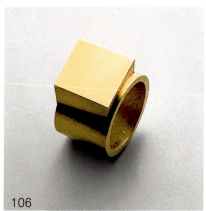

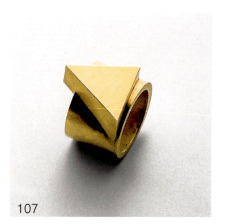

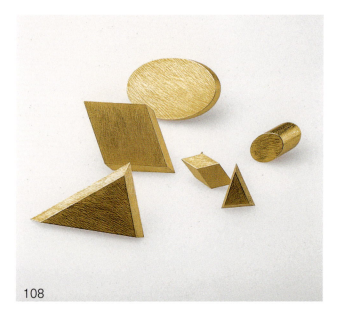

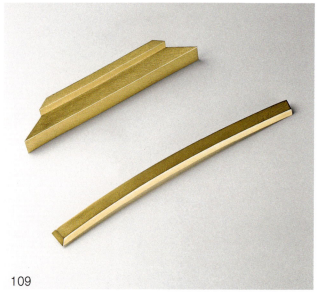

110 Bracelet, yellow gold 750, 1988
111 Rings, yellow gold 750, 1988
112 Brooch, yellow gold 750, 1988
113 Earrings, yellow gold 750, 1988
114 Ring, yellow gold 750, 1988
115 Ring, yellow gold 750, diamonds, 1988
116 Brooch, yellow gold 750, 1988

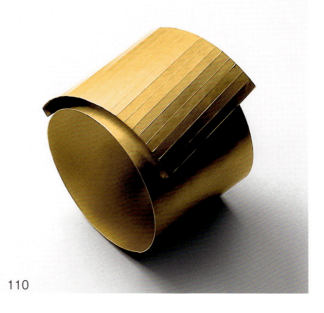
110

111

112

113

114

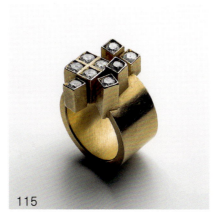
115

116

107

117 Brooch "Da Pontormo", yellow gold 750, 1990

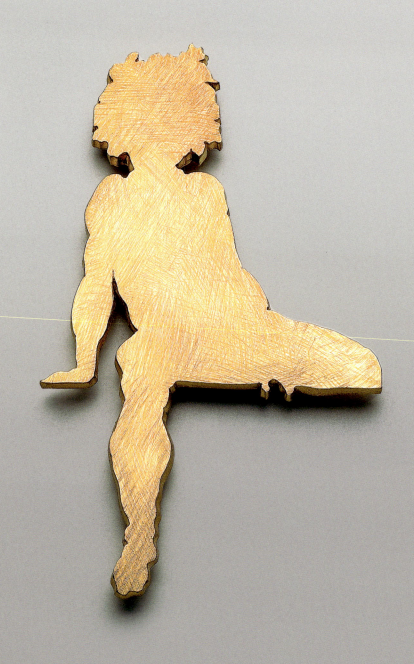

118 Brooch "Da Pontormo", yellow gold 750, green gold 500, silver 800, 1989
119 Brooch "Da Pontormo", yellow gold 750, 1990
120 Brooch "Da Pontormo", yellow gold 750, 1990
121 Brooch "Da Pontormo", yellow gold 750, 1989
122 Brooch "Da Pontormo", yellow gold 750, 1990
123 Brooch "Da Pontormo", yellow gold 750, 1989

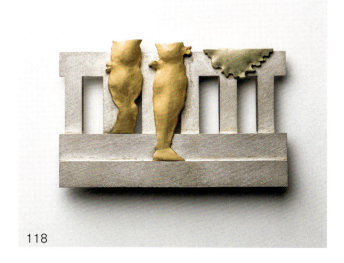

118

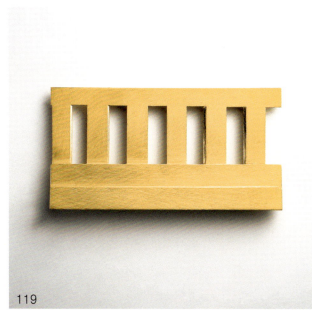

119

120

121

122

123

109

124 Ring, yellow gold 750, 1990

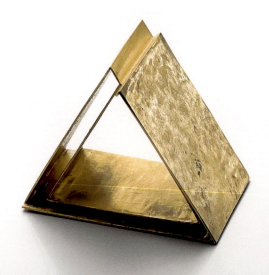

125 Ring, yellow gold 750, 1991

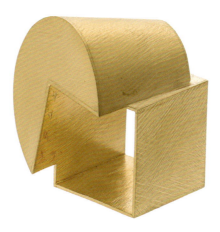

126 Ring, yellow gold 750, 1991

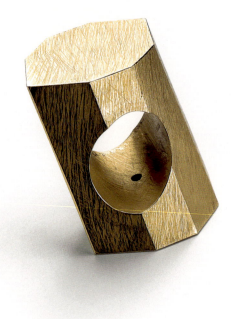

127 Ring "Da Pontormo", yellow gold 750, green gold 500, copper, 1991

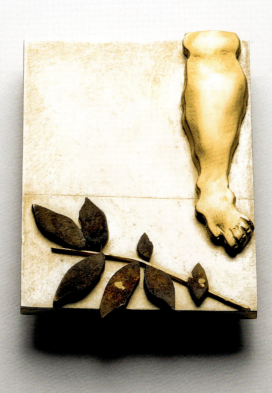

128 Brooch, yellow gold 750, pigment, 1991
129 Brooch, yellow gold 750, pigment, 1992

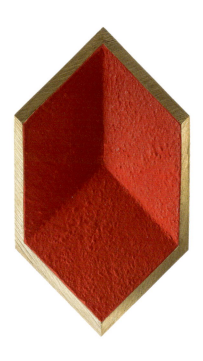

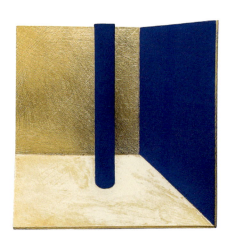

130 Necklace, yellow gold 750, pigment, 1992

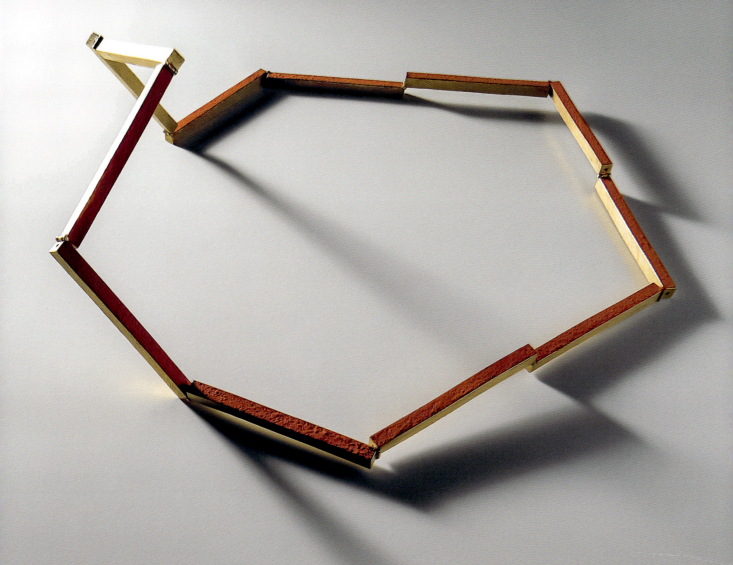

131

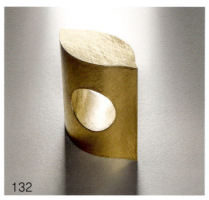
132

131 Ring, yellow gold 750, 1990
132 Ring "Da Pontormo", yellow gold 750, 1990
133 Earrings "Da Pontormo", yellow gold 750, 1990
134 Earrings, yellow gold 750, 1990
135 Ring, yellow gold 750, 1990
136 Ring, yellow gold 750, niello, 1991
137 Earrings, yellow gold 750, niello, 1991
138 Bracelet, yellow gold 750, 1990
139 Bracelet, yellow gold 750, 1990

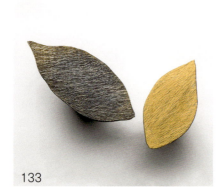
133

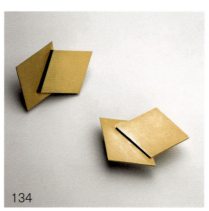
134

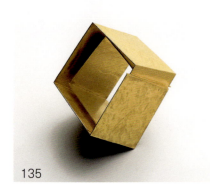
135

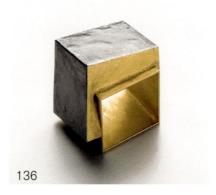
136

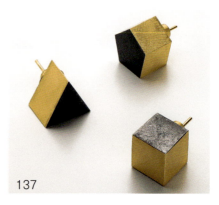
137

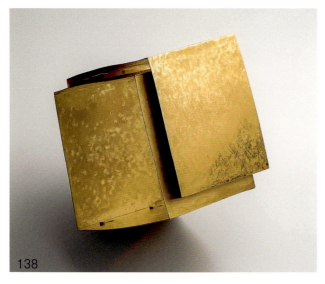
138

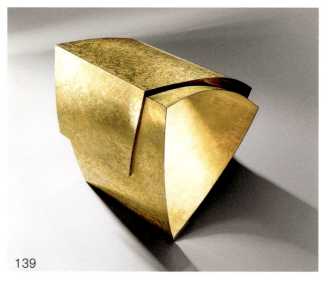
139

140 Brooch, yellow gold 750, niello, 1990
141 Brooch, yellow gold 750, niello, 1991
142 Ring "Da Pontormo", yellow gold 750, green gold 500, copper, silver 800, 1991
143 Brooch "Da Pontormo", yellow gold 750, 1991
144 Brooch "Da Pontormo", yellow gold 750, copper, silver 800, 1991
145 Ring "Da Pontormo", yellow gold 750, green gold 500, copper, 1991
146 Ring "Da Pontormo", yellow gold 750, green gold 500, copper, 1991
147 Ring "Da Pontormo", yellow gold 750, green gold 500, copper, 1991

140

141

142

143

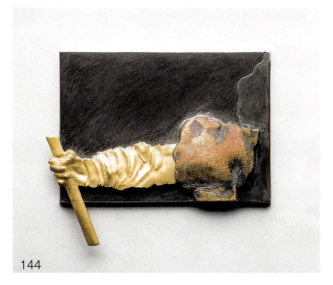
144

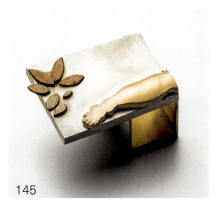
145

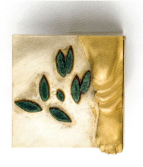
146

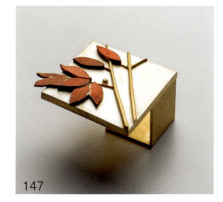
147

148 Brooch, yellow gold 750, 1992
149 Brooch, yellow gold 750, 1992
150 Brooch, yellow gold 750, 1992
151 Earrings, yellow gold 750, pigment, 1992
152 Bracelet, yellow gold 750, 1992
153 Brooch, yellow gold 750, pigment, 1992
154 Necklace, yellow gold 750, 1992

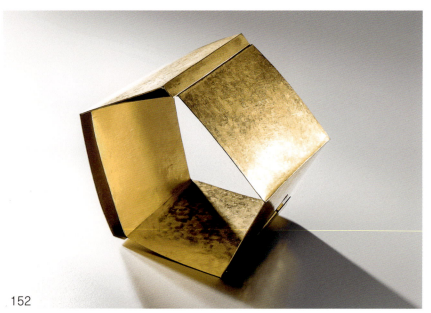
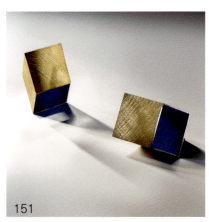
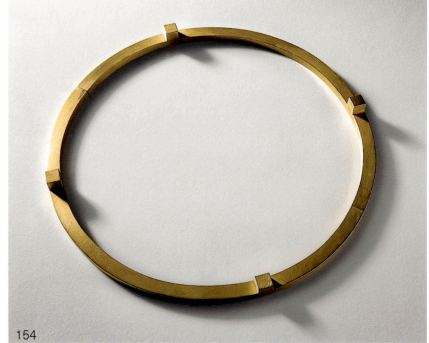
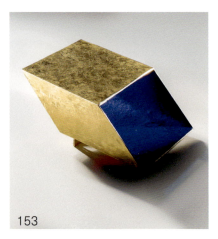

155 Earrings, yellow gold 750, pigment, 1993
156 Ring, yellow gold 750, pigment, 1992
157 Brooch, yellow gold 750, pigment, 1993
158 Earrings, yellow gold 750, pigment, 1993
159 Bracelet, yellow gold 750, pigment, 1992
160 Brooch, yellow gold 750, pigment, 1992
161 Bracelet, yellow gold 750, 1992
162 Bracelet, yellow gold 750, 1993
163 Ring, yellow gold 750, pigment, 1993

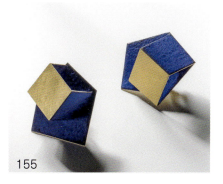
155

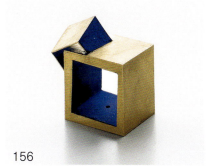
156

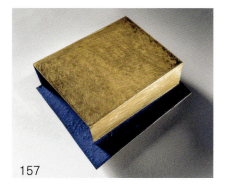
157

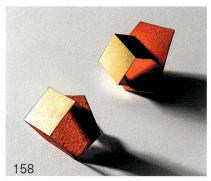
158

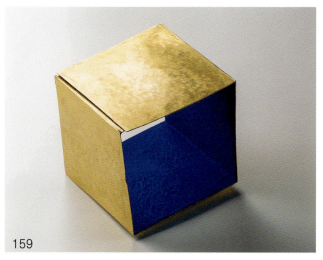
159

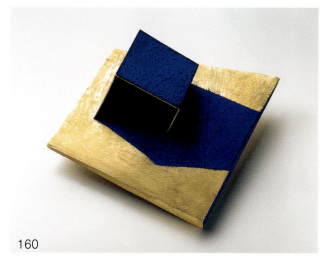
160

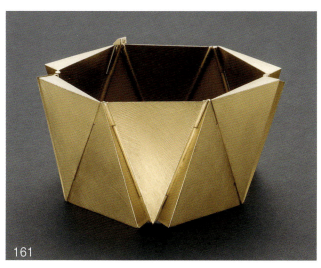
161

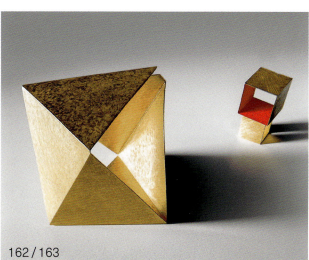
162 / 163

164 Ring, white gold 750, niello, diamond, 1992

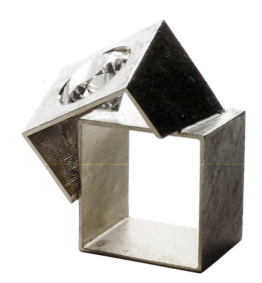

165 Earrings, yellow gold 750, pigment, 1993

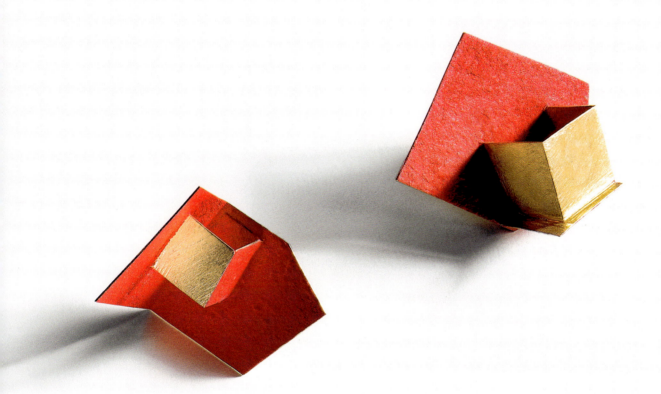

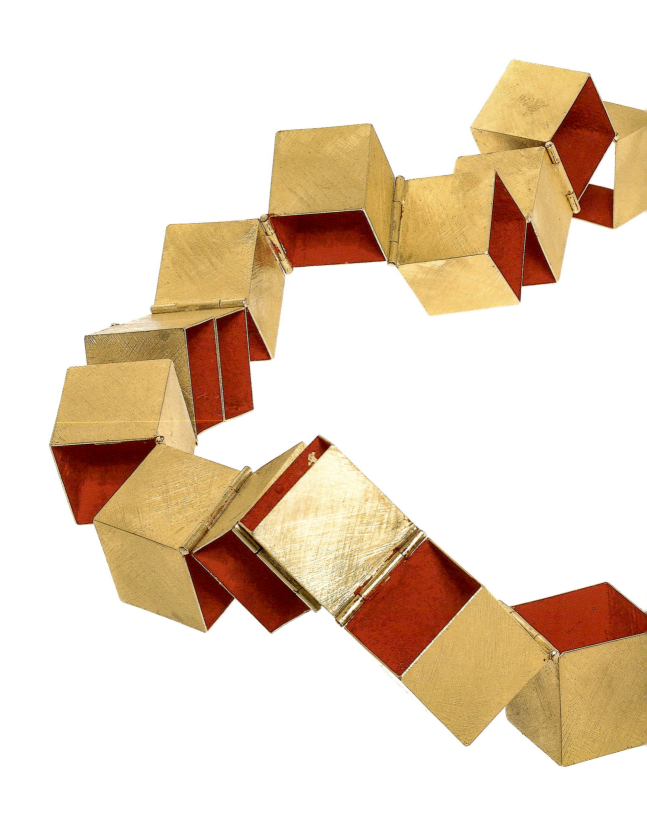

166 Necklace, yellow gold 750, pigment, 2010

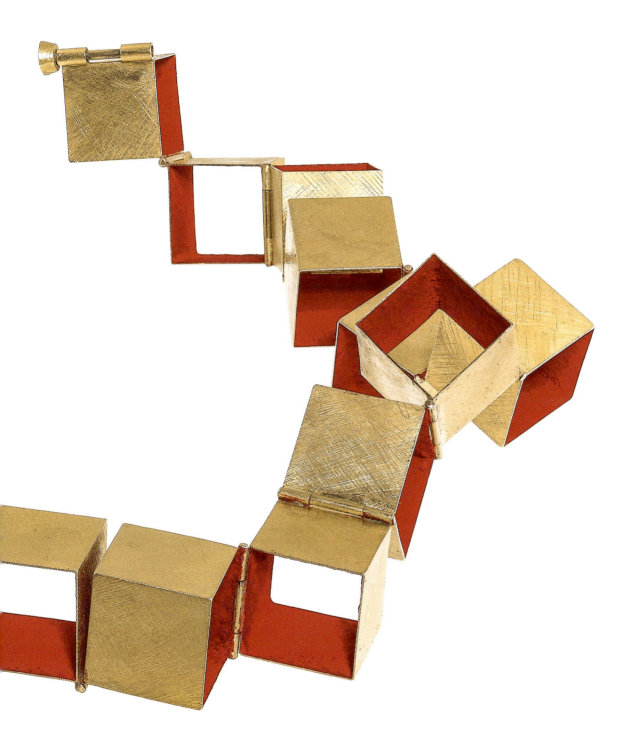

167 Brooches, yellow gold 750, 1995

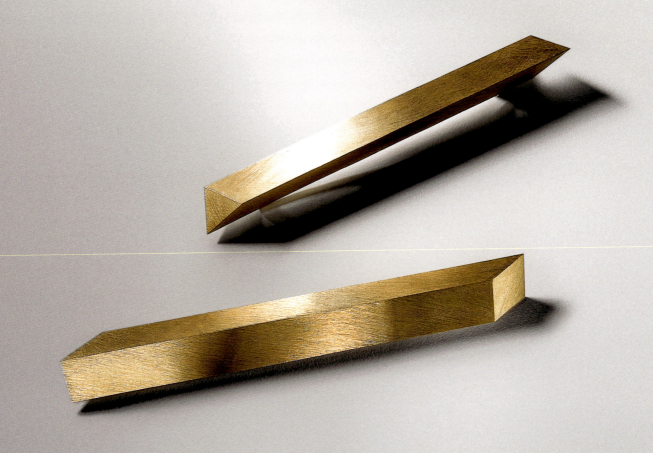

168 Bracelet "Da Pontormo", yellow gold 750, green gold 500, copper, 1995

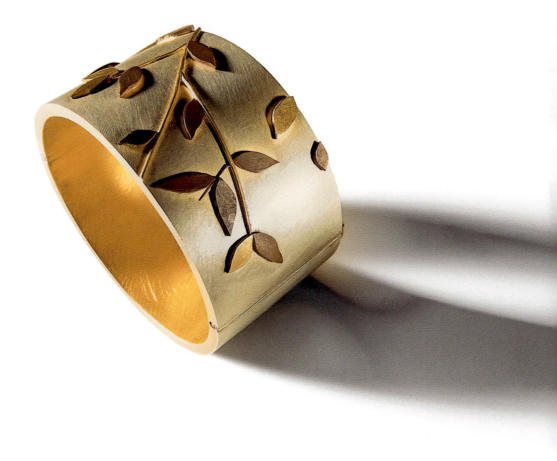

169

170

171

172

173

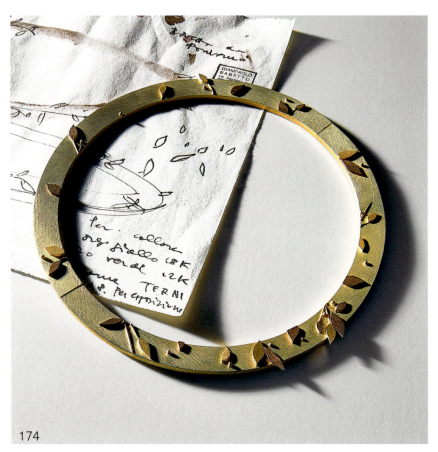
174

175

176

169 Brooch, yellow gold 750, 1993
170 Ring, yellow gold 750, 1994
171 Earring, yellow gold 750, niello, pearls, 1994
172 Earrings, yellow gold 750, 1994
173 Brooch "Da Pontormo", yellow gold 750, 1995
174 Necklace "Da Pontormo", yellow gold 750, green gold 500, copper, 1995
175 Brooch "Da Pontormo", yellow gold 750, 1995
176 Earrings "Da Pontormo", yellow gold 750, 1995

177 Brooch "Da Pontormo",
 yellow gold 750, 1995
178 Earring "Da Pontormo",
 white gold 750, 1995
179 Brooch "Da Pontormo",
 yellow gold 750, 1995
180 Brooch "Da Pontormo",
 yellow gold 750, 1995
181 Brooch "Da Pontormo",
 yellow gold 750, 1995
182 Earrings "Da Pontormo",
 yellow gold 750, white gold 750,
 1995
183 Brooch "Da Pontormo",
 white gold 750, pigment, 1995
184 Brooch "Da Pontormo",
 white gold 750, pigment, 1995

177

178

179

180

181

182

183

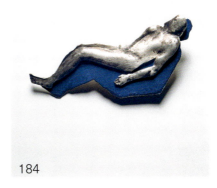
184

127

185 Ring, white gold 750, rutilated quartz, 1995
186 Brooch, yellow gold 750, pigment, 1995

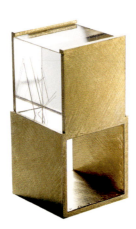

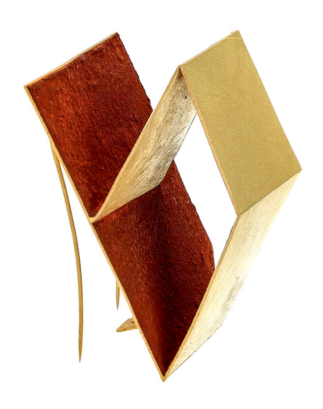

187 Brooch, yellow gold 750, 1998

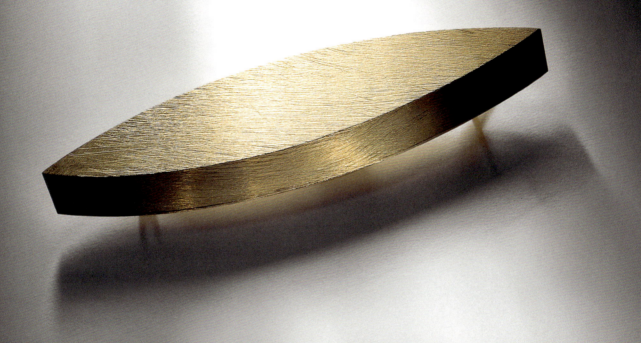

188 Necklace, white gold 750, pigment, 1998

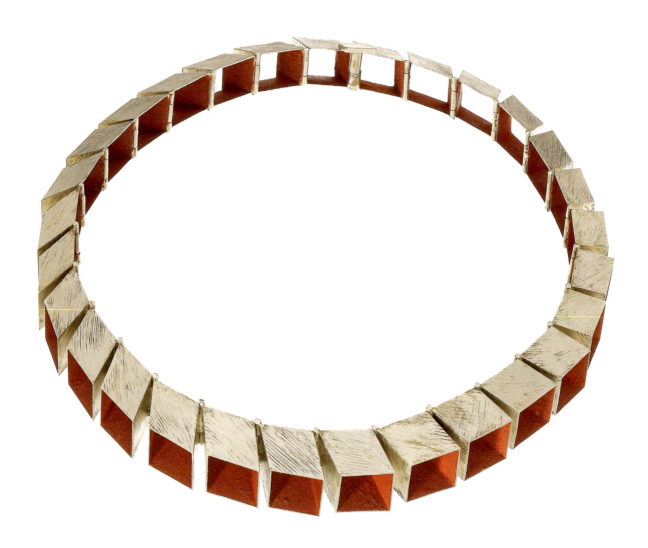

189 Necklace, white gold 750, pigment, 1998

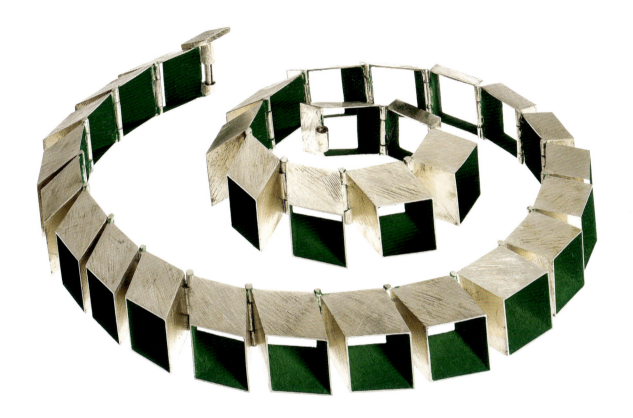

190 Ring, white gold 750, 1995
191 Ring, white gold 750, niello, pigment, 1995
192 Ring, white gold 750, niello, pigment, 1995
193 Ring, white gold 750, niello, pigment, 199
194 Brooch, white gold 750, niello, pigment, 1995
195 Brooch, yellow gold 750, pigment, 1995
196 Brooch, white gold 750, niello, pigment, coral, 1995
197 Brooch, white gold 750, niello, pigment, 1995

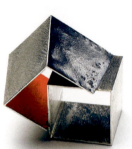
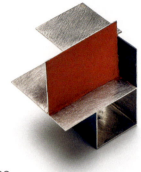
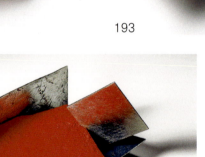
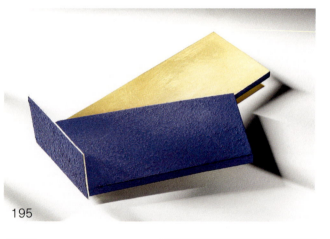
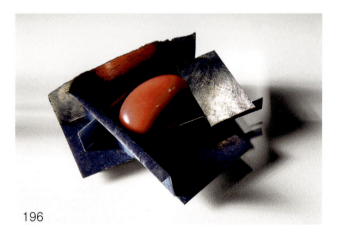
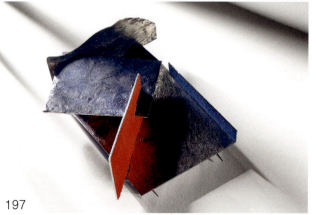

132

198 Earring, white gold 750, niello, pigment, 1995
199 Earring, white gold 750, niello, pigment, 1995
200 Ring, white gold 750, niello, pigment, 1995
201 Ring, white gold 750, diamonds, 1995
202 Earrings, white gold 750, niello, pigment, 1995
203 Brooch, white gold 750, niello, pigment, 1995
204 Necklace, white gold 750, niello, pigment, 1995

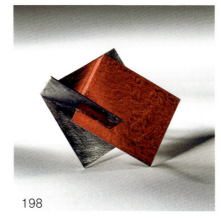

198

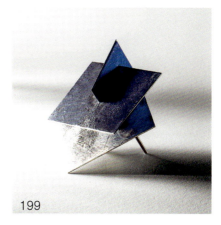

199

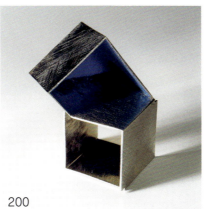

200

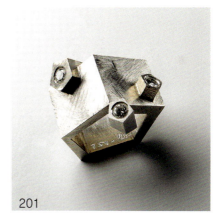

201

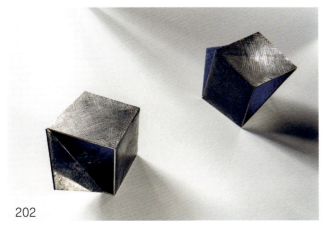

202

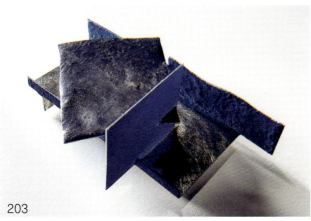

203

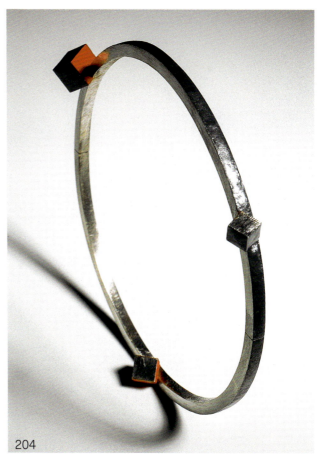

204

133

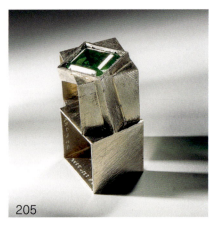
205

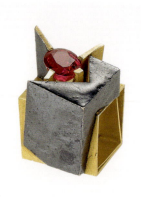
206

205 Ring, white gold 750, emerald, 1995
206 Ring, yellow gold 750, niello, ruby, 1995
207 Earrings, white gold 750, emerald, 1995
208 Earrings, white gold 750, pigment, 1996
209 Bracelet, white gold 750, pigment, 1996
210 Ring, yellow gold 750, diamond, 1995
211 Bracelet, yellow gold 750, emerald, 1996
212 Ring, white gold 750, aquamarine, 1995

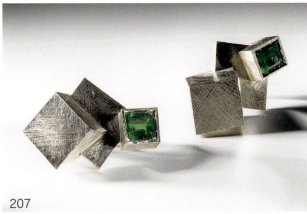
207

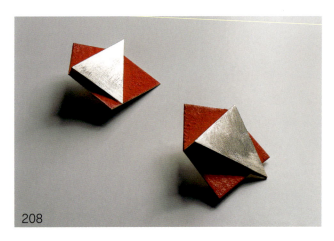
208

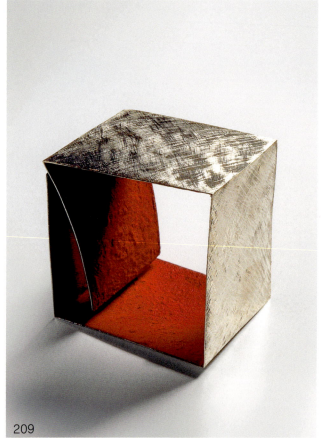
209

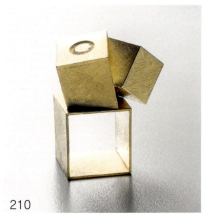
210

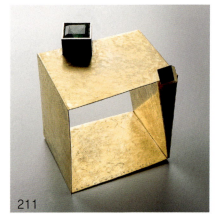
211

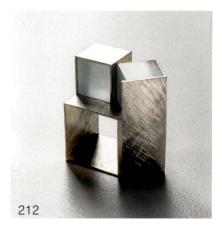
212

134

213 Ring, white gold 750, pigment, 1996
214 Ring, white gold 750, niello, 1996
215 Earrings, yellow gold 750, pigment, 1996
216 Brooch, yellow gold 750, pigment, 1996
217 Bracelet, yellow gold 750, 1996
218 Bracelet, yellow gold 750, niello, pigment, 1996

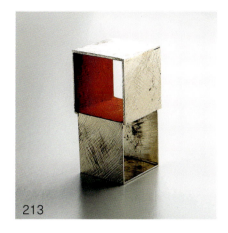

213

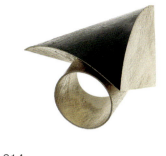

214

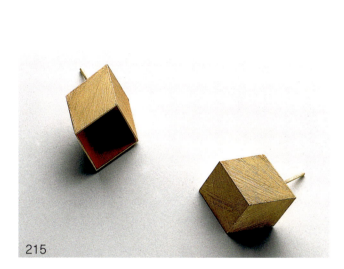

215

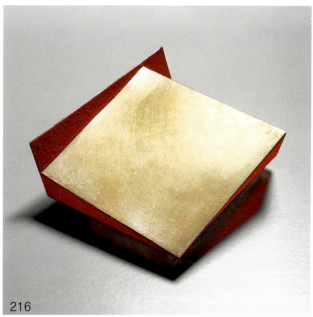

216

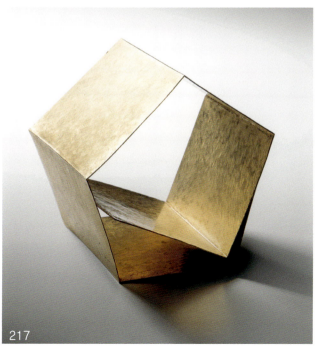

217

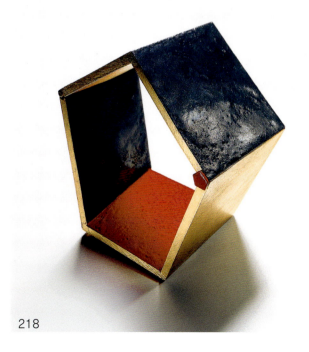

218

135

219 Brooch, white gold 750, pigment, 1996

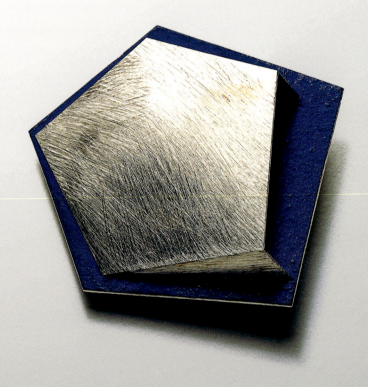

220 Bracelet, white gold 750, 1998

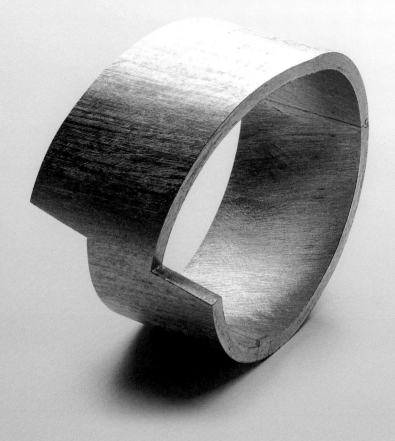

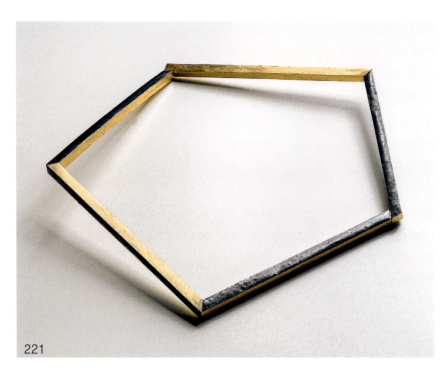

221 Necklace, yellow gold 750, niello, 1996
222 Necklace, yellow gold 750, 1997
223 Bracelet, yellow gold 750, diamonds, 1997
224 Ring, white gold 750, 1997
225 Ring, white gold 750, niello, black diamond, 1997
226 Ring, white gold 750, 1997

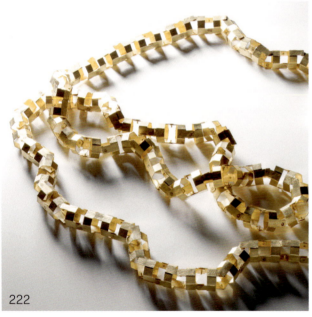
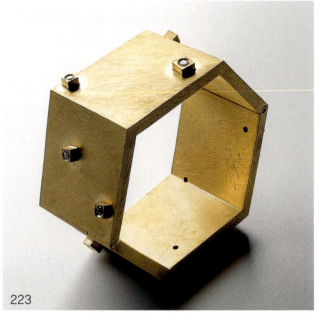
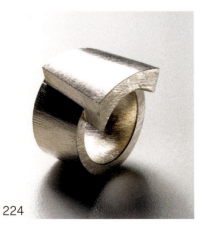
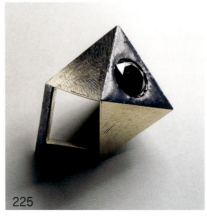
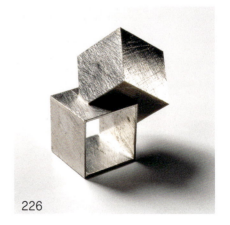

227 Earrings, white gold 750, diamonds, 1997
228 Ring, yellow gold 750, emerald, 1997
229 Ring, white gold 750, niello, resin, 1996
230 Ring, white gold 750, diamonds, 1997
231 Brooch, yellow gold 750, 1997
232 Brooch, white gold 750, niello, 1997
233 Ring, yellow gold 750, pearls, 1997
234 Brooch, yellow gold 750, pigment, sapphire, 1997

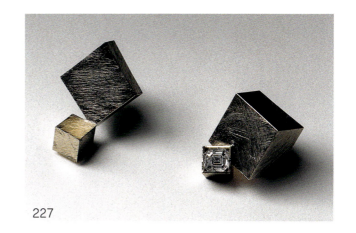

227

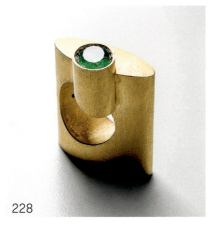

228

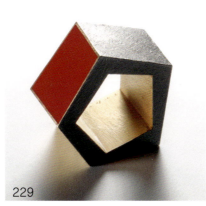

229

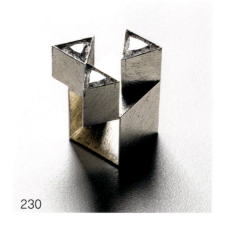

230

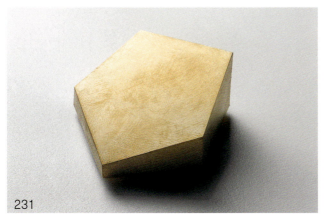

231

232

233

234

235

235 Brooch, yellow gold 750, 1997
236 Brooch, yellow gold 750, 1997
237 Brooch, white gold 750, niello, pigment, 1997
238 Earrings, yellow gold 750, 1997
239 Brooch, white gold 750, 1997
240 Brooch, white gold 750, 1998

237

236

238

239

240

241 Brooch, white gold 750, 1998
242 Brooch, white gold 750, 1998
243 Earrings, white gold 750, 1998
244 Ring, yellow gold 750, 1998
245 Brooch, white gold 750, niello, 1998
246 Bracelet, white gold 750, 1998
247 Bracelet, yellow gold 750, 1998
248 Bracelet, white gold 750, 1999

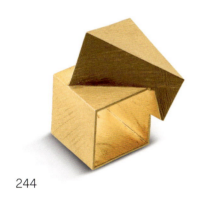
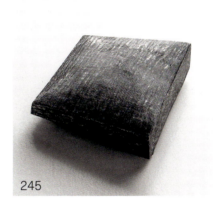
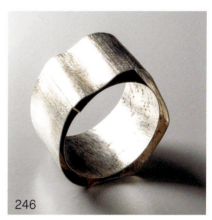
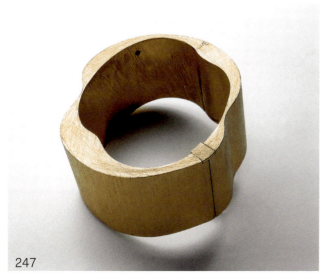
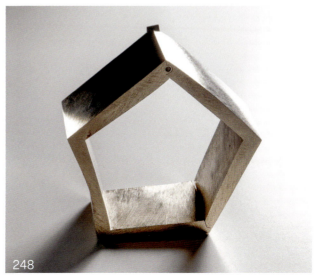

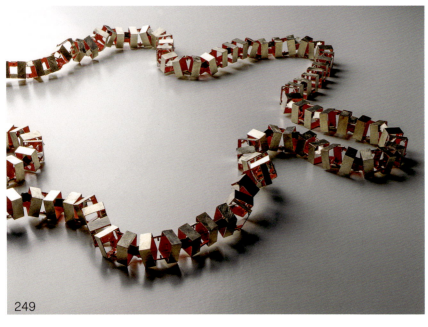

249 Necklace, white gold 750, resin, 1999
250 Ring, white gold 750, niello, diamonds, 1999
251 Ring, white gold 750, niello, diamonds, 1999
252 Brooch, yellow gold 750, 1999
253 Brooch, white gold 750, 1999
254 Brooch, white gold 750, niello, 1999
255 Brooch, white gold 750, niello, 1999

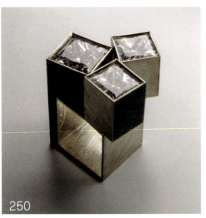
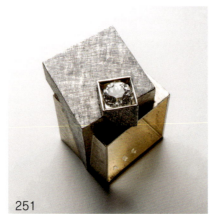
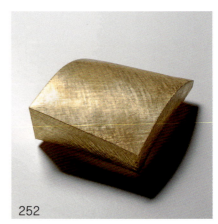
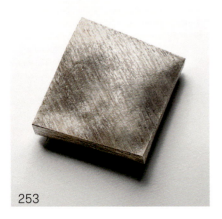
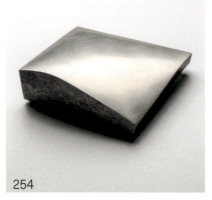
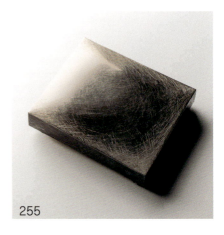

256 Brooch, white gold 750, niello, 1999
257 Brooch, white gold 750, 1999
258 Brooch, white gold 750, niello, 1999
259 Brooch, white gold 750, 1999
260 Earrings, white gold 750, niello, resin, 1999
261 Earrings, yellow gold 750, pigment, 1999
262 Earrings, white gold 750, niello, 1999
263 Earrings, yellow gold 750, niello, pigment, 1999

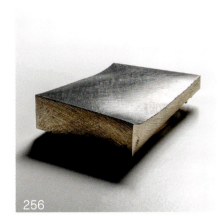
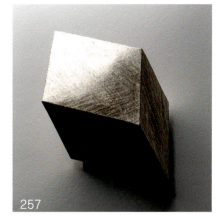
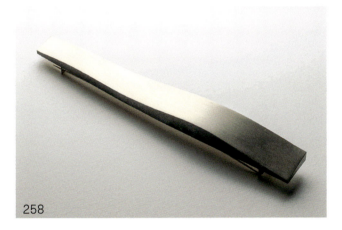
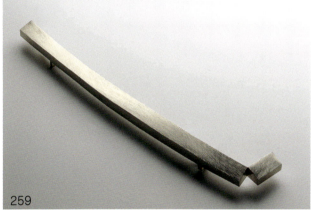
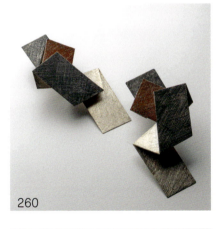

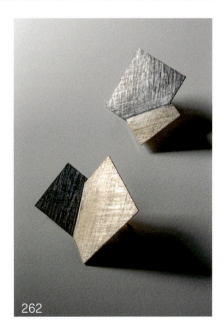
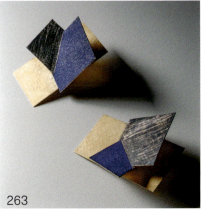

264 Brooch "Pozzanghera", white gold 750, niello, 1999

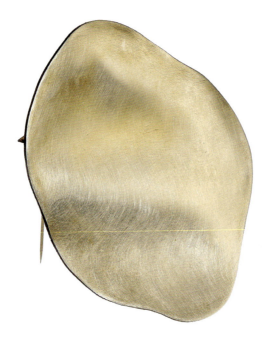

265 Necklace, yellow gold 750, niello, 2000

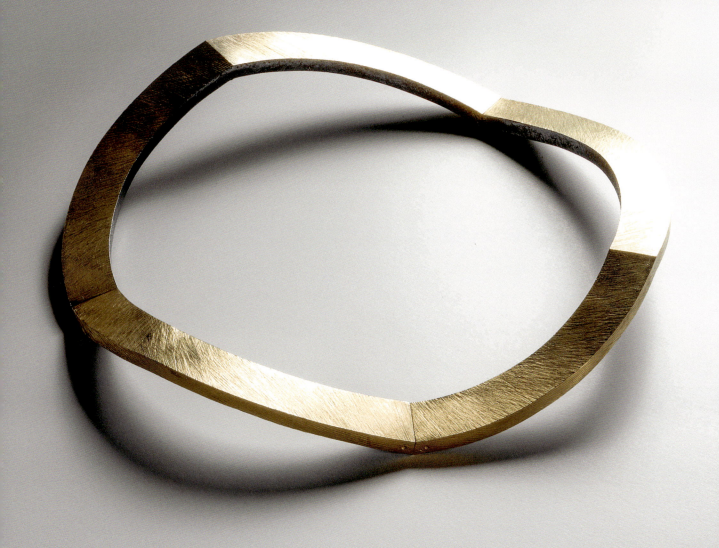

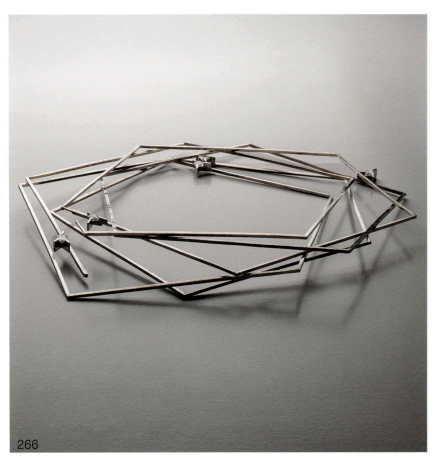

266 Necklace, white gold 750, diamonds, 2000
267 Earrings, white gold 750, niello, 2000
268 Bracelet, white gold 750, niello, 2000
269 Ring, white gold 750, niello, diamond, 2000
270 Brooch, white gold 750, niello, 2000
271 Bracelet, white gold 750, niello, 2000
272 Bracelet, white gold 750, niello, 2000

266

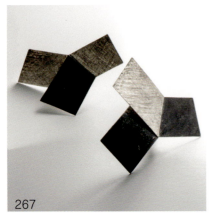

267

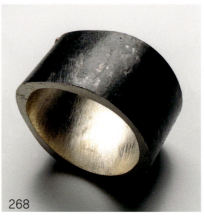

268

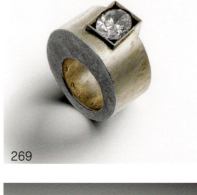

269

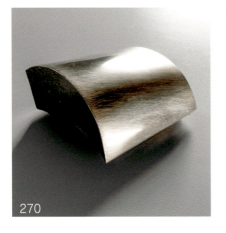

270

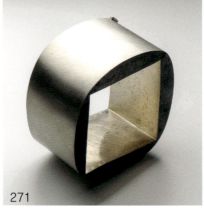

271

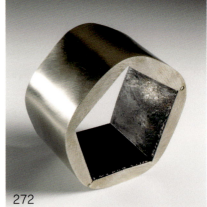

272

273 Ring, white gold 750, niello, diamonds, 2000
274 Ring, white gold 750, 2000
275 Earrings, white gold 750, niello, 2000
276 Brooch, white gold 750, niello, 2000
277 Necklace, white gold 750, niello, 2000
278 Ring, white gold 750, niello, mother-of-pearl, 2000
279 Ring, white gold 750, niello, 2000
280 Ring, white gold 750, niello, 2000

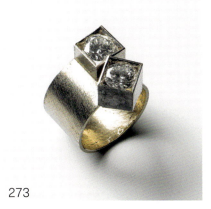
273

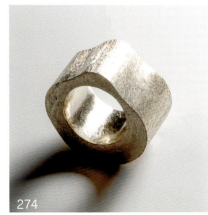
274

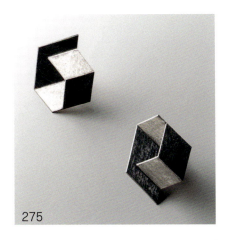
275

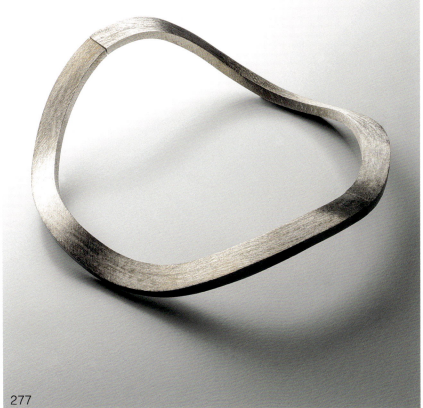
277

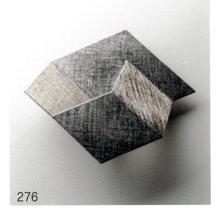
276

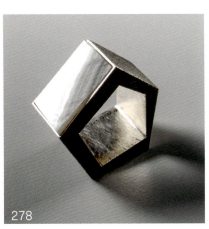
278

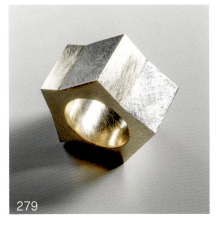
279

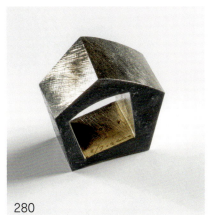
280

147

281 Brooch, white gold 750, methacrylate, 2000
282 Ring, white gold 750, methacrylate, 2001

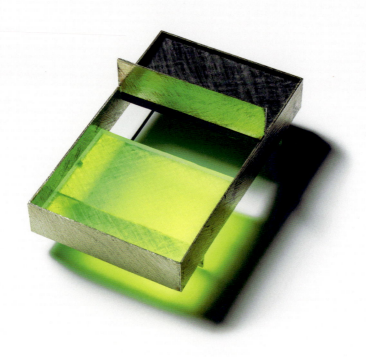

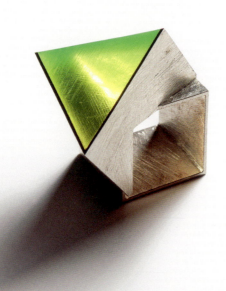

283 Necklace, yellow gold 750, 2000

284 Brooch, white gold 750, methacrylate, 2001

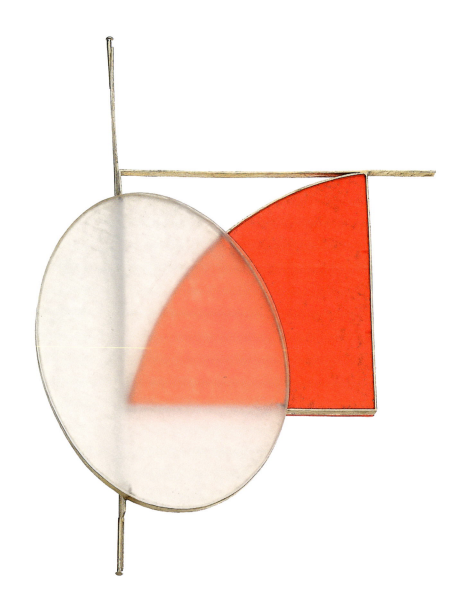

285 Ring, white gold 750, methacrylate, 2001
286 Ring, white gold 750, niello, pigment, 2001

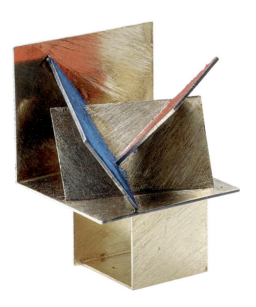

287 Brooch, white gold 750, methacrylate, 2002

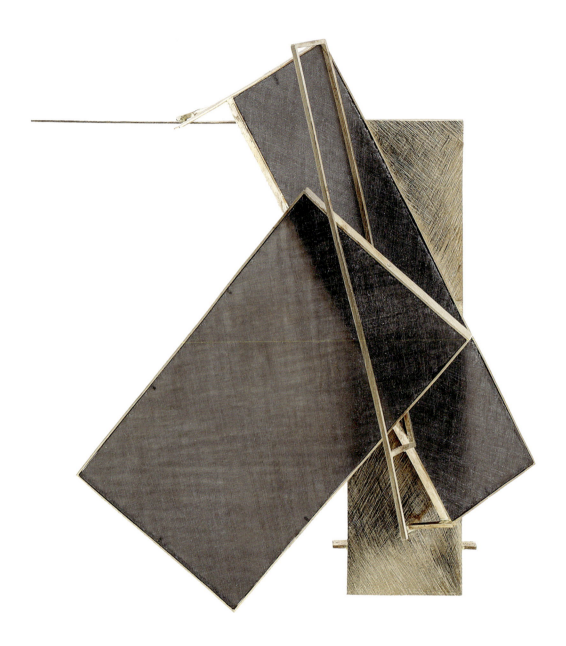

288 Brooch, white gold 750, methacrylate, 2002

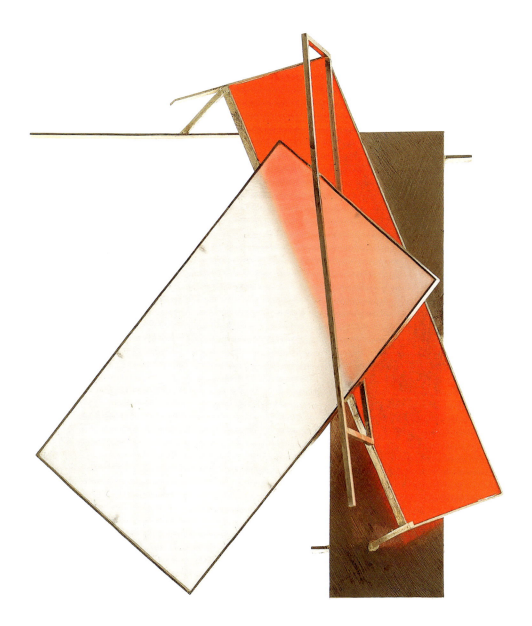

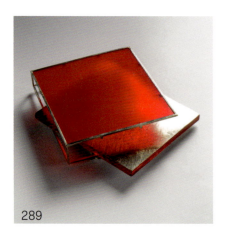

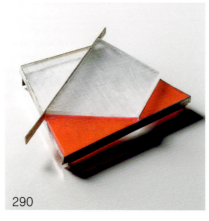

289 Brooch, white gold 750, methacrylate, 2000
290 Brooch, white gold 750, methacrylate, 2001
291 Brooch, white gold 750, methacrylate, 2001
292 Brooches, white gold 750, methacrylate, 2000
293 Earrings, white gold 750, methacrylate, 2001
294 Brooch, white gold 750, methacrylate, 2001
295 Earrings, white gold 750, methacrylate, 2000

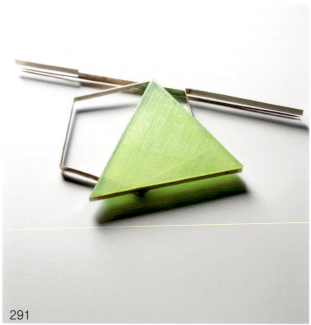

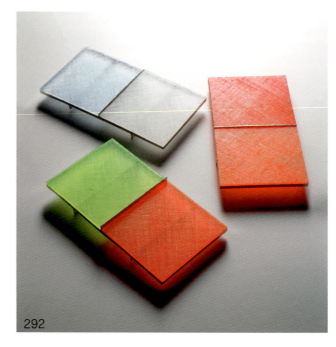

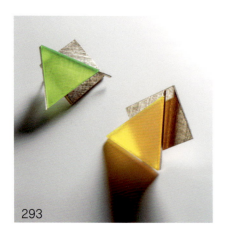

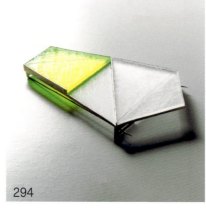

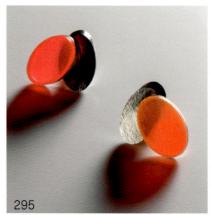

296 Brooch, white gold 750, methacrylate, 2001
297 Earrings, white gold 750, methacrylate, 2001
298 Ring, white gold 750, methacrylate, 2001
299 Cuff links, white gold 750, methacrylate, 2001
300 Ring, white gold 750, methacrylate, diamonds, 2001
301 Ring, white gold 750, niello, pigment, diamond, 2001
302 Brooch, white gold 750, methacrylate, diamonds, 2001

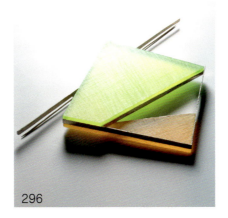
296

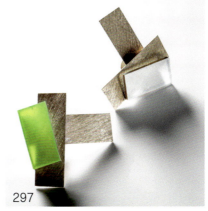
297

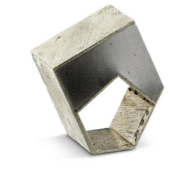
298

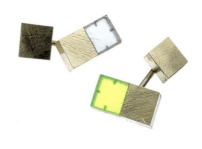
299

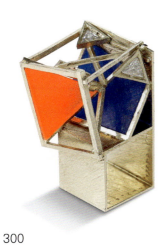
300

301

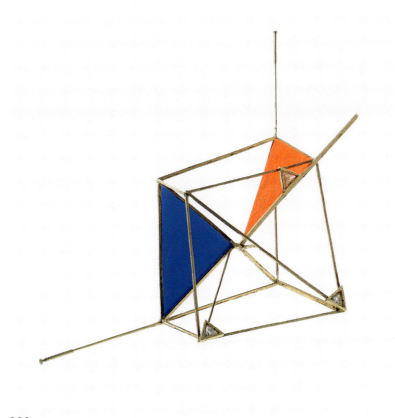
302

155

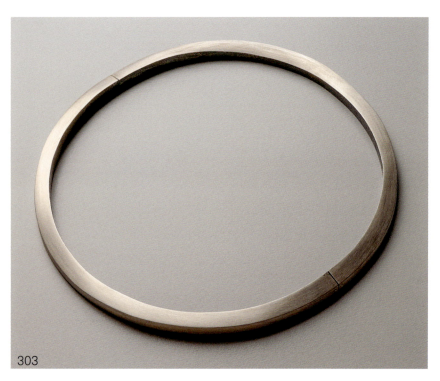

303 Necklace, white gold 750, niello, 2001
304 Earrings, white gold 750, niello, methacrylate, 2002
305 Brooch, white gold 750, methacrylate, 2002
306 Brooch, white gold 750, methacrylate, 2002
307 Brooch, white gold 750, methacrylate, 2002
308 Necklace, white gold 750, methacrylate, 2002

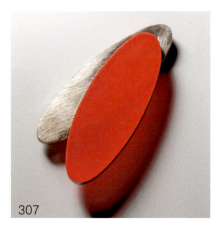
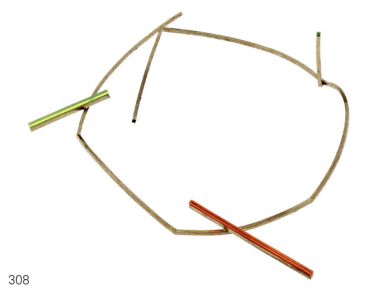

309 Brooch, white gold 750, niello, 2001
310 Brooch, white gold 750, niello, 2002
311 Brooch, yellow gold 750, pigment, 2002
312 Brooch, yellow gold 750, pigment, 2002
313 Earrings, yellow gold 750, pigment, 2002
314 Brooch, yellow gold 750, pigment, 2002
315 Ring, yellow gold 750, pigment, 2002

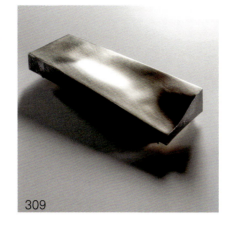
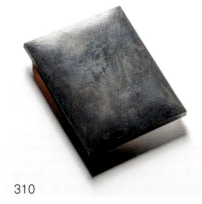

157

316 Earrings, white gold 750, diamonds, 2003

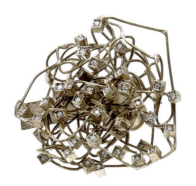
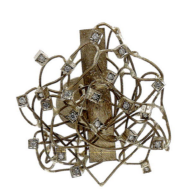

317 Necklace, white gold 750, glass, 2004

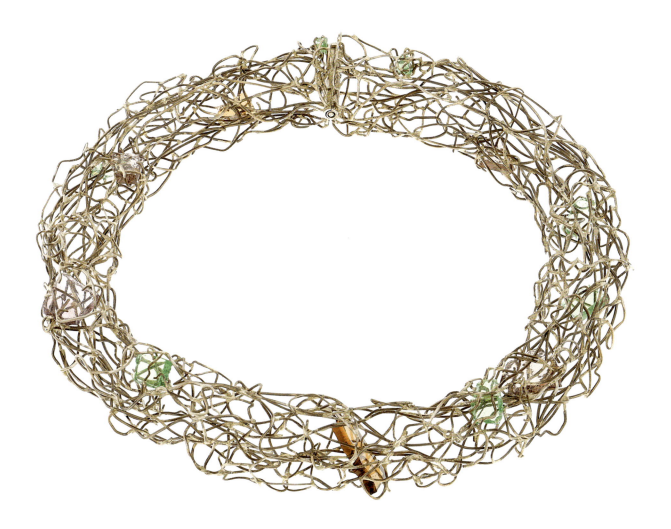

318 Brooch, white gold 750, pigment, diamonds, 2005

319 Brooch, white gold 750, niello, pigment, 2005

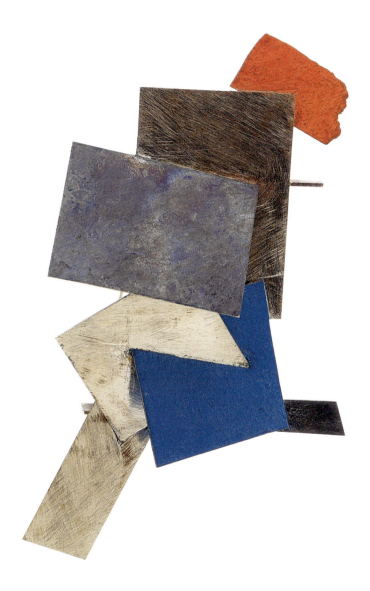

320 Brooch, yellow gold 750, pigment, 2003
321 Brooch, yellow gold 750, pigment, methacrylate, 2003
322 Brooch, white gold 750, glass, diamonds, 2003
323 Brooch, white gold 750, glass, pigment, 2003
324 Brooch, white gold 750, mirror, pigment, diamonds, 2003
325 Bracelet, white gold 750, diamonds, 2003

320

321

322

323

324

325

326 Brooch, yellow gold 750, pigment, 2003
327 Brooch, white gold 750, 2003
328 Brooch, yellow gold 750, glass, 2004
329 Necklace, yellow gold 750, 2003
330 Ring, white gold 750, diamonds, 2003
331 Earrings, white gold 750, diamonds, 2004
332 Brooch, white gold 750, glass, methacrylate, pigment, 2004

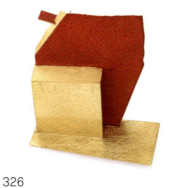

326

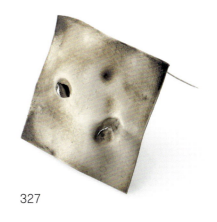

327

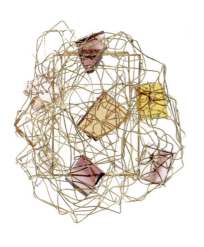

328

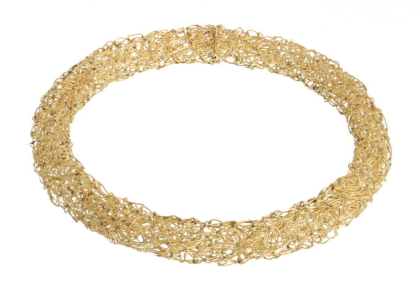

329

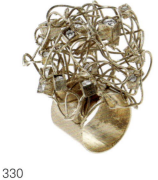

330

331

332

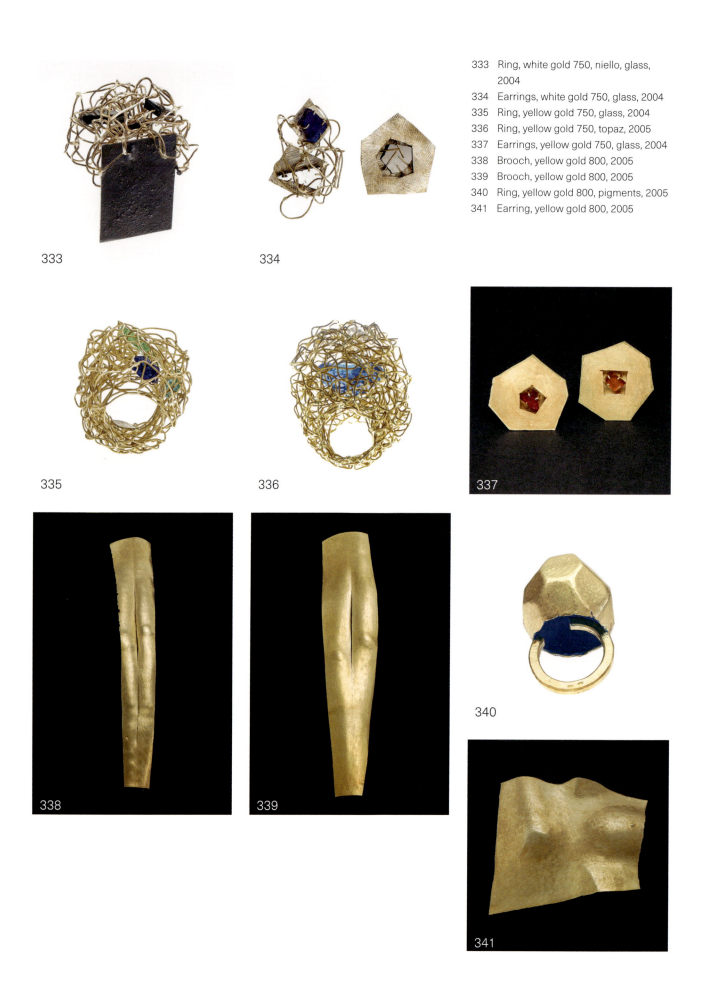

333 Ring, white gold 750, niello, glass, 2004
334 Earrings, white gold 750, glass, 2004
335 Ring, yellow gold 750, glass, 2004
336 Ring, yellow gold 750, topaz, 2005
337 Earrings, yellow gold 750, glass, 2004
338 Brooch, yellow gold 800, 2005
339 Brooch, yellow gold 800, 2005
340 Ring, yellow gold 800, pigments, 2005
341 Earring, yellow gold 800, 2005

342 Brooch "Da Pontormo", white gold 750, pigment, 2005
343 Brooch, yellow gold 800, 2005
344 Ring, white gold 750, niello, 2006
345 Brooch, yellow gold 800, 2005
346 Ring, white gold 750, niello, 2006
347 Earrings, white gold 750, niello, pigment, 2005
348 Brooch, white gold 750, niello, pigment, 2005

342

343

344

345

346

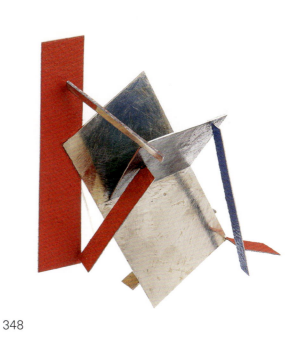

348

347

349 Ring, white gold 750, methacrylate, 2006

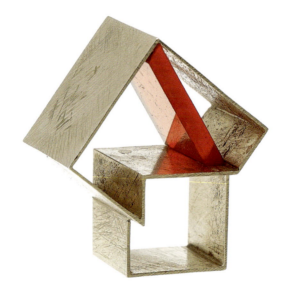

350 Bracelet, yellow gold 750, niello, 2007

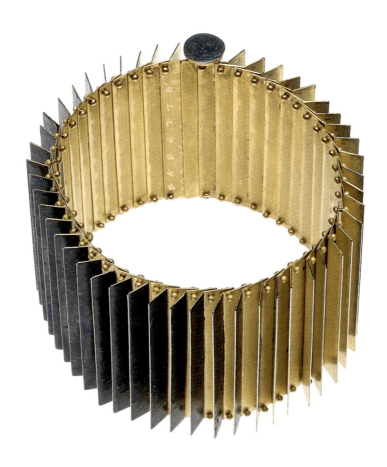

351 Brooch "Da Pontormo", white gold 750, pigment, 2005

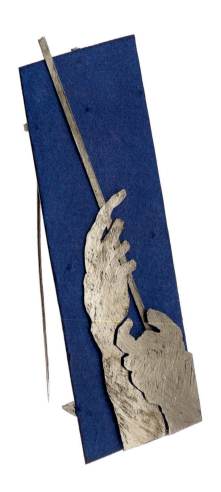

352 Brooch "Da Pontormo", white gold
750, niello, pigment, 2009

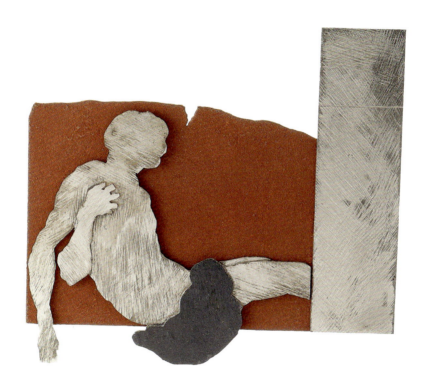

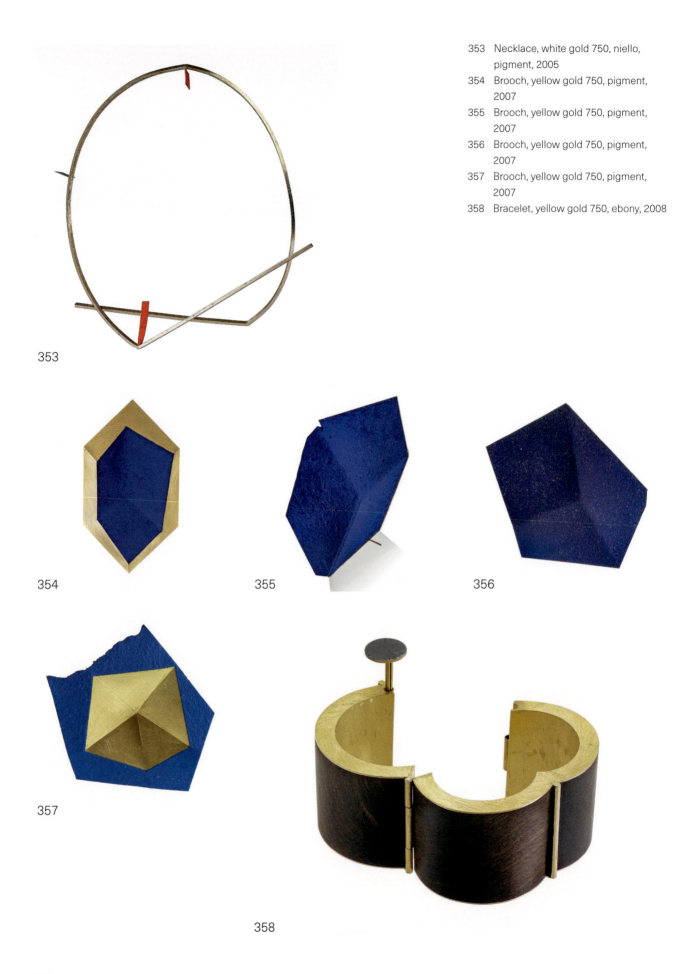

353 Necklace, white gold 750, niello, pigment, 2005
354 Brooch, yellow gold 750, pigment, 2007
355 Brooch, yellow gold 750, pigment, 2007
356 Brooch, yellow gold 750, pigment, 2007
357 Brooch, yellow gold 750, pigment, 2007
358 Bracelet, yellow gold 750, ebony, 2008

359 Brooch "Da Pontormo", white gold 750, glass, pigment, 2009
360 Brooch, yellow gold 750, niello, synthetic emerald, 2008
361 Brooch, yellow gold 750, pigment, 2007
362 Earrings, yellow gold 750, niello, methacrylate, 2008
363 Earrings, yellow gold 750, pigment, 2010
364 Ring, white gold 750, niello, diamond, 2008

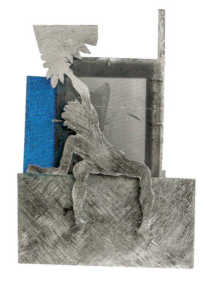

359

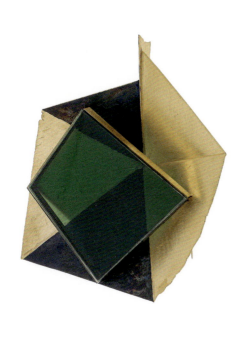

360

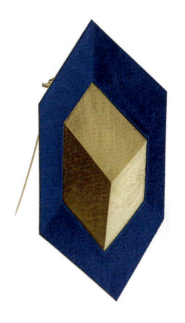

361

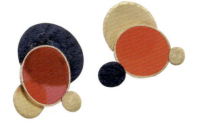

362

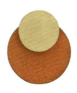

363

364

171

365 Earrings, white gold 750, niello, diamonds, 2009

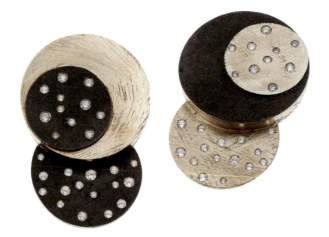

366 Bracelet, white gold 750, niello, sapphires, 2009

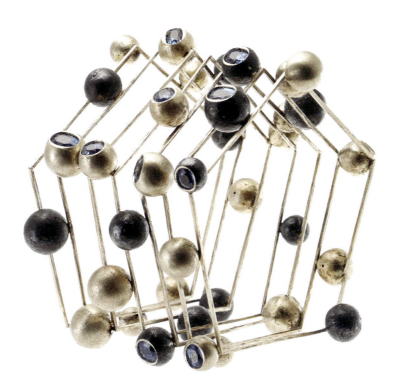

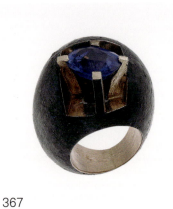

367

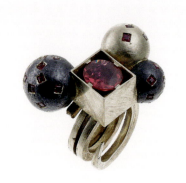

368

367 Ring, white gold 750, niello, sapphire, 2009
368 Ring, white gold 750, niello, rubies, 2009
369 Earrings, white gold 750, niello, diamonds, 2009
370 Earrings, white gold 750, niello, pigment, 2009
371 Ring, yellow gold 750, niello, pigment, pearl, 2009
372 Earrings, yellow gold 750, niello, methacrylate, 2009
373 Brooch, yellow gold 750, niello, pigment, pearl, mother-of-pearl, 2009

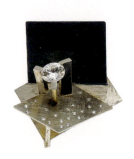

369

370

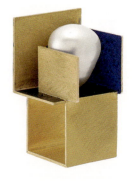

371

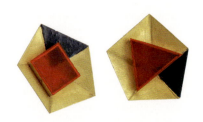

372

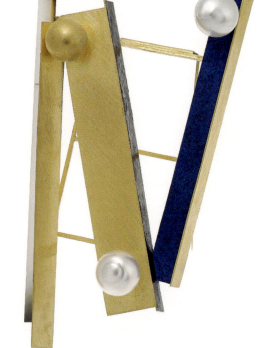

373

174

374 Bracelet, white gold 750, niello, 2009
375 Ring, white gold 750, resin, 2009
376 Ring, white gold 750, niello, pigment, 2009
377 Brooch, yellow gold 750, niello, 2010
378 Ring, yellow gold 750, pigment, 2010
379 Ring, yellow gold 750, 2010
380 Brooch, yellow gold 750, pigment, 2009

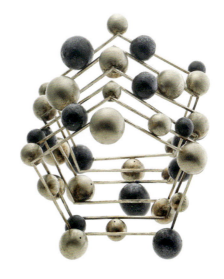

374

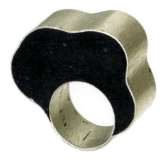

375

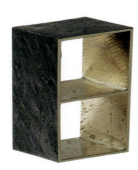

376

377

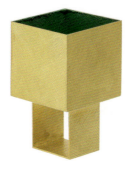

378

379

380

175

381 Brooch, white gold 750, niello, pigment, 2009

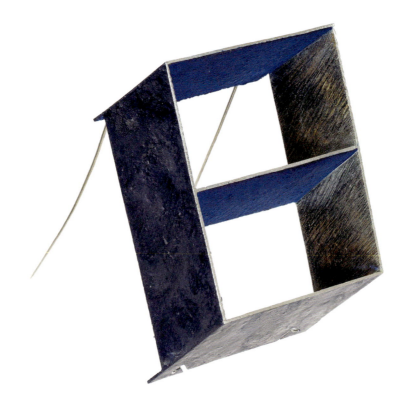

382 Brooch, white gold 750, niello, 2010

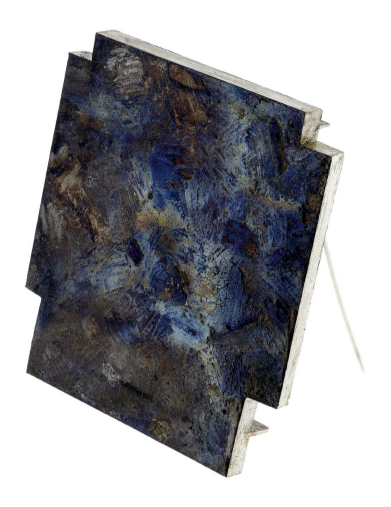

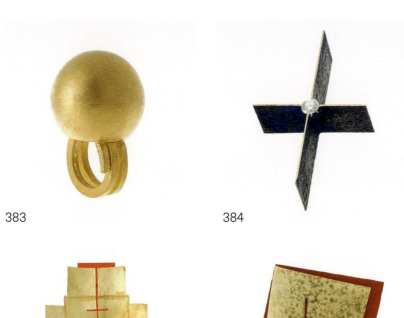
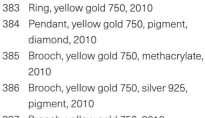

383 Ring, yellow gold 750, 2010
384 Pendant, yellow gold 750, pigment, diamond, 2010
385 Brooch, yellow gold 750, methacrylate, 2010
386 Brooch, yellow gold 750, silver 925, pigment, 2010
387 Brooch, yellow gold 750, 2010
388 Pendant, yellow gold 750, 2010
389 Pendant and chain, yellow gold 750, 2010

383

384

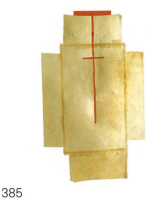
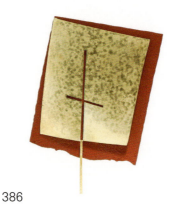

385

386

387

388

389

390 Brooch, yellow gold 750, niello, 2010
391 Brooch, yellow gold 750, pigment, 2011
392 Brooch, yellow gold 750, 2010
393 Brooch, yellow gold 750, 2010
394 Brooch, white gold 750, niello, 2010
395 Brooch, yellow gold 750, pigment, 2011
396 Brooch, yellow gold 750, pigment, 2011
397 Ring, yellow gold 750, pigment, 2011

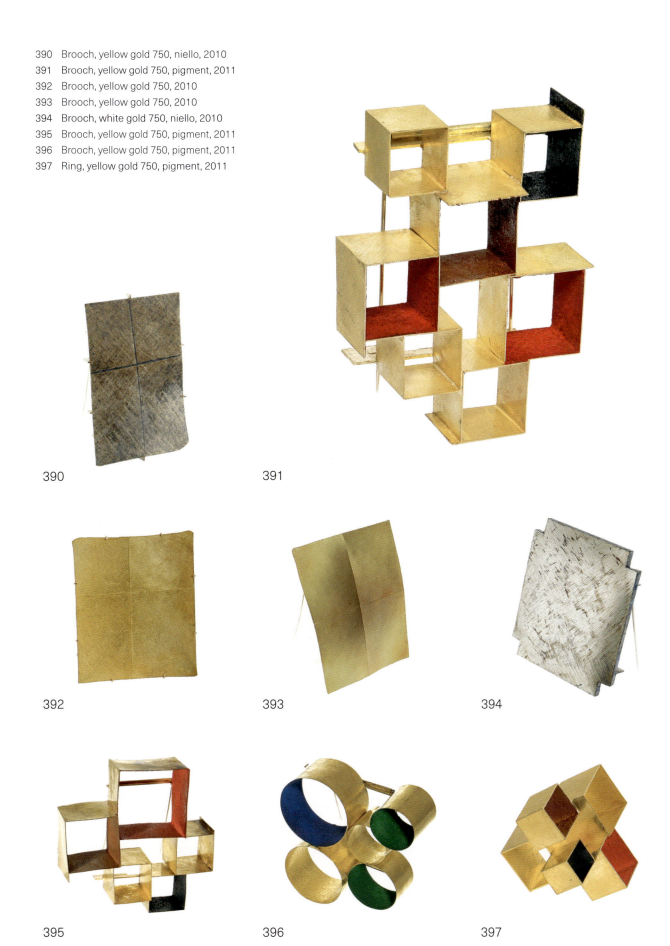

398 Pendant, white gold 750, pigment, 2010

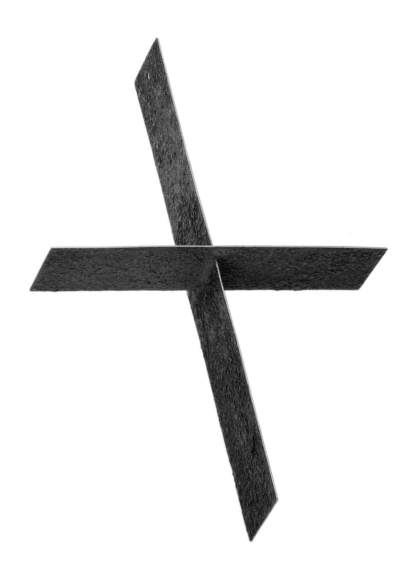

399 Pendant and chain, white gold 750,
niello, diamond, 2010

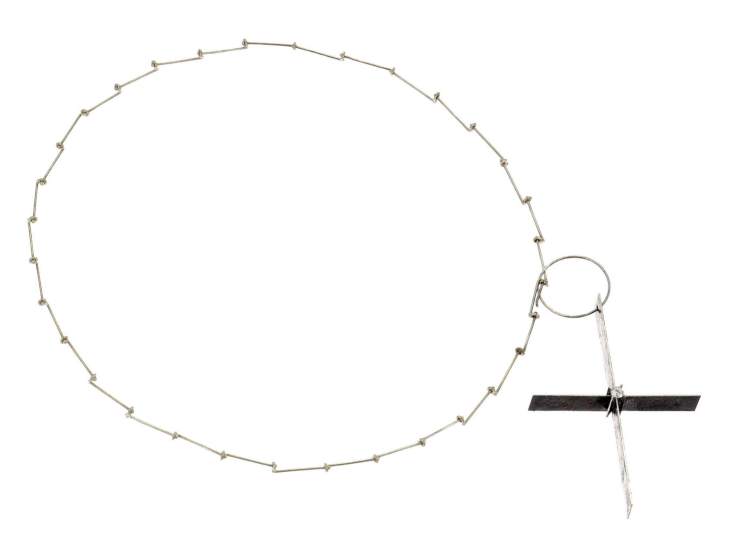

400 Necklace, white gold 750, niello, 2010

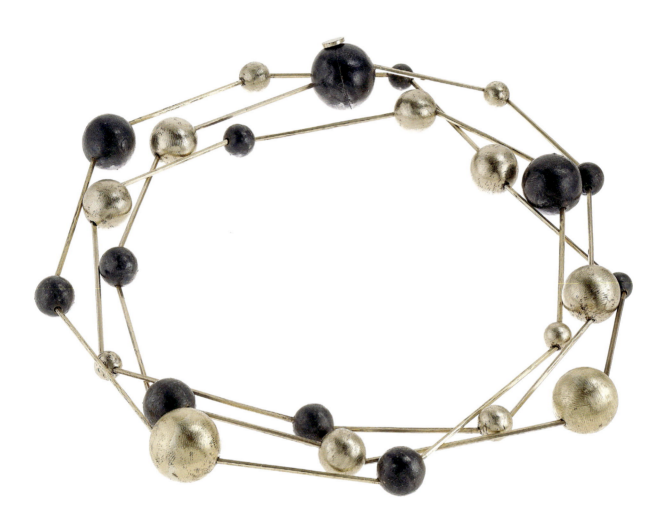

401 Brooch, yellow gold 750, pigment, 2011

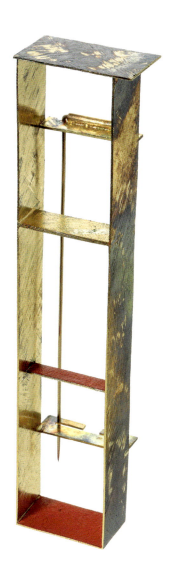

402

402	Earrings, yellow gold 750, pigment, 2011
403	Earrings, yellow gold 750, pigment, 2011
404	Earrings, yellow gold 750, pigment, 2012
405	Brooch, yellow gold 750, 2011
406	Brooch, yellow gold 750, pigment, 2011

403

404

405

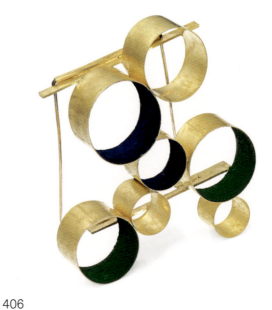

406

184

407 Necklace, yellow gold 750, pigment, 2012
408 Earring, yellow gold 750, pigment, 2011
409 Bracelet, yellow gold 750, pigment, 2012
410 Brooch, yellow gold 750, pigment, 2012
411 Necklace, yellow gold 750, pigment, 2012
412 Necklace, yellow gold 750, pigment, niello, fancy diamonds, 2012

407

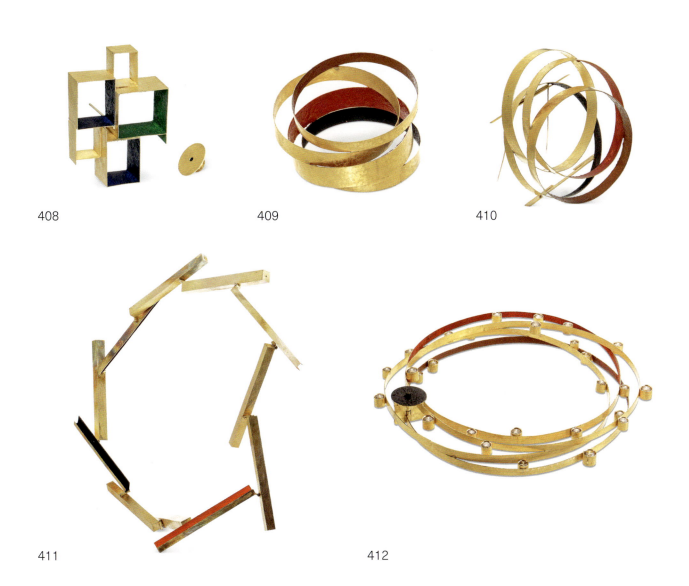

408 409 410

411 412

413 Bracelet, yellow gold 750, pigment, 2012

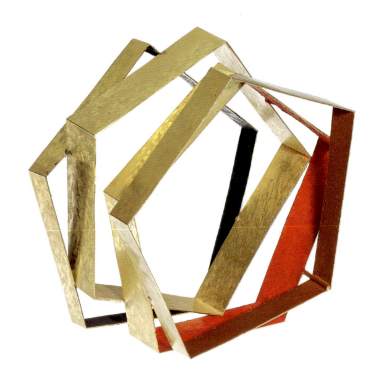

414 Brooch, yellow gold 750, pigment, 2012

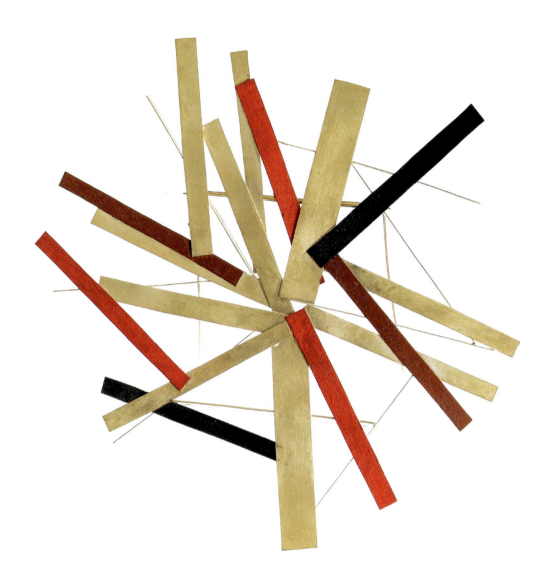

415 Ring, yellow gold 750, niello, pigment, 2012

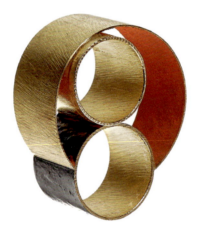

416 Necklace, yellow gold 750, pigment, 2012

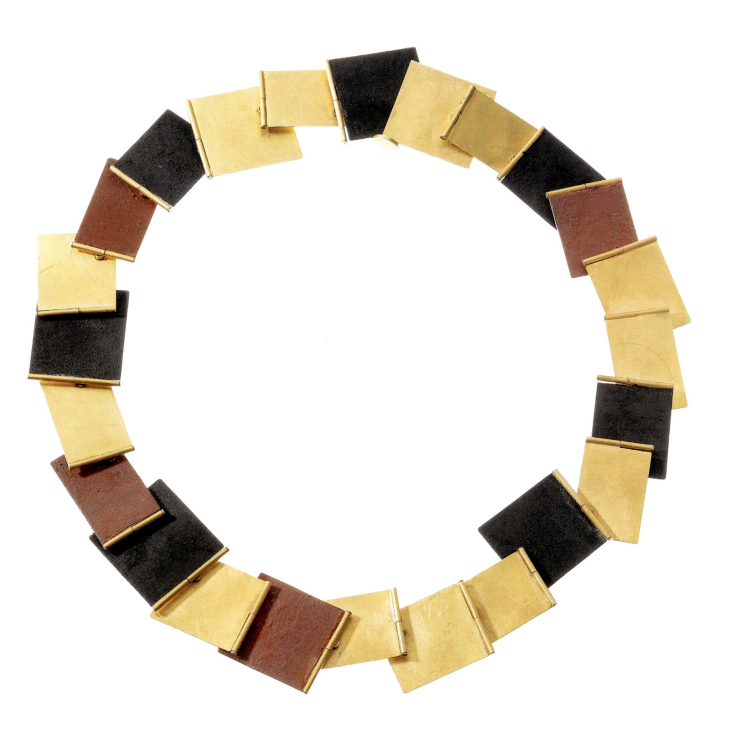

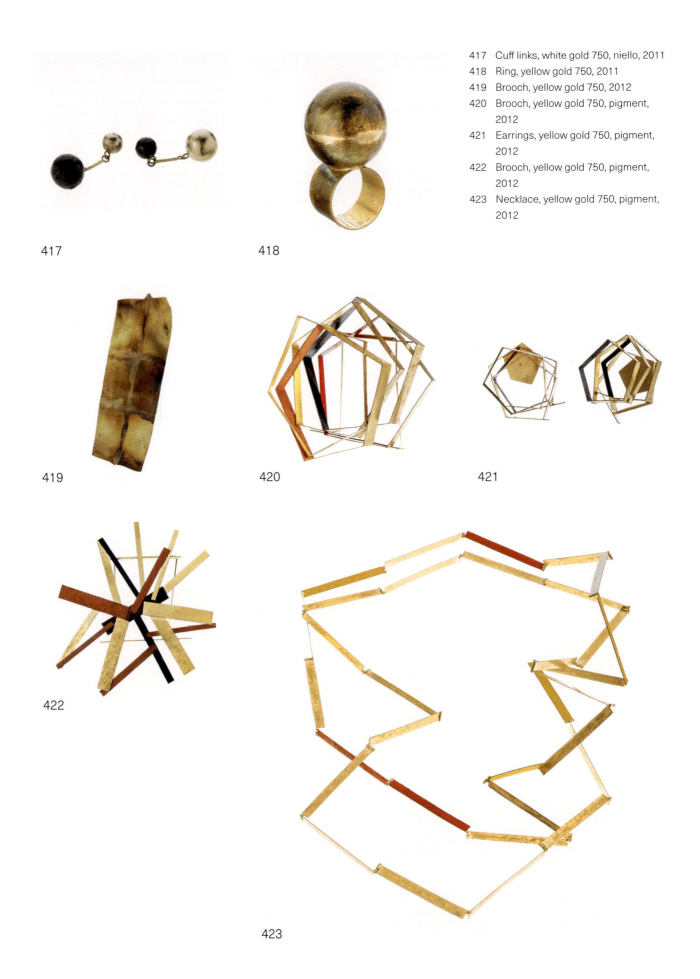

417 Cuff links, white gold 750, niello, 2011
418 Ring, yellow gold 750, 2011
419 Brooch, yellow gold 750, 2012
420 Brooch, yellow gold 750, pigment, 2012
421 Earrings, yellow gold 750, pigment, 2012
422 Brooch, yellow gold 750, pigment, 2012
423 Necklace, yellow gold 750, pigment, 2012

424 Ring, white gold 750, 2012
425 Ring, yellow gold 750, niello, 2012
426 Ring, white gold 750, pigment, 2013
427 Ring, white gold 750, glass, 2012
428 Ring, white gold 750, 2013
429 Ring, yellow gold 750, pigment, 2011
430 Brooch, yellow gold 750, 2013
431 Earrings, yellow gold 750, pigment, 2012

424

425

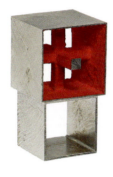

426

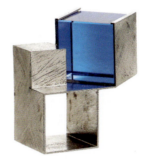

427

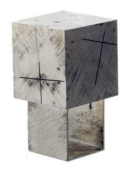

428

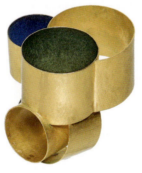

429

430

431

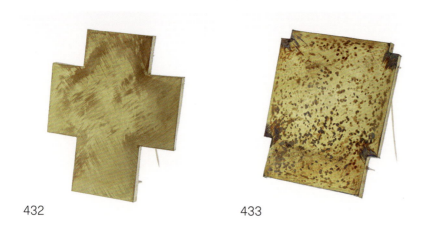

432

433

432	Brooch, yellow gold 750, 2013
433	Brooch, yellow gold 750, 2013
434	Brooch, white gold 750, pigment, gold leaf, 2013
435	Brooch "Martiri", white gold 750, 2013
436	Brooch "Martiri", yellow gold 750, 2013
437	Brooch "Martiri", yellow gold 750, 2013

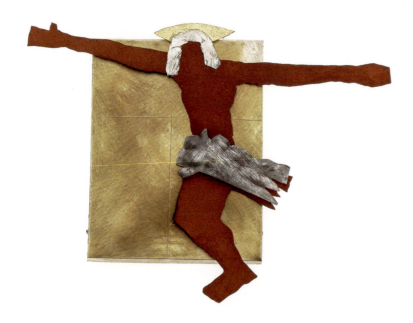

434

435 436 437

438 Brooch "Martiri", white gold 750, 2013

439 Ring, yellow gold 750, methacrylate, 2013

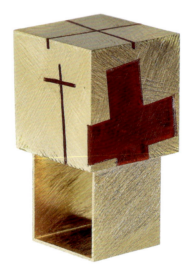

440 Brooch, yellow gold 750, silver 925, pigment, 2013

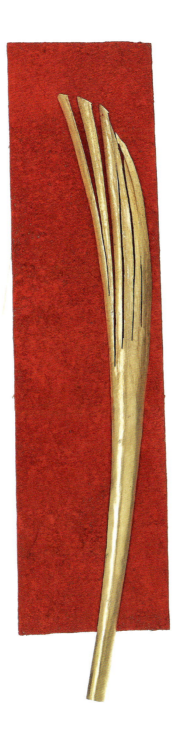

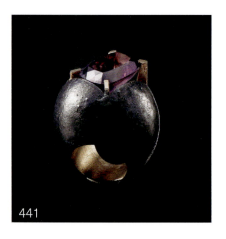
441

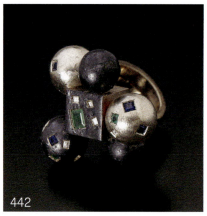
442

441 Ring, white gold 750, niello, amethyst, 2009
442 Ring, white gold 750, niello, diamonds, emeralds, sapphires, 2014
443 Ring, white gold 750, quartz, 2013
444 Ring, white gold 750, glass, 2013
445 Ring, white gold 750, niello, diamonds, emeralds, sapphires, 2014
446 Brooch "Da Antonello Semitecolo", yellow gold 750, silver 925, methacrylate, 2013
447 Brooch, white gold 750, diamonds, sapphires, 2014

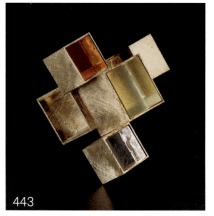
443

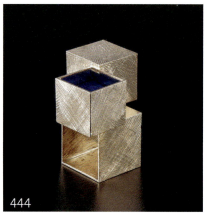
444

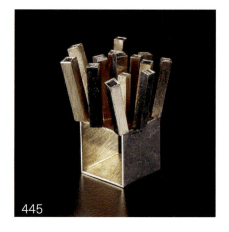
445

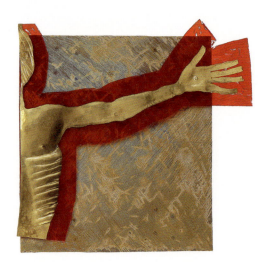

446

447

448 Ring, white gold 750, glass, onyx, 2014
449 Ring, white gold 750, glass, lemon quartz, 2014
450 Brooch, white gold 750, glass, obsidian, 2014
451 Brooch "Da Antonello Semitecolo", yellow gold 750, silver 925, pigment, 2013
452 Necklace, white gold 750, pigment, 2014

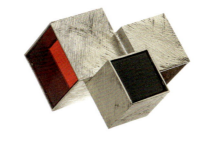
448

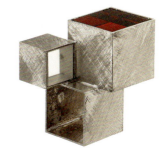
449

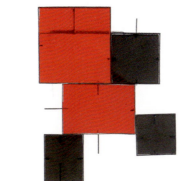
450

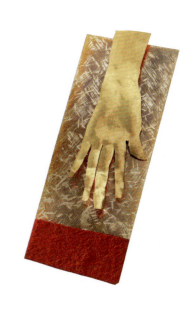
451

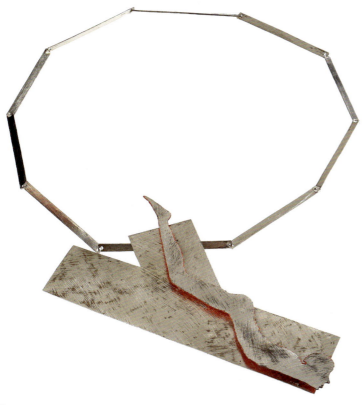
452

197

453 Ring, yellow gold 750, glass, 2014

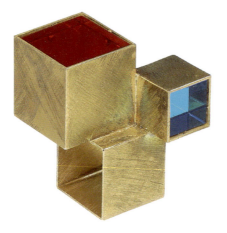

454 Brooch, white gold 750, methacrylate, 2014

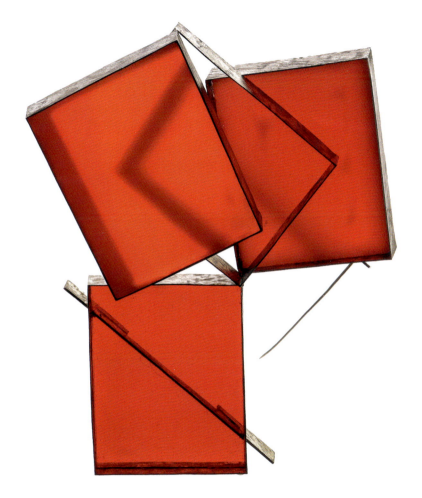

455 Brooch "Joséphine", white gold 750, silver, niello, resin, diamond, 2014

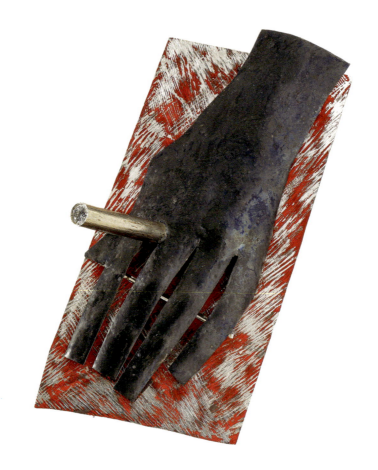

456 Brooch, white gold 750, 2014

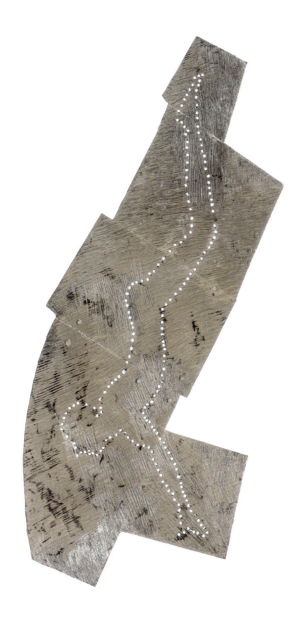

457　Brooch, yellow gold 750, 2015

458 Necklace, white gold 750, niello, 2017

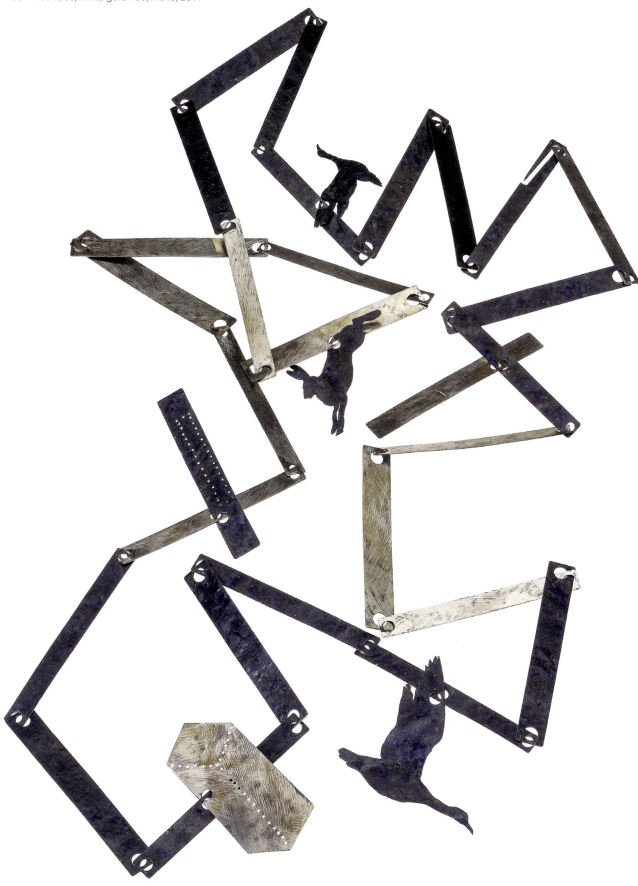

459

460

459 Brooch, white gold 750, methacrylate, 2014
460 Brooch, white gold 750, methacrylate, 2014
461 Brooch, yellow gold 750, silver 800, pigment, 2014
462 Earrings, white gold 750, 2014
463 Ring, white gold 750, silver 925, pigment, 2014
464 Earrings, yellow gold 750, 2014
465 Brooch, white gold 750, methacrylate, 2014

461

462

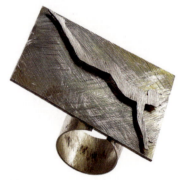
463

464

465

204

466 Ring, white gold 750, methacrylate, 2014
467 Ring, white gold 750, methacrylate, 2014
468 Brooch, white gold 750, diamonds, 2015
469 Ring, white gold 750, niello, diamonds, 2015
470 Ring, white gold 750, niello, emeralds, 2015
471 Ring, yellow gold 750, 2014
472 Necklace, white gold 750, niello, 2014

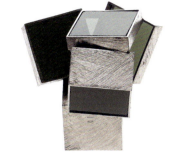
466

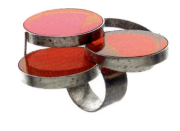
467

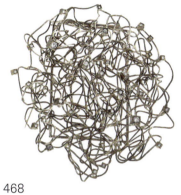
468

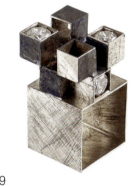
469

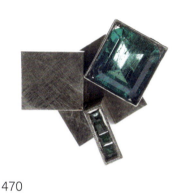
470

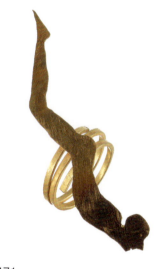
471

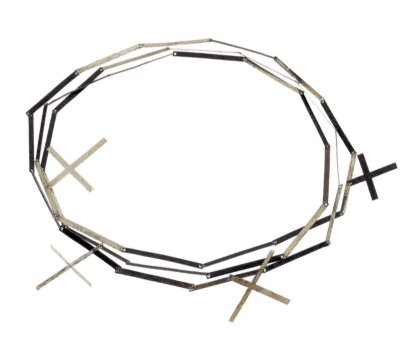
472

205

473 Bracelet, silver 925, 2016
474 Bracelet, silver 925, 2016

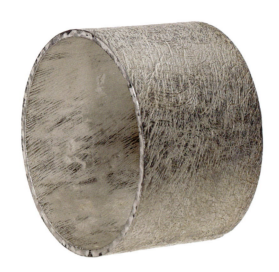

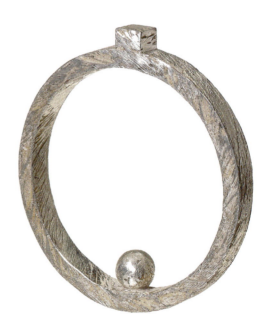

475 Necklace, silver 925, white gold 750, 2017

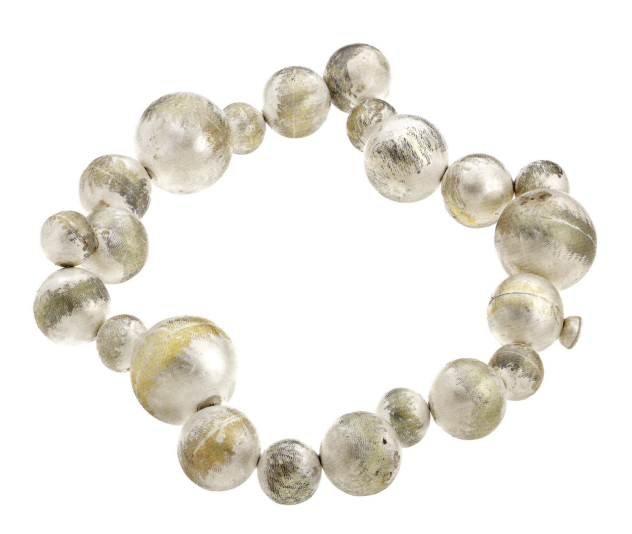

476 Necklace, yellow gold 750, pigment, 2017

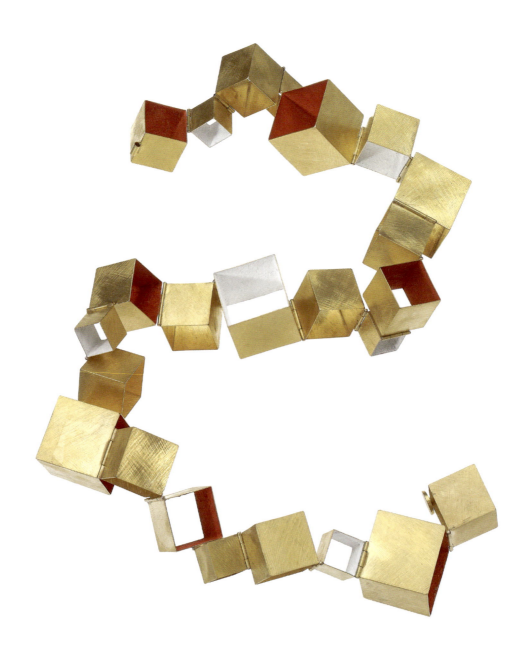

477 Necklace, yellow gold 750, 2017

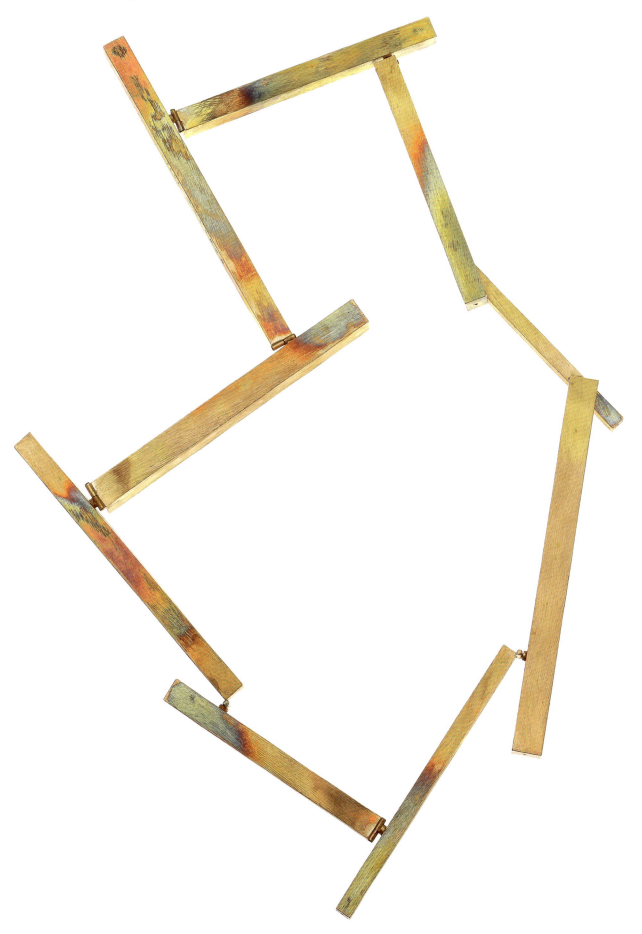

478

479

478 Earrings, yellow gold 750, 2016
479 Ring, white gold 750, methacrylate, 2017
480 Bracelet, silver 925, 2016
481 Bracelet, silver 925, 2016
482 Bracelet, silver 925, 2016
483 Earrings, yellow gold 750, pigment, 2017
484 Necklace, yellow gold 750, 2017

480

481

482

483

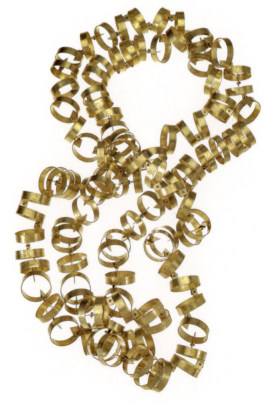
484

210

485 Ring "Rigatoni", silver 925, 2017
486 Ring "Rigatoni", silver 925, 2017
487 Ring "Maccheroni, pomodoro e basilico", yellow gold 750, resin, 2017
488 Ring, white gold 750, niello, pigment, 2017
489 Ring, yellow gold 750, pigment, 2015
490 Earrings "Pastiera", white gold 750, ceramic, 2017
491 Earrings "Rigatoni", silver 925, 2017
492 Ring, yellow gold 750, 2017
493 Ring, silver 925, gold leaf, 2017
494 Ring, white gold 750, niello, 2017

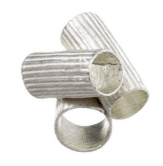

485

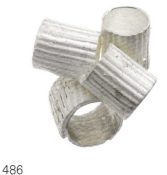

486

487

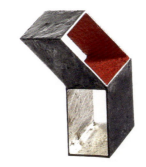

488

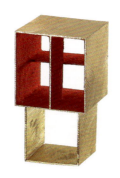

489

490

491

492

493

494

495 Ring, yellow gold 750, methacrylate, 2017

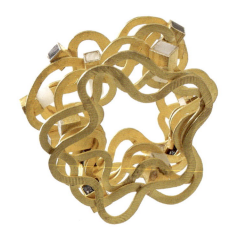

496 Ring, yellow gold 750, 2017

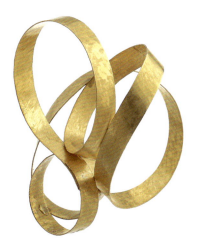

497 Ring, yellow gold 750, methacrylate, 2017
498 Ring, yellow gold 750, pigment, 2018

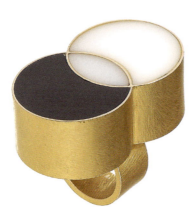

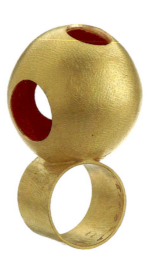

499 Necklace, yellow gold 750, 2019

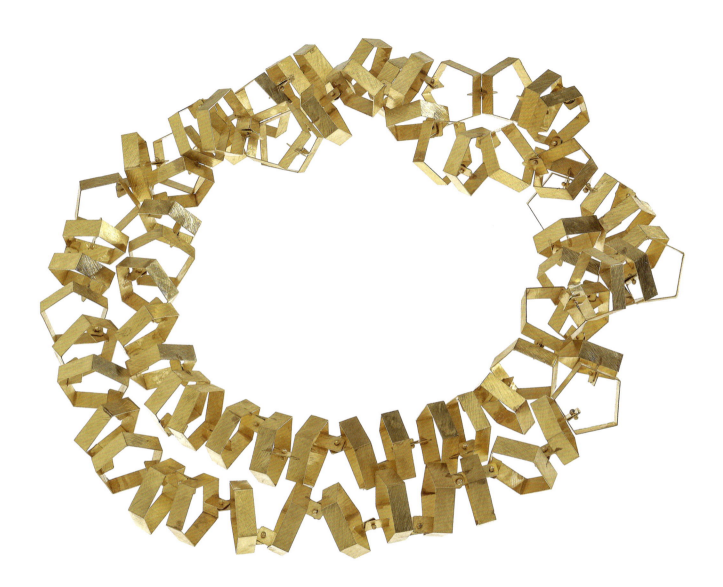

500　Necklace, yellow gold 750, pigment, 2019

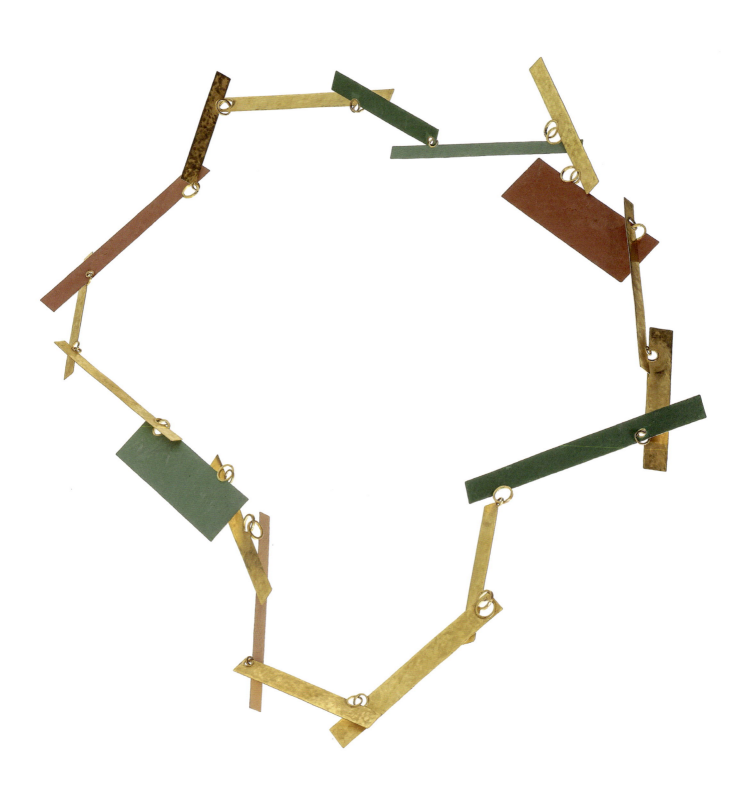

216

501　Necklace, white gold 750, 2019

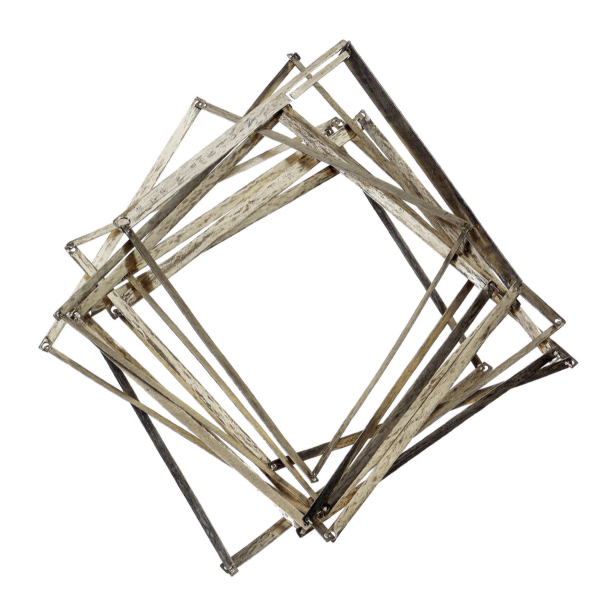

502 Brooch, yellow gold 750, 2020

503 Brooch, yellow gold 750, silver 925,
gold leaf, silver leaf, methacrylate, 2020

504 Ring, yellow gold 750, glass, 2021
505 Ring, yellow gold 750, silver 925, glass, 2021
506 Ring, yellow gold 750, glass, 2020

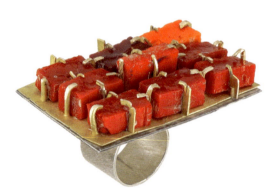
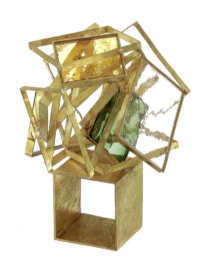

507 Brooch, white gold 750, silver 925, glass, 2020

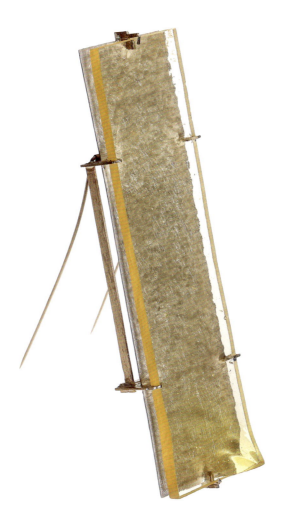

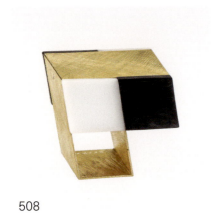

508

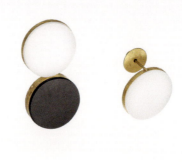

509

508 Ring, yellow gold 750, methacrylate, 2017
509 Earrings, yellow gold 750, methacrylate, 2017
510 Brooch, yellow gold 750, methacrylate, 2017
511 Ring, white gold 750, methacrylate, 2018
512 Ring, white gold 750, methacrylate, 2018
513 Ring, yellow gold 750, 2018
514 Earrings, yellow gold 750, 2018
515 Necklace, yellow gold 750, 2017

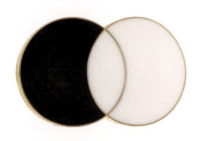

510

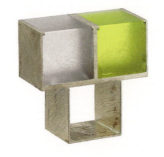

511

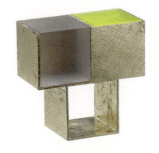

512

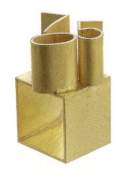

513

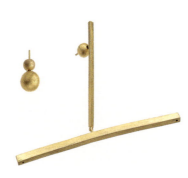

514

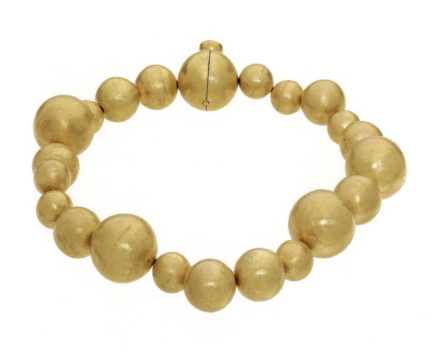

515

222

516 Ring, yellow gold 750, pigment, 2018
517 Ring, yellow gold 750, 2019
518 Earrings, yellow gold 750, pigment, 2018
519 Earrings, yellow gold 750, pigment, 2019
520 Ring, white gold 750, niello, 2019
521 Ring, yellow gold 750, 2019
522 Brooch, white gold 750, 2019
523 Brooch, white gold 750, 2019

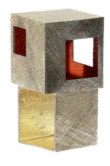

516

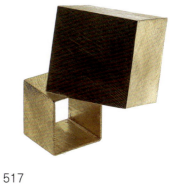

517

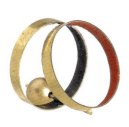

518

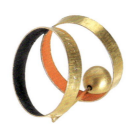

519

520

521

522

523

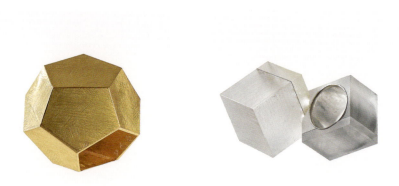

524 Ring, yellow gold 750, 2020
525 Ring, silver 925, methacrylate, gold leaf, 2020
526 Earrings, white gold 750, niello, 2019
527 Ring, yellow gold 750, glass, 2021
528 Necklace, yellow gold 750, 2019

524

525

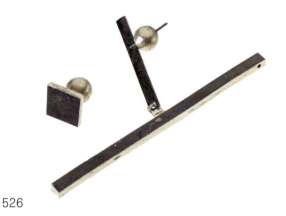

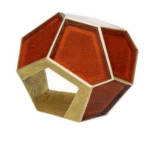

526

527

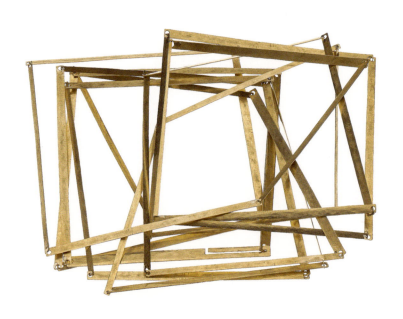

528

529 Brooch, silver 925, 2020
530 Brooch, yellow gold 750, glass, 2021
531 Brooch, yellow gold 750, glass, 2020
532 Brooch, yellow gold 750, glass, 2020
533 Earrings, yellow gold 750, glass, 2021

529

530

531

532

533

225

534 Brooch, silver 925, stone, silver leaf, 2021

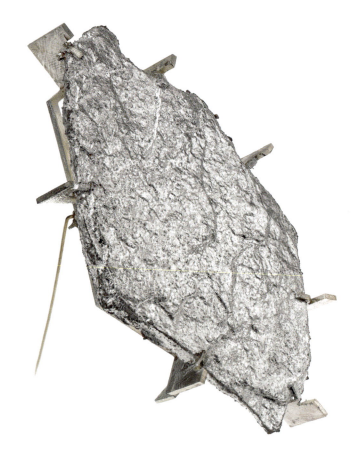

535 Brooch, yellow gold 750, glass, 2021

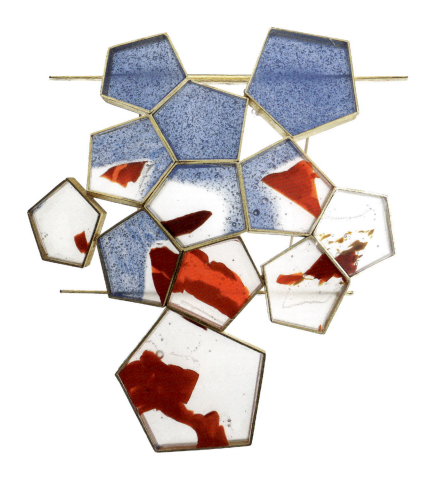

536

536 Earrings, yellow gold 750, glass, 2020
537 Brooch, silver 925, methacrylate, 2020
538 Brooch, yellow gold 750, glass, 2021
539 Brooch, yellow gold 750, glass, 2021
540 Brooch, yellow gold 750, glass, 2021

537

538

539

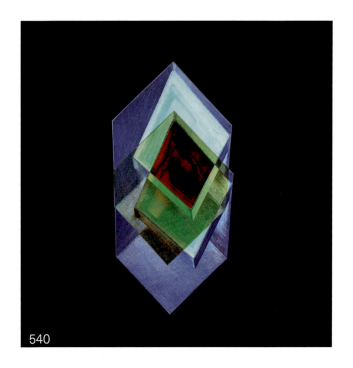

540

228

541 Ring, yellow gold 750, glass, 2021
542 Ring, yellow gold 750, glass, gold leaf, 2021
543 Brooch, yellow gold 750, pigment, 2021
544 Brooch, yellow gold 750, silver 925, glass, 2021
545 Brooch, silver 925, pigment, 2020

541

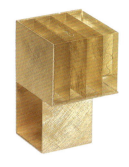

542

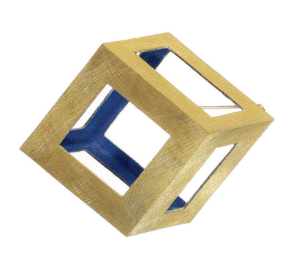

543

544

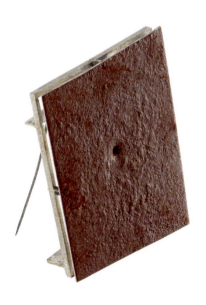

545

229

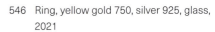

546 Ring, yellow gold 750, silver 925, glass, 2021
547 Brooch, yellow gold 750, glass, 2021

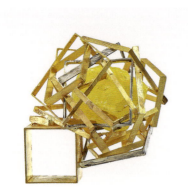

546

546

547

548 Ring, yellow gold 750, glass, 2021

548

548

549 Brooch, yellow gold 750, glass, gold leaf, 2020

549

Fred Jahn

Giampaolo Babetto's Drawings as Part of a Diverse Oeuvre

For all Giampaolo Babetto's fame as an artist, his drawings are not widely known. They were occasionally shown at early exhibitions of his work, where several of them were mounted at once, heedlessly, as it were, in a single frame, with their sketchiness emphasised, as if intended to provide extra instructive material. In any case, they were presented inconspicuously, even diffidently. Only later, when I had begun to go into Babetto's drawings in more depth, was my attention drawn by Rüdiger Joppien to an exhibition shown at the Kunstverein für die Rheinlande und Westfalen in Düsseldorf and the Museum für Kunst und Gewerbe in Hamburg in 1992–93. Featuring a Babetto drawing on the cover, the catalogue represents the first fairly generous selection of Babetto sketches and fully executed drawings with a direct bearing on his jewellery. Each of the three texts contributed to the catalogue by Rüdiger Joppien, Jiri Svestka and Suse Wassibauer explicitly points out the significance of the drawings for the conceptual clarification and design of the artist's work. Nonetheless, for some inexplicable reason

I disegni di Giampaolo Babetto come parte integrante della sua opera universale

Nonostante la fama dell'artista, i disegni di Giampaolo Babetto sono poco conosciuti. Nelle prime mostre era possibile trovarli occasionalmente, montati in gruppo in un'unica cornice, quasi con noncuranza, sottolineando il carattere di schizzo, e intesi a mo' di apparato didattico. In ogni caso, la loro era una presentazione timida, in sordina. Solo più tardi, quando mi stavo occupando in dettaglio dei disegni di Babetto, Rüdiger Joppien mi segnalò la mostra del 1992-93 al Kunstverein für die Rheinlande und Westfalen di Düsseldorf e al Museum für Kunst und Gewerbe di Amburgo. Il catalogo, la cui copertina mostra il dettaglio di un disegno, è il primo a presentare un numero sostanzioso di schizzi e tavole definitive direttamente connessi ai gioielli di Babetto. I tre contributi di Rüdiger Joppien, Jiri Svestka e Suse Wassibauer sottolineano ciascuno l'importanza dei disegni per il lavoro di ricerca sulle idee e sulle forme nell'opera dell'artista. Eppure, inspiegabilmente, tutto ciò è rimasto senza conseguenze per la ricezione dell'opera grafica di Giampaolo Babetto. E così per molto tempo mi furono noti solo alcuni schizzi, finché all'inizio del nuovo millennio chiesi a Babetto più espressamente se avesse sempre

Giampaolo Babettos Zeichnungen als Teil seines universellen Œuvres

Bei aller Berühmtheit des Künstlers sind Giampaolo Babettos Zeichnungen wenig bekannt. In seinen frühen Ausstellungen fand man sie gelegentlich ausgestellt, zu mehreren in einen Rahmen montiert, fast achtlos, den skizzenhaften Charakter betonend, quasi als didaktische Beigabe verstanden. Sie waren in jedem Falle unauffällig und schüchtern vorgetragen. Später erst, als ich mich ausführlich mit Babettos Zeichnungen beschäftigte, wurde ich von Rüdiger Joppien auf eine Ausstellung in den Jahren 1992/93 im Kunstverein für die Rheinlande und Westfalen in Düsseldorf und im Museum für Kunst und Gewerbe in Hamburg aufmerksam gemacht. Der Katalog, dessen Umschlag mit einem Ausschnitt einer Zeichnung gestaltet ist, bildet erstmals eine größere Anzahl von Skizzen und ausgeführten Zeichnungen in direkter Verbindung mit Babettos Schmuck ab. Die drei Textbeiträge von Rüdiger Joppien, Jiri Svestka und Suse Wassibauer betonen jeweils die Bedeutung der Zeichnungen für die konzeptionelle Klärung und Formfindung im Werk des Künstlers. Doch blieb dies unverständlicherweise für die Rezeption von Giampaolo Babettos zeichnerischem Werk ohne Folgen. So kannte ich lange Zeit nur ein paar Skizzen, bis ich Anfang der 2000er Jahre dann doch intensiver bei Babetto nachfragte, ob er denn schon immer und regelmäßig ge-

this approach to responding to Giampaolo Babetto's work was not further pursued. Hence, for a long time afterwards I was only familiar with a few sketches until I took the step of pointedly asking Babetto whether he had always drawn and, if he had done so, regularly, and whether he attached any significance of his own to his drawings.

In 2000 we showed Babetto's silver bowls, beakers and vases for the first time at our gallery. A friend of ours, Hermann Breulmann, a Jesuit father, was so taken with them that he begged me to ask the artist whether he might be interested in making liturgical vessels (*vasa sacra*) for celebrating the Eucharist for his rectory church at the time, St Michael's, the Jesuit church in Munich. Babetto was enthusiastic about the idea, and a large-scale, long-term project grew out of that commission, culminating in a magnificent monstrance that was consecrated in 2008. This protracted process entailed a lot of regular travel between Munich and Arquà Petrarca. That was also the time Babetto presented his extensive portfolios of drawings going back to 1965 – that is, the year before he took his diploma at the Instituto Statale d'Arte Pietro Selvatico in Padua at the age of eighteen. The portfolios varied in format and were recognisably from different periods of his career. The drawings lay loose and unsorted in the portfolios, some of

disegnato con regolarità, magari dando ai disegni un significato proprio.

Nel 2000 abbiamo esposto per la prima volta nella nostra galleria le ciotole d'argento, i calici e i vasi di Babetto. Un nostro amico, il padre gesuita Hermann Breulmann, ne rimase a tal punto affascinato che mi chiese di informarmi presso l'artista se fosse interessato a realizzare vasi liturgici (*vasa sacra*) per la chiesa gesuita di Sankt Michael a Monaco di Baviera, di cui egli era rettore. Babetto ne fu entusiasta e dalla commissione nacque un progetto ingente e di lunga durata che culminò nel magnifico ostensorio consacrato poi nel 2008. Durante quella fase ci fu un regolare andare e venire tra Monaco e Arquà Petrarca. Fu allora che Babetto mi mostrò il suo ampio

zeichnet und ob er seinen Zeichnungen auch eigene Bedeutung gegeben habe.

Im Jahr 2000 stellten wir in unserer Galerie zum ersten Mal Babettos Silberschalen, Becher und Vasen aus. Sie begeisterten unseren Freund, den Jesuitenpater Herman Breulmann derart, dass er mich bat, den Künstler zu fragen, ob er interessiert wäre, für die Jesuiten-Kirche St. Michael in München, deren Kirchenrektor er seinerzeit war, liturgische Gefäße (vasa sacra) für die Abendmahlsfeier zu fertigen. Babetto war begeistert, und

aus diesem Auftrag entwickelte sich dann ein großes, lang andauerndes Projekt bis hin zur großartigen Monstranz, die im Jahr 2008 geweiht wurde. Während dieses Prozesses gab es regelmäßigen Reiseverkehr zwischen München und Arquà Petrarca. Das war dann auch die Zeit, als mir Babetto seine umfangreichen Mappen mit Zeichnungen vorlegte. Sie reichten bis zurück in das Jahr 1965, also ein Jahr vor dem Diplom am Instituto Statale d'Arte „Pietro Selvatico" in Padua. Babetto war damals 18 Jahre alt.

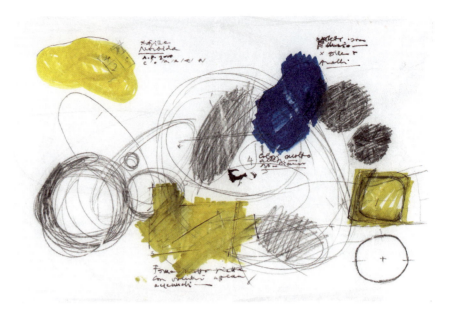

portfolio di disegni. Datavano fin dal 1965, e dunque fino all'anno precedente il suo diploma presso l'Istituto Statale d'Arte "Pietro Selvatico" di Padova. Babetto aveva all'epoca diciotto anni.
Le cartelle, di vari formati, risalivano chiaramente a periodi diversi. Al loro interno i disegni erano inseriti singolarmente, non ordinati, in parte accartocciati, senza cura apparente. Tuttavia notai subito che tutti i fogli erano firmati e datati sul davanti. La maggior parte di essi riportava inoltre il titolo o la denominazione degli oggetti illustrati, nonché, a partire dagli anni Ottanta, mostrava un timbro dello studio eseguito dall'artista stesso, con nome, indirizzo e numero di telefono. Come far conciliare tutto ciò?

In ogni caso, mi ritrovai impegnato per due giorni, prima a visionare il tutto e poi, come si è soliti fare in questi casi, a ordinare in maniera cronologica. Divenne subito chiaro che fino alla fine degli anni Ottanta il numero di schizzi eseguiti a partire da idee per pezzi di gioielleria è quello più corposo all'interno dell'intera produzione. I motivi sono concepiti a partire dal gioiello; lo stile del disegno, sebbene si tratti di figure geometriche, è quasi approssimativo, a testimoniare con quanta forza le idee spingano la mano a fare in fretta, per annotare gli elementi più importanti. Ma già sullo stesso foglio le intuizioni si sviluppano, variano, i corpi geometrici vengono fissati da vari punti di vista. Ne risulta che le idee vengono eseguite in una varietà di dettagli.

Die Mappen hatten verschiedene Formate und waren deutlich erkennbar unterschiedlichen Alters. Die Zeichnungen lagen lose, unsortiert, teilweise verknittert und scheinbar achtlos in den Mappen. Mir fiel aber auch schnell auf, dass alle Blätter signiert und datiert waren, und zwar auf der Vorderseite, und die meisten auch Titel oder Bezeichnungen der behandelten Gegenstände aufwiesen. Auch trugen seit den 1980er Jahren die meisten Zeichnungen einen vom Künstler entworfenen Atelierstempel, mit Namen, Adresse und Telefonnummer. Wie passt das zusammen? Jedenfalls war ich zwei Tage damit beschäftigt, erst einmal alles zu sichten und dann, wie man das eben so macht, in eine zeitliche Abfolge zu sortieren. Dabei wurde deutlich, dass die Anzahl der Ideenskizzen für Schmuckstücke die größte Gruppe im gesamten Schaffen bis Ende der 1980er Jahre darstellt. Die Motive sind vom Schmuck her gedacht, der Zeichenstil ist, obwohl er geometrische Figuren behandelt, fast flüchtig. Er zeigt, wie stark die Ideen die Hand zur Eile drängen, damit das Wich-

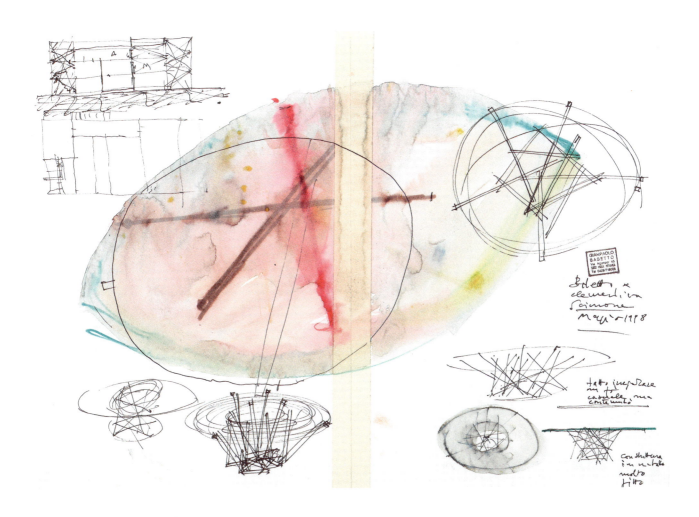

tigste notiert wird. Aber schon auf den gleichen Blättern werden die Einfälle ausgefaltet, variiert, unterschiedliche Ansichten der geometrischen Körper festgehalten. Es findet also eine Ausführung dieser Ideen in vielfältigen Details statt. Es ist auch festzuhalten, dass schon in den frühen Zeichnungen durch Kolorierung mit Aquarellfarben, Buntstiften, Ölkreiden, verriebenen reinen Pigmenten und durch Collagen eine eigenständige künstlerische Aussage gewollt und eine starke bildhafte Wirkung angestrebt ist.

them even crumpled and seemingly carelessly stowed away. But it didn't take long for me to notice that all sheets had been signed and dated, and most of them also had titles or captions relating to the objects depicted. Most drawings done since the 1980s also bore a studio stamp designed by the artist with his name, address and telephone number. How to explain the discrepancy?

In any case, I spent two days looking through everything first and then, as you do, sorting the sheets chronologically. Doing that I became aware that up to the end of the 1980s the conceptual sketches for jewellery represented the numerically largest group in the entire body of drawings. The motifs had been conceived for jewellery, and the style of drawing is almost cursory although it is applied to geometric figurations. It shows how forcefully ideas urge the hand to haste so that the most important aspect is jotted down. But on the same sheets the ideas are expanded on and varied to capture different views of the geometric solids. All this means that these ideas are executed in intricate detail. It is also noticeable that, even in the early drawings, colouring with watercolours, coloured pencils, oil pastel sticks and whisked pure pigments as well as using collages indicates that an autonomous aesthetic statement was desired and a strongly pictorial

Va inoltre notato che sin dai primi disegni l'intento è quello di una dichiarazione artistica a se stante, come risulta dalla scelta di colorare, con acquerelli, matite colorate, pastelli a olio, pigmenti puri sfregati, o realizzare collage, nel desiderio di ottenere un forte effetto pittorico. Muovendo da idee scultoree quali "motivi" tratti da un répertoire personale, si sviluppa un inconfondibile stile grafico che fino a oggi è rimasto fedele a se stesso e che riflette l'ampia panoramica di temi dell'intera produzione dell'artista. In questo senso, i disegni di Giampaolo Babetto si differenziano dai classici disegni di uno scultore, ma anche dai disegni preparatori del minimalismo americano, che negli anni Sessanta introdussero una nuova tipologia di disegno. Ma dunque, è possibile

Brooch "Da Pontormo", yellow gold 750, 1990

Ausgehend von plastischen Ideen als „Motive" eigener Referenz, entwickelt sich ein unverwechselbarer Zeichnungsstil, der bis heute seine Handschrift beibehält und die vielfältigen Themen des gesamten Schaffens von Babetto umsetzt. Hierin unterscheiden sich Giampaolo Babettos Zeichnungen von klassischen Bildhauerzeichnungen, aber auch von den Working-Drawings der amerikanischen Minimal Art, welche in den 1960er Jahren einen neuartigen Zeichnungstypus einführten. Sind Babettos Zeichnungen nun Goldschmiede-Zeichnungen? Gibt es so etwas heute? Babetto ist ja auch Designer, entwirft Möbel, hat Architektur-Projekte realisiert. Es ist heute nicht üblich, dass Künstler vor allem solche mit großen Karrieren, in unterschiedlichen Disziplinen Gleichwertiges schaffen. Doch war das ja eigentlich Tradition, zumal in Italien, wo seit Jahrhunderten Maler Kirchen gebaut, Goldschmiede Skulpturen gegossen, Architekten gemalt haben und ein jeder von ihnen gezeichnet hat. Ab den späten 1980er Jahren beginnt Giampaolo Babetto das große Projekt „Da Pontormo". Zeichnend exzerpiert er aus Jacopo da Pontormos Fresken (z. B. Sommervilla der Medici in Poggio a Caiano), aber auch aus Gemälden (Kreuzabnahme Christi, Santa Felicità, Florenz) Figuren, Szenen, Blätter und unscheinbare Details, die er mit scharfer Kontur versieht und deren Binnenformen er zu einer homogenen Fläche werden lässt. Erstaunlicherweise sieht man in der Zeichnung bereits die fertige Brosche, so klar ist alles in diesem Zyklus angelegt. Ein Prozess kurzer Übertragungswege.

effect intended. Starting with sculptural ideas as 'motifs' for his own reference, Babetto developed an inimitable style of drawing which has remained his signature to the present day and realises the entire range of diverse subjects addressed in his oeuvre. In this respect, Giampaolo Babetto's drawings differ from classic sculptor drawings as well as the working drawings of American Minimal Art, which introduced a novel type of drawing in the 1960s. So are Babetto's drawings goldsmith's drawings? Does anything of that kind even exist nowadays? Babetto is, after all, also a designer: he designs furniture and has realised architecture projects. Nowadays it isn't usual for artists, especially ones with stellar careers, to produce work of the same high standard in a wide range of disciplines. Still, that was traditional, particularly in Italy, where painters have been building churches, goldsmiths have cast sculpture and architects have painted for centuries – and every one of them has done drawings.

In the late 1980s Giampaolo Babetto embarked on *Da Pontormo* [After Pontormo]. In drawings he made excerpts from Jacopo da Pontormo's frescoes (for instance, the Medici summer villa in Poggio a Caiano) and also paintings (the *Deposition from the Cross*, Santa Felicità, Florence): figures, scenes, sheets and inconspicuous details that he provided with crisp

intendere i disegni di Babetto come disegni da orafo? Esistono loro simili al giorno d'oggi? Va detto che Babetto è anche un designer, progetta mobili e ha realizzato progetti architettonici. È cosa insolita, oggi, che gli artisti, specie se di fama, raggiungano gli stessi livelli in varie discipline. In realtà, questo era ciò che accadeva tradizionalmente, soprattutto in Italia, dove per secoli i pittori hanno costruito chiese, gli orafi fuso sculture, gli architetti dipinto e tutti hanno disegnato.

Dalla fine degli anni Ottanta, Giampaolo Babetto dà avvio al grande progetto "Da Pontormo". Dagli affreschi del Pontormo (come quelli della villa medicea di Poggio a Caiano) e dai dipinti (*Deposizione*, Santa Felicita, Firenze), il maestro attinge figure, scene, foglie e dettagli poco appariscenti, e lo fa disegnando, rendendoli con un contorno netto e trasformando i singoli particolari che li costituiscono in superficie omogenea. Sorprendentemente, nel disegno risulta già chiara la spilla che ne deriverà – in questo ciclo è tutto definito, il procedimento caratterizzato da passaggi brevi.

In seguito alla realizzazione delle opere sacre l'artista inizia a esplorare la forma della croce. Qui il disegno è di nuovo alla ricerca della forma. Sul principio muovendosi a tentoni, e con interrogativi, si fa gradualmente più sicuro e dinamico. Qui è evidente tutta la forza cromatica dei pigmenti che Babetto usa per i gioielli. In questo gruppo di lavori risulta chiaro anche negli oggetti realizzati quanto sia fluido il passaggio dal gioiello all'oggetto.

Im Zuge seiner sakralen Werke hat der Künstler begonnen, sich mit der Form des Kreuzes zu befassen. Hier ist die Zeichnung wieder auf der Suche nach der Form. Anfänglich tastend und mit großen Fragen auf den Weg gemacht, wird sie sicherer und zupackender. Es erscheint hier die starke Farbigkeit der Pigmente, wie sie Babetto für seinen Schmuck verwendet. In dieser Werkgruppe ist auch bei den ausgeführten Gegenständen ein fließender Übergang vom Schmuck zum Objekt zu bemerken.

In Giampaolo Babettos großer Retrospektive „Inspirazioni" 2013 im Museo Diocesano di Padova (Diözesan Museum Padua), die von ihm zusammen mit dem Direktor Andrea Nante gestaltet wurde, hatten die Zeichnungen neben den Werkbereichen Schmuck, liturgische Gerätschaften und Objekte, sowie Architektur – verwirklicht hier in der Gestaltung der Ausstellungsräume – erstmals in einem Museum einen imposanten Auftritt. Eine reine Zeichnungen-Ausstellung, begleitet von einem kleinen Katalog, gab es bisher

contours while turning the forms within them into homogeneous surfaces. Astonishingly, such is the immediacy of all the drawings in this cycle that a finished brooch can already be seen in the drawing. A transcription process that abridges the transmission path.

While engaged in sacral works, the artist began to investigate the form of the Cross. Here drawing is once again in the pursuit of form. Initially tentative and with a big question mark hanging over it, the drawing becomes more assured and immediate. This is where the vibrant colouration of the pigments as Babetto uses them for his jewellery emerges. In this group of works, a fluid transition from jewellery to object can also be observed in the pieces as executed.

In *Inspirazioni*, the grand 2013 Giampaolo Babetto retrospective mounted at the Museo Diocesano di Padova and co-designed by Babetto and Andrea Nante, director of the museum, the drawings made their first commanding entrance in a museum alongside the disciplines of jewellery, liturgical vessels and objects as well as architecture, which was realised in the design of the exhibition spaces. In 2014 our drawings gallery in Munich mounted the only show devoted before or since exclusively to his drawings. This body of drawings has, however, the potential for making a far greater impact.

Nella grande retrospettiva sull'opera di Giampaolo Babetto intitolata *Ispirazioni*, che è stata realizzata nel 2013 presso il Museo Diocesano di Padova e progettata insieme al direttore Andrea Nante, i disegni sono stati presentati in un museo per la prima volta in maniera solenne accanto alle sezioni dedicate ai gioielli, agli oggetti liturgici e all'architettura – qui presente sotto forma di design delle sale espositive. Una mostra interamente dedicata ai disegni, accompagnata da un piccolo catalogo, si è tenuta in precedenza solo nel 2014 presso la nostra galleria di disegni a Monaco. Tuttavia, l'insieme dei disegni di Giampaolo Babetto ha tutto il potenziale per una presentazione ben più ampia.

nur 2014 in unserer Zeichnungsgalerie in München. Der Fundus von Giampaolo Babettos Zeichnungen hat jedoch das Potenzial für einen größeren Auftritt.

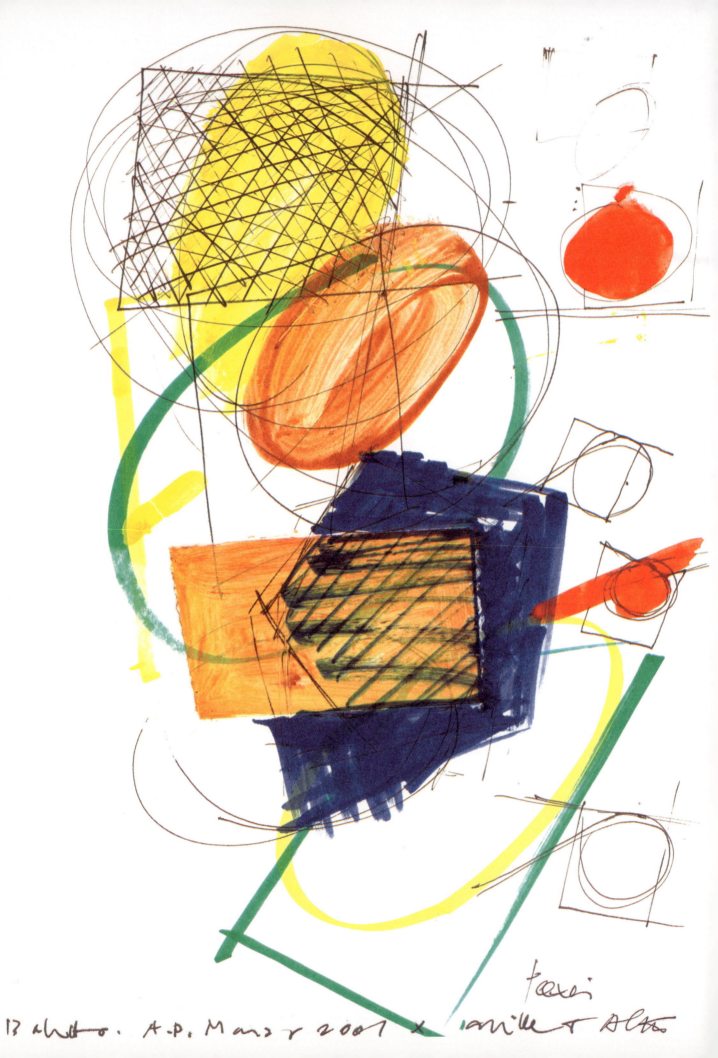

Drawings
Disegni
Zeichnungen

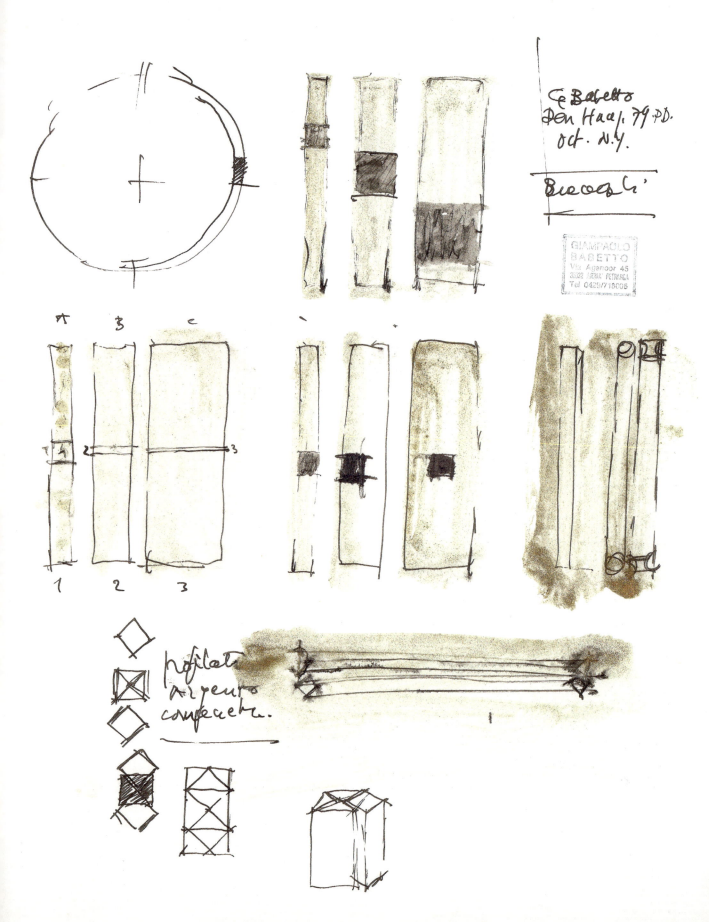

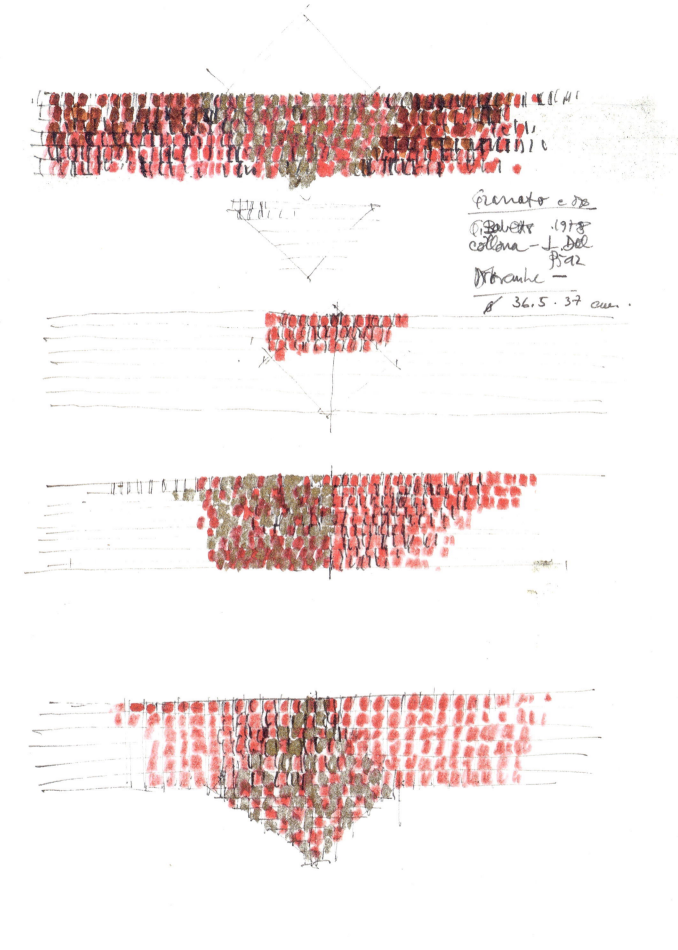

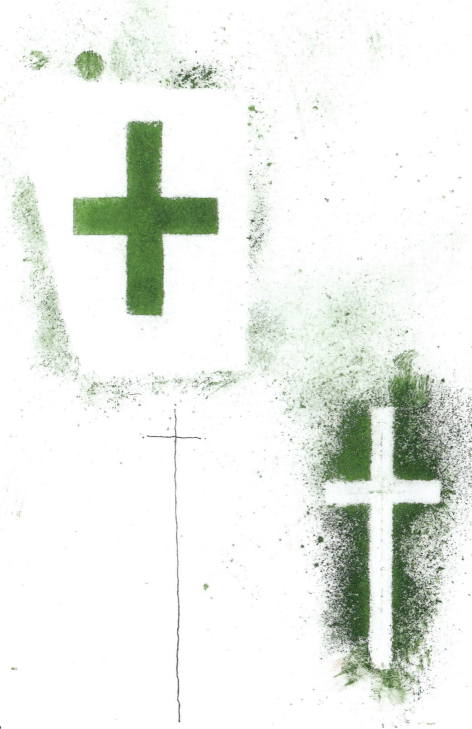

Buletto 'Croci
S8D. 2009
A. Pet.

Silver
Argenti
Silber

550 Vases and bowl, silver 925, 2015/2019

551 Vase, silver 925, 2005

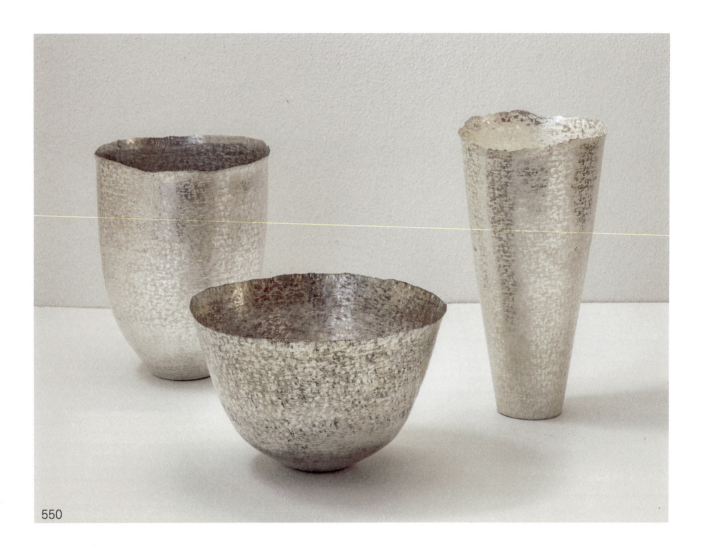

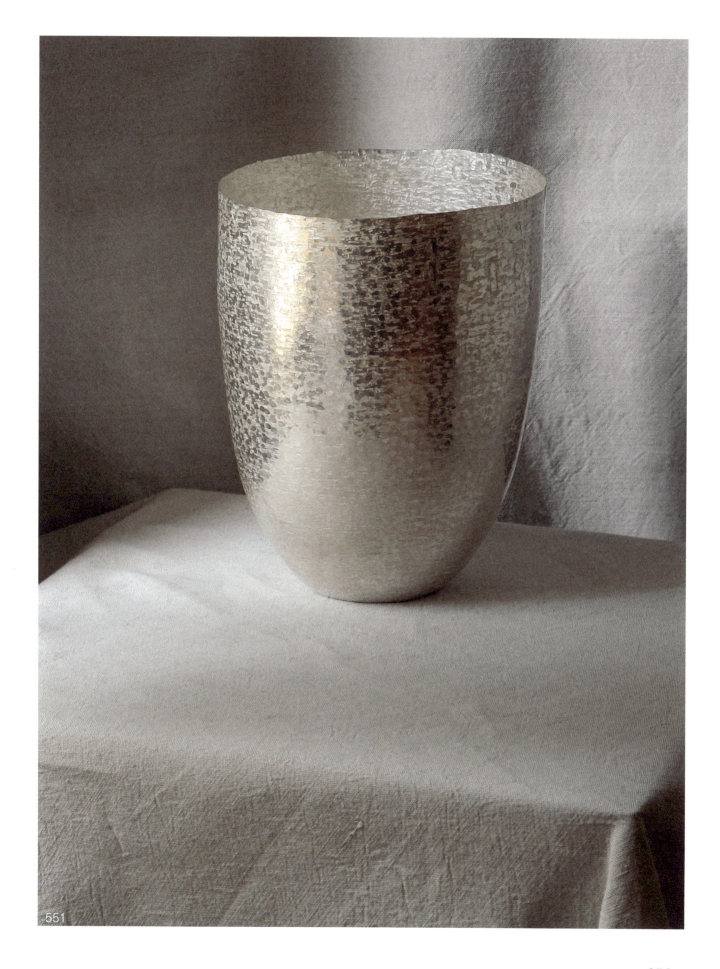
551

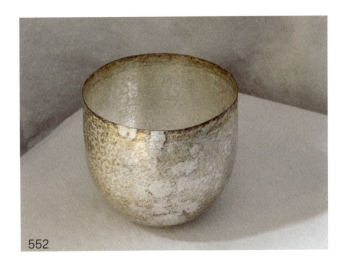
552

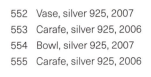

552 Vase, silver 925, 2007
553 Carafe, silver 925, 2006
554 Bowl, silver 925, 2007
555 Carafe, silver 925, 2006

556 Vase, silver 925, 2004

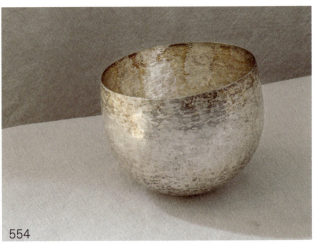
554

553

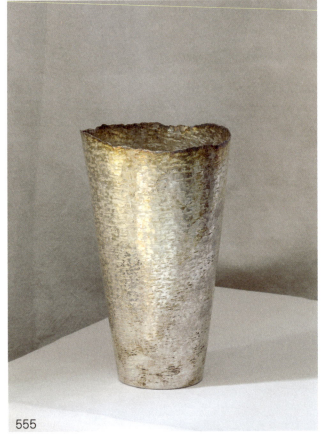
555

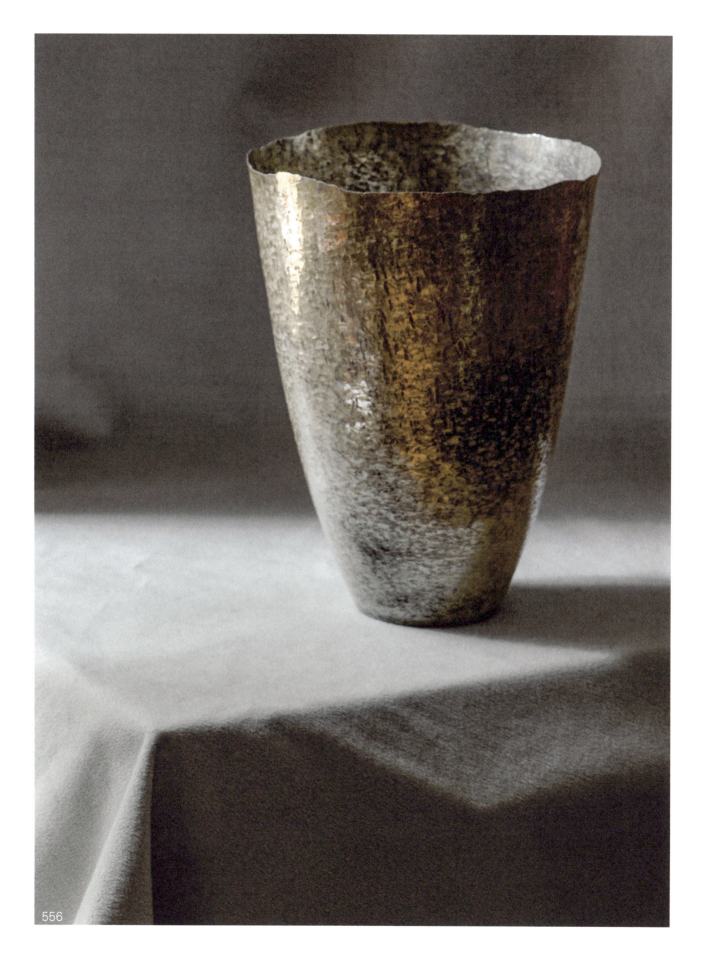

557 Bowl, silver 925, 2005
558 Bowl, silver 925, 2005

559 Candle holders, silver 925, 2004

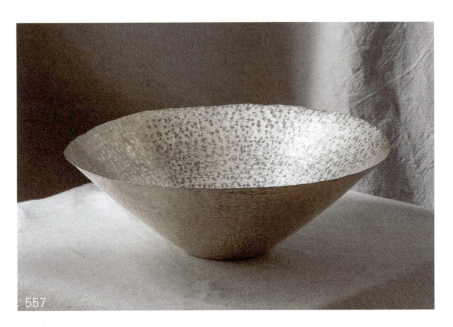

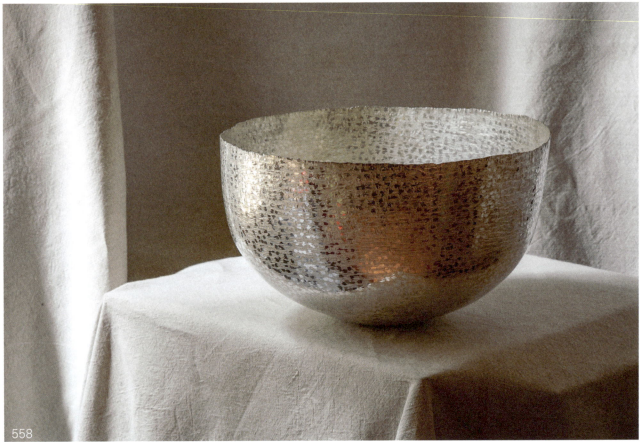

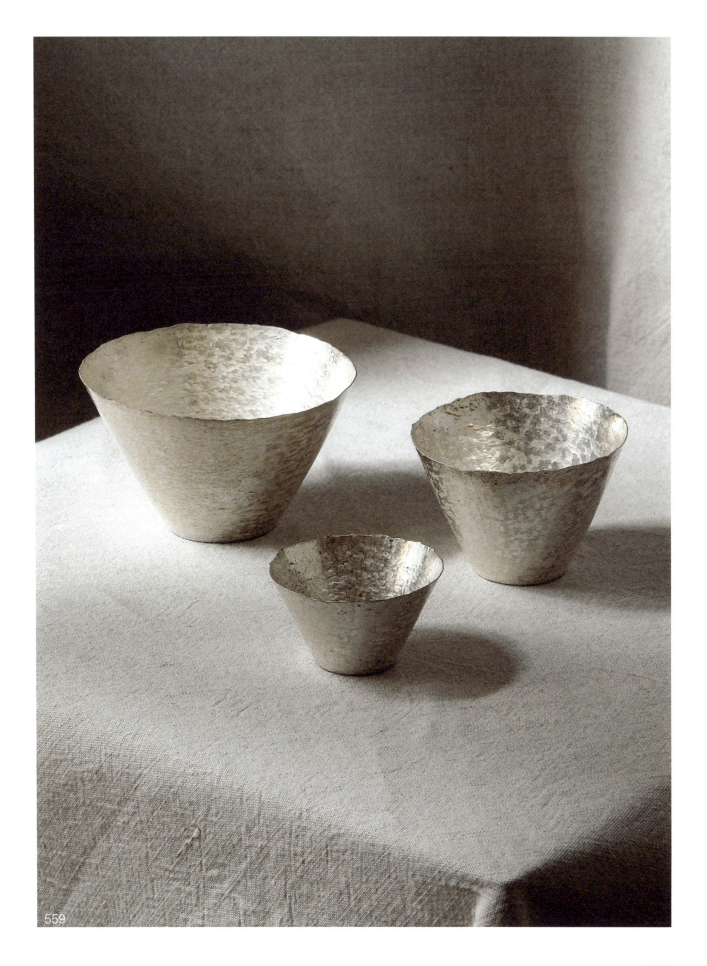

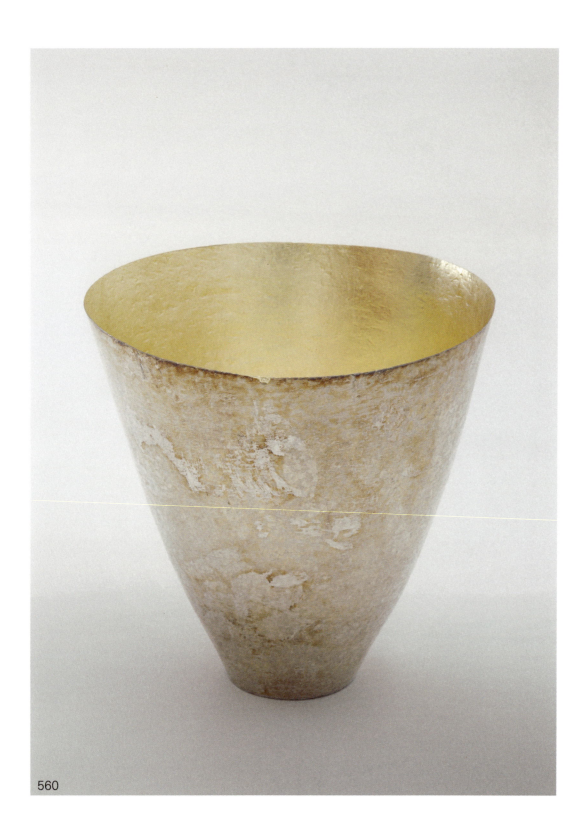

560 Vase, silver 925, gilding, 2015

561 Bowl, silver 925, gilding, 2009
562 Bowl, silver 925, gilding, 2009

Next page:
563 Bowls Set, silver 925, wooden base, 2004

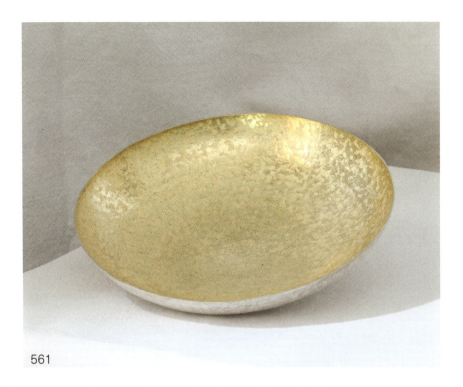
561

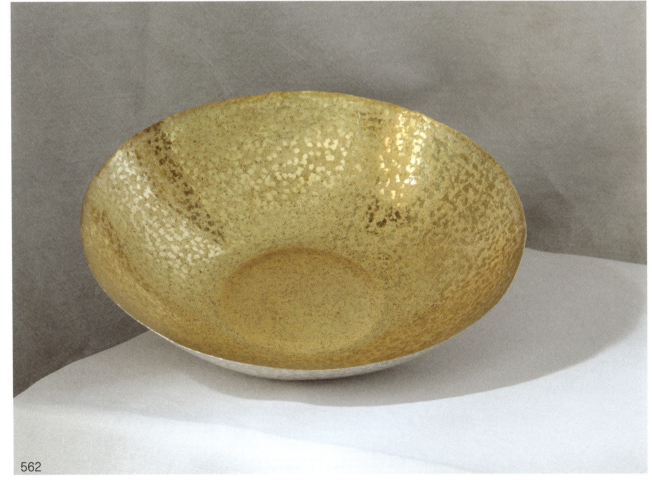
562

259

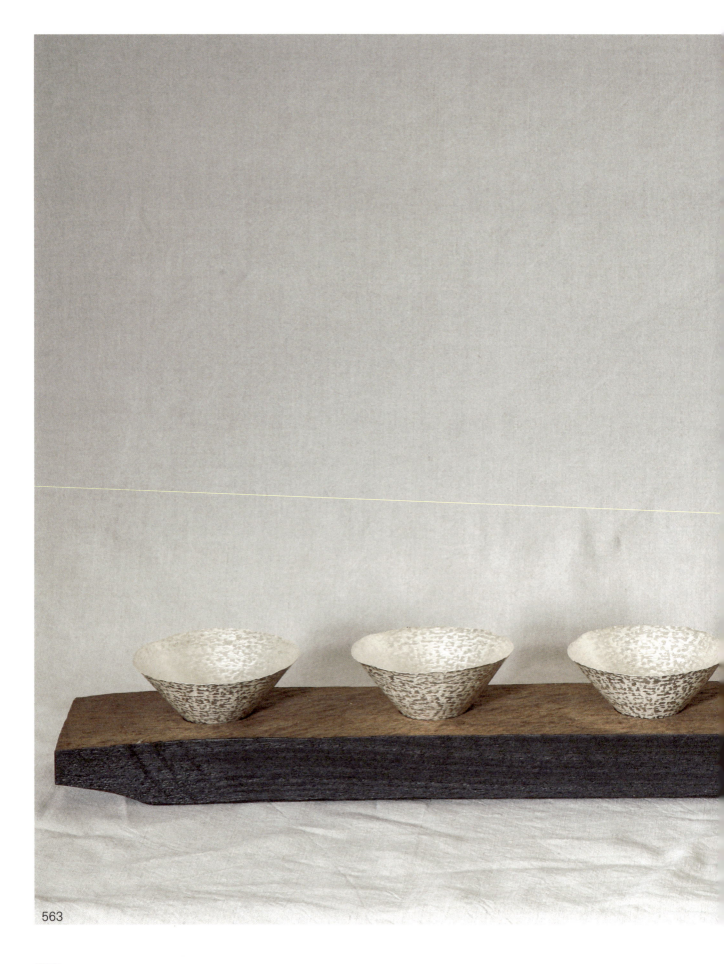
563

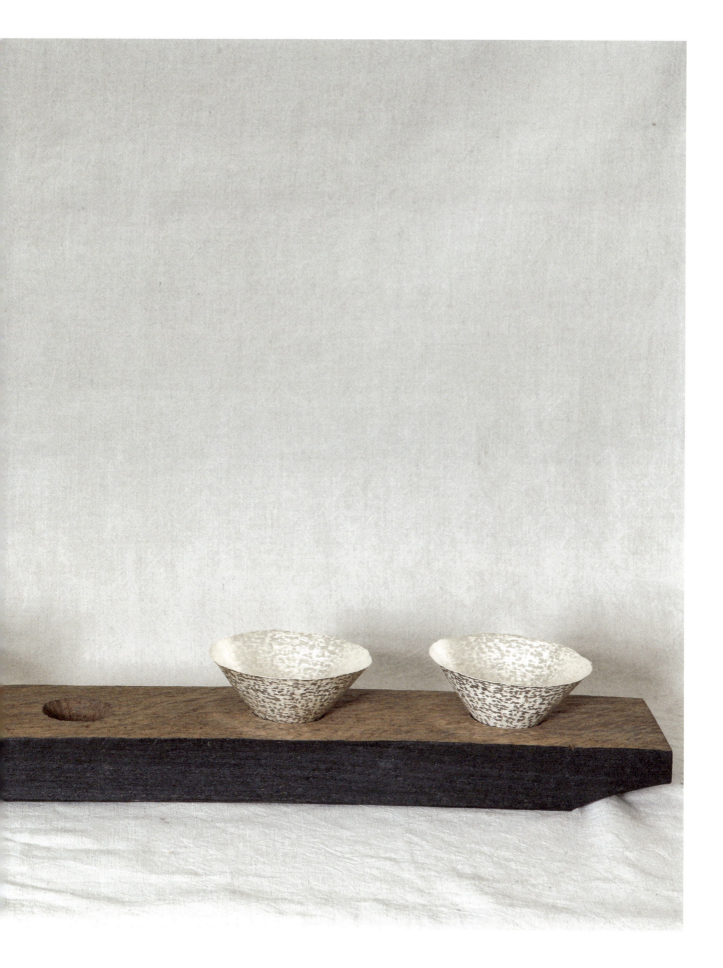

564 Sugar bowl and spoon, silver 925, wooden base, 2004

565 Sugar bowl and spoon, silver 925, gilding, bois de rose base, 2008

566 Sugar bowl and spoon, silver 925, gilding, wooden base, 2009

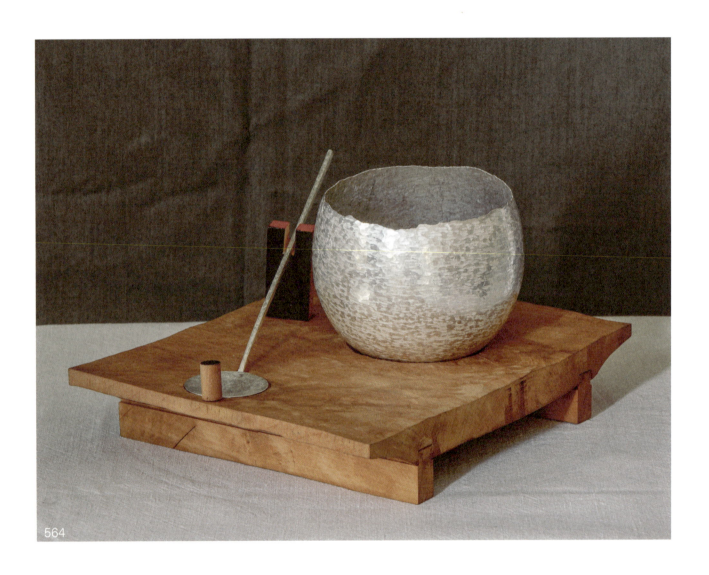

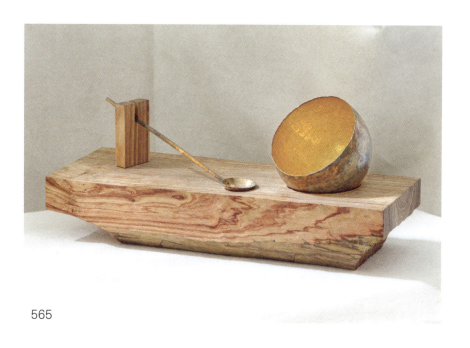

565

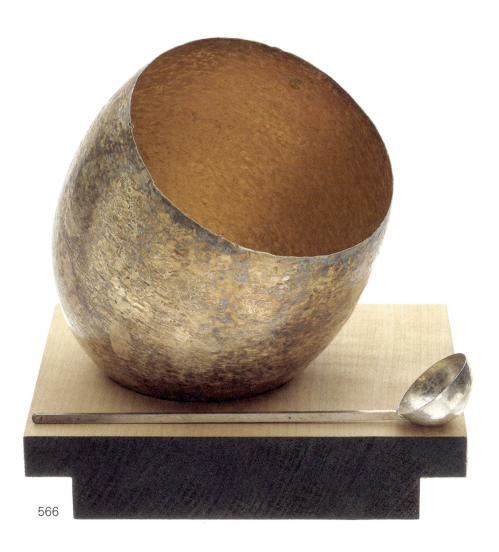

566

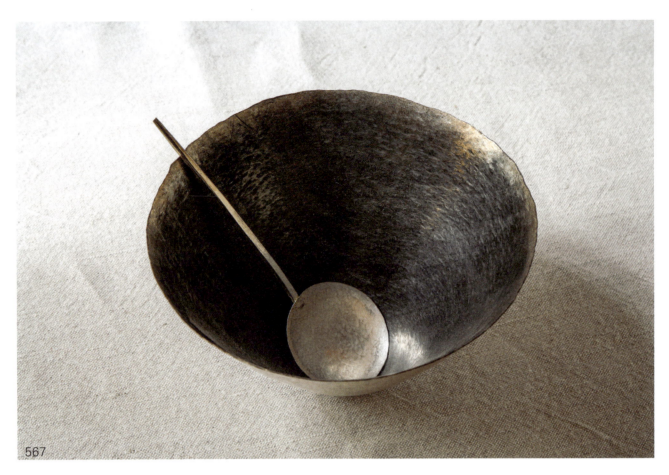
567

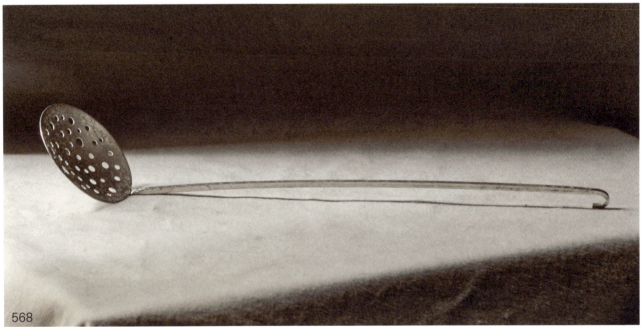
568

567 Bowl with spoon, silver 925, 2004
568 Skimmer, silver 925, 2004

569 Salad Serving Set, silver 925, 2004
570 Ladle, silver 925, 2004

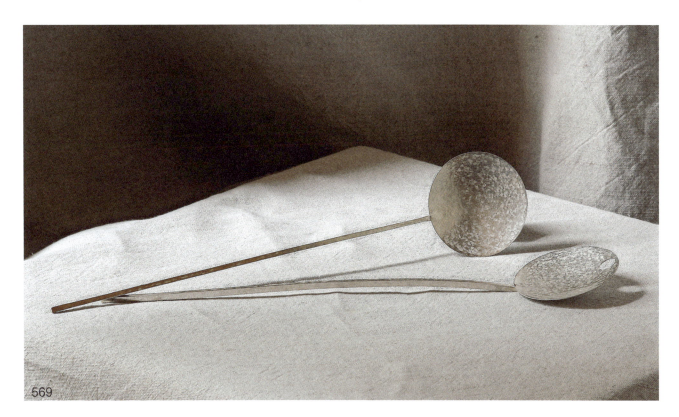

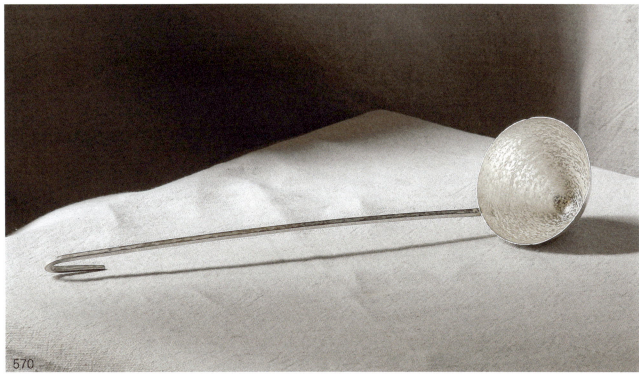

571–573 Door handles, silver 925, 2017
574 Bowl, silver 925, 2013

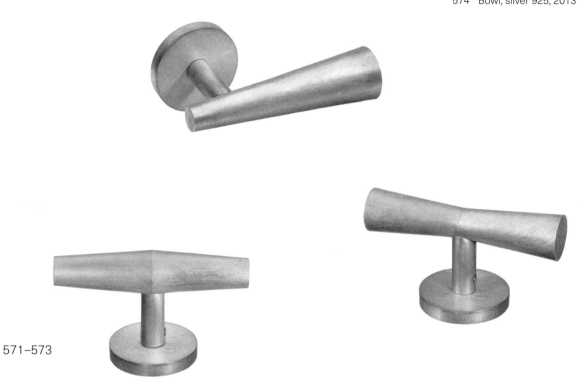

571–573

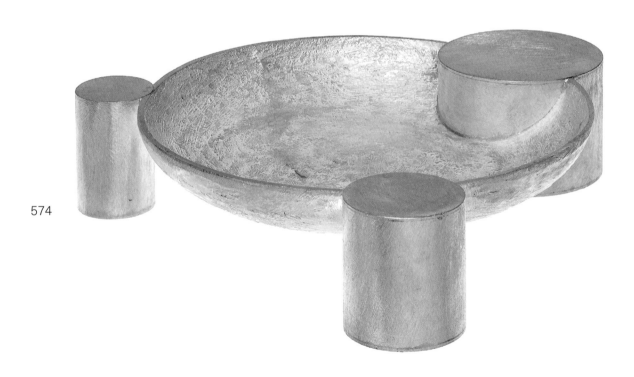

574

575 "Foundamentals", table set, silver 925, for Doppia Firma, with Sudio Swine, 2018

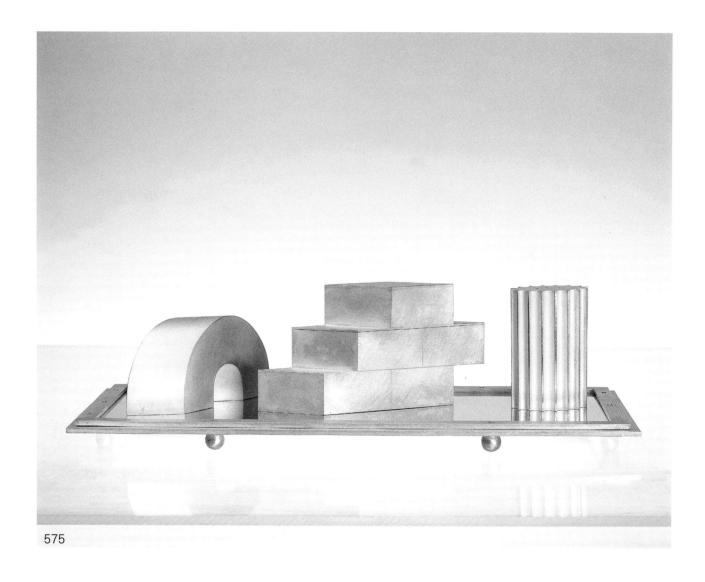

575

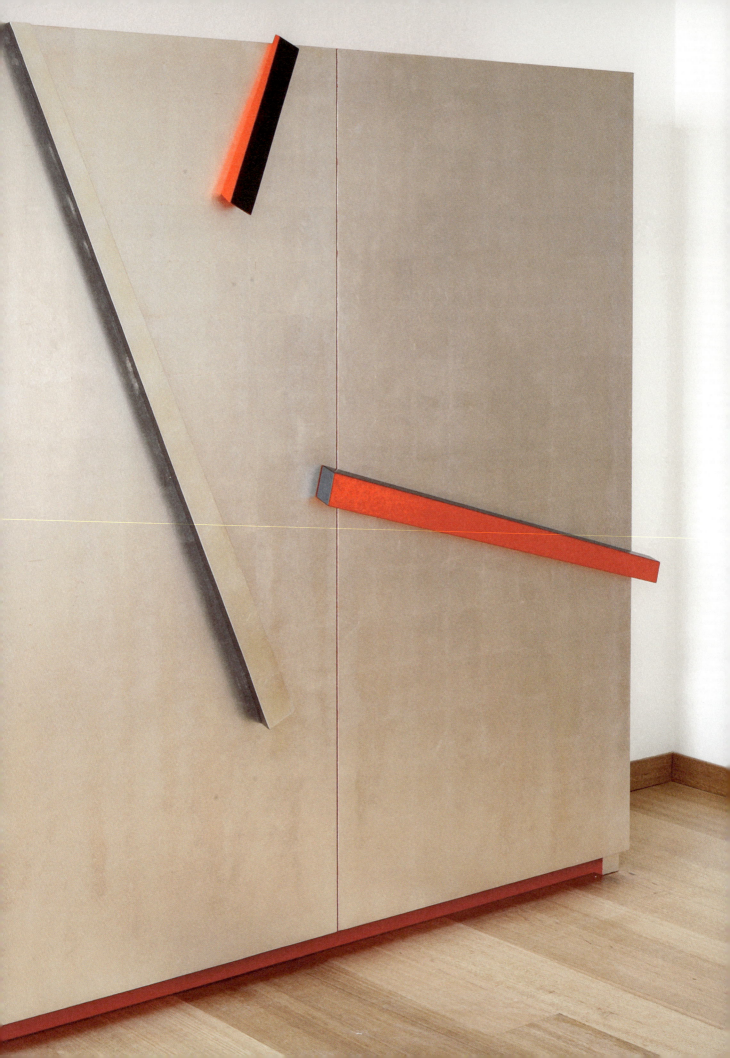

Furniture
Mobili
Möbel

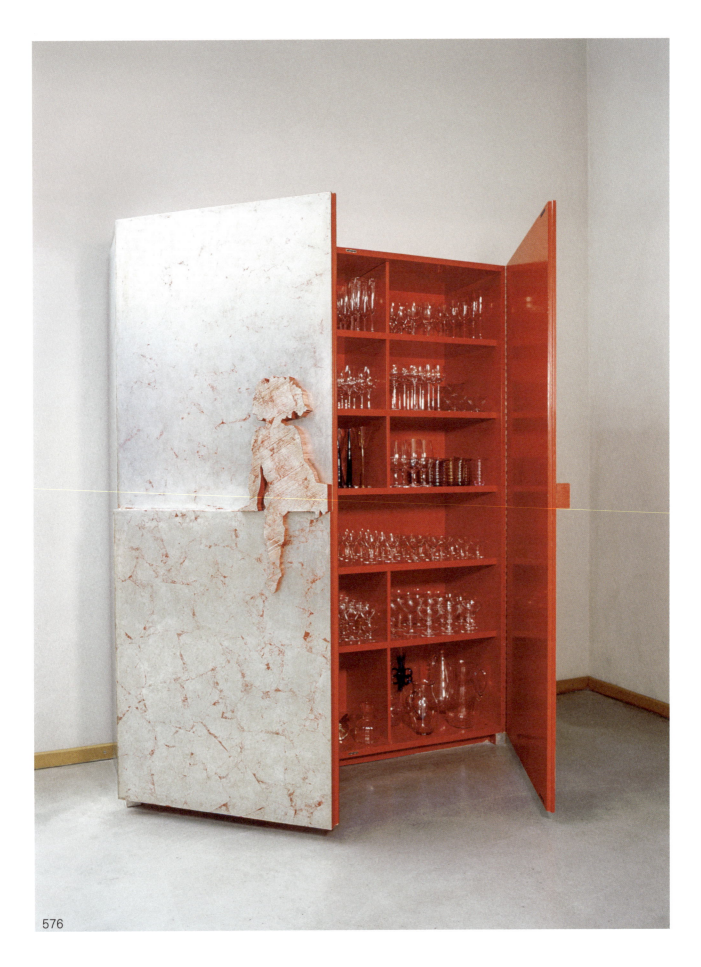
576

576 Cupboard, "Da Pontormo", lacquered wood, silver leaf, 1991
577 Cupboard, lacquered wood, silver leaf, 2003

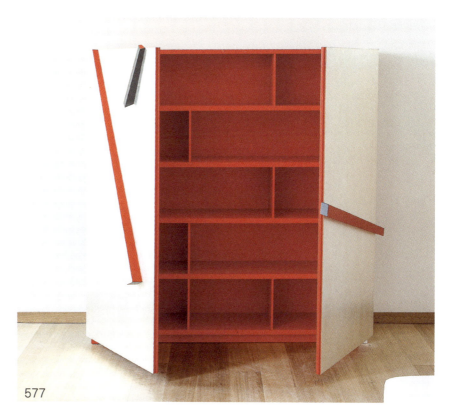

577

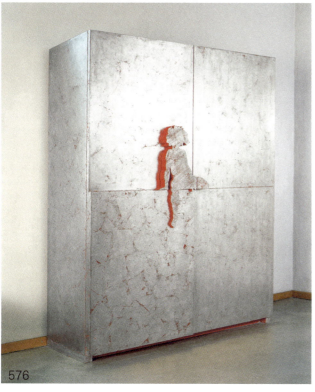

576

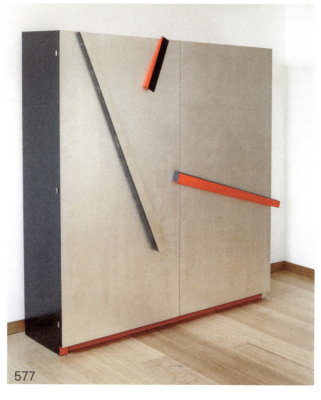

577

578 Divans, leather, 2002

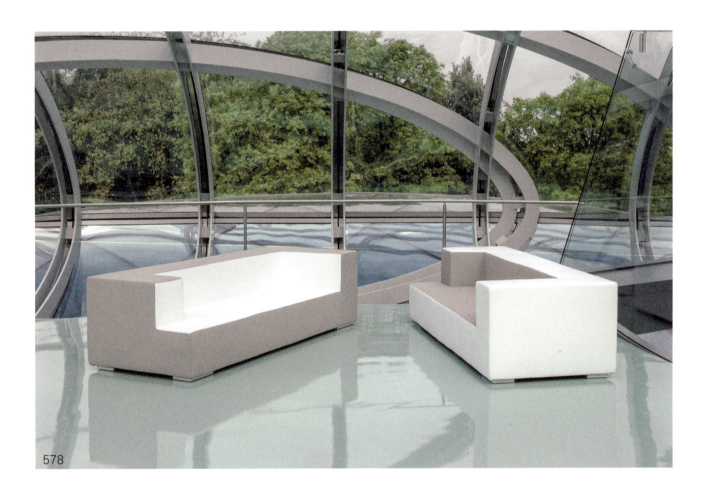

579 Divan, stainless steel, leather, 2002
580 Divan, stainless steel, leather, 2002

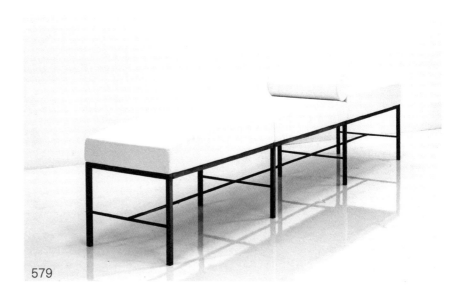

579

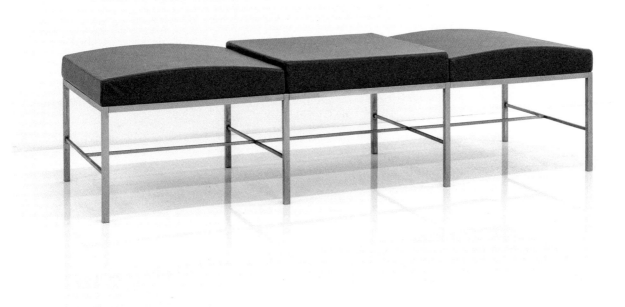

580

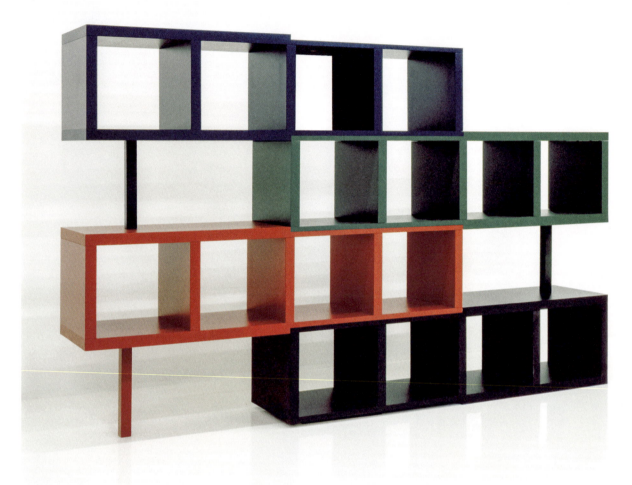

581

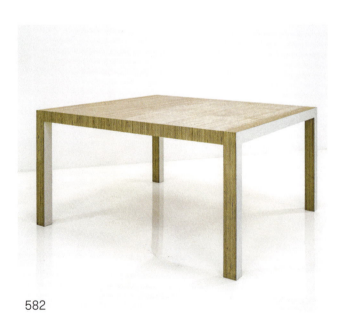

582

581 Bookshelf, lacquered wood, 2001
582 Table, multilayered and laminated wood, 2001

583 Table, laminated, 2007
584 Cabinet, lacquered wood, 2003

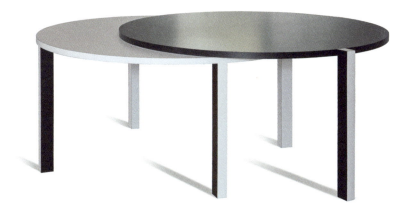

583

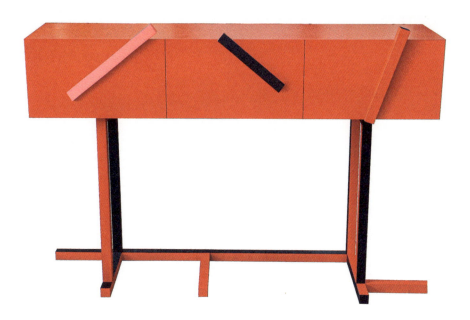

584

585 Table, colored ash wood, methacrylate, 1998
586 Table, colored ash wood, methacrylate, 1998

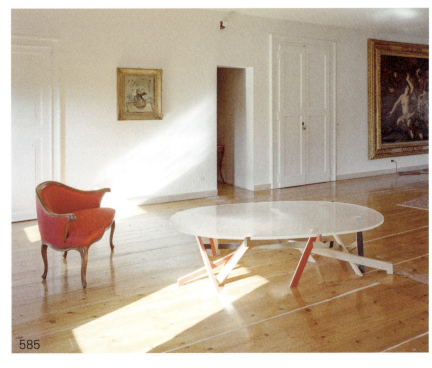

587 Table, ash wood, 1991
588 Table, wood, glass, 2002

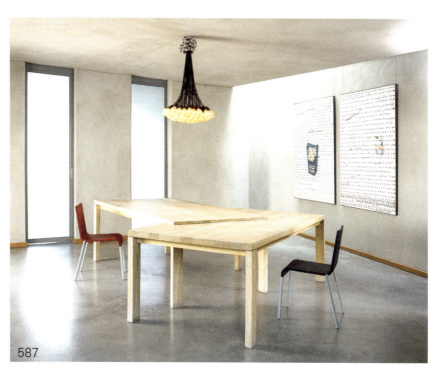

587

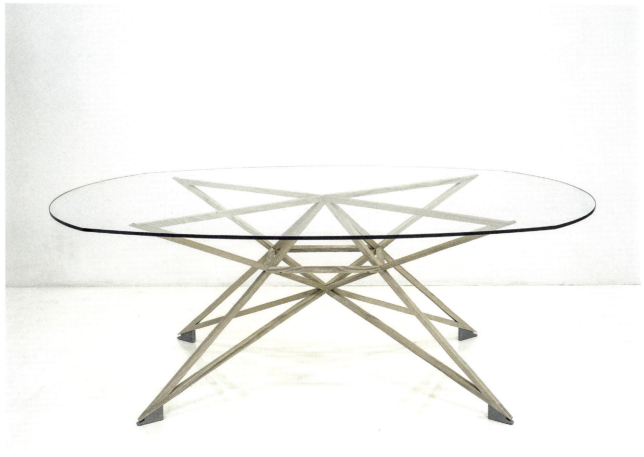

588

589 Table, stainless steel, teak wood, 2002
590 Table, cherry wood, 1991
591 Table, cherry wood and laminate, 1996

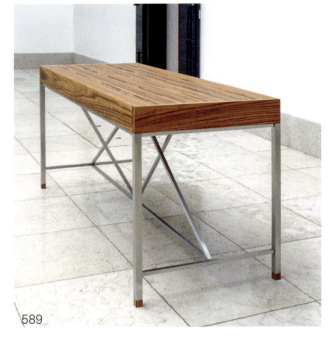

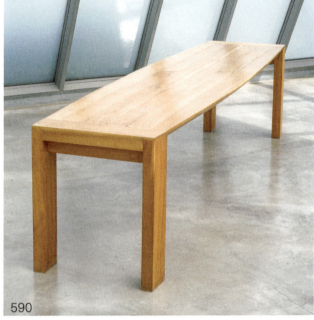

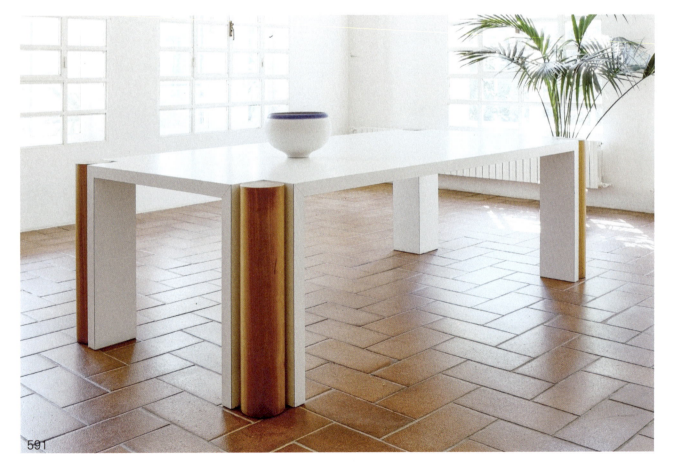

592 Table, laminated, 2000
593 Table, colored ash wood, 2021

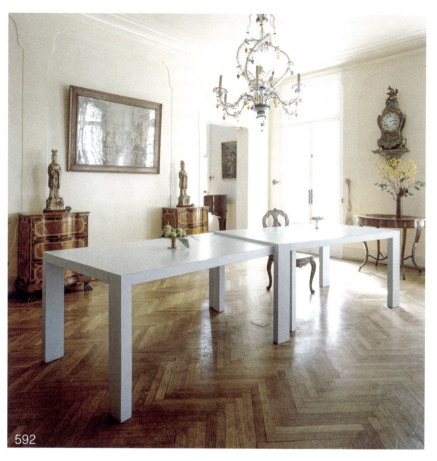

592

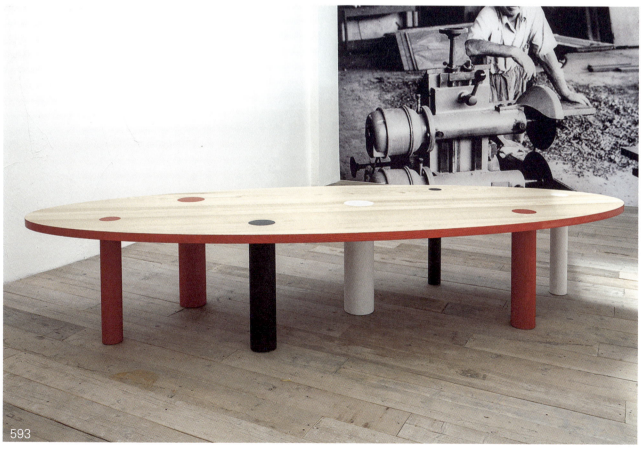

593

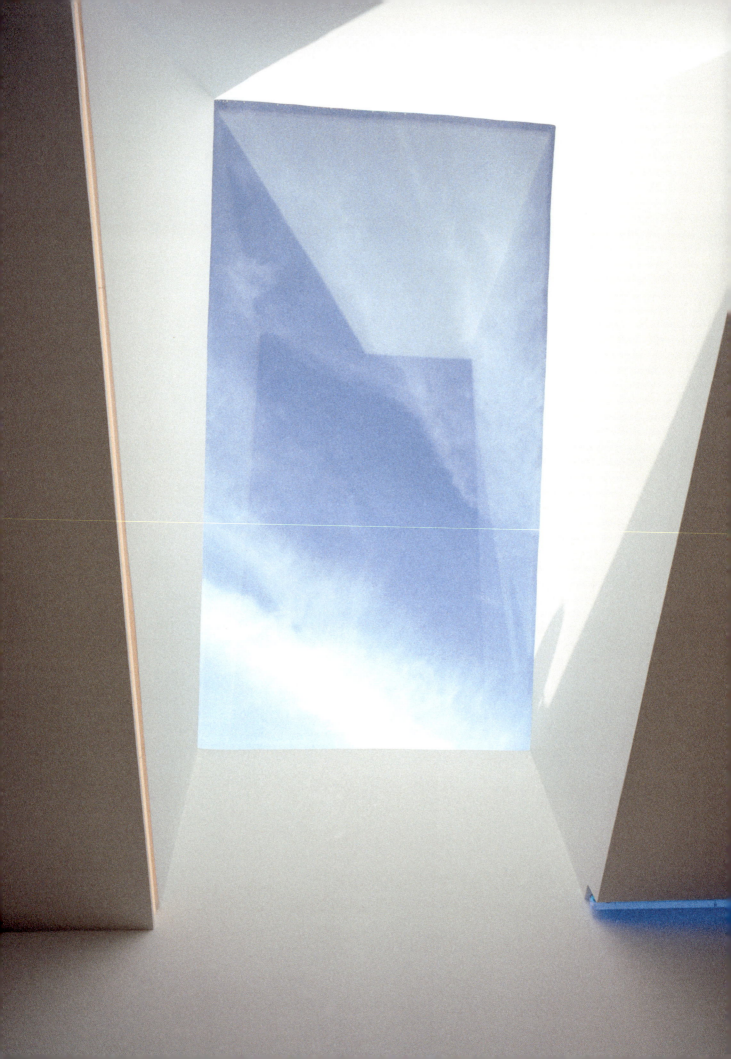

Architecture
Architetture
Architektur

594 Stairwell lights, Padova, 1998
595 Staircase, Padova, 1997

596 Murals, Bassano del Grappa, 2000
 Bathroom, Bassano del Grappa, 2000

596

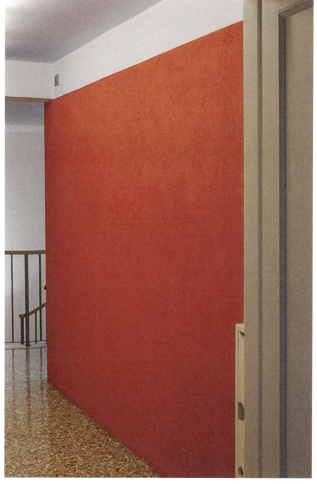

596

 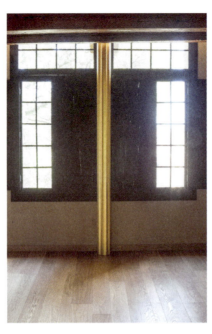

597 Column, gold leaf, Arquà Petrarca, 2020
Staircase, Arquà Petrarca, 2020
Door, methacrylate and steel, Arquà Petrarca, 2000

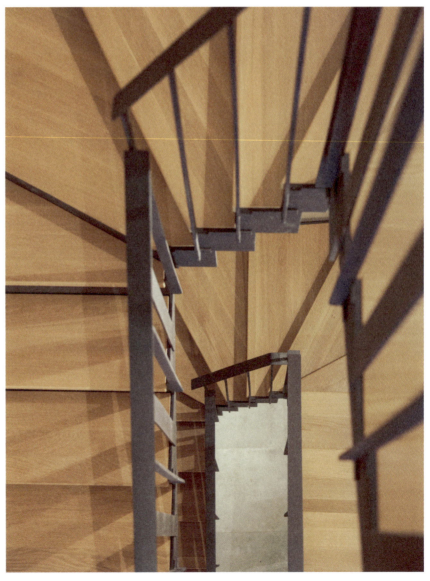

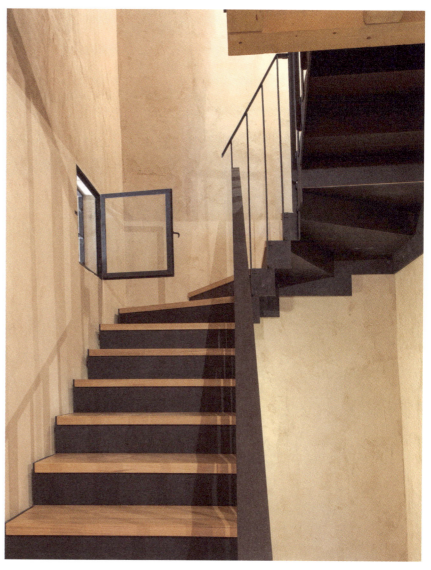
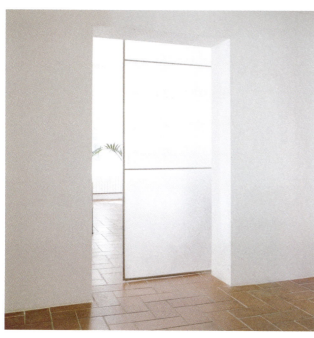

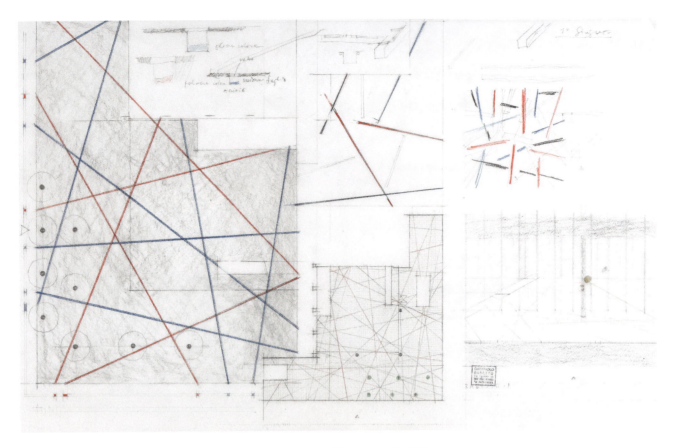
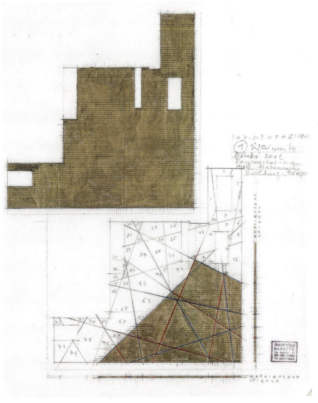

598 Marunouchi Building, Mitsubishi Estate
Co. Ltd., Tokyo, sketches, 2002

Marunouchi Building, Mitsubishi Estate
Co. Ltd., Tokyo, 2002
Marunouchi Building, Mitsubishi Estate
Co. Ltd., Tokyo, floor detail, 2002

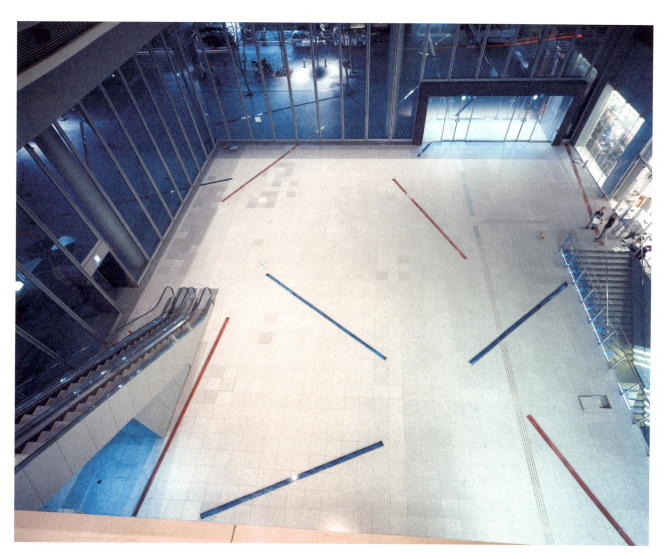

599 Nardini Pavilion, Bassano del Grappa, 2012

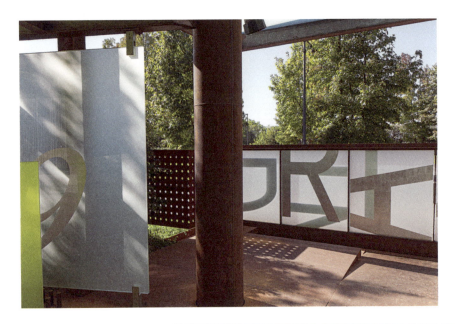

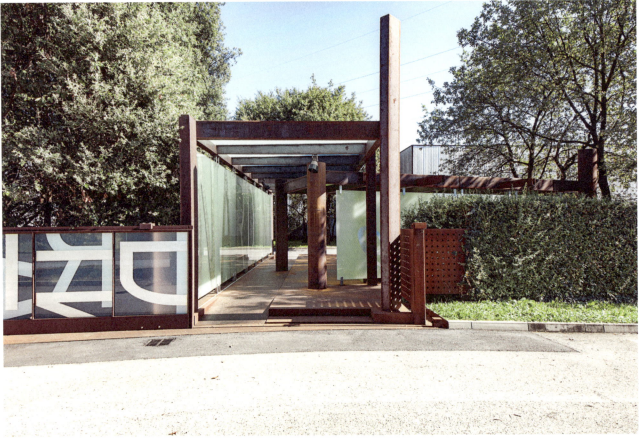

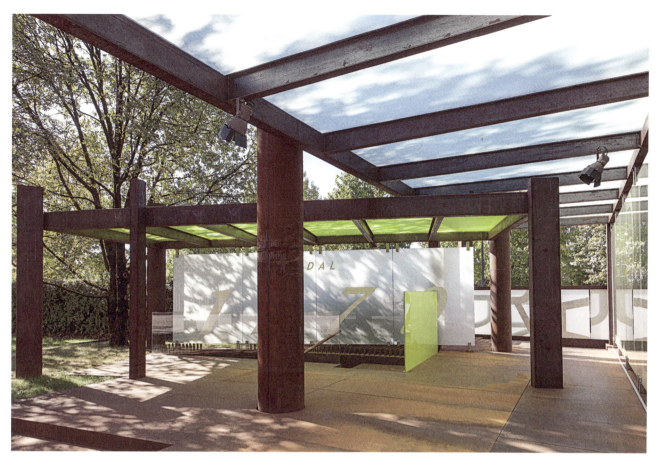
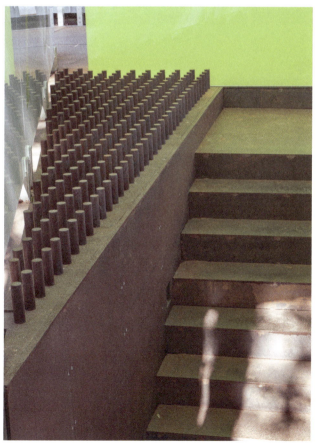

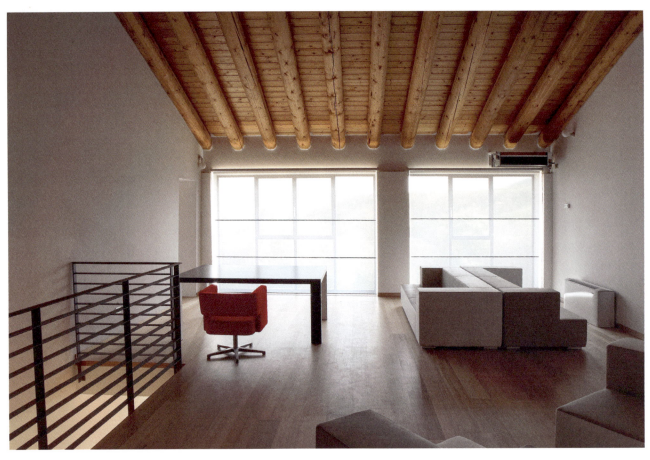

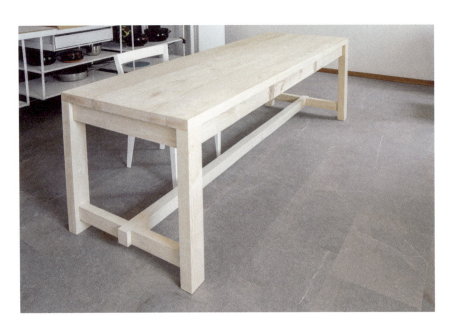

600 Room – railing, furniture, Arquà Petrarca, 2006

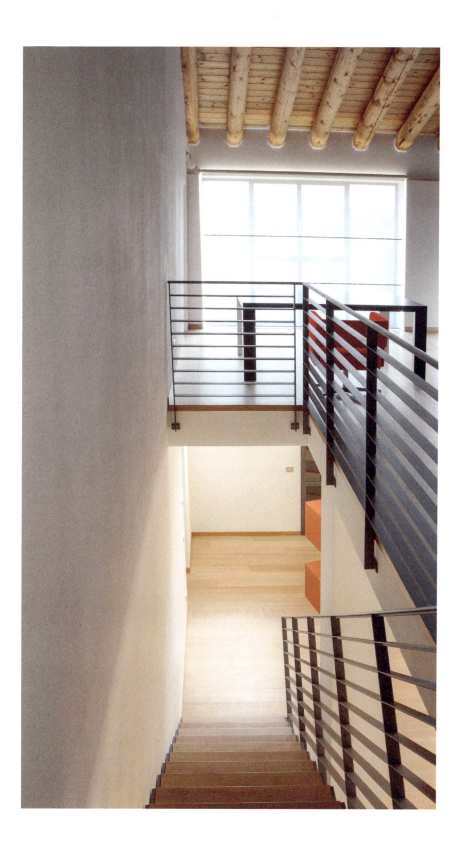

More Works
Altre Opere
Weitere Werke

601 Silver casting 925, 2013
602 Silver casting 925, 2013
603 Sculpture, iron wire, pigment, 2016

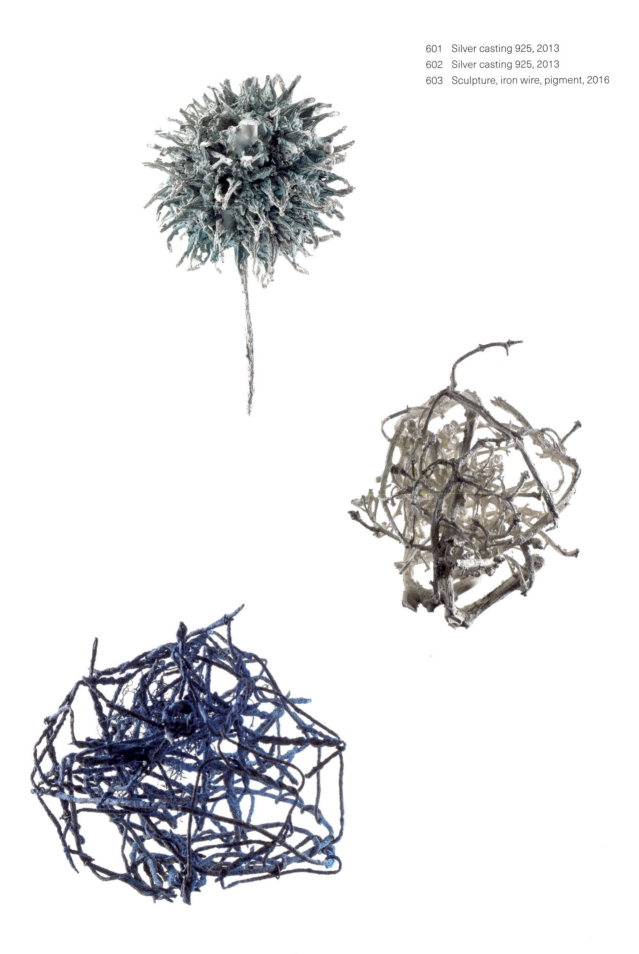

604, 605 Sculptures, iron wire, rock, 2014

606　Form, paper, silver leaf, 2013
607　Form, silver 925, 2013

608 Colored, carved wood, bois de rose, 2013
609 Bronze casting, 2013

610 Brooch, yellow gold 800, 2005
611 Glass sculpture, 2004

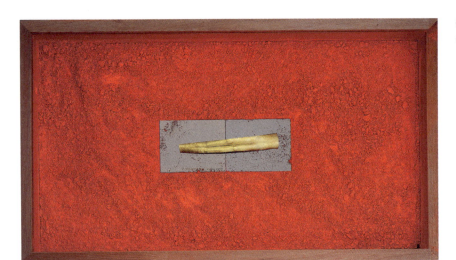

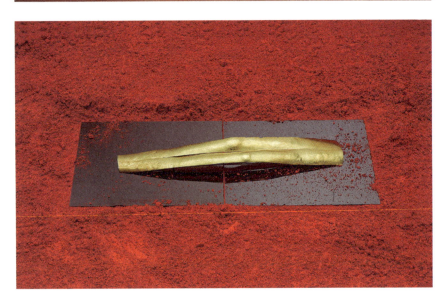

612 Brooch, yellow gold 750, 1992
613 Ring, yellow gold 800, pigment, 2004

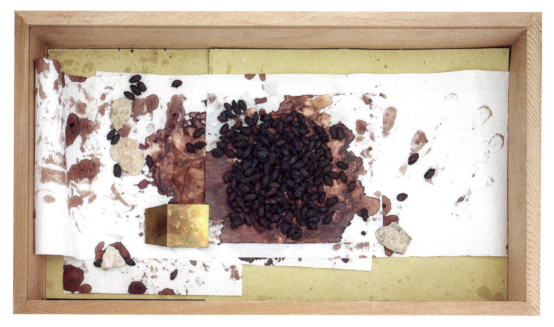

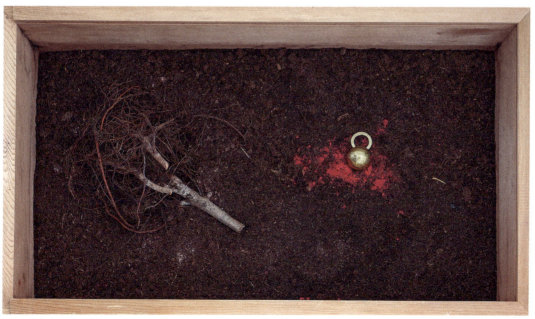

614 Branches, cast silver 925, 2013

615 Branch, cast bronze, 2013

Andrea Nante

Giampaolo Babetto: The Man, the Artist

The artist speaks through his works. Most of the time he does not know how to express himself except through his art. More than verbal eloquence he favours the language of matter, the silent thought that harmonises with a tangible sign. And Giampaolo Babetto, as well as being a craftsman-goldsmith famous all over the world for his creations, is also an artist to all intents and purposes. An artist in precisely the sense that was defined over the course of the Renaissance, starting with Ghiberti and Donatello, when the artist freed himself from craftsmanship and the goldsmith's art became increasingly associated with the greatest visual arts, basing itself on theoretical principles, seeking kindred paths and reaching the highest echelons. Babetto embodies this model: technique is the instrument that translates the idea; the mastery of the means allows him to mould the matter of which he is master. A matter that comes from nature and is destined to be intellectual, sensitive and beautiful insofar as it is an essence, and that brings him to converse with all that is deposited in tradition. Wishing to linger a little longer in the imaginative world of the Renaissance, in the case of Babetto

Giampaolo Babetto: l'uomo, l'artista

L'artista parla attraverso le sue opere, il più delle volte non sa esprimersi se non con la sua arte, all'eloquenza verbale preferisce il linguaggio della materia, il pensiero silenzioso che si accorda a un segno tangibile. E Giampaolo Babetto, oltre a essere l'orafo artigiano conosciuto in tutto il mondo per le sue creazioni, è a pieno titolo artista; artista proprio nell'accezione che viene a definirsi nel corso del Rinascimento fin da Ghiberti e Donatello, quando l'artista si affranca dall'artigianato e l'arte orafa si associa sempre più alle arti visive maggiori, basandosi su fondamenti teorici, cercando percorsi affini, raggiungendo livelli altissimi. Babetto incarna questo modello: è la tecnica lo strumento che traduce un'idea, è la padronanza dei mezzi che consente di plasmare la materia di cui è maestro; materia che proviene dalla natura e che è destinata all'essere intellettivo, sensibile, bello in quanto creatura, e che lui fa dialogare con quanto è sedimentato nella tradizione.

Se volessimo sostare ancora per poco nell'immaginifico mondo rinascimentale, nel caso di Babetto potremmo riesumare per l'appunto l'espressione umanistica di "homo faber", giacché i suoi interessi spaziano abilmente dal design all'architettura con l'intento preciso di restituire funzionalità e armonia alla vita dell'uomo e del suo

Giampaolo Babetto: der Mensch, der Künstler

Der Künstler spricht durch seine Werke. Oft kann er sich allein durch sie ausdrücken, zieht der Eloquenz der Worte die Sprache der Materie vor – das stille Denken, das sich mit fassbaren Zeichen verbindet. Giampaolo Babetto ist nicht nur ein weltweit für seine Kreationen bekannter Goldschmied, er ist Künstler. Künstler in jenem Sinne, wie er sich seit der italienischen Renaissance, seit Ghiberti und Donatello herausgebildet hat, als der Künstler sich vom Handwerker löste und die Goldschmiedekunst sich mehr und mehr den bildenden Künsten annäherte, aufbauend auf den gleichen theoretischen Grundlagen, ähnliche Wege gehend, höchstes Niveau erreichend. Babetto verkörpert diesen Typus. Technik ist für ihn das Werkzeug, das eine Idee übersetzt. Die Beherrschung ihrer Mittel erlaubt es, Materie zu gestalten, deren Meister er ist. Materie, die aus der Natur stammt und als Schöpfung dazu bestimmt ist, geistig, sinnlich, schön zu sein, und die der Künstler mit dem, was sich in der Tradition abgelagert hat, in ein Gespräch treten lässt.
Um noch einmal die Vorstellungswelt der Renaissance zu bemühen, könnte man im Fall Babettos das Humanistenwort vom Homo faber verwenden, bewegen sich seine Interessen doch virtuos vom Design bis zur Architektur mit dem einen Ziel, dem Leben und dem Habitat des Menschen Funktionalität und

we would certainly be authorised to use the humanist expression 'homo faber', since his interests range masterfully from design to architecture with the precise intention of restoring functionality and harmony to man's life and his habitat. And we can therefore fully understand why he has always drawn inspiration from a system in which the world is governed and fashioned by geometry, proportion and dynamism. These are the hallmarks of his work, revealing a clear mind and a linear mentality, matured through experience and contacts with the cultures of northern Europe and America. Further, Giampaolo Babetto works with the humble wisdom of those who find the spirit of their research in silence and in solitude, of those whose days are governed by the passage of time. Almost like a monk who seeks the essentiality of things in the perseverance of litanies and heartbeats.

Looking at his creations without knowing Babetto the man and the artist, without 'reliving the encounter between the artist creator and the object', as Romano Guardini put it, we would still be unable to understand his works and to feel wonder before them.

In *Sign and Light* (2022) at Church of San Giorgio Maggiore, Babetto illustrates the path he has pursued from the 1960s to today – more than sixty

habitat. E ben si comprende allora il suo ricondursi da sempre a un sistema in cui geometria, proporzione, dinamismo regolano e disegnano il mondo. Sono riferimenti che segnano la sua opera, rivelando una mente lucida e un pensiero lineare, maturati a contatto con esperienze e culture di paesi nordeuropei e d'oltreoceano. Vi è di più. Giampaolo Babetto opera con l'umile sapienza di chi trova nel silenzio e nella solitudine lo spirito della sua ricerca, di chi regola la giornata di lavoro attraverso lo scorrere del tempo. Quasi un monaco che nell'ostinazione di litanie e battiti cerca l'essenzialità delle cose.

Guardare alle sue creazioni senza conoscere l'uomo, l'artista Babetto, senza "rivivere l'incontro dell'artista

Harmonie zurückzugeben. Es sind Bezüge, die sein Werk kennzeichnen und einen wachen Geist und ein geradliniges Denken offenbaren, die in der Begegnung mit Erfahrungen von jenseits der Alpen gereift sind. Aber da ist noch mehr. Giampaolo Babetto handelt mit der demütigen Weisheit dessen, der in Stille und in Einsamkeit den Geist seines Wirkens findet; der den Arbeitstag vom Verfließen der Zeit regieren lässt. Wie ein Mönch, der in der Beharrlichkeit seiner Litaneien dem Wesen der Dinge auf den Grund geht, lässt Babetto beharrlich seinen Hammer pochen. Wer auf Babettos Werke blickt, ohne den Menschen und Künstler zu kennen, ohne „die Begegnung des künstlerischen Schöpfers mit dem Objekt nachzuerleben", wie Romano Guardini sagen würde, vermöchte seine Werke nicht zu begreifen und zu bewundern.

In der Ausstellung „Segno e Luce", zu sehen Anfang 2022 in der Basilika San Giorgio Maggiore in Venedig, tritt der Weg offen in Erscheinung, den Babetto von den 60er Jahren bis heute durchmessen hat. Über fünfzig Jahre

"Segno e Luce", Basilica di San Giorgio
Maggiore, Venezia, 2022

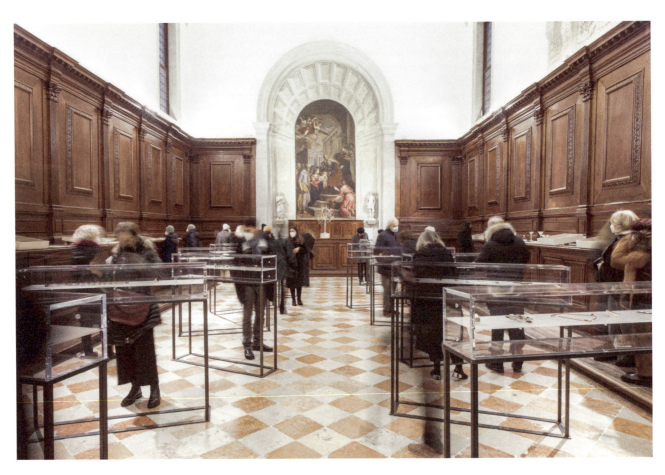

years of activity and a production that, despite the recurrence of forms and the variety of objects, reveals a constant search for spirituality in which the dimension of the sacred is defined more closely in certain circumstances. The artist goldsmith has entered the Benedictine site with a sensitivity that transcends the real, revealing it in numerous meanings and functions. We realise that objects conceived for different settings speak a single language. Thus, in the sacred space even the metal containers conceived for domestic use evoke the liturgical function of the sacred vessels displayed alongside them. They have the same shape as those designed for St Michael's Church in Munich. Reflexes and oxidation mark the time of a surface that has been bent by heat and repeated hammering, while the unalterable inner gilding glows in the transubstantiation of the Eucharistic ritual. Similar reflexes are to be found in the candleholders of various sizes. They recall those made for the church of St Martin-in-the-Fields in London: the crosses cut into the metal are an unequivocal sign; wounds open onto the fire and the hope of light in the dark night of humanity.

Giampaolo Babetto's research on the subject of the Cross led him to address one of the oldest symbols, the epitome of Christianity, emblem of an identity that is no longer only tradition. In his works these intersecting

creatore con l'oggetto", come direbbe Romano Guardini, non saremmo in grado di comprendere e provare stupore di fronte alle sue opere.

A San Giorgio Maggiore (*Segno e Luce*, 2022), Babetto rende manifesto il cammino percorso dagli anni sessanta a oggi, più di cinquant'anni di attività, una produzione che, pur tra ricorrenze di forme e varietà di oggetti, svela una ricerca costante di spiritualità, in cui la misura del Sacro è definita più prossima in alcune circostanze.

Nel contesto benedettino l'artista orafo si è potuto inserire con una sensibilità che trascende il reale rivelandolo nei tanti significati e funzioni. Ci si accorge che oggetti pensati per ambiti diversi parlano un unico linguaggio. Così, nello spazio sacro anche i contenitori in metallo, concepiti per ambienti domestici, evocano l'uso liturgico dei vasi sacri esposti insieme. Hanno la medesima forma di quelli progettati per la chiesa di San Michele a Monaco. Riflessi e ossidazioni segnano il tempo di una superficie che è stata piegata al calore e all'uso di ripetuti colpi, l'inalterabile doratura interna rifulge nella transustanziazione del rito eucaristico. Ritroviamo analoghi riflessi nei candelabri di diverse dimensioni. Ricordano quelli realizzati per la chiesa londinese di Saint Martin-in-the-Fields, i tagli incrociati sulla lamina sono segno inequivocabile, ferite aperte sul fuoco e speranza di luce nella notte umana.

La ricerca sul tema della croce ha portato Giampaolo Babetto ad affrontare uno dei simboli più antichi, simbolo

eines Schaffens, das im Kommen und Gehen der Formen, der großen Zahl von Kunstwerken dennoch eine konstante Suche nach einer spirituellen Dimension und manchmal eine große Nähe zum Sakralen erkennen lässt. Der Künstlergoldschmied hat sich in den benediktinischen Kirchenraum mit einem das Reale transzendierenden Gespür eingefügt, das die vielfältigen Bedeutungen und Funktionen des Realen offenbart. Er macht begreiflich, dass für unterschiedliche Kontexte gedachte Objekte doch eine gemeinsame Sprache sprechen. So lassen im sakralen Raum auch jene Metallgefäße, die für den häuslichen Gebrauch bestimmt sind, die rituelle Verwendung der gemeinsam ausgestellten liturgischen Gefäße anklingen. Ihre Form gleicht jener der von Babetto für die Michaelskirche in München entworfenen Stücke. Lichtreflexe und Oxydationsspuren sind Zeichen der Zeit auf einer Oberfläche, die von Hitze und Hammerschlägen in Biegung gebracht wurde. Der unvergängliche Goldschein in ihrem Inneren strahlt in der Wandlung des

lines become work and life, as demonstrated by the numerous sketches and drawings. In an entirely personal approach he has succeeded in transforming them into an informal gesture, freed of a strictly devotional reading so as to sublimate the meaning and represent the strength of the sign, intersections that are not always perpendicular, lozenge-shaped perspective angles, casting flaws, opaque surfaces, scratches, memories of sacrifice. While in these geometries we can recognise the founts that inspired his earlier reflection, from Mondrian to the Dutch neo-plastic artists, over the last decade the echo of nature appears to be stronger. It is the nature that surrounds his home-laboratory, that changes its appearance from one day to the next, from one season to the next. The uprooted shrub, the branches of the pruned olives, the dried acanthus and beech leaves suggest forms in which matter is transformed. Upon them Babetto has designed the memory of new things. In the signs, the traces of pencil or ink of the numerous drawings, we can find these same fragments of nature, of life, like anatomical parts of human beings.

In the solo exhibition at San Giorgio Maggiore, Babetto placed on the large lectern in the centre of the sixteenth-century hemicycle of the choir an installation that, without being pedagogical, carries a strong theological

per eccellenza del Cristianesimo, emblema di un'identità che non è solo più tradizione. In lui queste linee così intersecate divengono lavoro, vita, e i tanti schizzi e disegni lo provano. Grazie a un approccio del tutto personale, ha saputo renderle gesto informale, liberate da una lettura rigorosamente devozionale per sublimare il loro significato e rappresentarne la forza del segno. Incroci non sempre perpendicolari, tagli prospettici "a diamante", sbavature di fusione, opacità di superfici, graffi, memoria del sacrificio. Se in queste geometrie riconosciamo le fonti che ispirano la sua prima riflessione, Mondrian e gli artisti del neoplasticismo olandese, nell'ultimo decennio appare più forte l'eco della natura, quella natura che circonda la sua casa-laboratorio, che muta di aspetto di giorno in giorno, di stagione in stagione. L'arbusto estirpato, i rami degli ulivi potati, le foglie di acanto e dei faggi rinsecchite suggeriscono forme che trasformano la loro materia. Su di esse Babetto ha disegnato la memoria di cose nuove. Nei segni, nelle tracce a matita o a inchiostro dei tanti disegni raccolti ritroviamo gli stessi frammenti di natura, di vita come parti anatomiche di esseri umani. Nella personale di San Giorgio Maggiore, Babetto mette sul badalone, al centro dell'emiciclo cinquecentesco del coro, un'installazione dal richiamo fortemente teologico, senza tuttavia essere didascalica. È ispirata a *Jesse*, il padre di re David, da cui ha inizio la *Genealogia Christi*. Quel legno di cui Cristo è germoglio, si riveste di oro e prima ancora di elevarsi affonda le sue radici nel profondo

eucharistischen Ritus wieder auf. Ein vergleichbarer Widerschein geht auch von den unterschiedlich groß dimensionierten Kerzenleuchtern aus. Sie erinnern an die für die Kirche von Saint-Martin-in-the-Fields in London entstandenen Leuchter. Wie dort sind die in die Metallhaut geritzten Kreuzschnitte auch hier unübersehbare Zeichen, über dem Feuer aufgerissene Wunden und zugleich Sinnbild für die Hoffnung auf Licht im Dunkel des Menschlichen.
Die Beschäftigung mit dem Zeichen des Kreuzes hat Giampaolo Babetto zur Auseinandersetzung mit einem der ältesten Symbole, dem Symbol des Christentums schlechthin, geführt, dem Sinnbild einer Identität, die nicht mehr allein als Tradition verstanden werden kann. Bei Babetto werden die sich durchkreuzenden Linien zu Arbeit, zu Leben – zahlreiche Zeichnungen und Skizzen legen Zeugnis davon ab. Aus einer gänzlich individuellen Perspektive heraus hat der Künstler die Linien in eine abstrakte Geste verwandelt, befreit vom Zwang zur frommen Lesart. Er sublimiert ihre Bedeutung und macht die

Palazzo Pitti, Florence, 2007

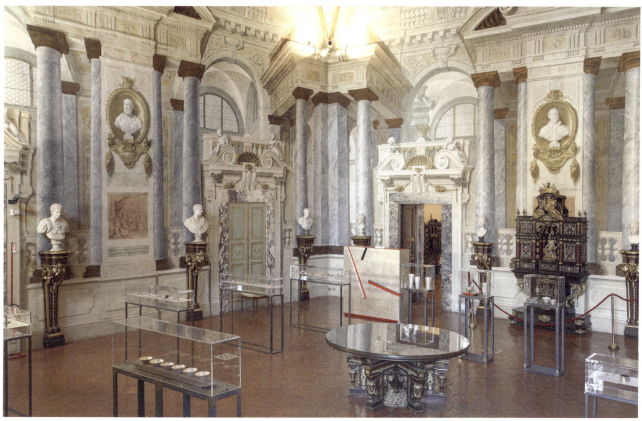

Panorama view, "Ispirazioni", Museo Diocesano, Padova, 2013

charge. It is inspired by Jesse, the father of King David, the origin of the genealogy of Jesus. The wood of which Christ is the bud is clothed in gold and before rising upwards sinks its roots into the deep Herculaneum blue covering the top of the antique lectern. In this tangle of roots and branches there is life, the life that is the song sung to the antiphonaries laid upon the large lectern. God-made man has earthly roots; the transcendence originates in the immanence of the organic material. The golden light clothes humanity and assigns it celestial dignity. Conversation makes way for contemplation, it is the time of the Spirit, and the language of nature in its simple syntax reveals to us higher things, only seemingly incomprehensible. Giampaolo Babetto draws inspiration from nature, synthesising it in a personal abstractism that reflects his thought and continual spiritual research. From the noblest material to the simplest or the most artificial, what transpires is a gaze that is free towards what the artist sees and what surrounds him. There are stories and encounters to be found in the objects and works, as well as in his serene introspection. For this very reason it is a gaze that is a sacralisation of life.

What Babetto calls *Pure and Impure* are none other than two components of the same essence that find completeness in the diptych as in life. This

blu Ercolano steso sul piano del mobile antico. Nel groviglio di radici e rami c'è vita, la vita che è canto intonato sugli antifonari posati sul grande leggio. Il Dio fatto uomo ha radici terrene, la trascendenza prende origine nell'immanenza della materia organica; l'oro-luce ricopre l'umanità e le assegna dignità celeste. La conversazione lascia spazio alla contemplazione, è il tempo dello Spirito, e il linguaggio della natura, nella sua semplice sintassi, ci rivela le cose più alte, solo apparentemente incomprensibili.

Dalla natura Giampaolo Babetto trae ispirazione facendone sintesi in un personale astrattismo che riflette il suo pensiero e la continua ricerca spirituale. Dalla materia più nobile a quella più semplice o artificiale traspare lo

Kraft des Zeichens wieder sichtbar. Kreuzungsformen ohne rechten Winkel, prismenförmige Perspektivschnitte, Gussspuren, Opazität von Oberflächen, Ausgekratztes, Gedächtnis des Opfers.
Sind in diesen Geometrien Mondrian und die Formensprache von De Stijl als anfängliche Inspirationsquellen des Künstlers erkennbar, wird im letzten Jahrzehnt das Echo der Natur im Werk Babettos immer vernehmbarer. Natur, die Babettos Wohnhaus und Werkstatt umgibt; Natur, die Tag für Tag und Monat für Monat in wechselndem Gewand erscheint. Ein ausgerissener Strauch, geschnittene Ölzweige, trockene Blätter von Buche und Akanthus: Erscheinungsformen eines Gestaltwandels von Materie.
In sie hat Babetto Neues eingeschrieben. In den Strichen, den Bleistift- oder Tuschespuren aus der großen Sammlung seiner Zeichnungen kehren die Bruchstücke der Natur, des Lebens, als Körperglieder menschlicher Anatomien wieder.
In Venedig zeigt Babetto auf dem großen Lesepult im Rund des frühbarocken Chorgestühls von San Giorgio Maggiore eine Arbeit, die starke theologische Bezüge aufweist, ohne plakativ zu sein (siehe Abb. S. 70/71). Das Werk nimmt das Motiv der *Wurzel Jesse* auf, der mittelalterlichen Verbildlichung des auf Jesse, den Vater des biblischen Königs David zurückreichenden Stammbaums Jesu. Das Holz, aus dem Christus entsprossen ist, umkleidet sich mit Gold. Bevor es in die Höhe wächst, senkt es seine Wurzeln tief in einen Grund aus herkulanischem Blau. Im Gewirr der Wurzeln und der Zweige lebt

is a duality already identified in the artist's production in a publication by Germano Celant (1996) when he describes how Babetto 'aspires to retie the knot between spirit and matter, joining male and female, natural and artificial, past and present in the purifying vortex of gold.' His very jewels encapsulate contrasts, as the artist himself likes to recall: 'heavy-light, solid-void, modern-traditional ... that merge into one another'.

For Babetto the signs and the geometries are a way of conceiving the world, of interpreting it. They are elements that he needs to experience the essentiality that is now sought by 'reducing everything to the minimum, even to just matter'. And the observation, the listening – like the graphic elaboration that is an essential phase of the project – are conditions essential to his creative process. The large number of drawings conserved in the archive at Arquà that are part of the graphic work of study illustrate the *modus operandi* of an craftsman artist whose craft, as already mentioned, has more to do with thought and art than with production alone. These are repeated studies in pencil or pen in which colour is sometimes used to gradually delineate the forms, albeit without arriving at the perfection that is reserved for the finished and inhabited matter. And it is precisely the jewels that document the evolution of Babetto's spiritual thought: matter that comes to

sguardo libero nei confronti di ciò che l'artista vede e lo circonda; negli oggetti, nelle opere si ritrovano storie, incontri e anche la sua serena introspezione. Uno sguardo che proprio per questo è di sacralizzazione della vita.

Quelli che lui chiama *Puro e Impuro* altro non sono che due componenti della stessa essenza e che nel dittico come nella vita trovano completezza. È una dualità che già Germano Celant (1996) individua nella produzione dell'artista che "aspira a ricucire il nodo tra spirito e materia, congiungendo, nel vortice purificatorio dell'oro, maschile e femminile, naturale e artificiale, passato e presente". I suoi stessi gioielli sono oggetti di contrasti, come l'artista stesso ama ricordare: "pesante-leggero, pieno-vuoto, moderno-tradizionale... che si fondono nell'uno".

I segni e le geometrie sono per lui un modo di concepire il mondo, di interpretarlo. Sono elementi che gli servono per vivere l'essenzialità, oggi ricercata "riducendo tutto al minimo, quasi la sola materia". E l'osservazione, il mettersi in ascolto come la rielaborazione grafica, fase imprescindibile del progetto, sono condizioni necessarie del suo processo creativo. La grande quantità di disegni conservati nell'archivio di Arquà, parte del lavoro grafico di studio, è l'attestazione del *modus operandi* di un artigiano artista, il cui mestiere, come si diceva più sopra, ha più a che fare con il pensiero e l'arte che con la sola produzione: iterazioni a lapis, a penna su cui a volte il

dasselbe Leben wie im Gesang der einstmals auf dem großen Holzpult aufgestellten Chorbücher. Der von Gott geschaffene Mensch hat irdische Wurzeln. Transzendenz nimmt ihren Ursprung in der Immanenz der organischen Materie. Goldenes Licht umschließt die Menschennatur und verleiht ihr die Würde des Himmels. Konversation lässt Raum für Kontemplation, die Zeit des Geistes ist angebrochen. Die Sprache der Natur in ihrer Einfachheit enthüllt die erhabensten, nur scheinbar unbegreiflichen Dinge.

Giampaolo Babetto bezieht seine Inspiration aus der Natur und verdichtet diese zu einer individuellen Abstraktion, die das Denken des Künstlers ebenso reflektiert wie seine unaufhörliche spirituelle Suche. Die edelsten nicht anders als die schlichtesten oder auch synthetischen Materialien im Werk des Paduaner Goldschmieds verraten den freien Blick des Künstlers auf das, was er sieht und was ihn umgibt. In seinen Werken verbergen sich Geschehnisse und Begegnungen, es spricht aber auch die Stille der Introspektion.

life, minimal objects that, from sculptures to be worn, become fragments of corporeal architecture, intimate poems that converse with those who wear them. And they don't
have to be made of precious metal. A shard of stone, a piece of bark or a crumpled piece of paper speaks of precious humanity in the same way. They convey the essence of a life, of everyday experience.

There is another component that emerges in Babetto's poetics, a sort of marker that in some phases of his career is more visible and pronounced. Namely, the great artists of the past, those who have left indelible traces and still have a great deal to say. This exchange with the art of the past has always been present in Babetto, who has felt it to be the inevitable starting point. Knowing how to listen, to retrieve the memory of a tradition became crucial passages for him to generate initial ideas, unforeseen suggestions. These are often translated into simple geometries, and at other times are transformed into authentic poetry, for instance when he looks at the masters of the Tuscan Renaissance, at Donatello and Pontormo.

At the end of the 1980s Babetto found himself working in Florence. The impact of the monumental architecture designed in the early Renaissance and the Mannerist culture that matured at the Medici court in the first half

colore va gradualmente a delinearne la forma senza però pervenire a una perfezione, poiché essa viene riservata alla materia finita e abitata.

E sono proprio i gioielli a documentare l'evoluzione del suo pensiero spirituale, materia che si anima, oggetti minimali che da sculture da indossare divengono frammenti di architettura corporale, poesie intime che dialogano con chi li porta. E non conta siano di metallo nobile. Una scheggia di pietra, un resto di corteccia o una carta accartocciata parlano altrettanto di preziosa umanità. Comunicano l'essenza di un vissuto, di una quotidianità.

Nella sua poetica emerge un'altra componente, una sorta di marcatore, che in alcune fasi del suo percorso si fa più visibile e dichiarato. E sono i grandi artisti del passato, coloro che hanno tracciato solchi indelebili e hanno ancora molto da dire.

Il confronto con l'arte antica è sempre stato presente in Babetto, lo ha sentito come inevitabile punto di partenza. Il saper mettersi in ascolto, recuperare la memoria di una tradizione, diventano per lui passaggi fondamentali che generano prime idee, impreviste suggestioni che il più delle volte si traducono in semplici geometrie, altre si trasformano in vere e proprie poesie e questo accade quando guarda ai maestri del Rinascimento toscano, a Donatello, a Pontormo.

Alla fine degli anni ottanta Babetto si trova a lavorare a Firenze; l'impatto con l'architettura monumentale proget-

Ein Blick, der gerade deshalb eine Sakralisierung des Lebens umfasst. Was Babetto *Puro e Impuro*, Reines und Unreines, nennt, ist nichts anderes als die zwei Grundelemente desselben Wesens, welche in dem so betitelten Diptychon einander ebenso ergänzen wie im Leben. Germano Celant (1996) hat diese Dualität im Werk Babettos benannt, der, so der Theoretiker der Arte Povera „den Knoten zwischen Materie und Geist neu zu knüpfen versucht, indem er im reinigenden Strudel des Goldes Männliches und Weibliches, Natürliches und Künstliches, Vergangenheit und Gegenwart zusammenführt."

Babettos Schmuckarbeiten sind Kontrastobjekte. Er selbst hat es immer wieder betont: „Schwer und leicht, erfüllt und leer, modern und traditionell ... in Eins verschmolzen." Linien und geometrische Formen sind für Babetto eine Art, die Welt aufzufassen, sie zu interpretieren; Elemente, die er benutzt, um das Wesentliche zu gewinnen, dem heute die Suche gilt, „indem alles auf ein Minimum reduziert wird, fast bis zur

of the sixteenth century was incisive and fostered meditation on the figurative art of the great masters. He was particularly attracted by the work of Pontormo at the Certosa of Galluzzo and in the Capponi Chapel in Santa Felicità. Indeed, Babetto returned several times to the subject of the *Deposition from the Cross* in various brooches, as he did to certain motifs in the decoration of the Medici Villa of Poggio a Caiano. Details that can be recognised as Pontormo-type contours were nevertheless transfigured by the original slant of the reliefs, by the vibration of the metallic surface and by the colours of the pigments used. They became citations resonating with his state of mind, with passages of his personal life.

The same is true of the wooden *Crucifix* of Santa Maria dei Servi in Padua, recently attributed to Donatello. Once again, it provided Babetto with the opportunity to meditate on a great masterpiece of Italian art and to return to the theme of the Cross and the mystery of suffering. At the 2013 exhibition *Inspirations*, held at the Museo Diocesano di Padova, Babetto allowed himself to be stimulated by an almost unknown fourteenth-century Venetian painter, Nicoletto Semitecolo. Gazing at the *Trinity* and the *Scenes from the Life of Saint Sebastian*, Babetto sought in the most telling details the traces of his human experience: the superimposed hands of the Father and the

tata nel primo Rinascimento e la cultura manierista maturata alla corte medicea nella prima metà del Cinquecento, è incisivo e dà origine a meditazioni sull'arte figurativa dei grandi maestri. In particolare, ad attrarlo è il Pontormo della Certosa del Galluzzo e della Cappella Capponi in Santa Felicita. Sul tema della *Deposizione di Gesù*, il Maestro infatti ritornerà più volte in alcune spille, come pure sui motivi della decorazione della villa medicea di Poggio a Cajano. Dettagli riconoscibili in sagome pontormesche vengono tuttavia trasfigurati dal taglio originale dei rilievi, dalla vibrazione della superficie metallica, dalle cromie dei pigmenti usati. Diventano citazioni che risuonano sullo stato d'animo, su passaggi di vita personali. Accade così anche per il *Crocifisso* ligneo di Santa Maria

bloßen Materie". Das Beobachten, das Zuhören der zeichnerischen Ausarbeitung, die für Babetto untrennbar zur Entwurfsphase gehört, sind notwendige Voraussetzung des kreativen Prozesses. Die große Zahl an Entwurfszeichnungen, die der Künstler in seinem Archiv in Arquà aufbewahrt, ist ein Zeugnis des *modus operandi* eines Künstlers und Handwerkers, dessen Profession, wie bereits hervorgehoben, mehr mit Denken und Kunst gemein hat als mit bloßem Herstellen: Iterationen in Bleistift oder Tusche, zuweilen tritt Farbe hinzu, die Form wird schrittweise herausgearbeitet, ohne je zum Stadium der Perfektion zu gelangen, denn diese ist der durchgeformten Materie vorbehalten.

Es sind gerade auch Babettos Schmuckarbeiten, die die Entwicklung seines spirituellen Denkens dokumentieren: beseelte Materie, minimalistische Objekte, auf dem Leib zu tragende Skulpturen, Bruchstücke einer körperlichen Architektur, intime Gedichte, im Gespräch mit dem, welcher sie trägt. Welches Material, spielt dabei keine Rolle: Ein Steinsplitter, ein Stück Rinde, ein Stück Papier sprechen nicht weniger vom Reichtum des Menschlichen, von der Essenz des Gelebten, vom Schatz des Alltäglichen als das edelste aller Metalle.

In Babettos künstlerischer Poetik spielt ein weiterer Faktor eine Rolle, eine Art ‚Marker', der in manchen Werkphasen besonders sichtbar und explizit wird. Die Rede ist von der Präsenz der großen Künstler der Vergangenheit, jener, die eine unauslöschliche Spur hinterlassen und noch vieles zu sagen haben. Die Aus-

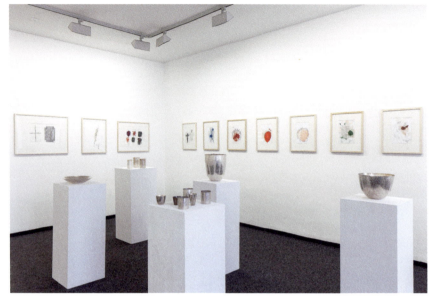

Galerie Fred Jahn, Munich, 2016

"Ispirazioni", Museo Diocesano, Padova, 2013

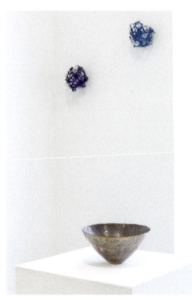

dei Servi (Padova), da pochi anni restituito a Donatello. È ancora una volta l'occasione per lui di meditare su un grande capolavoro dell'arte italiana, di ritornare sul tema della croce e del mistero della sofferenza. Nell'ambito della mostra *Ispirazioni* del 2013 al Museo Diocesano di Padova, si lascia provocare da un pittore veneziano del Trecento, pressoché sconosciuto, Nicoletto Semitecolo. Davanti alla *Trinità* e alle *storie di san Sebastiano*, Babetto cerca nei dettagli più incisivi le tracce della sua esperienza umana: le mani sovrapposte del Padre e del Figlio, la freccia del martirio del santo diventano segni parlanti di un corpo che si plasma nell'alterità, a contatto con quanto circonda l'essere umano, sia esso amore o offesa, torto subito. La palma trasposta nel metallo più prezioso,

einandersetzung mit den Alten Meistern war für Babetto immer ein unabdingbarer Ausgangspunkt seiner Arbeit. Die Fähigkeit, auf die Überlieferung zu hören und sie sich zu eigen zu machen, gehört zur künstlerischen Grundhaltung des Paduaners. Sie vermittelt erste Ideen, gibt unerwartete Richtungen vor, die sich meist in einfachen geometrischen Gedanken niederschlagen, zuweilen auch in poetischen Formfindungen. So ergeht es Babetto, wenn er auf die toskanischen Renaissancemeister blickt, auf Donatello, auf Pontormo.

Ende der 80er Jahre arbeitet Babetto in Florenz. Die Architektur der Frührenaissance und die manieristische Kultur am Hof der Medici aus der ersten Hälfte des 16. Jahrhunderts hinterlassen bleibende Eindrücke bei Babetto und werden zum Ursprung von Meditationen über die künstlerische Formensprache der großen Meister. Besondere Anziehung üben die Bilder Pontormos in der Kartause von Galuzzo und der Cappella Capponi in der Kirche Santa Felicita auf Babetto aus, der das Thema der *Kreuzabnahme* in mehreren Broschen-

arbeiten aufgreift wie auch Motive aus den Fresken der Medicivilla in Poggio a Caiano. Versatzstücke von Umrissen aus Pontormos Fresken kehren wieder – verwandelt durch die vibrierende Reliefkontur der Metallarbeit und die Chromatik des verwendeten Pigments – und werden zu Reminiszenzen, die das Innere des Künstlers in seinen Lebensphasen spiegeln.

So auch im Fall des hölzernen Kruzifix der Servitenkirche in Padua, das vor einigen Jahren Donatello zugeschrieben werden konnte. Babetto

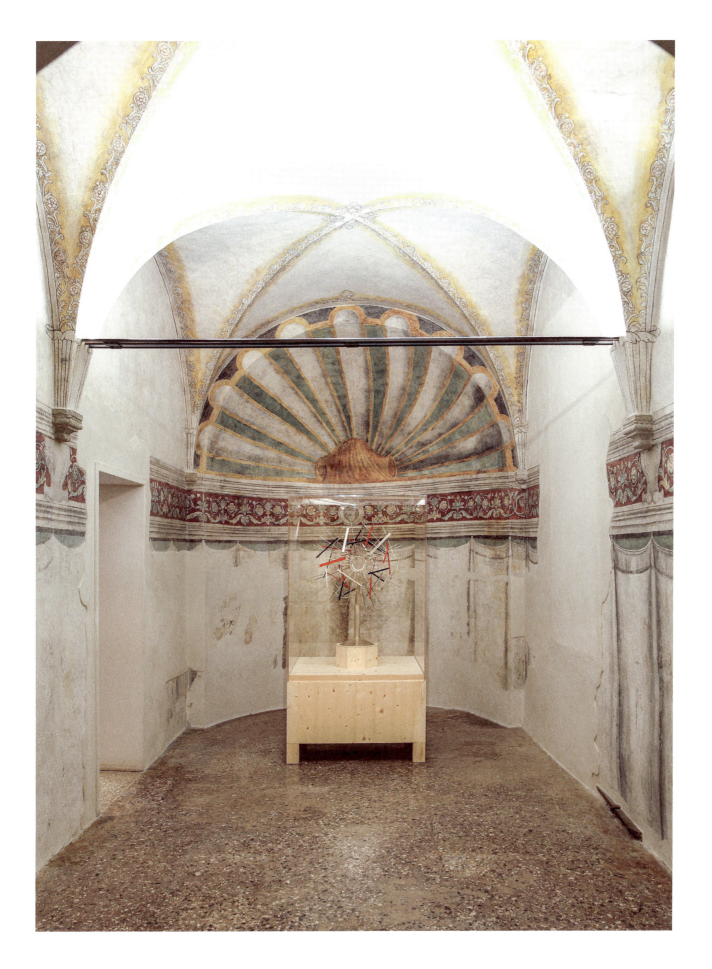

Son and the Saint's arrow of martyrdom became the speaking signs of a body moulded in otherness, in touch with what is around the human being, whether it is love or offence or wrong suffered. The palm transposed into the most precious metal, the felicitous echo of the gold ground of Venetian tradition, reinforces the idea of the triumph of life over death. It is pinned to the breast, just like the arrows that strike our bodies every day. This was the inspiration for the *Martyrs*, surfaces pierced by small rods, curved lines suggesting anatomies, species of shrouds laid over offended bodies. For those close to him it is easy to imagine to whom the artist pays greatest attention and from whom he draws inspiration.

More recently the search for transparency and new luminosity has led Babetto to insert into his jewels more or less regular fragments of vitreous material in warm, acid colours, sometimes also selected in cooler shades. And it is this very exploration of the artificial material of glass that leads to his very latest plastic results in which the purity of form is combined with the capacity of a body to transmit rays of light contaminated by signs, irregularities and different colours.

These are glass sculptures produced using the lost wax casting technique, where the negative cast is subjected to extremely high temperatures,

felice eco del fondo oro di tradizione veneziana, rafforza l'idea del trionfo della vita sulla morte. La si appunta al petto, proprio come le frecce che ogni giorno colpiscono il nostro corpo. Da queste nascono i *Màrtiri*, superfici trafitte da piccole aste, tratti ricurvi che suggeriscono anatomie, sorta di sudari stesi su corpi oltraggiati. Per chi gli è vicino è facile immaginare a chi l'artista rivolge la sua principale attenzione e da cui prende ispirazione.

Più recentemente la ricerca di trasparenze e di nuove luminosità porta Babetto a inserire nei gioielli frammenti più o meno regolari di materiali vitrei dai colori acidi, caldi, talvolta selezionati nei toni più freddi. Ed è proprio questa indagine sulla materia artificiale del vetro a condurlo ai più ultimi esiti plastici, in cui la purezza di forme

gibt einen abermaligen Anstoß, über das Werk eines der großen Meister der italienischen Renaissance zu meditieren und das Thema von Kreuz und Leidensmysterium wiederaufzugreifen. Auch für die Ausstellung mit dem Titel „Ispirazioni" im Diözesanmuseum von Padua 2013 lässt er sich von einem nahezu unbekannten Maler aus dem 14. Jahrhundert, Nicoletto Semitecolo, herausfordern. Im Angesicht von dessen *Dreifaltigkeit* und den *Szenen aus der Sebastianslegende* des Venezianers sucht Babetto in ihren ausdrucksstärksten Details nach Spuren der menschlichen Existenz. Die ineinander ruhenden Hände von Gott-Vater und Gott-Sohn, die Pfeile im Leib des Blutzeugen – sie werden zu sprechenden Zeichen eines Körpers, der in der Andersheit geformt wird, in Berührung mit dem, was dem Menschen widerfährt, ob innigste Liebe oder schmachvoll erlittene Gewalt. Die Palme, die Babetto hier in das wertvollste aller Metalle überträgt (Echo des Goldgrunds der venezianischen Malerei), betont den Gedanken des Triumphs des Lebens über den Tod. Sie werden an die Brust gesteckt wie die Pfeile, die tagtäglich unseren Körper treffen. So entsteht Babettos Werkreihe *Martiri*, von kleinen Stäben durchbohrte Flächen, geschwungene Konturen, die Körperformen erahnen lassen wie Schweißtücher auf misshandelten Leibern. Wer den Künstler kennt, dem fällt es nicht schwer, sich vorzustellen, woher dieser seine Inspiration schöpft.

In jüngeren Schmuckarbeiten verwendet Babetto in einem neuerwachten Streben nach Licht und Transparenz mehr oder weniger regelmäßig ge-

melting the pieces of coloured glass that flow into all the tiny details of the prepared mould. Matter that burns gives off light; the pieces of coloured glass merge into each other to yield a colour that is more or less transparent, more or less opaque. The colours dilate and invade the grooves carved out to design the sign that is impressed on our retina. At first glance what our eyes are struck by is the block of glass, a simple polyhedron; then suddenly the idea of what has always been thought becomes clear. Not cerebral visions. The rays traverse the mass saturating its volume, infusing luminosity into what surrounds it. Baltic amber, midnight blue and carmine red reveal the sign that everything seems to lead to. It is matter and light, it is symbol, and what it is made of is *the entity of being*.

si combina con la capacità di un corpo di trasmettere radiazioni luminose contaminate da segni, ruvidità e cromie diverse.
Sono sculture di vetro realizzate con la tecnica della cera persa in alto spessore, nella cui forma negativa, posta a temperature altissime, vanno a fondersi pezzi di vetro colorati destinati a recuperare tutti i dettagli della cavità predefinita. La materia che brucia restituisce luce, i vetri pigmentati si fondono insieme per ritornare colore più o meno trasparente, più o meno opacizzato. I colori dilatano e invadono i solchi scavati a disegnare quel segno che si imprime sulla nostra retina. A un primo sguardo si impone ai nostri occhi il blocco di vetro, un semplice poliedro, poi improvvisamente si palesa l'idea di ciò che è stato pensato da sempre. Non visioni cerebrali. I raggi attraversano la massa saturandone il volume, e infondono luminescenza a ciò che è intorno. L'ambra del Baltico, il blu della notte, il rosso carminio rivelano il segno a cui tutto sembra ricondurre. È materia e luce, è simbolo, quello di cui è fatta *l'entità dell'essere*.

formte Versatzstücke aus Glasmaterialien teils in stechenden, teils in warmen, manchmal auch kälteren Farbtönen.
Auf Babettos Auseinandersetzung mit Glas als plastischem Material gehen auch seine jüngsten Arbeiten zurück. Puristische Grundformen und die Strahlkraft des transparenten Mediums verbinden sich mit rauen, von Spuren gezeichneten Oberflächentexturen, unter denen sich chromatische Kontraste entfalten. Die Glasskulpturen werden im Wachsausschmelzverfahren mit einem massereichen Gusskern hergestellt. Unter hohen Temperaturen wird dabei auch farbiges Glas in vorgeformte Strukturen gegossen. Erhitzte Materie setzt Licht frei, farbige Glasmasse verschmilzt zu mehr oder weniger transparenten Farbpartien, dringt in die Furchen der Gussform, füllt sie aus, läuft über. So entsteht die plastische Formenzeichnung, die auf unserer Netzhaut ihren Abdruck hinterlässt. Auf den ersten Blick erkennen wir nur einen schlichten Glasblock. Aber dann scheint darin plötzlich die Idee auf, die immer schon gedacht wurde. Keine zerebralen Visionen. Lichtstrahlen durchdringen die Materie und sättigen die Form, werfen einen Schimmer auf alles rings herum. Der Bernsteinton des Baltikum, das Blau der Nacht, Karminrot bringen zum Vorschein, worauf alles hinauszulaufen scheint. Es ist Materie und Licht, es ist Sinnbild – das, woraus *die Einheit des Seins* gemacht ist.

Appendix
Appendice
Anhang

Chronology
Cronologia
Chronologie

1947	Born in Padova, Italy, lives and works in Arquà Petrarca.
1969-83	Lecturer at Istituto d'Arte "P. Selvatico", Padova.
1979-80	Visiting lecturer at the Rietveld Academie, Amsterdam.
1983	Visiting lecturer at the Rietveld Academie, Amsterdam.
1984	Concept and architectural design of the exhibition "Gioiello: Arte Contemporanea d'Austria", Ateneo di San Basso, Biennale di Venezia.
1985	Professor at the Fachhochschule, Düsseldorf.
1987	Visiting lecturer at the San Diego University, USA.
1990	Professor at the Royal College of Art, London.
1993	Visiting lecturer at the Sommerakademie, Graz.
1994	Visiting lecturer at the Rhode Island School of Design, Providence, USA.
1995	Professor at the Sommerakademie, Salzburg.
1996	Visiting lecturer at the Rhode Island School of Design, Providence, USA.
1998	Professor at the Sommerakademie, Salzburg.
2002	Project of the Marunouchi Building, Mitsubishi Estate Co. Ltd., Tokyo.
2004	Collaboration with the Pastoe Fabriek, Utrecht, for the table design "Quadro". Design and execution of a medal for the Comune di Arquà Petrarca on the occasion of celebrating the 700th anniversary of the birth of Francesco Petrarca.
2006	Executes silver objects for ceremony services for the church St. Michael, München.
2007	Workshop at the school "Le Arti Orafe", Lucca.
2008	Workshop at the school "Le Arti Orafe", Lucca. Executes the "Ostensorio" in silver for the church St. Michael, München, and the new "Teca per il Sacro Cingolo Mariano" in white gold and silver, Prato.
2009	Workshop at the school "Le Arti Orafe", Firenze.
2012	Project of Padiglione Nardini spazio "Bolle", Bassano del Grappa.
2015/16	Executes Candleholders, Chalice and Paten in silver for The Dick Sheppard Chapel, St Martin-in-the-Fields, London.
2018	Executes a table set in brushed silver, "Foundamentals" by Studio Swine and Giampaolo Babetto, for Doppia Firma.

Solo Exhibitions
Mostre Personali
Einzelausstellungen

2022	Giampaolo Babetto, Museo Civico di Asolo; "Segno e Luce", Basilica di San Giorgio Maggiore, Venezia.
2021	Caterina Tognon, Venezia.
2019	Giampaolo Babetto/Carlo Scarpa, Istituto Italiano di Cultura, Paris.
2018	Galerie Heike Curtze, Wien.
2017	Galerie Heike Curtze, Wien.
2016	Caroline Van Hoek Gallery, Bruxelles; Galerie Naïla de Monbrison, Paris; Galerie Fred Jahn, München.
2015	Galleria Antonella Villanova, Firenze.
2014	Giampaolo Babetto "lavori su carta", Galerie Fred Jahn, München; Giampaolo Babetto "La dolce vita", Caroline Van Hoek Gallery, Bruxelles; Galerie Heike Curtze, Salzburg; Giampaolo Babetto "Argenti", Dommuseum, Salzburg.
2013	"Ispirazioni", Museo Diocesano, Padova; Galerie Heike Curtze, Salzburg.
2012	Galerie Heike Curtze, Wien.
2011	Museum im Palais, Universalmuseum Joanneum, Graz; Galerie Heike Curtze, Wien.
2010	Die neue Sammlung, Pinakothek der Moderne, München; Galerie Fred Jahn, München; Galerie Heike Curtze, Wien.
2009	Associazione Culturale Maurer Zilioli – Contemporary Arts, Brescia.
2008	Museo dell'Opera del Duomo "Le Volte", Prato.
2007	Palazzo Pitti, Museo degli Argenti, Firenze.
2006	Design Flanders, Bruxelles.
2005	Galerie Heike Curtze, Wien; Galerie Heike Curtze, Salzburg; Galerie Fred Jahn, München; Nardini Centro Ricerche e Auditorium, Bassano del Grappa (VI).
2004	Galerie Heike Curtze, Salzburg.
2003	Scuderie Medicee, Poggio a Caiano; Eurema Interni, Dolo;

2002	Internationales Design Zentrum, Berlin.	1986	Gallery VO, Washington.	2015	"Glamour", Museum Villa Stuck, München; Galleria Alessandro Bagnai, Firenze; "A cross/The cross", Caroline Van Hoek Gallery, Bruxelles; The European Fine Art Fair (TEFAF), Maastricht; "Miart", Galleria Antonella Villanova; Caroline Van Hoek Gallery, Design Miami/Basel, Basel.
	Galerie Handwerk, München.	1985	Galerie Orfrèvre, Düsseldorf.		
2001	Galerie Fred Jahn, München; Museum für Angewandte Kunst, Frankfurt; Galerie Zell am See, Zell am See; Galleria Marcolongo, Padova.	1984	Galerie CADA, München; Galerie am Graben, Wien.		
		1983	Schaufenster Nr. 34, München; Galerie am Graben, Wien; Galerie Nouvelles Images, Den Haag.		
2000	Museo Correr, Venezia; Gewerbemuseum, Winterthur; Heike Curtze & Suse Wassibauer, Salzburg.	1981	Galerie Nouvelles Images, Den Haag.		
		1980	Art Wear Gallery, New York; Harcus Kracow Gallery, Boston; Galerie Orfrèvre, Düsseldorf.	2014	"Glamour", Cagnes-sur-Mer; "Positionen des Gestaltens", Galerie Handwerk, München; The European Fine Art Fair (TEFAF), Maastricht; "The Bright House", Galleria Antonella Villanova, Firenze; Caroline Van Hoek Gallery, Design Miami/.
1998	Galerie Naïla De Monbrison, Paris; Taideteollisuusmuseo, Helsinki; Galerie Heike Curtze, Salzburg.				
1997	Galerie Fred Jahn, München; Palazzo del Monte di Pietà, Padova; Galerie Figl, Linz; Galerie Heike Curtze, Düsseldorf.	1977	Stedelijk Museum, Amsterdam; Galerie Nouvelles Images, Den Haag; Gemeentelijk Van Reekum Museum, Apeldoorn.		
		1976	Electrum Gallery, London.	2013	The European Fine Art Fair (TEFAF), Maastricht; "Gioiello Italiano Contemporaneo. Maestri", Palazzo Thiene Bonin Longare, Vicenza; Caroline Van Hoek Gallery, Bruxelles; "Sconfinamenti/Disgressioni", Piano Nobile Pedrocchi, Padova; "Inediti accostamenti", Studio GR.20, Padova.
1996	Galerie Heike Curtze, Wien; Loggia Rucellai, Firenze; Galerie Heike Curtze, Düsseldorf; Galerie Magari, Barcelona; Franklin Parrasch Gallery, New York.	1974	Galleria della Trinità, Roma.		
		1973	Galerie Nouvelles Images, Den Haag.		
		1972	Galerie Nouvelles Images, Den Haag.		
1995	Peggy Guggenheim Collection, Venezia; Galerie Heike Curtze, Wien; Galerie Heike Curtze, Salzburg; Museu Tèxtil i d'Indumentària, Barcelona; Galerie Zell am See, Zell am See; Fanourakis Jewellery, Athens; National Gallery of Victoria, Melbourne.	**Group Exibitions** **Mostre Collettive** Ausstellungsbeteiligungen		2012	"4 Padovani e un Torinese", Maurer Zilioli Contemporary Arts, Brescia; "Giampaolo Babetto & Anna Heindl", Galerie Sofie Lachaert, Tielrode; "Mirrors and candles" Galerie Sofie Lachaert, Tielrode; Caroline Van Hoek Gallery, Bruxelles; "Maestri e opere dell'arte orafa", Museo delle Arti e dei Mestieri, Cosenza; "The Beauty Chase", Espace Le Carré, Lille; "Incontro Giampaolo Babetto e Rudolf Bott", Galerie Rosemarie Jäger, Hochheim.
		2019	The European Fine Art Fair (TEFAF), Maastricht.		
		2018	"Rigore e libertà", Fondazione Marino Marini, Pistoia; "Le Ruée vers l'or", Galerie Naïla de Monbrison, Paris; Galleria Antonella Villanova, Design Miami/Basel, Basel; The European Fine Art Fair (TEFAF), Maastricht.		
1994	Neue Galerie der Stadt Linz; Museum für Konkrete Kunst, Ingolstadt; Galerie Figl, Linz.				
1993	Museum für Kunst und Gewerbe, Hamburg; Galerie Herta Zaunschirm, Zürich-Zollikon; Galleria Mauro Brucoli, Milano.				
		2017	"Corpo, Movimento Struttura", MAXXI, Roma; Galleria Antonella Villanova, Design Miami/Basel, Basel; "Intrecci preziosi", Museo del Gioiello, Vicenza; "Forgiato", Handwerkskammer für München und Oberbayern, München; "Medusa", Musée d'Art Moderne de la Ville de Paris, Paris.	2011	The European Fine Art Fair (TEFAF), Maastricht; "Omaggio a Guariento", L'oro contemporaneo, Studio GR.20, Padova; Caroline Van Hoek Gallery, Bruxelles.
1992	Musée d'Art Moderne et d'Art Contemporain, Nizza; Kunstverein, Düsseldorf.				
1991	Galerie für Modernen Schmuck, Frankfurt; Galerie CADA, München; Galerie Thaddaeus Ropac, Salzburg.				
				2010	The European Fine Art Fair (TEFAF), Maastricht.
1990	Galerie Louise Smit, Amsterdam.			2009	"Nuovi Segnali", Eurema interni, Dolo; "Still Life", Galerie Sofie Lachaert, Tielrode.
1989	Provinciaal Museum voor Moderne Kunst, Oostende; Galerie Nouvelles Images, Den Haag.	2016	Galleria Antonella Villanova, Artgenève, Genf; "Miart", Galleria Antonella Villanova, Milano; "Brilliant! The Futures of Italian Jewellery", La Triennale di Milano, Milano; "Turmspitzen", Galerie Orfrèvre, Düsseldorf; Museo Poldi Pezzoli, Milano; "Private Confessioni", CODA Museum Apeldoorn; Museum Villa Stuck, München.		
1987	Galleria Stevens, Padova; Galerie Kunstformen Jetzt, Salzburg; Galerie Herta-Zaunschirm, Zürich-Zollikon; Galerie CADA, München; Lucy Jordan Galerij, Oostende.			2008	"Gioielli d'autore, Padova e la scuola dell'oro", Palazzo della Ragione, Padova; Galerie Fred Jahn, München; "Gioiello Italiano Contemporaneo", Palazzo Valmarana Braga, Vicenza; "Zeitgenössische Schmuckkunst der Italieni-

	schen Avantgarde", Galerie Stühler, Berlin; "Eternal Platinum", Triennale di Milano, Milano.		tional Craft Triennal", Art Gallery of Western Australia, Perth and Power House Museum, Sydney.
2007	"GlassWear", Museum of Arts and Design, New York; "Gioiello Italiano Contemporaneo", Fiera di Vicenza, Vicenza; "Giampaolo Babetto, Young-Jae Lee, German Stegmaier e Riccardo de Prà", Casa Camilla, Arquà Petrarca.	1989	"Ornamenta I", Pforzheim.
		1988	"Biennale Svizzera del gioiello d'Arte Contemporanea", Villa Malpensata, Lugano; "Tragezeichen", Museum Morsbroich, Leverkusen; "Segnali per il corpo 2", Studio Pao, Milano; Studio GR.20, Padova.
2006	Affaires Culturelles, Cagnes-sur-Mer; Sculpture Objects & Functional Art Fair (SOFA), New York; Marijke Studio, Padova; "Plastica, Oro Contemporaneo", Studio GR.20, Padova; Venice Design Gallery, Venezia; "Armonici Contrasti", Le Arti Orafe, Firenze; Galerie Marzee, Nijmegen.	1987	"Schmuck: Zeichen am Körper", Museum Francisco-Carolinum, Linz; "Europea Joieria Contemporània", Fundaciò Caixa de Pensions, Barcelona; "Aspetti dell'Arte Italiana", Galerie Nouvelles Images, Den Haag; Biennale du Bijou, Paris.
2005	Triennale di Milano, Milano; "Transformations", National Gallery of Australia, Canberra.	1986	Galerie Wim van Krimpen, Amsterdam; "Prestige and Art", Seibu Department Store, Tokyo; XIV Biennale del Bronzetto, Padova; "Nove artisti di scuola padovana", Museo Civico Eremitani, Padova; Art Gallery San Diego State University, San Diego; Craft and Folk Museum, Los Angeles; Concepts Gallery, Palo Alto; Hoffman Gallery, School of Art and Craft, Portland, Oregon; Concepts Gallery, Carmel, California; Bellevue Art Museum, Bellevue.
2004	Galleria Paolo Marcolongo, Padova.		
2001	Rhode Island School of Design Museum (RISD Museum), Providence; American Craft Museum (ACM), New York.		
1996	"New Times, New Thinking: Jewellery in Europe & America", Crafts Council Gallery, London.		
1995	Musée des Arts Décoratifs, Lausanne.		
1994	"In Touch", de Sandvigske Samliger, Lillehammer; "Schmuckszene 94", Internationale Schmuckschau, München.	1985	Geementen Museum, Den Haag; Galerie Nouvelles Images, Den Haag; Galerie Werkstatt, Berlin; "Goldsymposium", Handwerkskammer, Köln.
1993	"93 The Art of Jewellery", Japan Jewellery Designers Association (JJDA), Tokyo; "Facet 1", International Jewellery Biennale, Kunsthal Rotterdam.	1984	"Contemporary Jewellery America, Australia, Europe and Japan", National Museum of Modern Art, Kyoto and National Museum of Art, Tokyo; "Jewellery International" American Craft Museum, New York.
1993	"13 Goldschmiede: von Amsterdam bis Tokyo," Bayerische Akademie der Schönen Künste, München.		
1992	Triennale du Bijou, Musée des Art Décoratifs, Paris; Centrum Beeldende Kunst, Groningen.	1983	"International Jewellery Art Exibition", Isetan Art Museum, Tokyo and Nabio Gallery, Osaka; "10 Orafi padovani", Schmuckmuseum, Pforzheim; Deutsches Goldschmiedehaus, Hanau; Diamanten Museum, Antwerpen; Bellerive Museum, Zürich; "Material" Schmuck und Gerät, Sonderschau der Internationalen Handwerksmesse, München.
1991	"Europäisches Kunsthandwerk", Haus der Wirtschaft, Stuttgart.		
1989-90	Galerie Thaddaeus Ropac, Salzburg; Galerie Slavik, Wien; "Gioielli e legature Artisti del XX secolo", Biblioteca Trivulziana, Milano; Triennale du Bijou, Paris; "Perth Interna-		

1982	"Schmucktendenzen 1982", Schmuckmuseum Pforzheim; "Soggetti d'oreficeria", Museo Civico, Padova.
1981	"Art 12/81 Kunstmesse", Electrum Gallery, London; Galerie Teufel, Köln.
1980	"Schmuck International 1900/1980", Künstlerhaus, Wien.
1979	Galerie Thomas, München.
1977	"Schmucktendenzen", Schmuckmuseum Pforzheim.
1975	Galerie Nouvelles Images, Den Haag; "Form + Qualität", Internationale Schmuckschau, München.
1970	Museum Boijmans Van Beuningen, Rotterdam; Arte del Metallo, Gubbio.
1967	"Form + Qualität" Internationale Schmuckschau, München; Galleria Bevilacqua La Masa, Venezia.

Awards
Onoreficenze
Auszeichnungen

2022	Archeometra Lifetime Achievement Award
2019	Wallpaper* Design Award "Best stealth health", "Fundamentals" table set by Giampaolo Babetto and Studio Swine, for Doppia Firma.
2018	MAM – Maestro d'Arte e Mestiere.
2012	Andrea Palladio International Jewellery Awards, Vicenza; Sigillo della Città di Padova, Padova.
2003	RISD New York Athena Awards for "excellent carrier", Providence.
1998	Ring of Honour, Gesellschaft für Goldschmiedekunst, Hanau.
1991	Goldmedaille des Freistaates Bayern, München.
1985	Herbert Hoffmann Preis, München.
1983	Grand Prix, Japan Jewellery Design Association, Tokyo.
1975	Herbert Hoffmann Preis, München.

Public Collections
Collezioni Pubbliche
Öffentliche Sammlungen

Schmuckmuseum, Pforzheim.
Die neue Sammlung – The Design Museum. Permanent Loan from the Danner Foundation, München.
Victoria and Albert Museum, London.
National Gallery of Western Australia, Perth.
Musée des Art Décoratifs, Paris.
Musée d'Art Moderne et d'Art Contemporain, Nice.
National Museum of Scotland, Edinburgh.
Museum für Kunst und Gewerbe, Hamburg.
Nordenfjeldske Kunstindustrimuseum, Trondheim, Norway.
Kunstgewerbemuseum, Berlin.
Museum für Konkrete Kunst, Ingolstadt.
Museu Textil i d'Indumentaria, Barcelona.
Museum of Art, Rhode Island School of Design, Providence, Rhode Island, USA.
Museum für Angewandte Kunst, Frankfurt.
Grassi Museum, Leipzig.
Musei Civici, Complesso Museale Palazzo Zuckermann, Padova.
National Gallery of Australia, Canberra.
Museo degli Argenti, Firenze.
Universalmuseum Joanneum, Graz.
Die Neue Sammlung – The Design Museum, München.
Los Angeles County Museum of Art, Los Angeles.
Metropolitan Museum of Art, New York.
Museum of Fine Arts, Houston, The Helen Williams Drutt Collection.
Hermitage Museum Foundation, New York.
Museo Diocesano, Padova.
Ilias Lalaounis Jewelry Museum, Athína.
Cooper Hewitt, Smithsonian Design Museum, New York.
Schweizerisches Nationalmuseum, Zürich.
Dallas Museum of Arts, The Edward W. and Deedie Potter Rose Collection (former Inge Asenbaum Collection, Wien), Dallas.
Fondazione MAXXI – Museo Nazionale delle Arti del XXI secolo, Roma.
Kolumba, Kunstmuseum des Erzbistums Köln.

Selected References
Selezione Bibliografica
Auswahlbibliographie

[Exh. cat.] Sieraden. Galerie Nouvelles Images. Den Haag 1973.

[Exh. cat.] Giampaolo Babetto. Stedelijk Museum, Amsterdam. Den Haag 1977.

[Exh. cat.] Schmuck 77 – Tendenzen. Schmuckmuseum im Reuchlinhaus. Pforzheim 1977.

[Exh. cat.] Kunst – Schmuck: 26 Goldschmiede. Galerie Thomas. München 1978.

[Exh. cat.] Babetto. Art Wear Gallery, New York. Den Haag 1980.

[Exh. cat.] Schmuck international 1900–1980. Künstlerhaus. Wien 1980.

[Exh. cat.] Schmuckmuseum Pforzheim. Von der Antike bis zur Gegenwart. Pforzheim 1981.

[Exh. cat.] Schmuck 82 – Tendenzen? Schmuckmuseum im Reuchlinhaus. Pforzheim 1982.

[Exh. cat.] International Jewellery Art Exhibition. The 5th Tokyo Triennial. Isetan Art Museum. Tokyo 1983.

[Exh. cat.] Material. Schmuck und Gerät. Sonderschau der Internationalen Handwerksmesse. München 1983.

[Exh. cat.] 10 Orafi Padovani. Moderne Goldschmiedekunst aus Italien. Schmuckmuseum im Reuchlinhaus. Pforzheim 1983.

[Exh. cat.] Ando, Babetto, Bischoff, Marx. Galerie Mattar. Köln 1984.

[Exh. cat.] Contemporary Jewellery: The Americas, Australia, Europe and Japan. The National Museum of Modern Art. Kyōto 1984.

[Exh. cat.] Form, Formel, Formalismus. Schmuck 1985. Sonderschau der Internationalen Handwerksmesse. München 1985. Cartlidge Barbara, Twentieth-Century Jewelry. New York 1985.

[Exh. cat.] 25 Jahre Galerie Nouvelles Images. Haags Gemeentemuseum. Den Haag 1985.

[Exh. cat.] 14. Biennale Internazionale del Bronzetto Piccola Scultura, Padova 1986. Palazzo della Ragione. Padova 1986.

[Exh. cat.] Giampaolo Babetto. Oreficerie. Galleria Stevens Arte Contemporanea. Padova 1987.

[Exh. cat.] Schmuck: Zeichen am Körper. Linzer Institut für Gestaltung (ed.). Oberösterreichisches Landesmuseum, Francisco Carolinum, Linz. Wien 1987.

[Exh. cat.] Biennale du Bijou. Hotel de Sens, Bibliotheque Forney. Paris 1987.

[Exh. cat.] Arte Italiana. Aspecten van hedendaagse Italiaanse kunst. Galerie Nouvelles Images. Den Haag 1987.

[Exh. cat.] Joieria Europea Contemporània. Fundació Caixa de Pensions. Barcelona 1987.

[Exh. cat.] Tragezeichen. Stadt Leverkusen (ed.), Der Oberstadtdirektor. Museum Morsbroich. Leverkusen 1988.

[Exh. cat.] Biennale Svizzera del Gioiello d'Arte Contemporaneo. Villa Malpensata. Lugano 1988.

[Exh. cat.] Giampaolo Babetto. Provinciaal Museum voor Moderne Kunst. Oostende 1989.

[Exh. cat.] Giampaolo Babetto da Pontormo. Studio Ton Berends. Den Haag 1989.

[Exh. cat.] Erlhoff Michael, Fritz Falk, Jens-Rüdiger Lorenzen et al. (eds.). Ornamenta 1, Internationale Schmuckkunst. Schmuckmuseum im Reuchlinhaus, Pforzheim. München 1989.

[Exh. cat.] Gioielli e Legature. Artisti del XX Secolo. Biblioteca Trivulziana. Milano 1990.

[Exh. cat.] 30 jaar Nouvelles Images. Galerie Nouvelles Images. Den Haag 1990.

[Exh. cat.] Schmuck Europa '90. Beispiele zeitgenössischer Gestaltung. Sonderschau Internationale Frankfurter Herbstmesse, Frankfurt a. M. Ulm 1990.

[Exh. cat.] Europäisches Kunsthandwerk 1991. Haus der Wirtschaft. Stuttgart 1991.

[Exh. cat.] Neoteric Jewelry. Snug Harbor Cultural Center. Staten Island 1991.

[Exh. cat.] Babetto – Konzeptueller Schmuck. Kunstverein für die Rheinlande und Westfalen. Düsseldorf 1992.

[Exh. cat.] Giampaolo Babetto. Studio Ton Bernds. Den Haag 1992.

[Exh. cat.] Der Stamm des Tannenbaumes ist das Herz des Schmuckes (von innen nach außen]. K-Raum Daxer. München 1992.

[Exh. cat.] IIleme Triennale du Bijou. Musée des Arts Décoratifs. Paris 1992.

[Exh. cat.] Ringe. Galerie Michèle Zeller. Bern 1992.

[Exh. cat.] Giampaolo Babetto „I vuoti d'oro". Galleria Mauro Brucoli. Milano 1993.

[Exh. cat.] Schmuck: Die Sammlung der Danner-Stiftung. Bestandskatalog. Schriftenreihe des Bayerischen Kunstgewerbevereins e.V., Heft 4. Galerie für angewandte Kunst. München 1993.

[Exh. cat.] 13 Goldschmiede. Von Amsterdam bis Tokyo. Bayerische Akademie der Schönen Künste. München 1993.

[Exh. cat.] Kunststoff Schmuck Kunst 1923–1993. Galerie Biró. München 1993.

[Exh. cat.] Facet 1. International Jewellery Biennale. Kunsthai, Rotterdam. Gent 1993.

[Exh. cat.] '93 The Art of Jewellery. Japan Jewellery Designers Association. Setagaya Art Museum. Tokyo 1993.

[Exh. cat.] Giampaolo Babetto Ritratti. Museum für Konkrete Kunst, Ingolstadt. Padova1994.

[Exh. cat.] Weber-Stöber Christianne (ed.), Schmuck und Gerät unserer Zeit. Deutsches Goldschmiedehaus, Hanau. München/Berlin 1994.

[Exh. cat.] Schmuck unserer Zeit 1964–1993. Museum Bellerive. Zürich 1994.

[Exh. cat.] Schmuckszene '94. Internationale Schmuckschau. Sonderschau der 46. Internationalen Handwerksmesse. München 1994.

[Exh. cat.] "Gli Ori" di Giampaolo Babetto alla Collezione Peggy Guggenheim. Palazzo Venier dei Leoni. Venezia 1995.

[Exh. cat.] Lippuner Rosmarie, Quatre createurs de bijoux contemporains. Giampaolo Babettto, Gijs Bakker, Johanna Dahm, Daniel Kruger. Musée des Arts Décoratifs. Lausanne 1995.

[Exh. cat.] Italian Gold. Contemporary Italian Goldsmiths: Giampaolo Babetto, Francesco Pavan. National Gallery of Victoria. Melbourne 1995.

[Exh. cat.] Turner Ralph, Jewelry in Europe and America. New Times, New Thinking. Crafts Council Gallery. London 1996.

[Exh. cat.] Folchini Grassetto Graziella (ed.), Gioielli. Arte Programmata e Cinetica. Studio GR.20. Arti Applicate XX secolo. Padova 1996.

[Exh. cat.] Subjects 96. International Jewellery Art Exhibition. Retretti Art Centre, Punkaharju, Finnland. Helsinki 1996.

[Exh. cat.] British Gold – Italian Gold. The Scottish Gallery. Edinburgh 1998 Dictionnaire International du Bijou. Paris 1998.

[Exh. cat.] Game Amanda u. Elizabeth Goring, Jewellery moves: Ornament for the 21st century. National Museums of Scotland. Edinburgh 1998.

[Exh. cat.] Falk Fritz u. Cornelie Holzach, Schmuck der Moderne 1960–1998. Bestandskatalog der modernen Sammlung des Schmuckmuseums Pforzheim. Stuttgart 1999.

[Cat.] World Contemporary Craft Now. Cheongju International Craft Biennale 99. Cheongju 1999.

[Exh. cat.] Folchini Grassetto Graziella (ed.), Gioielleria Contemporanea in Europa. Casino Municipale di Venezia. Venezia 2000.

[Exh. cat.] Babetto 1996–2000. Geometrie di Gioielli. Museo Correr. Venezia 2000.

[Exh. cat.] Alamir Marie u. Carole Guinard, Parures d'ailleurs, parures d'ici: incidences, coïncidences. Musée de design et d'arts appliqués contemporains. Lausanne 2000.

[Exh. cat.] Walgrave Jan, The Ego Adorned. 20th-Century Artists' Jewellery. Koningin Fabiolazaal. Antwerpen 2000.

[Exh. cat.] Felderer Brigitte, Erika Keil and Herbert Lachmayer (eds.), Alles Schmuck. Museum für Gestaltung, Zürich. Baden/Schweiz 2000.

[Exh. cat.] A View by Two: Contemporary Jewelry. Museum of Art, Rhode Island School of Design. Providence 2001.

[Exh. cat.] The Art of Jewelry and the Artists Jewels in the 20th Century. Museo degli Argenti. Firenze 2001.

[Exh. cat.] Radiant Geometries. American Craft Museum. New York 2001.

[Exh. cat.] Giampaolo Babetto. Gioielli di cultura. Galerie Handwerk; München. Prato 2002.

[Cat.] La Collection de Bijoux du Musée des Arts Décoratifs à Paris. Paris 2002.

[Exh. cat.] Babetto, JewelDesignArtLink. Schmuck und Möbel 1968–2003. Internationales Design Zentrum. Berlin 2003.

[Cat.] Recovery of Use. The International Invitational Exhibition 2003. The International Committee of Cheongju (ed.) International Craft Biennale, Korea. Cheongju 2003.

[Exh. cat.] Jewellery, the Choice of the Europarliament. Bringing art and parliamentarians together. Europäisches Parlament, Bruxelles. Nijmegen 2004.

Le Van Marthe (ed.), 1000 Rings. Inspiring Adornments for the Hand. New York 2004.

[Exh. cat.] Schmuck 2005. Sonderschau der 57. Internationalen Handwerksmesse. München 2005.

[Exh. cat.] Il design dellagioia: il gioiello fra progetto e ornamento. Triennale di Milano. Milano 2004.

[Exh. cat.] Il Selvatico, una scuola per l'arte dal 1867 a oggi. Palazzo del Monte di Pieta und Istituto d'Arte „P. Selvatico". Padova 2006.

[Exh. cat.] Bijou contemporain. Regard sur l'Italie. Martinazzi, Babetto, Zanella. Espace Solidor. Cagnes-sur-Mer 2006.

[Exh. cat.] Leidenschaft – Lieblingsschmuckstücke. Schriftenreihe des Bayerischen Kunstgewerbe-Vereins e. V., Vol. 39. Galerie für angewandte Kunst. München 2006.

[Exh. cat.] Babetto gioielli e ... altro. Design Flanders, Bruxelles. Zürich 2006.

[Exh. cat.] Harmonic clashes. Le Arti Orafe Art Gallery. Firenze 2006.

[Cat.] Holzach Cornelie, Schmuckmuseum Pforzheim. Museum guide. Stuttgart 2006.

[Cat.] Casazza Ornella (ed.), Gioiello contemporaneo al Museo degli Argenti di Palazzo Pitti. Livorno 2006.

[Exh. cat.] Babetto 1967–2007. Museo degli Argenti, Palazzo Pitti, Firenze. Livorno 2007.

[Exh. cat.] Ilse-Neumann Ursula, Cornelie Holzach u. Jutta-Annette Page, GlassWear. Glass in contemporary Jewelry/Glas im zeitgenössischen Schmuck. Glass Pavillion, Toledo Museum of Art, Toledo. Stuttgart 2007.

[Exh. cat.] Strauss Cindi, Ornament as Art. Avant-Garde Jewelry from the Helen William Drutt Collection, The Museum of Fine Arts, Houston. Stuttgart 2007.

[Exh. cat.] Cisotto Nalon Mirella and Anna Maria Spiazzi, Gioielli d'Autore. Padova e la Scuola dell'oro. Palazzo della Ragione, Padova. Turin 2008.

[Exh. cat.] Cappellieri Alba, Gioiello Italiano Contemporaneo. Palazzo Valmarana Braga, Vicenza. Milano 2008.

[Exh. cat.] "Masters Gold". Major works by leading Artists. New York 2009.

[Exh. cat.] Giampaolo Babetto "L'italianità dei gioielli", Florian Hufnagl (ed.). Stuttgart 2010.

[Exh. cat.] P. Hermann Breulmann S.J., P. Friedhelm Mennekes S. J. Babetto für Sankt Michael. München. Freising 2010.

[Exh. cat.] Gioiello Contemporaneo due. Livorno 2010.

[Exh. cat.] Preziosa "Contemporary Jewellery". Le Arti Orafe. Jewellery School. Firenze 2010.

[Exh. cat.] Jewelry by Artists "In the studio 1940–2000". Selections from the Daphne Farago Collection. MFA Publications. Boston 2010.

[Exh. cat.] Gioielli del Novecento "Dall'Art Nouveau al design contemporaneo in Europa e negli Stati Uniti". Ginevra-Milano 2010.

[Exh. cat.] Roberta Bernabei (ed.) "Contemporary Jewellers", Interviews with european artists, ed. Berg, Oxford, New York 2011.

[Exh. cat.] Marthe Le Van "21st Century Jewellery". The Best of the 500 Series. New York 2011.

[Exh. cat.] Giampaolo Babetto "Ispirazioni". Museo Diocesano di Padova. Pistoia 2013.

[Exh. cat.] Cosenza Preziosa Maestri e opere dell'arte orafa, Museo delle arti e dei mestieri Cosenza 2013.

[Exh. cat.] Giampaolo Babetto "Arbeiten auf Papier 1965–2009" Galerie Fred Jahn, München. Freising 2014.

[Exh. cat.] Joya 2014. "Barcelona Art Jewellery Fair". Barcelona 2014.

[Exh. cat.] AUTORENSCHMUCK und noch mehr, Sammlung Katrin Basiner. Passau 2015.

[Exh. cat.] "A Passion for Jewellery". Barbara Cartlidge and Electrum Gallery. Stuttgart 2016.

[Exh. cat.] Il gioiello italiano del XX secolo. Milano 2016.

[Exh. cat.] "Brilliant. I futuri del gioiello Italiano". Mantova 2016.

[Exh. cat.] "Beyond Bling. Contemporary Jewelry from the Lois Boardman Collection". California 2016.

[Exh. cat.] "Private confessions. Drawing & Jewellery". Stuttgart 2016.

[Exh. cat.] "Schmuck der 1990er. Die Sammlulng Hans Schullin". Stuttgart 2017.

[Exh. cat.] "Medusa. Bijoux et Tabous", Musée d'Art Moderne de la Ville de Paris. Paris 2017.

[Exh. cat.] MAM Maestro d'arte e Mestiere seconda edizione. Brescia 2018.

[Exh. cat.] "Homo Faber. Crafting a more human future". Venezia 2018.

[Exh. cat.] Babetto/Scarpa "Architecture et bijou contemporain" Istituto Italiano di Cultura. Paris 2019.

[Exh. cat.] "Schmuck" Die Neue Sammlung Danner Stiftung. Jewelry 1920/2020. Pinakothek der Moderne München. Stuttgart 2020.

[Exh. cat.] Ring Redux. The Susan Grant Lewin Collection. Stuttgart 2021.

[Exh. cat.] Giampaolo Babetto "Segno e Luce". Basilica San Giorgio Maggiore. Venezia. Papergraf Iternational S.r.l.azienda del gruppo LOGO 2022.

Photo Credits
Crediti Fotografici
Fotonachweis

Giustino Chemello: p. 2, 13, 16, 20/21, 23, 24, 27, 33, 34/35, 38, 40, 43, 45–49, 52, 54–72, 74, 75; p. 78: nr. 31, 33; p. 81, 84, 86/87, 88; p. 90: nr. 53; p. 91: nr. 61, 62, 65; p. 93, 97–98; p. 105: nr. 100; p. 107: nr. 114, 116; p. 111; p. 114: nr. 128; p. 118: nr. 150; p. 119: nr. 161; p. 122/123; p. 127: nr. 183; p. 128: nr. 186; p. 130, 131; p. 132: nr. 191; p. 134: nr. 206; p. 135: nr. 214; p. 141: nr. 244; p. 143: nr. 261; p. 144; p. 146: nr. 269; p. 149–153; p. 155: nr. 298–300, 302; p. 156: nr. 308; p. 158–233, 239, 247, 249–268; p. 271: nr. 577; p. 272; p. 275; p. 279: nr. 593; p. 283–284; p. 285 right; p. 288–301, 304, 307–309, 314–315

Lorenzo Trento: p. 76–77; p. 78: nr. 28–30, 32; p. 79–80, 82–83, 85, 89; p. 90: nr. 49–52, 54–58; p. 91: nr. 59, 60, 63–64, 66; p. 92, 94–96, 99–104; p. 105: nr. 101–103; p. 106; p. 107: nr. 110–113, 115; p. 108–110, 112–113; p. 114: nr. 129; p. 115–117; p. 118: nr. 148, 149, 151–154; p. 119: nr. 155–160, 162/163; p. 120–121, 124–126; p. 127: nr. 177–182, 184; p. 128: nr. 185; p. 129–133; p. 134: nr. 205, 207–212; p. 135: nr. 213, 215–218; p. 140; p. 141: nr. 241–243, 245–248; p. 142; p. 143: nr. 256–260, 262, 263; p. 145; p. 146: nr. 266–268, 270–272; p. 147, 148; p. 154; p. 155: nr. 296, 297, 301; p. 156: nr. 303–307; p. 157, 236–238, 244–246, 248, 273, 274, 276; p. 277: nr. 588; p. 278: nr. 589, 591; p. 279: nr. 592; p. 280, 282–283, 285 bottom; p. 286; p. 287 bottom

Giampaolo Babetto: p. 242

Franziska Ermert and Norm Bazan: p. 270; p. 271: nr. 576; p. 277: nr. 587; p. 278: nr. 590

Tesuhito Tanaka: p. 287 top

Fred Jahn: p. 314

© 2022 Giampaolo Babetto, arnoldsche
Art Publishers, Stuttgart, and the authors

All rights reserved. No part of this work may be reproduced or used in any form or by any means (graphic, electronic or mechanical, including photocopying or information storage and retrieval systems) without written permission from the copyright holders.
www.arnoldsche.com

Authors
Fred Jahn
Friedhelm Mennekes
Andrea Nante
Thereza Pedrosa

Translations
Aelmuire Helen Cleary (Italian/English)
Joan Clough (German/English)
Dr. Achim Wurm (Italian/German)
Dania D'Eramo (German/Italian)

Copy editing
Wendy Brouwer, Stuttgart

arnoldsche project coordination
Isabella Flucher, Matthias Becher

Graphic designer
Silke Nalbach, Mannheim

Offset reproductions
Schwabenrepro, Fellbach

Printed by
Schleunung Druck, Marktheidenfeld

Bound by
Hubert & Co., Göttingen

Paper
Galaxi Supermat 170 g/qm
Magno Natural 140 g/qm

Bibliographic information published by the Deutsche Nationalbibliothek The Deutsche Nationalbibliothek lists this publication in the Deutsche Nationalbibliografie; detailed bibliographic data are available at www.dnb.de.

ISBN 978-3-89790-663-1

Made in Europe, 2022